The Dutch Painters

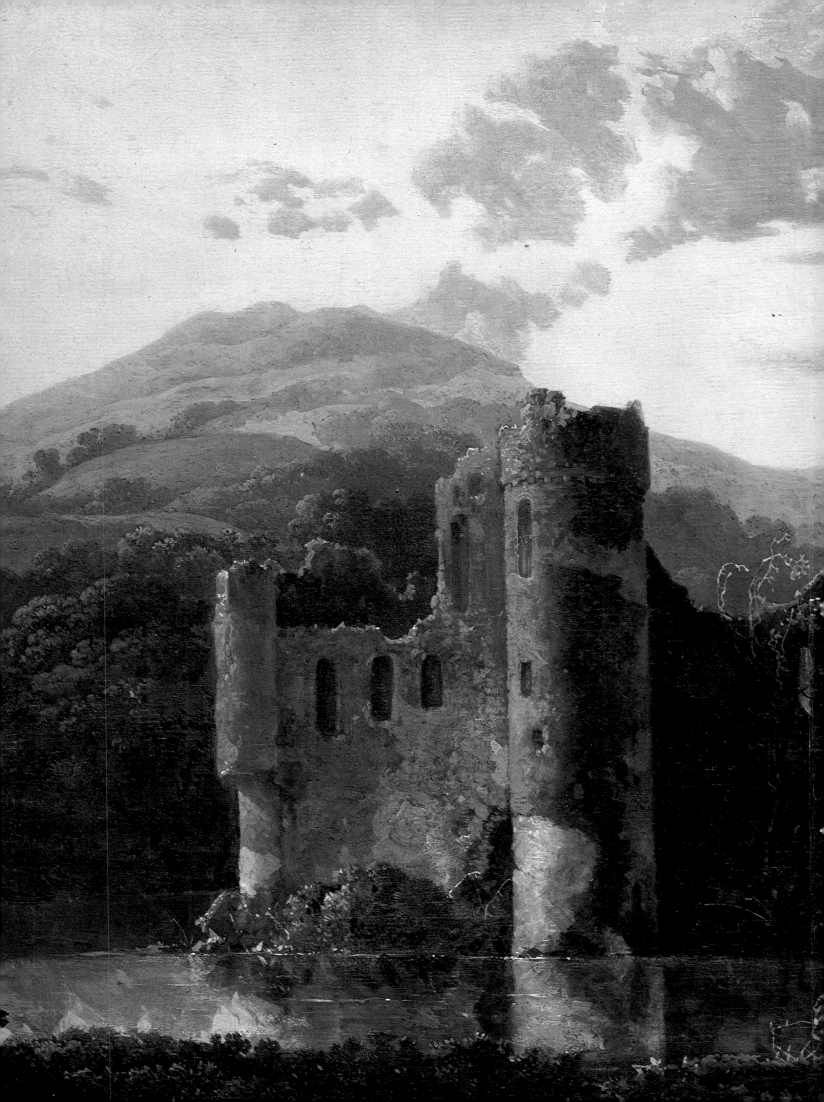

The Dutch Painters

100 Seventeenth Century Masters

Christopher Wright

ORBIS PUBLISHING · London

A complete anthology of the Dutch painters of the seventeenth century would fill several volumes; the inclusion of well over a hundred of them in this book has meant that there has been a strong element of personal choice. All the acknowledged great names are there, but I hope that the reader will forgive me if he does not find a reproduction of a particular favourite. Some painters are omitted, not because I do not consider them to be important or interesting but simply because there was not space in one book to include them all.

During the work on this book many people have been kind with those little extra things which are not always part of their official duties and which lessen an author's difficulties. I would like to mention Alex Robertson and Robert Oresko in particular, as well as the staffs of the Rijksbureau voor Kunsthistorisches Documentatie in The Hague and the Witt Library at the Courtauld Institute in London. Alan Jacobs, Claire Jacobs and William Thuillier kindly read my manuscript at proof stage and made several helpful suggestions for which I am most grateful. Anne Hunter kept a watchful eye on my efforts and offered encouragement when it was needed. I am especially grateful to John Roberts at Orbis Publishing, who has gently but firmly posed all the questions which editors ought but do not always think of asking. Lawson Nagel has been patient with my battered typescript and Steve Chapman overcame many problems in designing a book with so many reproductions. Finally I hope that Caroline and Hector, to whom this book is dedicated, will continue to enjoy and explore the infinitely varied range of Dutch painting, even from their present exile in a remote part of this country.

Christopher Wright London, March 1978

Endpapers: Pieter Claesz.'s *Still Life,* probably painted in the mid-1640s (Bristol City Art Gallery)

Title page: Aelbert Cuyp's *Ubbergen Castle,* probably painted in the mid-1650s (National Gallery, London)

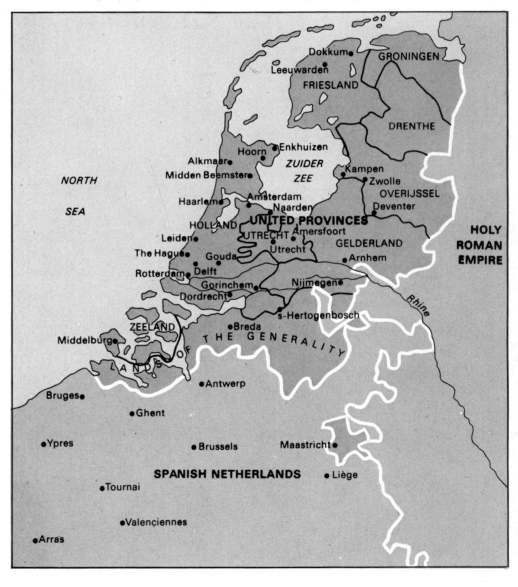

Contents

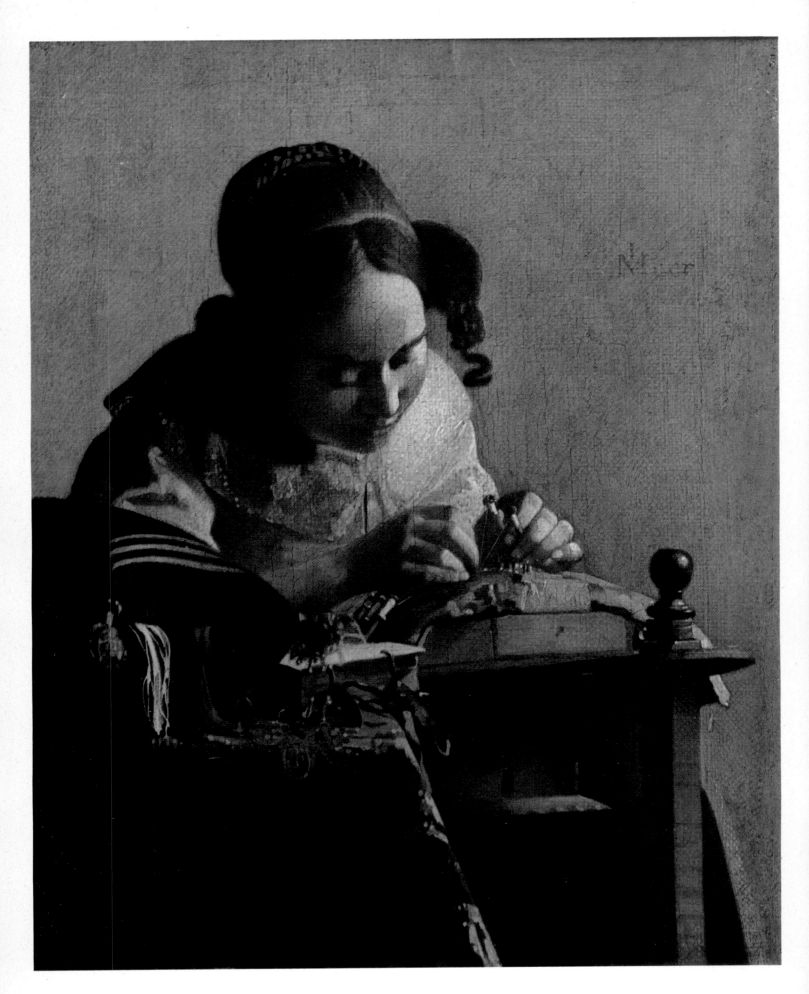

6

Introduction

Johannes Vermeer of Delft
The Lacemaker
Canvas 24 × 21 cm (9½ × 8¼ in) Signed on
the wall at the right: JvMeer. Probably
painted in the early 1670s.
PARIS, Musée du Louvre
*The miniscule scale of this picture allows
Vermeer's painstaking technique to be studied
with ease. He often uses tiny pin-points of
light to suggest the form of the object, and this
is a technique which appears throughout his
career. It has often been suggested that Vermeer
used a kind of light-box or camera obscura
to achieve the scintillating effect of the light
falling on different textures, but this has never
been fully explained.*

*The picture was first recorded in the sale of
the Delft bookseller Jacob Dissius in 1696. It
was then lost sight of until the end of the
eighteenth century. It then appeared in many
different sales, including the Laperière Sale in
Paris in 1817 in which was also Rembrandt's*
Landscape with a Bridge *(page 167). It was
acquired by the Louvre in 1890 for a relatively
small sum.*

REMBRANDT, HALS and VERMEER are rightly
considered to be the three greatest painters
of the seventeenth-century Dutch school.
They stand above an enormous number
of lesser masters who were active
throughout the Dutch Republic, and
many of these also deserve to be known
as 'great' painters—Aelbert CUYP, Meyn-
dert HOBBEMA, Pieter de HOOGH and
several dozen others. Indeed, there was
such an outburst of activity that no one
school before or since has been so prolific.

There is no simple answer to the ques-
tion of why Dutch society should have
supported so many painters of quality at
the same time. A comparison with France,
a very much larger country, provides a
striking contrast—far fewer painters were
active there, even though Louis XIV
encouraged the arts.

It has often been thought that the
Dutch painters appeared on barren soil,
but in fact they took over many ideas
from the art of the two previous cen-
turies; this earlier tradition of painting
was partly determined by the history and
geography of the Low Countries. The
structure of the Netherlands during the
fifteenth and sixteenth centuries was very
simple. They were always (apart from
small enclaves like Liège, which was ruled
by the church) under one ruler. In the
fifteenth century it was the Dukes of
Burgundy, and in the following century
the whole area from Arras to Groningen
became part of the Spanish Empire. There

was no political boundary between the
northern and southern parts of the
Netherlands, although a natural bound-
ary existed—the wide mouth of the river
Rhine, which split into many broad and
slow-flowing tributaries. The southern
part of the Netherlands was immensely
rich—indeed, it was one of the wealthiest
parts of Europe. There were the cities
of Bruges, Ghent, Arras, Tournai, Ypres,
Antwerp, Valenciennes and Brussels. The
northern part was very different as there
were far fewer towns and very much
less manufacture and trade. The largest
town, Leiden, could hardly compete with
Ghent.

The tradition of painting was equally
unbalanced between north and south. The
fifteenth century had seen a whole school
of great painters, starting with Jan van
Eyck, who worked in Ghent and Bruges
and also for the Duke of Burgundy in
his French territory. He was followed by
Rogier van der Weyden, Hans Memlinc,
Dieric Bouts and Hugo van der Goes. By
comparison there was very little artistic
activity in the north, and only in the very
last years of the fifteenth century is it
possible to see some increase.

An enquiry into which painters were
active in Haarlem, Leiden, Utrecht,
's-Hertogenbosch and several other towns
subsequently to become part of the Dutch
Republic would have been much simpler
had it not been for the calamity which be-
fell the artistic tradition of the north in the

middle years of the sixteenth century. This was the religious crisis, which took the form of a wave of anti-Catholic feeling and resulted in the complete destruction of almost all the paintings which were in the churches and monasteries. As the church was the chief patron of painting at this time, very little survived the holocaust. Even pictures by living painters were not spared, although the touching *Head of a Cow* by Pieter Aertsen, which formed part of an *Adoration of the Shepherds*, was cut from the whole composition and saved because it was thought to be so well painted.

The destruction was so effective that in the first years of the seventeenth century Carel van Mander, who wrote a history of the rise of the Netherlandish school of painting, *Het Schilderboek* (Haarlem, 1603/04), had great difficulty in finding information on painters who had lived barely a hundred years before.

A few painters have left behind them more than a handful of examples, and it is just possible to work out which artists had a wide influence on their contemporaries. The most important painter in the last years of the fifteenth century, a man who was to be influential in the

following 50 years, was the Leiden-born artist Geertgen tot Sint Jans. He died at Haarlem before he was 30, sometime in the 1490s, and van Mander mentioned his painting of the *Exterior of the Grote Kerk (St Bavo), Haarlem* which is still in the church there. Geertgen, who was primarily a religious painter, in this carefully recorded view expressed his interest in topographical painting. Pieter Jansz. SAENREDAM, painting a hundred years later, saw this very picture as he recorded part of it in his *Interior of the Grote Kerk, Haarlem* (page 180).

Geertgen's chief pupil was Jan Mostaert (Haarlem c. 1472/5–(?) 1555), who introduced a much wider range of subject-matter, especially portraiture. An astonishing picture entitled an *Episode in the Conquest of America*, plausibly attributed to Mostaert, shows how at this early date there was a pre-occupation with exotic subjects; it forms a precedent for the Haarlem painter of exotica, Frans POST.

Painting in Haarlem remained relatively isolated from the rest of the northern Netherlands, relying as it did on the influence of Geertgen. In Utrecht the general trend of painting took a different course. There was an increasing trend towards portraiture as wealth increased and more people could afford pictures. But the actual change in the style of painting can be attributed to an unexpected event. This was the election, in 1523, of the Archbishop of Utrecht to the papacy as Hadrian VI. He took with him to Rome a young and energetic painter, Jan van Scorel (Schoore 1495–Utrecht 1562) and made him official

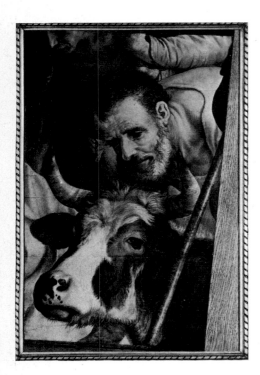

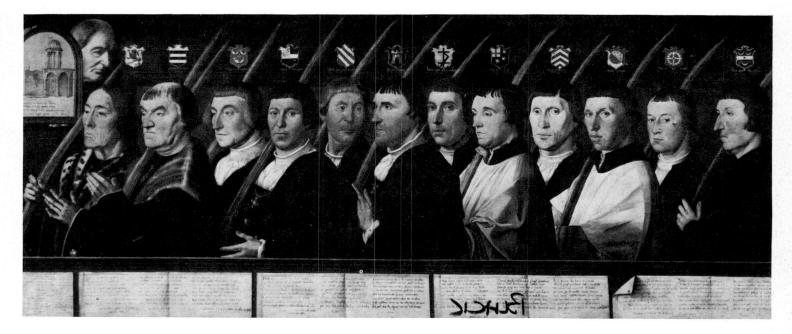

painter to the papacy. At this moment Raphael had only been dead for three years and Michelangelo was at the height of his powers; the sudden prominence of the young man from Utrecht must have caused a stir. Hadrian died after less than two years, and not surprisingly, having lost his patron, Scorel returned to the north. He brought with him a number of half-understood ideas about Italian painting which were uneasily grafted onto his own northern sensibility. Scorel was enormously influential and kept a large studio, producing complex altarpieces. His chief pupil and imitator was Maerten van Heemskerck (Heemskerk 1498–Haarlem 1574).

Scorel was also a portraitist of ability. He followed the conventions of his time when painting group portraits by placing the sitters in a long line, as in the *Knightly Brotherhood of the Holy Land at Haarlem*. But he made one great change — he observed his sitters directly and produced obvious likenesses. Previously, portraits had tended to be stereotyped images handed down by tradition. The move towards the realistic treatment of the subject is seen in Heemskerck's *Family Group*, which anticipates so much seventeenth-century group portraiture in its informal atmosphere and candid approach to the sitters.

Another tradition was practised in Amsterdam and was typified by Pieter Aertsen (Amsterdam 1508–1575). He specialized in kitchen and market scenes as well as religious pictures. Aertsen's most important pupil was the Antwerp painter Joachim Bueckelaer (Antwerp

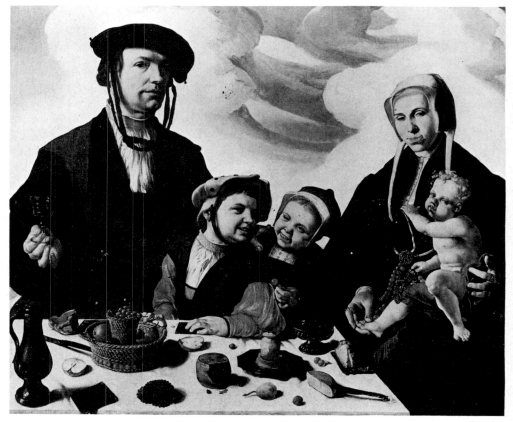

1530–1573/4), who also specialized in market scenes which were to be widely influential in the following century. His *Fish Market* looks remarkably like a seventeenth-century picture. The subject, but not the technique, is exactly what was favoured in the following century.

There is no feeling of impending crisis in the painting of the middle years of the century, and the fury of the iconoclasts must have shocked many painters and discouraged them from further activity.

Top: Jan van Scorel's Knightly Brotherhood of the Holy Land at Haarlem, *probably painted between 1527 and 1529. Unlike earlier official commissions of this type, Scorel painted accurate portraits. The artist is third from the right. (Haarlem, Frans Hals Museum)*

Above: Maerten van Heemskerck's Family Group, *painted in about 1530. The artist's informal and realistic approach is echoed in seventeenth-century Dutch portaits. (Kassel, Staatliche Gemäldegalerie)*

The religious turmoil had the sympathy of an influential proportion of the population, but the Spanish authorities saw no reason to tolerate religious dissension and attempted to reconvert the north to Catholic unity by force. This caused resistance in many but not all the towns, and the north gradually slid from the control of the Spanish authorities. This did not happen all at once, and the 1560s and 1570s were a time of misery. Alkmaar, for example, was besieged with terrible bloodshed in 1573. By the 1580s things had become calmer, even though the Spanish government in Madrid and Brussels refused to recognize the fact that parts of the northern Netherlands were now beyond their jurisdiction.

The people of the north thus found themselves in the novel position of having to set about ruling themselves, and this is how the Dutch Republic eventually came into being. The individual pockets of anti-Spanish resistance gradually coalesced into seven provinces; they were only 'United' against Spain, and throughout the seventeenth century they pursued fiercely independent and sometimes conflicting policies. The evolution of the Dutch Republic was virtually complete by about 1600, although it was not until 1648 that the Spanish government finally recognized it (see Gerard Terborch's painting, page 189, for a record of the event).

This troubled period was not an easy one for painters, who were understandably cautious about undertaking commissions for churches when their work could so easily be destroyed by a zealous Protestant. Similarly, the towns were often in such a state of administrative chaos that there were few municipal commissions.

The development of painting was hesitant. In Utrecht, which remained staunchly Catholic (although rebelling against the Spanish administration), painters were far less disturbed than elsewhere and the last years of the sixteenth century saw the establishment of Abraham BLOEMAERT and Joachim WTEWAEL. In Haarlem, painting was also re-established quite early by the active and influential CORNELIS van Haarlem, who began working in the 1580s.

All these painters were more or less influenced by Italian art, although some of them had never been to Italy. Large numbers of engravings reached the north, especially copies of the works of Michel-angelo and Raphael, and were utilized extensively by the Haarlem and Utrecht painters, who filled their pictures with figures derived from Italian works. These artists were also very active teachers, and the tradition of Italian-oriented painting died hard as Cornelis, Bloemaert and Wtewael were long-lived. The exact process by which they lost their dominance is mysterious. Nobody knows why the young Frans Hals, brought up in the severe and formal tradition of Antwerp portraiture, should suddenly have loosened his style and produced works which relied on free brushwork and an informal approach to the sitter.

The possible reasons for these changes have to be sought in the slowly changing demands of society. Official commissions —what few there were—demanded a formal Italian style, as seen in Cornelis van Haarlem's *Marriage of Peleus and Thetis*, painted in 1593 for Haarlem town hall. Even as late as the 1630s, when the Huis ten Bosch near the Hague was being decorated for the stadholder, the Italian-trained Gerrit van HONTHORST was preferred. There is, in fact, no precise turning point. Official commissions were rarely given to inventive or experimental painters, but Dutch society was ordered so that officialdom played less part in the patronage of art than in any other seventeenth-century society. Perhaps the real explanation for the diversity of Dutch seventeenth-century painting lies in the power of the individual. Mercantile wealth brings with it individual wealth. The Catholic church had been destroyed as a patron of art, and the Protestant faith had little place for religious imagery. Instead, wealthy collectors pursued their individual tastes to such an extent that in the middle years of the century Amsterdam was said to have supported 300 painters at once.

There were also several factors in common all over the country. For instance, every town, however small, had to keep companies of militia which could be drawn on if there was danger of attack by the Spanish. As security increased in the early years of the seventeenth century, these militia companies met for social purposes and often had themselves painted in full regalia. This gave rise to a convention of group-portrait painting, of which Rembrandt's *Night Watch* is the most famous example. Every town supported one or more painters who solemnly recorded the burghers, dressed

Abraham van Beyeren
Still Life
Canvas 126 × 106 cm (49⅝ × 41¾ in) Signed AVB F. Probably painted in the 1660s. AMSTERDAM, Rijksmuseum
This is an excellent example of van Beyeren's approach to the banquet-piece, to which the Dutch gave the special name Pronkstilleven. *The artist was particularly sensitive to the differing textures of the bloom of the grapes or the pith of the lemon, but the painting of the less brightly coloured crab and the chasing on the silver objects is equally brilliant. The picture was purchased by the museum in 1958.*

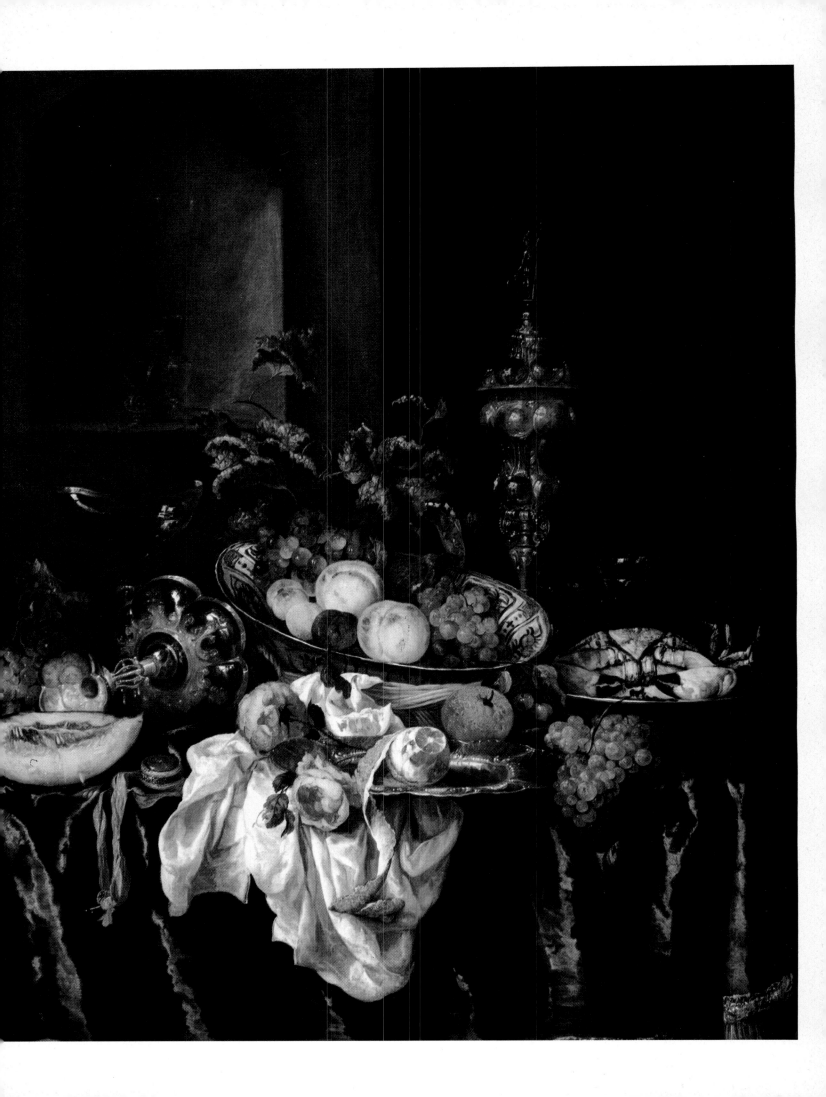

in black, and slightly less solemnly recorded the drinking bouts of the militia companies. The museums of Gouda, Hoorn, Alkmaar and the Historisch Museum of Amsterdam contain many surviving examples of this type of picture.

Although the seven provinces of the Dutch Republic had some sorts of patronage in common, they were in many ways quite different from one another. Six of them—Zeeland, Overijssel, Gelderland, Groningen, Utrecht and Friesland—were basically rural with one dominant town in each area. Drenthe and most of the area against the border with the Spanish Netherlands were ruled directly by the States General and did not count as provinces. All these areas were usually loyal to the stadholder, who had control over their military affairs. The seventh province, Holland, on the other hand, contained almost all the major cities except Utrecht. The chief places were Amsterdam, Delft, Leiden and Haarlem; The Hague and Rotterdam were of lesser importance. Holland was richer than all the other six provinces combined. The representatives from each province met at The Hague and it was there that the states jostled politically with one another, knowing that the stad-

holder, who was always a member of the Orange family, held great influence and sometimes control over six of them. But when it came to any matter which required collective action, for example the all-important issue of military expenditure, it was the seventh province, Holland, which effectively held the pursestrings. It could be said that the whole internal history of the seventeenth-century Dutch Republic was a struggle between two major factions, the rich burghers of the major cities of Holland and the interests of the stadholders.

The situation was further complicated by the diplomatic and dynastic interests of the Orange family, who repeatedly intermarried with the English Stuart dynasty. Quite often during the century Dutch and English colonial and mercantile interests clashed. This raised constant questions in the minds of republican Dutchmen as to the loyalties of the stadholder, with his dynastic connections with an enemy power. As if this was not enough, there was further consternation caused by the frequent presence of foreign royalty at The Hague as guests of the Orange family. The stadholder was not officially a sovereign for he derived his title of prince from the small principality

Above: Cornelis van Haarlem's Marriage of Peleus and Thetis, *painted for the Haarlem Town Hall in 1593. This is one of the most important surviving commissions from the last years of the sixteenth century, and it gives a clear idea of the uncompromising nature of Cornelis's style. Every pose is carefully worked out and then pieced together to form an elaborate composition. His contemporaries must have been proud of the fact that a Dutchman could produce a vast decorative canvas like this with almost the same panache as an Italian painter. (Haarlem, Frans Hals Museum)*

of Orange in the South of France. In the second and third decades of the century the exiled Elector Palatine and King of Bohemia, with his Stuart wife, Elizabeth, daughter of James I of England, lived at The Hague. Then Charles II of England paid two brief visits to the United Provinces during the period of the Cromwellian republic in England. The suspicious burghers of Amsterdam saw the presence of these exiled monarchs as a threat to their independence. They were right to be suspicious: a few years later Louis XIV of France was to intrigue with Charles II in his plans to annihilate the Dutch Republic. The result was the debacle of 1672 when Louis invaded the country, causing great destruction. The ensuing constitutional crisis and the disgrace of the republican party secured the Orange family in power for the rest of the century.

Although the Dutch could be described at this time as being a nation of bourgeois living in little towns, in small states jealous of each other, there was another side to their nature which made them great. This was their capacity for hard work and their outward-looking temperament. They sailed all over the known world, founding trading posts and colonies like New Amsterdam (later New York), Surinam in the East Indies, and South America. They became an international power based on maritime supremacy.

Their open-mindedness and commercial acumen had far-reaching effects on the artistic tradition. Amsterdam became the centre of the art market for the whole of northern Europe. The buying and selling of foreign works of art was regular. When Titian's so-called *Ariosto* (London, National Gallery) and Raphael's *Portrait of Baldassare Castiglione* (Paris, Louvre) were sold at auction in Amsterdam, Rembrandt made rapid drawings of them and the *Ariosto* certainly influenced one of his self-portraits (London, National Gallery).

The other international factor which affected the whole development of painting was the attraction of Italy, especially Rome. It became the fashion for young painters to travel southwards to seek their fortune and artistic education. Dutch painters became immensely popular in Rome and they cornered the market in small cabinet pictures, which appealed greatly to Italian taste. Those painters who returned to the north brought with them many new ideas, and new interpretations of old ones, which had far-reaching effects. Some painters, like Frans Hals in Haarlem, remained quite unaffected by the international character of Dutch painting, but an enormous number of artists, Rembrandt among them, became increasingly influenced by the richness and variety of Italian painting. One result for Rembrandt was that he developed a new richness of texture which can be attributed to his admiration for Titian. In the case of Honthorst the response was perhaps less happy, as he often copied the outward forms of Caravaggio's art without really coming to terms with his inner mentality.

Dutch painters were also able, by their enormous productivity, to dominate the market for painting in England and to an extent in France. The few official commissions in England went to Flemish or Italian painters; Charles I favoured Orazio Gentileschi, Rubens and Van Dyck, but Hendrick Gerritsz. POT and Honthorst both painted his portrait (Royal Collection and National Portrait Gallery, London, respectively). An enormous number of Dutch pictures were imported into England and Charles I even owned a self-portrait by Rembrandt (Liverpool, Walker Art Gallery) as early as 1633. Many Dutch painters also visited England for short periods to paint for specific clients.

In France the situation was rather different. The usual route for Italy, avoiding the Alps, was down the Rhône valley, and many painters stopped on the way at Lyons, where they would work for a few months. In Paris there was a group of Dutch painters who lived on the left bank of the Seine in the Saint-Germain-des-Prés area, which was just out of the jurisdiction of the Paris Guild of St. Luke. This painters' guild made repeated attempts to expel the Dutch artists from the city, as they supplied all the cabinet pictures and put the less-skilled Frenchmen out of work.

Because of a lack of information, it is very difficult to explain the richness and variety of painting throughout the Dutch Republic. By comparison, in seventeenth-century Italy it was the custom for connoisseurs and intellectuals to write biographies of great painters and to produce theoretical writings about the practise of art. It is on this enormous surviving mass of printed material that the history of Italian art in the seventeenth century can be written. Not only what happened is recorded—which pictures were painted at what time—but also what people thought about them.

When Dutch art is examined in a similar way the barrenness of the material comes as something of a shock. The fundamental source, Carel van Mander's *Schilderboek*, is useful for information about his contemporaries. This means that the first half of the careers of Abraham Bloemaert, Joachim Wtewael and Cornelis van Haarlem can be pieced together. The next book of importance was Samuel van HOOGSTRATEN's book on the theory and practise of art, *Inleyding tot de Hooge Schoole der Schilderkonst de Zichtbaere Werelt* (Rotterdam, 1678). It was not until 1718–21 that there appeared a comprehensive book on the lives of the main seventeenth-century painters; this was Arnold Houbraken's *De Groote Schouburgh der nederlandsche Konstschilders en Schilderessen*. Personal information from contemporary sources about the lives and characters of the main painters of the period is either fragmentary or non-existent. Vermeer remains a total enigma. His way of life can only be surmised; 12 children are documented, and therefore his household can in no way have resembled the exquisite calm of his pictures. In the 1630s Rembrandt wrote seven letters to his friend Constantin Huyghens, the stadholder's secretary, which have survived. These hardly illuminate his character, and his interests have to be conjectured from the inventory of the contents of his house, drawn up at the time of his bankruptcy in 1656. Hals has remained obstinately silent and it is not known whether he was a cheerful or melancholy soul. Much has been written about the social position of painters in the seventeenth century, and it has been remarked that they did not mix with royalty or government officials. This is not surprising, as these circles had little interest in art—they did not use it, as did the papacy, to increase the visual impact of their grandeur. Significantly, the largest building erected in the seventeenth century in the whole country was neither a church nor a palace, but the new town hall of Amsterdam.

The twentieth century cannot, therefore, pry into the private lives of seventeenth-century Dutch painters. What can be known has to be inferred from the surviving pictures. It is reasonable to

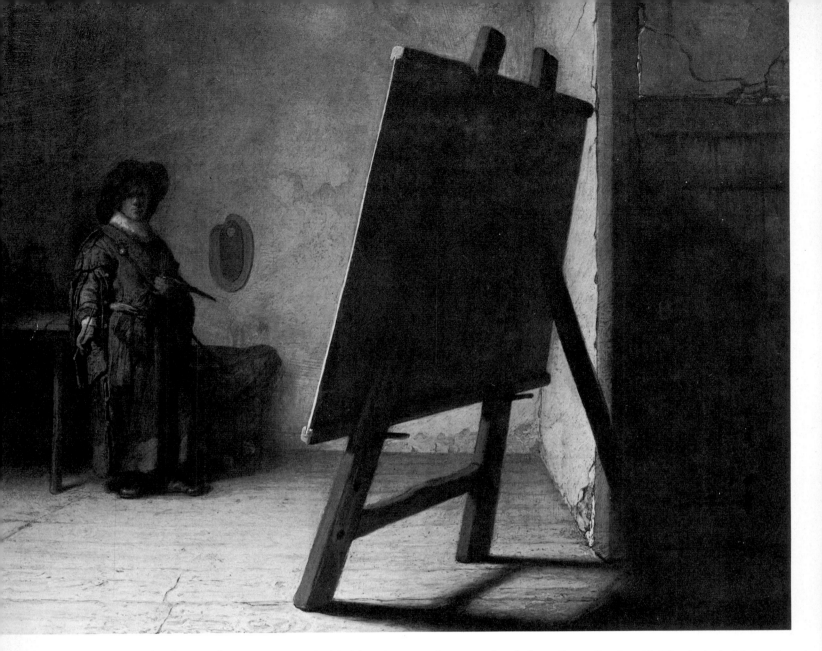

assume, for example, that Paulus POTTER was a lover of animals, as his renderings of them are usually so sympathetic and sensitive. He painted one picture in particular which may reveal his attitudes —the *Revolt of the Animals*, where the animals rise up and hunt the hunter and end up by roasting him on a spit.

The private lives and characters of painters like Meyndert Hobbema and Jacob van RUISDAEL remain obscure. Landscapes do not lend themselves to personal revelations. It is known that many painters, like Hobbema, had other jobs in order to supplement their incomes, because at times, especially in Amsterdam, the competition was so fierce that a painter could easily find himself in financial difficulties. Occasionally, as in the instance of Jan STEEN, the other occupation had some bearing on the painter's art. In the 1650s his father bought him a brewery to manage in Delft, and although the painter's Delft

period is his calmest and most refined, it is difficult to imagine that he did not observe very closely the way of life of people concerned with the making and consumption of drink.

The actual way in which artists painted, how they organized their days, what they talked about, what they read—all these things still remain largely unknown. Some pictures of artists in their studios survive, but not a single scrap of evidence seems to be known as to how, for instance, the Haarlem academy functioned. It was constituted by van Mander with Cornelis van Haarlem and Hendrick GOLTZIUS as the chief teachers, but it is likely that most painters followed their own individual inclinations. Each town had a Guild of St Luke which seems to have acted as a kind of club for those painters who were accepted into it, but there is little evidence of the guilds having any influence on the style of the pictures produced. When an artist

Above: Rembrandt's The Artist in his Studio, *painted in about 1628. Paintings of this subject are surprisingly rare, and this early Rembrandt gives an insight into the life of the young artist dominated by the huge panel before him. (Boston, Mass. Museum of Fine Arts)*

Right: Joost Cornelisz. Droochsloot's The Artist in his Studio *forms a dramatic contrast to Rembrandt's version. Painted in about 1640, it shows the middle-aged and successful artist completing one of the village scenes which made his reputation in Utrecht. (Macon, Musée des Ursulines)*

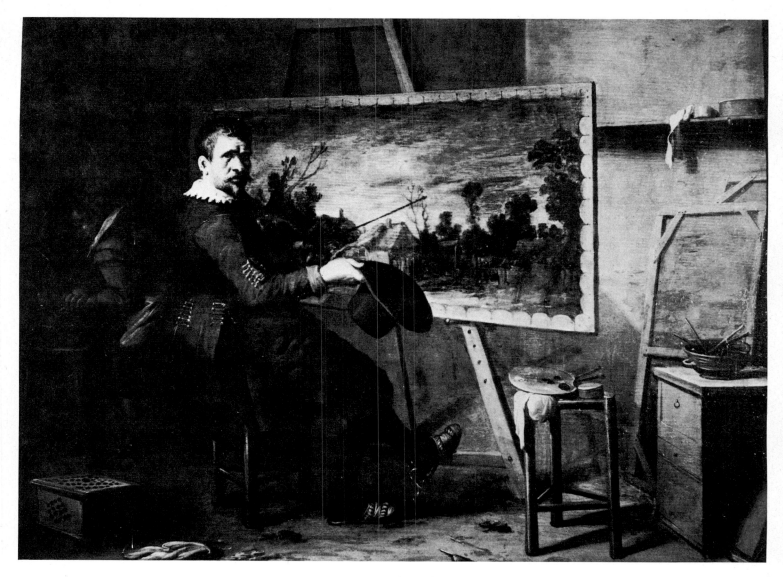

moved to another town he simply joined the guild there.

Rembrandt left behind him a moving record of the bare floorboards and flaking plaster of his Leiden studio in 1626 (Boston, Museum of Fine Arts) but it is difficult to know how much detail was suppressed in order to make a work of art—none of the paraphernalia of a painter's studio is visible. Painters seem to have worn the normal clothing of their time; artistic dress was a nineteenth-century invention. The self-portrait by the Utrecht artist Joost Cornelisz. Droochsloot is especially illuminating as it shows the painter quite formally dressed in the act of painting one of his typical village scenes. In the background a young apprentice is seen grinding colours.

On the whole, Dutch painters worked to a far less rigid set of rules than their Italian counterparts and there was a wide variety of techniques used. The Haarlem mannerists worked more or less in the Italian way, making preparatory drawings, many of which survive, and then carefully painting their figures on the canvas or panel in monochrome. Then the brilliant colour was applied by means of thin transparent glazes. Modifications of this method were also used by Rembrandt, who was the most versatile technician of the whole century. Some painters preferred to paint directly onto the canvas or panel almost at one sitting. Many of Frans Hals's pictures give this impression, as the highlights seem to be applied onto a ground which is still wet. Other artists liked to use the grain of the wooden panel as part of the effect of the picture. Sometimes a thin priming was used, sometimes none at all—the picture was thinly painted straight on to the panel; both Jan van GOYEN and Adriaen van OSTADE excelled at this method.

The opposite of this free method of painting was to use an enamelled technique where the surface was absolutely smooth with an even thickness of paint, the different textures being suggested by sleight-of-hand. Gerard DOU, Gabriel METSU and Gerard Terborch used this method and they were greatly admired for it. Then there were painters like Rembrandt who were able through sheer proficiency to do just as they pleased. Rembrandt's range included, especially in his early years, finely detailed pictures with smooth surfaces like the tiny *Good Samaritan* of 1630 in the Wallace Collection, London. Rembrandt is, of course, famous for his impasto, and apart from his close imitators heavy impasto is rare in Dutch painting. Some of Vermeer's early pictures have it, most significantly in the *View of Delft* (page 200). But Rembrandt's experiments with texture in his last years, in the 1660s, went so far that they were never imitated. His unfinished *Family Group* (Brunswick, Herzog-Anton Ulrich Museum) is made up of large areas of thick paint laid on, it

appears, with the palette knife. Over this has been laid a seemingly infinite number of glazes of the palest salmon pink, producing an inimitable effect, solid but shimmering.

With so many painters active, with such a variety of techniques and difference of subject matter, it is a complicated task to chart the development of painting in the seventeenth century by discussing the career of each individual painter. Rembrandt painted every possible subject, even seascapes (Boston, Isabella Stewart Gardner Museum), and a discussion of Rembrandt's development in isolation would inevitably leave out the importance of all the other painters on whom Rembrandt relied for his inspiration. On the other hand, the favoured method of dealing with the period is to divide it into subject categories. There were indeed many specialists, painting still-life, genre, portraits, seascapes, river scenes, dunescapes, and so on. Some painters, however, worked in many different genres. Thus Emanuel de WITTE assumed an important place in the development of the interior scene in the 1640s, featured in the latter part of his career as one of the best painters of church interiors, was a painter of market scenes, and also produced one superb seascape. No history of landscape painting can afford to ignore Vermeer's *View of Delft*, but it is in the history of genre painting that Vermeer occupies his niche.

The method adopted here is to discuss the course of painting in the individual towns and to see how they differed. Some towns like Leiden, Haarlem, Delft and Utrecht have clearly defined local traditions. Often, whole families of painters continued painting in the same town generation after generation—the Ruisdaels in Haarlem and the van Mieris family in Leiden being good examples. The Hague tended to receive a large number of visiting artists, usually with specific commissions to execute like the decoration of the stadholder's country retreat nearby, the Huis ten Bosch. Amsterdam did not become really dominant until the middle years of the century—it attracted enormous numbers of artists from other towns but relatively few were natives. The main towns in the province of Holland will be discussed first, followed by the few outlying places and the Catholic stronghold of Utrecht. The discussion of Amsterdam then leads quite naturally into the period of decline in production and vast increase in the buying and selling of pictures.

Apart from the numerous rivers forming the mouths of the Rhine, which flows from east to west across the United Provinces, there are no natural boundaries; not one of the individual provinces is a geographical entity. The modern topography of the country is misleading as so much has now been done to alter the character of the country by the draining of large areas of water.

The Province of Holland

Holland was by no means the largest province although it was the most densely populated. Artistic activity in the province of Holland can be divided into three quite distinct areas. The northern part, which was bounded by the North Sea on one side and the Zuyder Zee on the other, contained the towns of Alkmaar, Enkhuizen, Hoorn and Midden Beemster, all of which were centres of some important artistic activity although none of them sustained a continuous tradition. The central part contained Amsterdam on the eastern edge and Haarlem towards the west. This area was broken up by numerous small lakes, and Haarlem itself was almost completely surrounded by water. Although the two cities were barely a dozen miles apart, Haarlem and Amsterdam sustained quite different traditions and it is indeed surprising how little they owed to each other.

Then there was a short stretch of flat, open, waterlogged country and sand dunes which separated Haarlem from a cluster of towns and cities towards the south. The first was Leiden, which in the middle ages had been by far the largest town in the whole northern Netherlands. Immediately south of Leiden lay the capital, The Hague, with its close and much larger neighbour Delft. The distance which separated Delft and the river Maas was barely seven or eight miles, and on the river was Rotterdam, not yet as prosperous as in later centuries. A little to the east was Dordrecht, which sustained its own artistic tradition, although painters there tended to look to Utrecht or Amsterdam rather than Delft or Leiden, which were much closer.

The chief centres of artistic activity, apart from Amsterdam, which attracted painters from all over the country except Utrecht, were Haarlem, Leiden and Delft.

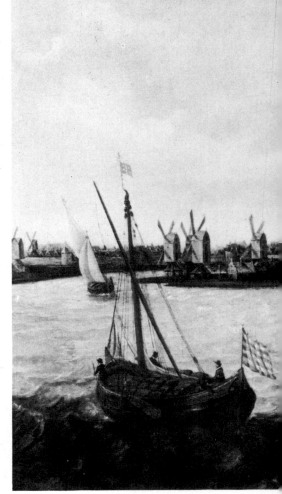

Above: Hendrick Cornelis Vroom's View of Haarlem from the Noorder Spaarne. *The considerable size of Haarlem in the early years of the seventeenth century is emphasized in this splendid composition. The positioning of the boats is elaborately contrived in order not to interfere with the town's silhouette, which is dominated by the Grote Kerk. The town hall, which is much smaller, is immediately to the right of the church. There was relatively little building in the sixteenth century, owing to the continual religious and political upheavals, and Haarlem still retains a largely medieval character in this picture. (Haarlem, Frans Hals Museum)*

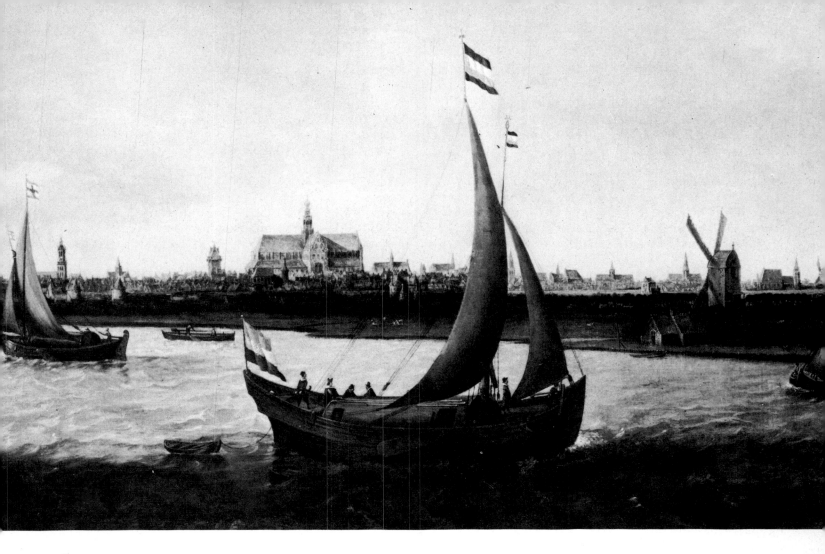

Haarlem: Frans Hals and his Contemporaries

They influenced each other rather less than might be expected. Painters from the northern part—from Alkmaar, for instance—tended to gravitate towards Haarlem, as did Rotterdam painters towards Delft. But there seems remarkably little interaction, apart from the ubiquitous Jan Steen, between Delft and Leiden or Haarlem and Rotterdam.

The late middle ages had seen a concentration of artistic activity in Leiden and Haarlem, although there had been painters active elsewhere. The two most influential painters were without doubt the painter and engraver Lucas van Leyden at Leiden and Geertgen tot Sint Jans at Haarlem. It is quite clear that of all the towns it was the artistic tradition of Haarlem which recovered the quickest from the disasters of the middle years of the sixteenth century, whereas Leiden lagged behind, dominated by Jacob Isaacsz. van Swanenburgh, and the town had to wait until the early years of the next century for its sudden burst of creativity. But it is easily forgotten that Rembrandt spent much of his early career there, staying as a student with Gerrit Dou, who was to dominate the middle years of the century.

The most important single figure in the development of painting in Haarlem was Carel van Mander. He appears to have painted little and only a few pictures from his hand have survived. Instead, he set about founding an academy of painting in Haarlem in the 1580s, and 20 years later published his famous *Schilderboek*. Apart from the lives of painters, it also contained a quantity of theoretical writing and didactic poetry. But it remains an isolated example of this type of writing in northern Europe and probably was not widely influential.

The other two founder members of the academy were both immensely forceful artistic personalities. Hendrick Goltzius, the engraver, worked with a skill which rivalled Lucas van Leyden himself, and he also, apart from many original compositions, engraved the work of his friend Cornelis van Haarlem. The town of Haarlem was not slow to commission Cornelis, and in 1583 he painted a large *Group Portrait*, followed by another in 1599 (both in Haarlem, Frans Hals Museum). In 1595 he painted the enor-

mous *Wedding of Peleus and Thetis* for the main chamber of the Town Hall. This elaborate composition with its many figures was obviously painted in emulation of the grand decorative schemes of Italy, which Cornelis had never seen and could only have known from engravings. He also produced innumerable small pictures of religious and mythological subjects. By 1600 painting was well established in Haarlem. The academy exercised artistic dictatorship, training a large number of painters to imitate them, most of whose reputations have long since vanished. Van Mander notes that Cornelis van Haarlem trained Pieter LASTMAN, the Amsterdam academic artist who was later to teach and influence the young Rembrandt.

The only real outsider to what can be called the Haarlem mannerist style of painting was Hendrick Cornelis VROOM, the marine painter. His view of *Haarlem from the Noorder Spaarne* shows that his preoccupation was with ships rather than topography, but gives an accurate idea of the town dominated by its vast church and surrounded by water. Unlike the other Haarlem painters Vroom was successful outside Haarlem, as he was com-

missioned by the States General in 1610 to paint two sea-pieces which were intended as a gift to the then heir to the English throne, Prince Henry.

In about 1600 a very young and insignificant painter arrived from his native Amsterdam who subsequently was to change the whole course of painting in Haarlem (and later elsewhere), diverting a great deal of artistic effort into the painting of landscape. Esaias van de VELDE is a 'little' painter—his pictures are small, and to modern eyes they lack the poetry of the van Goyen he influenced so strongly. But he was the first to paint in an unacademic way at a time when the whole course of painting was dominated by a style which discouraged originality. Esaias van de Velde stayed in Haarlem until about 1618, when he moved to The Hague, but before he left other changes were taking place.

In 1591 a family named Hals had arrived from the Spanish Netherlands and had settled in Haarlem; the younger son, Dirck Hals, was baptized in Haarlem in that year. When in 1616 his elder brother Frans, who had already begun to specialize in portraits, was commissioned to paint the *Militia Company of St George* (page 104), it was quite natural for him to copy the composition from Cornelis van Haarlem, only changing one figure from the latter's stiff and formal *Group Portrait* of 1599. In the same year the young van Goyen arrived from Leiden to study with Esaias van de Velde, and this brief apprenticeship was to have a far-reaching effect on van Goyen's subsequent development. But it has to be remembered that although both Goltzius and van Mander had died in the early years of the century, Cornelis van Haarlem lived on until 1638, his style virtually unchanged. He thus lived through almost all the changes which gathered momentum to make Haarlem, from about 1620 until the death of Frans Hals in the mid-1660s, second only to Amsterdam in richness and variety of artistic talent and experiment.

The general character of the Haarlem painters in the period of greatest activity was one of diversity of subject matter and technique. There was, however, one major difference from painters in other towns—the tendency towards near-monochrome colour schemes. The earlier generation of painters had produced precisely the opposite type of picture; Cornelis van Haarlem and his pupils favoured brilliant colours. Just occasionally this was followed up by the next generation, as in Dirck Hals's *Fête in a Park* (page 103). This austere character affects most types of pictures, irrespective of their subject matter or style, from the grey and pale yellow still-life pictures of Pieter CLAESZ. to the late group-portraits of Frans Hals.

The official or academic artists of the middle years of the century were in a far less secure position than their predecessors. The chief representatives of the academic style were Pieter de GREBBER, Salomon de Bray (Amsterdam 1597–Haarlem 1664) and Cesar van EVERDINGEN, who came to Haarlem from Alkmaar in the 1640s. They painted in a style which has caused them to be described as the Haarlem classicists. This is misleading, as their style of painting was far from classical as the term would be applied to Raphael. In fact they continued the traditions of Cornelis van Haarlem, painting highly polished and often nude figures on a large scale, with a preference for religious or mythological subject matter.

Perhaps the most dominant influence on all Haarlem painters was Frans Hals, but not in the way which might be expected from one of the greatest portrait painters of the age. As a portraitist he was too brilliant to be successfully imitated. The slightly more conventional portraiture of Jan VERSPRONCK was preferred by those who did not care for Hals's brushwork. Instead, Hals seems to have had a decisive influence on the course of genre painting, although he himself did not paint pictures of this type. It is likely that he taught his younger brother Dirck Hals, who specialized in small barrack-room and genre scenes which are carefully painted. A whole group of Haarlem painters began to specialize in such pictures and they are often difficult to distinguish from one another, as they all more or less imitated Hals's style. The chief specialists were Hendrick Gerritsz. Pot, who was also a portrait painter of ability, and Harmen Hals (Haarlem 1611–1669). Their influence was also felt in Amsterdam on Pieter CODDE and Willem DUYSTER.

The main group of painters who specialized in still-life established a tradition which remained remarkably consistent. The general character of such pictures is so stereotyped that to separate the different artists is often difficult. They evolved an austere way of painting still lifes which was quite alien to the much richer types preferred elsewhere—for instance those of Ambrosius Bosschaert. Their subjects were almost exclusively simple things—white cloths, half-peeled lemons, partly eaten pies and empty glasses. The earliest and most important was Pieter Claesz., who started painting his near-monochrome breakfast pieces quite early, about 1617. He was followed and imitated by Willem Claesz. HEDA and Gerrit Willemsz. Heda (working in Haarlem c. 1642–1647).

As might be expected, there were also working in Haarlem several painters who do not fall into a particular group. Pieter van LAER (Bamboccio) spent his early years in Haarlem before going to Rome, where he was to have an important influence on the painting of genre scenes in Italy in the late 1620s and 1630s. The enigmatic Hercules SEGHERS remained in Haarlem until about 1630, and although he had no discernible influence on landscape painting in the town, the effect of his broad and atmospheric landscape style on the Amsterdam painter Philips KONINCK and on Rembrandt himself was profound. As much of his output was in the medium of etching, the extent of his influence is easier to explain. Indeed, Rembrandt reworked one of his plates, striking out the figures and putting in their place a landscape.

The greatest painter of architecture, Pieter Jansz. Saenredam, spent much of his life in Haarlem. He had moved there by about 1612 and died there in 1665, although he was constantly travelling to observe the buildings he so lovingly painted. But he was a passionate individualist, and did not leave behind him a Haarlem school of architecture painting. Instead, the chief topographical painter was the much less imaginative Gerrit BERCKHEYDE, who painted endless brightly lit versions of the *View of St Bavo* (page 61) and who also did repeated views of the town hall.

The type of painting which had the most consistent development in Haarlem right through the century was landscape. There was a brief hiatus about 1620, as Esaias van de Velde had left for The Hague in 1618 and van Goyen had only spent a year in Haarlem in 1616. This left Pieter de MOLIJN, who continued to paint dunescapes in Esaias van de Velde's style until his death in 1661. The arrival of the young Salomon van RUYSDAEL in 1623 initiated a new phase in landscape painting which was to last for more than

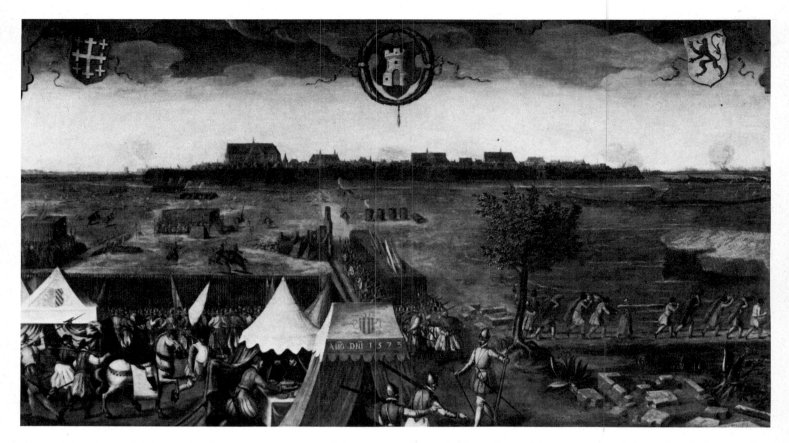

Above: The Siege of Alkmaar by the Spaniards in 1573. *This anonymous work is a great rarity—a presumably accurate representation of an actual event during the struggle for independence from Spain. The grim efficiency of the Spanish troops is carefully recorded; Alkmaar was sacked and took many years to recover. (Alkmaar, Stedelijk Museum)*

50 years. Salomon van Ruysdael's earliest pictures were, as might be expected, quite close to those of van Goyen or even Esaias van de Velde, but in the 1630s and 1640s Ruysdael evolved his own delightful manner of painting dunescapes and riverscapes. These are often bright in colour and quite freely painted, but never sketchy like van Goyen's mature and late style.

Salomon van Ruysdael's nephew, Jacob van Ruisdael, grew up to be the greatest landscape painter of his generation. He left Haarlem in 1657 when he was about 28, but he frequently returned to paint distant views of the town from the dunes. He could well have been influenced in his youth by the severe Scandinavian landscapes of mountain torrents by Allart van EVERDINGEN, who returned from Sweden in 1645 and remained in Haarlem for ten years. Ruisdael himself had an important influence on Haarlem landscape painters. Jan Vermeer of Haarlem, for example, carried on imitating his style until his death in 1691.

Ruisdael represented one particular type of landscape painting, and another style developed parallel to his. This was dunescape painting of the decorative type. Haarlem was, and still is, protected from the sea by extensive sand dunes. Ruisdael had recorded them faithfully and added

his own special melancholy. Philips WOUWERMANS responded in a quite different way to the decorative and picturesque possibilities of the endlessly shifting dunes. This was when he was not specializing in battle and camp scenes, of which he was the supreme master. He was either closely imitated by, or influenced by (nobody is quite sure which) Jan WYNANTS, who was active for 20 years in Haarlem until he left for Amsterdam in the 1660s.

Another landscapist of a quite different type was Nicolaes BERCHEM, who spent a long period in Haarlem from the 1640s until 1677 when he, too, went to Amsterdam. Berchem must have satisfied the demand for the more romantic and idealized type of landscape with its characteristic porcelain-blue skies and happy peasants. Even more exotic than Berchem was Frans Post, who, on his return from Brazil in 1644, spent the next 35 years painting scenes of South America from memory. It is amusing to note that the backgrounds to his landscapes have a resemblance to the sand dunes near Haarlem.

As if this was not enough variety, there were several generations of genre painters who were independent of Frans Hals's orbit and who were subject to other influences. Those directly dependent on

Hals in the middle years of the century were Jan Miensz. MOLENAER and his wife Judith LEYSTER, most of whose careers were spent in or near Haarlem except for a brief period in Amsterdam from about 1637 to 1648. They both liked to paint scenes of figures drinking and laughing, but Judith Leyster was able to introduce a new subtlety into her pictures, as in the *Young Flutist* (page 132).

The opposite pole was represented by Adriaen van Ostade. He was much influenced by the Flemish genre painter Adriaen Brouwer (d. Antwerp 1636), who had in fact worked in Haarlem in the 1620s and is thought to have been one of Hals's pupils. Adriaen van Ostade's small, brilliantly painted interiors of peasants misbehaving themselves established a tradition which died hard in Haarlem. The popularity of this type of painting enabled the consistently impecunious and itinerant Jan Steen to flourish from 1661 to 1670 in Haarlem. Together with van Ostade, he left a strong influence on the inferior but prolific painter Cornelis Dusart (Haarlem 1660–1704).

Frans Hals remains as the epitome of the individualistic painting tradition in Haarlem. He could on occasion be quite conventional and austere, and this brought him some distinguished sitters—René Descartes among them (the picture is in the museum at Copenhagen; the better known version in the Louvre is now thought to be a copy). He also satisfied the more modest demands of the prosperous classes of Haarlem, and many of them, whose names have not survived, went to Frans Hals for a faithful record of themselves. It is only at Haarlem that Frans Hals's genius for character can now be fully appreciated, through the series of eight group portraits in the museum there. They demonstrate his deep insight into the characters of the sitters as well as recording their physical appearance. They contrast dramatically with the equally numerous mythological paintings produced in the same period by Cornelis van Haarlem.

The less important towns in the north of Holland have already been alluded to. Alkmaar never seems to have recovered from the terrible Spanish seige of 1573. Several painters spent some of their time in the town, although no tradition developed—the brothers Allart and Cesar van Everdingen, although from Alkmaar, play a much more important role in Haarlem and The Hague. Saenredam painted several of his best pictures of the church at Alkmaar but did not reside there.

The other small towns of the north had a few local painters. Midden Beemster had the distinction of being the birthplace of the brothers Carel and Barent FABRITIUS, and their apparent fondness for the town is manifested by the fact that they constantly returned there. Hoorn had several painters, none of them of real distinction; a large number of local group-portraits survive in the town museum. Quite naturally Haarlem acted as the centre for these relatively isolated places, as it was the first really large town reached on the way to Amsterdam.

With the exception of Cesar van Everdingen, who worked in The Hague on the decorations of the Huis ten Bosch, very few artists travelled further south.

Leiden: Rembrandt's Early Years and Gerrit Dou

There seems to have been a very definite gap between Haarlem and the next large town to the south, Leiden, which had little stylistic contact with the Haarlem school of painting. In the middle ages Leiden had been by far the most important and populous town in the northern Netherlands, and it retained this pre-eminence until overtaken by Amsterdam in the early years of the seventeenth century. It had also been the chief place of activity of one of the greatest sixteenth-century Netherlandish painters, Lucas van Leyden. His influence, mainly through the medium of engravings, was felt all over Europe, and Dürer came to visit him. One of his large altarpieces, the *Last Judgement*, somehow survived the iconoclasts and is in the Lakenhal Museum at Leiden.

The second half of the sixteenth century was a difficult period for painting in Leiden. The dominant painter was Jacob Isaacsz. van Swanenburgh (1571–1638), whose name is recorded because he happened to have been Rembrandt's very first teacher. His art has been little studied and few of his works survive. He had grand ideas, grander even than those of Cornelis van Haarlem, and produced such dizzy fantasies as *Sibyl conducting Aeneas through the Underworld* (Danzig, Muzeum Pomorskie), where there are quite literally over a thousand figures in various attitudes of contortion mixed up with an incredible variety of devils and demons, both large and small. It is just possible, through this extravagance, to see that van Swanenburgh was repeating in a totally emasculated way some aspects of Lucas van Leyden's work.

The reasons for the changes which made Leiden the town with the most consistent tradition of painting are not clear. Rembrandt himself was born in Leiden in 1606 and was apprenticed to van Swanenburgh in 1621. Rembrandt also studied very briefly at the University of Leiden, which was in the forefront of knowledge in the seventeenth century, especially in the fields of botany, astronomy and medicine. There is little that is scientific or experimental, however, in the art of Gerard Dou or the van Mieris family, who dominated painting in Leiden for almost a hundred years.

Apart from one year (about 1624) spent in Amsterdam with Pieter Lastman, Rembrandt remained in Leiden until 1632. His Leiden period corresponds with the moment of the greatest variety of activity in the town, which would later settle down to a long and comfortable history dominated by Gerrit Dou. Rembrandt shared a studio with Jan LIEVENS, and together they produced many pictures in a new style which was not based on what Rembrandt had learned from Lastman in Amsterdam. Both artists' pictures often have a delicate bluish haze, are carefully painted, and often have bold lighting, as in the *Rembrandt in his Studio* (Boston, Museum of Fine Arts).

Just before he left for Amsterdam, Rembrandt also collaborated with Gerrit Dou in producing small pictures like the dramatically lit *Anna and the Blind Tobit* in the National Gallery, London. The moment Rembrandt left, Dou took over; there ensued an incredible period of artistic dictatorship. Dou's debt to Rembrandt was not great and he soon forgot it. Instead, he evolved a style of minute detail with a wide variety of subject matter. In his early years his pictures perhaps had more originality than later—he painted a finely detailed *Portrait of Rembrandt's Mother* (Amsterdam, Rijksmuseum). Perhaps the presence of other painters in the 1620s had a leavening effect—van Goyen was active in the town until he left for The Hague in 1631. After van Goyen's departure, Dou devoted himself more and more to the painting of genre subjects. Although he painted religious

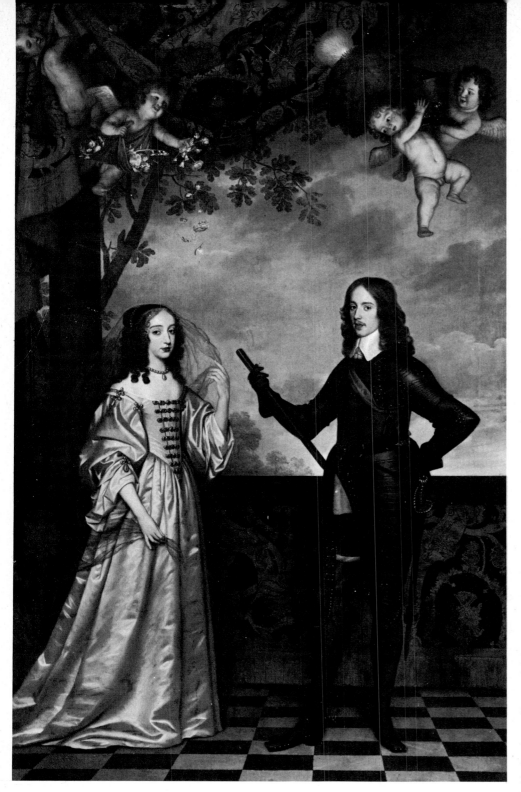

Above: Gerrit van Honthorst's The Stadholder Willem II and his wife Mary Stuart, *dated 1647. When painting clients of such importance, Honthorst did not hesitate to adopt the type of portraiture popular in the Catholic Spanish Netherlands to the south. Although there are no religious trappings, there is a clear attempt to depict the couple's royal dignity, in contrast to the informal character of most Dutch portraits at this time. (Amsterdam, Rijksmuseum)*

subjects as well, he managed to reduce most pictures to the form of elegant anecdotes. He did not, on the whole, paint peasants, but preferred middle-class interiors. His capacity for detail is a source of constant admiration; he was one of the few painters who managed to keep the whole picture in balance in spite of recording the weave of each fabric he painted.

Dou's most important pupil was Frans van MIERIS the Elder, who painted in a style which is very close to that of Dou's other pupil, Gabriel Metsu. Van Mieris used a lighter and more colourful palette than Dou and concentrated on middle-class domestic scenes. His two sons, Willem van Mieris the Elder and Jan van Mieris (1660–1690), continued to paint in their father's style, thus continuing the tradition right into the eighteenth century —Willem van Mieris died in 1747.

Gabriel Metsu spent the first 28 years of his life in Leiden, leaving in 1657 for Amsterdam, where he was away from the competition of his master, but Metsu was in Leiden long enough to acquire the unmistakable Leiden style. Godfried SCHALCKEN, too, was in the town in the 1650s. He acquired the same finesse of technique which has been called the Leiden manner of *fijnschilders*—literally 'fine-painters'—from which the English expression 'Fine Paintings', which is still used by art dealers, is probably derived.

Several other painters were drawn into Dou's circle, for instance Quiringh Gerritsz. van Brekelenkam (working 1648, d. Leiden 1667/8), who imitated Dou's genre pieces but made them coarser both in subject and technique. Jan Steen was a native of Leiden, but he spent little time there; the years 1649–70 were spent in other places.

By the last years of the century, Leiden painters had long since ceased to contribute anything new to the development of painting. The crucial decades of the 1620s and 1630s, when Rembrandt and Dou were young, had passed by, and the town settled down to a long history of precise and financially successful imitation of the paintings of a more vigorous age.

The Hague: Court Patronage

The Hague, meeting-place of the States General and residence of the stadholder, never supported a group of painters who founded a tradition. In this respect the town was quite unlike almost all the others in the province of Holland. But being the seat of government, it was the centre of what little court and official patronage which existed. This is of rather more interest than significance, as minor or foreign (particularly Flemish) painters tended to be chosen.

In the sixteenth century The Hague had been too small to support a large number of painters. The most important painter of the last years of the sixteenth century who was actually resident was Jan Anthonisz. van Ravesteyn (1570–1657),

who specialized in conventional portraits. Most of the important portrait commissions went to the Delft painter Michiel Jansz. van Mierevelt, who only lived four miles away.

The seventeenth century was dominated by the visits of several distinguished painters who satisfied the immediate demands of their patrons and then moved on. The most important residents or visitors in the early years of the century were Esaias van de Velde, who spent the years 1618–30 in the town but whose style had been formed in Haarlem. The enormously prolific Adriaen Pietersz. van de Venne, moving from Middelburg in 1625, spent the next 37 years painting small scenes of peasants quarrelling in his very distinctive monochrome style. The most distinguished permanent resident, however, was Jan van Goyen, who was in The Hague from 1631 until his death in 1656. Much of his time must have been spent travelling to other towns, both in the United Provinces and elsewhere, in search of new views to paint. In spite of his industry and proficiency he never really achieved a prominent position in the eyes of his contemporaries. He did not leave behind him an active school, merely a number of mediocre imitators. His landscapes were too personal to establish a real tradition of landscape painting.

The 1640s saw visits of the still-life painter Abraham van BEYEREN, who also returned in the 1660s, and Paulus Potter, the animal painter, for a brief period between 1649 and 1652. Jan Steen arrived in the same year as Potter and stayed five years before moving to nearby Delft. Karel DU JARDIN, the Italianate landscapist, was there in the 1650s. This constant coming and going shows that painters seemed not to find the town an ideal place to work permanently.

The Orange family had three residences in or near The Hague: Honselaersdijk, Rijswijk and the Huis ten Bosch. The first two have not survived and therefore comment has to be limited to the Huis ten Bosch, which was recorded in a tiny atmospheric picture by Jan van der Heyden. The patronage of the stadholder and his family was basically limited to portraiture and the decoration of the three houses. The type of art they favoured is quite unexpected, but the reasons for it can be explained. The wife of the Stadholder Frederick Henry, Amelia von Solms, played an important

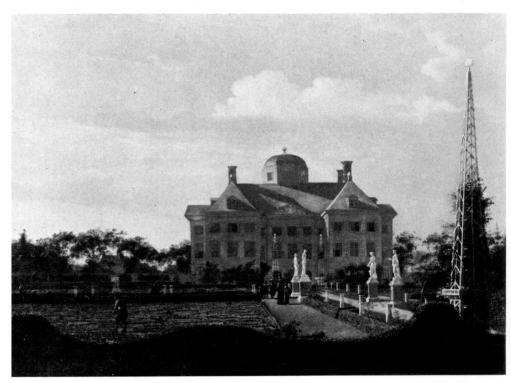

rôle and her position has somewhat been neglected.

It is a well-known fact that Rembrandt received the commission in the 1630s for a *Passion Series* (pages 43, 163) for Frederick Henry. This was organized through his secretary, Constantin Huyghens, whose sensitive features are recorded in a portrait by Jan Lievens. But what is less well known is the fact that Amelia von Solms sat for Rembrandt; the result was the exquisite portrait in the Musée Jacquemart-André in Paris which is so intimate that it was long thought to represent Rembrandt's wife Saskia. The death of Frederick Henry in 1647 left Amelia von Solms in charge of the decoration of the Huis ten Bosch and she decided to have the main room, the Oranjezaal, decorated as a memorial to her husband. A complicated scheme of allegorical subject matter was drawn up by Huyghens, exactly as an Italian prelate would have done in designing the decoration of a church ceiling. A large number of different painters were commissioned to take part in the decorations. From the surviving evidence it seems that the actual choice was in Huyghens's hands. The result gives a clear, if not always agreeable, impression of what was most highly esteemed by the court.

The Oranjezaal was large and had a central dome. The main commission went to Jacob Jordaens, the Flemish painter, which shows that Huyghens and Amelia

von Solms had no qualms about going across a frontier to the Catholic southern Netherlands for their painter. In attempting to explain this it is not often realized that there was little nationalism among rulers. Sovereigns belonged to a kind of confraternity which fought and intrigued largely to satisfy dynastic ambition without regard for the interests or opinions of the people they ruled. The stadholder of the United Provinces was an exception among rulers, as he had to contend with the wealthy and influential burghers of the towns of Holland, especially Amsterdam, whose over-riding preoccupation was the protection of their commercial interests. But when it came to art, a Flemish decoration in the Huis ten Bosch would hardly cause opposition by the Amsterdam burghers as long as the mouth of the river Scheldt was kept closed, thus blockading Antwerp from the sea and doing irreparable damage to the trade of the rival Spanish Netherlands.

Apart from Jordaens, Jan Lievens, who had himself spent some time in Antwerp, played an important part in the decorations. He was assisted by a whole host of painters, Cesar van Everdingen, Pieter de Grebber, Salomon de Bray and Gerrit van Honthorst, among others. The first three belong to the group of 'Haarlem classicists', and presumably their Italian-oriented style was what pleased their patrons.

Left: Jan van der Heyden's View of the Huis ten Bosch near The Hague, *probably painted about 1670. In this delightful atmospheric view of one of the stadholder's residences, van der Heyden has attempted to give the building an air of grandeur. But it still remains in essence a little house in a charming formal garden, quite miniscule when compared to Amsterdam's new Town Hall. (London, National Gallery)*

Below: Jan Lievens's Portrait of Constantin Huyghens. *The sitter, one of the most important figures of his time, was an early admirer of Rembrandt and obtained for him the commission to paint the Passion Series for the stadholder. But like most seventeenth-century intellectuals, he was not interested in art for art's sake; the subject was much more important than the way a picture was painted. (Douai, Musée de la Chartreuse, on loan to Amsterdam, Rijksmuseum)*

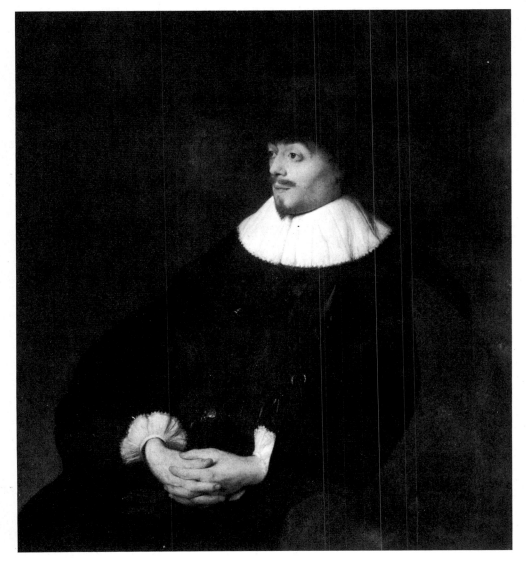

Apart from this relatively modest decoration—Amsterdam's town hall was to be far more ambitious—portraiture was the dominant subject-matter for painters in The Hague. Honthorst painted a splendid picture of the *Stadholder Willem II and his wife Mary Stuart*, but most portraiture was of a much more sober type. Adriaen Hanneman (1601–1671) supplied this need in a competent way, painting black-dressed figures without too many idiosyncracies of style—which made him appreciated in his time and forgotten by later generations.

In contrast to almost every other Dutch town, the last years of the century in The Hague saw an increase of activity both in portrait-painting and genre. The reason for this can be attributed to the dramatically changed status of the stadholder. In 1672 the Orange family became permanently entrenched as the foremost power in the country, owing to the collapse of confidence in the Amsterdam burghers, who had been unable to prevent Louis XIV's invasion by diplomatic action. The stadholder's successful resistance of the French armies meant that from that moment on he was regarded as the saviour of the country. His power and influence were further increased by his accession to the English and Scottish thrones following the Glorious Revolution of 1688. In this way, the two rival countries came to be united under one ruler for 13 years.

The chief painter of genre and portraiture from the 1650s until his death in The Hague in 1684 was Caspar NETSCHER. He painted a large number of small, carefully finished portraits, as well as the exquisite genre pictures for which he is famous, like the well-known *Lacemaker* in the Wallace Collection, London. This tradition was continued by Godfried Schalcken, who arrived in the town in the 1680s and stayed there until his death in 1706. He also visited London in order to paint the stadholder. By contrast to either Haarlem or Delft, there was much more activity in The Hague in the last years of the century, although of course the dominant style of painting had been evolved at least 50 years before.

Delft: Pieter de Hoogh and Vermeer

The very proximity of Delft—today Delft is a continuous urban area with The Hague—makes it all the more surprising that the two places had so little in common and that painters either active in or visiting The Hague were not aware of the exciting developments in the neighbouring town. In marked contrast to The Hague, Delft had in the early years of the sixteenth century seen two painters of merit, neither of whose names have survived. Both owe something to Geertgen and Mostaert. The earlier of the two has been christened the Master of the Virgo inter Virgines, one of whose vast altarpieces miraculously survives (although in a damaged state) in the Bowes Museum, Barnard Castle, County Durham. Works by the other, aptly named the Master of Delft, are equally rare, and it must be assumed that most of their pictures were destroyed by the iconoclasts. Painting in Delft therefore started completely afresh in the late sixteenth century with the prolific and successful portrait painter Michiel Jansz. Mierevelt

23

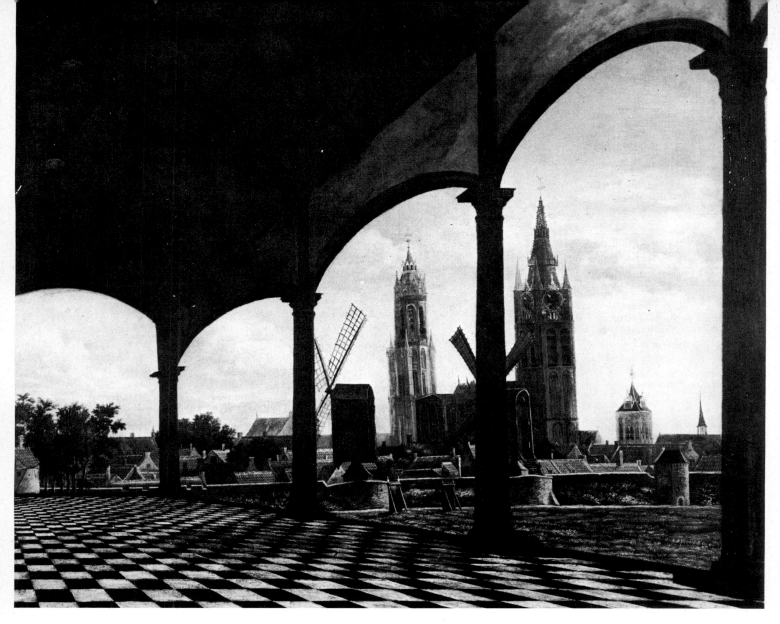

(1567–1641), and it was he who was able to supply all the necessary portraits of the stadholders in The Hague. In the Mauritshuis there, his highly polished armour-clad scions of the House of Orange stare down at the spectator as a reminder of his former reputation.

Like Utrecht and unlike the other Dutch towns so far discussed, Delft was and still is dominated by the presence of large medieval buildings. There seems to have been a diversity of religious belief—it is known, for instance, that Vermeer remained a Catholic. Like Utrecht, Delft did not see an enormous expansion in the seventeenth century, and painters like Daniel Vosmaer were already conscious of the picturesque qualities of the town's skyline. The brilliant painters who worked under the shadows of these gothic spires make the contrast with The Hague all the more telling.

In most people's minds Delft is closely associated with the name of Vermeer,

who spent all his life there. Frans Hals was just as much part of the artistic scene of Haarlem, but we speak of 'Vermeer of Delft' and not 'Hals of Haarlem'. But, like Hals, Vermeer was not an isolated painter. Apart from Mierevelt, most of whose patrons came from The Hague, the chief portraitist was Willem van der Vliet (c. 1583/4–1642), whose rather stiff style must have suited his now-anonymous sitters. The demand for religious and subject pictures was met by Leonaert BRAMER, who had spent the years 1614–28 in Italy. Most of his pictures are small in scale and quite dark. The figures are often barely discernible in the shadows.

The 1630s and 1640s saw a noticeable increase in activity, although there is no indication of the dramatic changes which were to take place in the 1650s. Simon de VLIEGER, the seascape painter, was active in the 1630s, and in the 1640s the young Emanuel de Witte arrived from Rotterdam and began to paint rather dark

interior scenes. Paulus Potter resided in Delft during the years 1646–9, and in the 1640s Willem van AELST, the still-life painter, was there. All this however, did not amount to much. There was no specifically Delft style, and most of the painters appear to have stayed for a relatively short time before moving on to other places.

Like so many important artistic changes, the reasons for Delft's changed position in the 1650s are difficult to find. There was no sudden change in economic growth, and in addition there was one calamity—the explosion in October 1654 of a powder magazine. This wrecked a considerable portion of the town and killed one great painter, Carel Fabritius, who had only been living there for three years.

Fabritius's arrival in 1651 had heralded a totally different period of painting which removed the previous dominance of portraiture. He brought with him some ideas derived from Rembrandt, whose

24

pupil he had been, but his style was basically original. The *Sleeping Sentinel* (Schwerin, Museum) shows how totally inventive Fabritius could be in his approach to the subject and the manner of painting it. The sentinel is shown sprawled asleep against a bare wall. It is not an anecdote such as Adriaen van Ostade would have painted, but the detached observation of an everyday event. Fabritius handled his paint quite broadly, as Rembrandt did, but with very pale colours. This light palette became typical of many Delft painters in the 1650s, especially Pieter de HOOGH, Hendrick van VLIET, and occasionally Vermeer himself. It is likely, therefore, that this could be put down to the influence of Fabritius, although the other painters produced works in quite different styles. Even the rumbustious Jan Steen, who arrived in 1654, the same year as Pieter de Hoogh, toned down his peasant extravagances and lightened his palette. Steen only remained for three years, de Hoogh for at least six—it is not known exactly when he left for Amsterdam, but it was not before 1660.

De Hoogh's Delft period was his most productive and original. He painted courtyard scenes and interiors which to modern eyes seem to catch perfectly the calm and order of provincial town life for those who were comfortably off. They raise to the level of great art the often-despised bourgeois virtues of the well-scrubbed floor and newly white-washed wall. The contrast with the equally exquisitely painted squalor of Adriaen van Ostade could not be greater.

The terrible explosion of 1654 caused considerable loss of life, and there are several painted records of the damage. The chief painter of the disaster was Egbert van der Poel (Delft 1621–Rotterdam 1664), and he painted an enormous number of versions of two main compositions. The first is of the explosion taking place (Rijksmuseum, Amsterdam) and the second is of the ruins immediately afterwards (London, National Gallery). Van der Poel specialized in pictures of looting, pillage and fires. In his *Conflagration at Night* he has observed carefully the ghastly effect of such an event. At the time, if a building caught fire there was little that could be done to save it, and later in the century the Amsterdam painter Jan van der Heyden was to be preoccupied with the same problems. Pictures of this type probably have their roots in the sixteenth-century tradition, where the subject was usually *Sodom and Gomorrah*.

Vermeer was 22 at the time of the explosion, and there is no reasonable explanation why his earliest pictures take a very different orientation. He started by painting large-scale genre and religious pictures, of which the best example is the Dresden *Procuress*, which is dated 1656. This is precisely the moment when Pieter de Hoogh was painting his first courtyard scenes and interiors. What prompted Vermeer to change his style about 1660 will never be known. From about this time must date the celebrated *View of Delft* (page 200). In this large-scale picture, Vermeer produced a unique vision of an ordinary subject—a town skyline. Both the colour and the light are intense; the water shimmers, the sun shines fitfully on the rooftops. The scant records of this picture's history indicate that it has always been esteemed, although Vermeer himself was quite forgotten in the eighteenth and the first half of the nineteenth centuries. In the sale of the Delft bookseller Jacob Dissius's collection in 1696 there were no less than 21 pictures described as by Vermeer, and the *View of Delft* was by far the most highly priced. All record of it was then lost until 1822, but on its sale its importance was such that the Dutch state intervened and secured it for the Mauritshuis in The Hague.

Vermeer could not have relied on a strong topographical tradition. There are a few recorded paintings of approximately the same time, but none can have inspired him. The elusive Daniel Vosmaer, about whom nothing is known, painted a splendid perspective view of the two churches at once and also a touching

Left: Daniel Vosmaer's View in Delft with the Towers of the Oude Kerk and the Nieuwe Kerk, *probably painted in the 1660s. More than any other artist, Vosmaer has succeeded in conveying the gothic grandeur of Delft with its claustrophobic medieval feeling. Vermeer's famous* View of Delft *(page 200) captures none of this, but relies instead on the open quality of the Dutch sky. (Delft, Stedelijk Museum)*

Right: Egbert van der Poel's Conflagration in a Dutch Town at Night, *painted in 1658. The artist had an unusual ability for catching the drama of a catastrophe and conveying it with maximum effect. The modern camera rarely . records with such graphic intensity the futile struggle of the victims to save themselves and their belongings. (Karlsruhe, Staatliche Kunsthalle)*

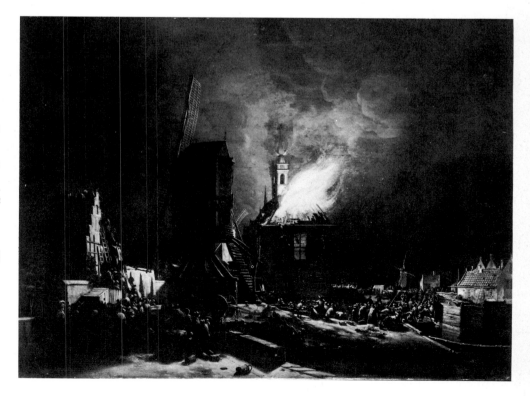

picture of the weed-grown ruins (Philadelphia, Johnson Collection). Much had also been made of Carel Fabritius's miniscule *View in Delft* (London, National Gallery). But none of these pictures have Vermeer's calm or breadth of vision.

The *View of Delft* did not herald a great flowering of landscape painting; it was isolated. Instead, Vermeer turned to genre painting. This ranged from humble subjects like the *Maidservant pouring Milk* (page 201) to the *Interior with a Lady and a Gentleman* (The Coquette) (Brunswick, Herzog Anton Ulrich-Museum) which depicts the more elegant side of life. Vermeer's maturity was when he was in his thirties, in the 1660s—he died at the age of 42 in 1675, after three years of disruption following the French invasion.

Many writers have tried to find the source for Vermeer's unique style. His subject matter is, of course, quite conventional and can be found in Metsu, Terborch or closer still in Pieter de Hoogh. There are, indeed, some affinities with de Hoogh, but the two painters are totally different in their approach.

A faint echo of Vermeer's style is found in the little-known painter Jacobus VREL. His street scenes are sometimes reminiscent of Vermeer's only surviving example (Amsterdam, Rijksmuseum) and his bare interiors recall in a distant way the bare walls of Vermeer. So little is known about Vrel that these affinities have led to the assumption that he, too, must have worked in Delft.

Vermeer lived in obscurity; he had to face continual financial difficulties and he

Below: Ludolf de Jonghe's View in Rotterdam with the Tower of St Laurenskerk, *painted before 1679. Of all Dutch towns, Rotterdam has changed most since the seventeenth century. De Jonghe has recorded in this picture the feeling of a quiet and unimportant country town. (Rotterdam, Boymans-van Beuningen Museum)*

Right: Aelbert Cuyp's View of Dordrecht. *Although the town appears in many of Cuyp's pictures, he was not a mere topographer; here the emphasis is on the evening light and the elaborate silhouettes of the boats. But the picture still conveys an accurate impression of the town's position on the busy estuary of the Maas. (Ascott, Bucks. The National Trust)*

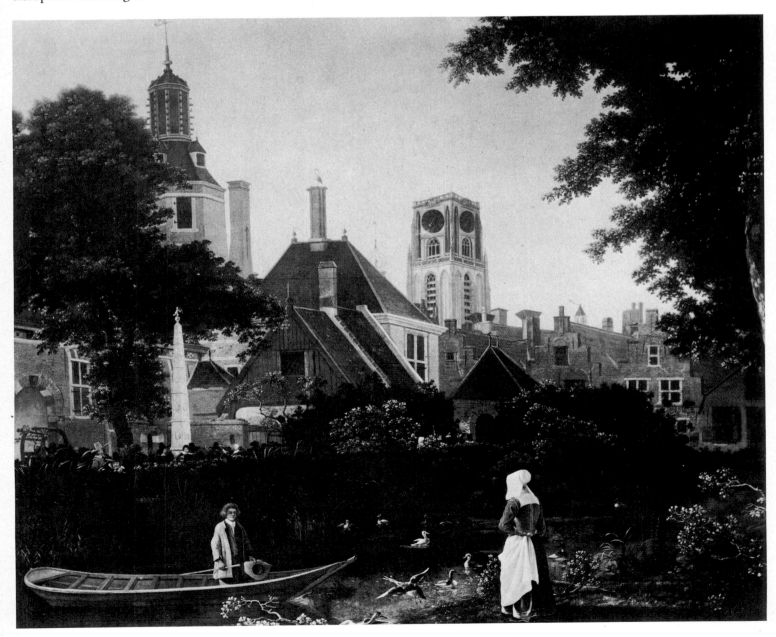

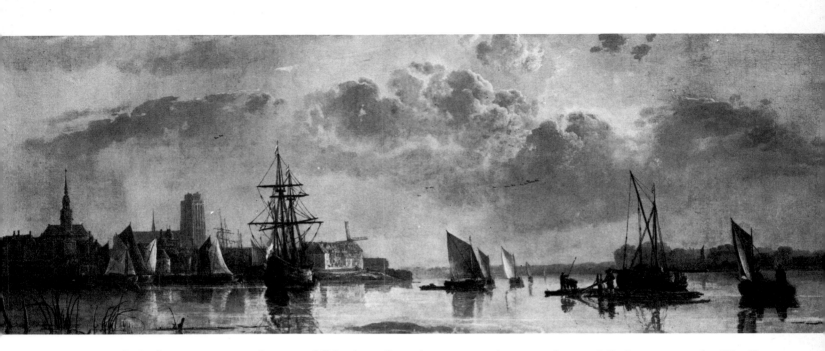

seems to have lacked patrons, even after the departure of his obvious rival Pieter de Hoogh, who was to have a successful career in Amsterdam painting a large number of rather less detailed genre scenes and interiors. Hendrick van VLIET was Vermeer's contemporary—he specialized in painting pale and quite beautiful interiors of the two main churches, but without the passion of a Saenredam.

Rotterdam: The Influence of Delft

It is quite likely that Vermeer's fellow townsmen lived in ignorance of the fact that he was a great painter. But an examination of the trends in nearby Rotterdam show that Vermeer's highly original way of painting had some effect, even if it was only on painters of second rank like Jacob OCHTERVELT. It is not generally realized that in the early seventeenth century Rotterdam had not really developed like so many other Dutch towns; its enormous prosperity was destined for later centuries. The first 40 years of the seventeenth century saw little or no important activity. Pieter de Hoogh had been born in the town, but had left for Delft when he was 25. There was a change about 1640 with the activity of the brilliant still-life painter Willem KALF and the young Emanuel de Witte (before he left for Delft).

However, in the second half of the century the status of Rotterdam improved with the influences from Delft on Ochtervelt and Janssens and with the

establishment of two important painters. Both Ochtervelt and Janssens must have been familiar with Vermeer and de Hoogh, and Janssens took these influences with him when he left for Amsterdam in 1656. Ochtervelt remained in Rotterdam for the rest of the century, painting his carefully modulated tonal interior scenes, which have been underestimated.

Rotterdam seems not to have attracted view-painters; the skyline obviously did not interest them as did that of Dordrecht, Utrecht or Delft, and pictures of Rotterdam are quite rare. An unusual view of Rotterdam by Ludolf de Jonghe (1616–1679) gives the impression of a quiet, small town compatible with the provincial art of Ochtervelt.

Rotterdam's position as an active centre of Dutch painting in the last years of the century has been neglected. As early as the 1650s Eglon Hendrick van der NEER established himself there and pursued a successful career as a genre and portrait painter. Adriaen van der WERFF spent his whole life in Rotterdam except when he was working for the electoral court at Düsseldorf. Houbraken regarded him as the greatest Dutch painter, and in the eyes of contemporaries Rotterdam must have acquired some of the sanctity of places associated with the famous.

The situation in Rotterdam in the last years of the century was therefore rather like that of The Hague (Netscher and Schalcken) or Leiden (the van Mieris family). The town was the centre for enormously prestigious artists whose chief secrets lay in their virtuoso technique. Neither Netscher, van der Neer,

the van Mierises nor van der Werff were innovators, they merely capitalized on the experience of predecessors like Dou and refined their technique to extremes which sometimes seem almost impossible.

Dordrecht: Aelbert Cuyp and Rembrandt's Pupils

Situated on a small island in the river estuary, not far from Rotterdam, was the town of Dordrecht. It was dominated by the enormous but unfinished gothic tower of the cathedral, which attracted many painters from other places, in particular Jan van Goyen. But painting in the town remained strangely isolated, apart from contacts with Amsterdam from the middle years of the century. Nevertheless one great painter spent all his life in Dordrecht—Aelbert CUYP.

As in so many other places, particularly those which lacked a medieval tradition, the chief painters in the early years of the century were portraitists. In Dordrecht, the leading example was Jacob Gerritsz. Cuyp (1594–1652), the father of Aelbert Cuyp. He obviously satisfied the demand for conventional and competently painted portraits. Exactly as in Delft, there was no real indication that there would be produced, in virtual isolation, a series of masterpieces which came to be regarded (in the eighteenth and nineteenth centuries, at least) as some of the highest achievements in the art of landscape painting.

Aelbert Cuyp did in fact paint a few portraits in the manner of his father, but

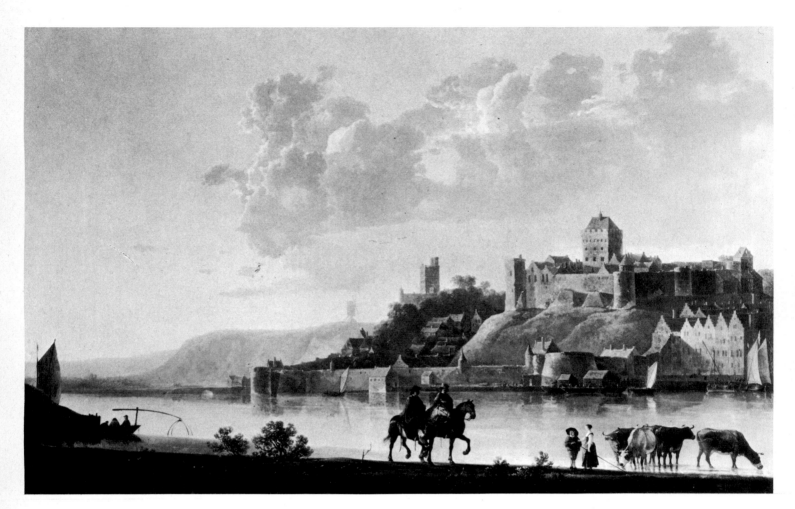

his earliest surviving pictures, which date from the 1640s, are frankly imitative of Jan van Goyen, who was already entering his last phase. Cuyp would have known van Goyen from the latter's visits to Dordrecht. But about the middle of the 1640s Cuyp underwent a dramatic change of direction. The turning-point seems to have come through contact with the newly fashionable Italianate landscapes suddenly being painted in Utrecht. The return of Jan BOTH from Italy had completely changed the emphasis of painting in Utrecht, and Cuyp was clearly influenced by this new Italian-based landscape style with its use of golden light. But Cuyp was too much of an individualist to be completely imitative. Instead, he went his own way and was at his best when inspired by the local countryside.

Cuyp was original; most of the paintings in his style which litter the older picture-galleries of Europe are by his numerous imitators. Most of his topographical pictures are set in or near Dordrecht. Occasionally he travelled further up the river—to Nijmegen, for instance, where he made several pictures of the picturesque castle *Het Valckhof*—

but he was by no means as adventurous as van Goyen, who travelled all over the United Provinces and the Spanish Netherlands too.

Cuyp favoured views which included the cathedral tower; one of the most poetic is the *View of Dordrecht* at Ascott. At his best, as in this type of picture, Cuyp could produce a feeling of relaxation and calm which is rarely found in Dutch painting—it occurs occasionally in the best seascapes by Jan van de CAPPELLE or Willem van de VELDE the Younger. Cuyp's isolation and originality is all the more marked in view of the events of the middle years of the century—the contact with Amsterdam and the influence of Rembrandt, in particular, on a whole young generation of Dordrecht painters.

A surprising number of Rembrandt's pupils came from or worked in Dordrecht. Ferdinand BOL had spent the first 20 or so years of his life in the town before leaving in about 1635 for Rembrandt's studio. His later career in Amsterdam was so successful that he had no need to return to Dordrecht. On the other hand, Samuel van Hoogstraaten and Nicolaes MAES both returned to

Above: Aelbert Cuyp's View of Het Valckhof at Nijmegen, *probably painted in the 1650s. The town and castle appear remote and empty, for Nijmegen was a commercial and artistic backwater. Cuyp has used it as a backdrop for his real interest—the fall of light on water and the delicate golden quality of the sky. (Woburn Abbey, Beds. The Bedford Estates)*

Right: Adriaen van der Venne's The Harbour at Middelburg, *painted about 1625. Pictures of this type are of great importance in reconstructing the way of life at the time. The different styles of dress are very obvious, and on the right is an interesting record of the way low-lying fields were cultivated. But the most important feature is the dominance of shipping. Middleburg had been growing as a trading centre since its foundation in the late fifteenth century, but after the date of this picture it went into decline. (Amsterdam, Rijksmuseum)*

Dordrecht in the 1650s after having worked in Rembrandt's studio.

Maes spent a long period (1654–73) in the town, at first painting very much in Rembrandt's style and then evolving his own genre type of painting which has affinities with developments in Delft in the 1650s, especially Pieter de Hoogh's work. Hoogstraten soon abandoned his Rembrandtesque manner, too, and started to paint perspective views (page 124), for which he was justly famous.

Several other painters also were influenced by Rembrandt, preferring to paint rather dark, heavily impasted pictures. Among them were the obscure Jacob LEVECQ and later the prolific and successful Aert de GELDER, who lived on until 1727 as the last survivor of Rembrandt's pupils, still painting in the master's free style. The genre and portrait painter Godfried Schalcken spent the 1660s and 1670s in Dordrecht before moving to The Hague, where he was to find such popularity with the stadholder's court.

The character of the Dordrecht 'school' divides quite neatly into two parts. The first basically consists of Cuyp and his school, with imitators like Abraham van Calraet (1647–1722), and the second is an all-pervasive Rembrandt influence.

There was little contact with the other towns; both Delft and Utrecht were very much closer than Amsterdam and both had strong traditions at different points in the century.

The Province of Zeeland

South of Rotterdam was a large expanse of water and south-west lay the province of Zeeland, which was largely made up of a group of marshy islands. Apart from the far north of Friesland, this was the most remote part of the United Provinces and there was no really important town, the largest being Middelburg. Several painters were active in the town, none of them really important, but the artistic scene in Middelburg is left out of most discussions of Dutch painting, because, like Rotterdam, it did not contribute to the mainstream.

Ambrosius BOSSCHAERT's arrival in 1593 from Antwerp marks the beginning of the development of painting in the town. He remained there for 20 years, and during this time, although few pictures survive, he must have painted many of his brightly coloured pictures of flowers, which are among the most

meticulous flower-pictures ever painted. Not surprisingly they are to some extent, especially in the arrangement, derived from the tradition popular in Antwerp, especially the flower pieces of Jan (Velvet) Brueghel (1568–1625). Bosschaert had one native of Middelburg as his pupil, Balthasar van der Ast (1593/4–Delft 1657). Today van der Ast's pictures are little known, but he continued a meticulous and brightly coloured type of still-life painting until the middle years of the century, painting mostly in Delft.

The departure of Bosschaert from Middelburg in 1613 almost coincided with the arrival of Adriaen Pitersz. van der Venne, who spent 11 years in the town from 1614 onwards. It was there that he painted, probably in 1625 (although this is not certain as the signature is no longer visible) the view of the *Harbour of Middelburg*. The picture has also been thought to depict the departure of Elizabeth Stuart, wife of the Elector Palatine and King of Bohemia. But whatever the actual event, van der Venne has made what looks like an accurate record of a Dutch port in the early years of the seventeenth century. The aspect of the town still appears largely medieval, and there is an impression of tremendous

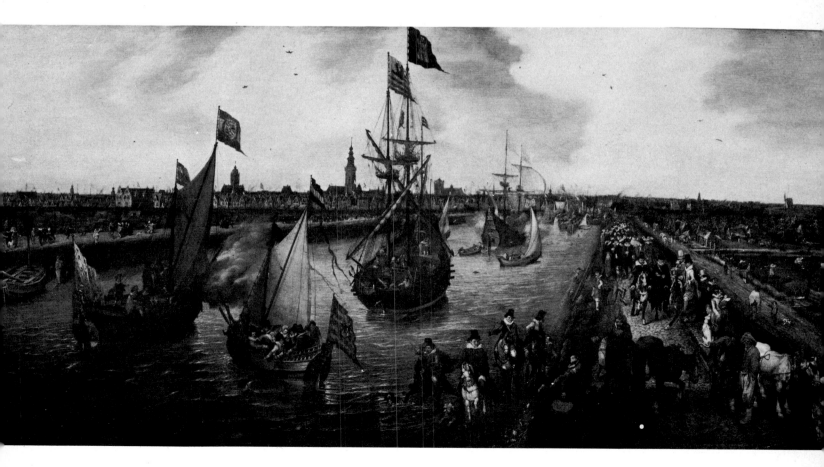

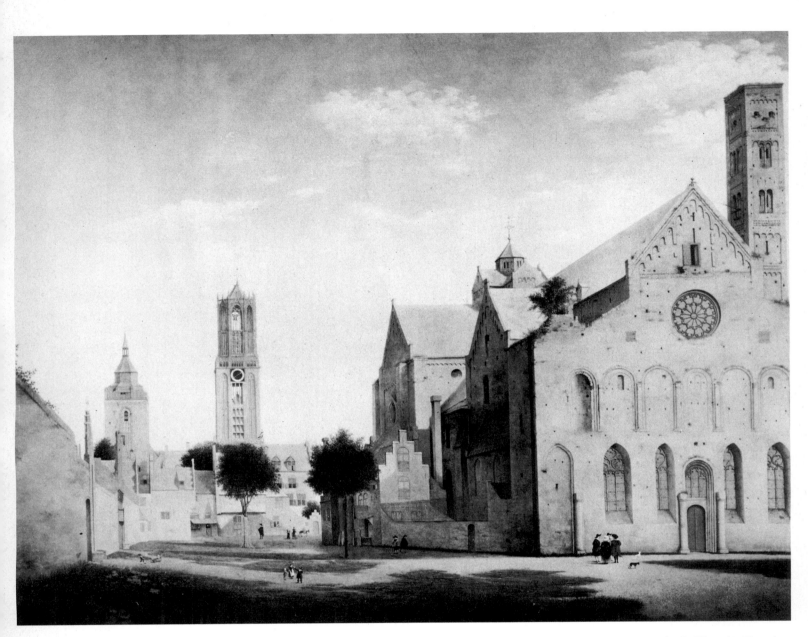

organization and order with soberly dressed elder citizens contrasting with the peasants in the foreground. In fact at this time Amsterdam, although expanding very rapidly, had not developed its overwhelming commercial pre-eminence; the inhabitants of Middelburg would hardly have been conscious that their town was never to increase its prosperity.

After the departure of van der Venne in 1625 no other important painter seems to have visited Middelburg. One of the best of the lesser masters was the unjustifiably neglected Johannes Goedaert (1617–1688), one of whose best pictures is in the Victoria and Albert Museum, London. It is a view on the island of Walcheren with the main church-spire of Middelburg in the distance. The picture is exquisitely painted in clear tones and bright colours, as if the long-since-

departed Ambrosius Bosschaert had indirectly influenced his style. But Goedaert remained in total isolation and was quite apart from the mainstream of landscape painting.

The last years of the century saw the appearance of another minor painter, Adriaen COORTE, who is so obscure that his dates of birth and death are unknown. The dates on his few surviving pictures range from 1683 to 1707, and he was active in Middelburg itself and also possibly in Zierickzee, which was nearby. Coorte specialized in still-life painting, using a careful technique as personal as that of Bosschaert a hundred years before. But unlike Bosschaert, Coorte concentrated on a very limited number of objects—three medlars or a bundle of asparagus—and as the seventeenth century came to a close with the astounding

Above: Pieter Saenredam's View in Utrecht with St Mary's Church, the Buurkerk and the Cathedral Tower, dated 1663. Saenredam rarely painted three churches at once; he usually preferred corners of one building. This picture forms an important record of Utrecht in the 1660s, dominated as it was by vast and crumbling churches. Part of the massive cathedral fell in 1675 and was never rebuilt. (Rotterdam, Boymans-van Beuningen Museum)

international successes of Godfried Schalcken and Adriaen van der Werff there remained in obscurity in remote and declining Middelburg one of the most poetic and delicate still-life painters of the period.

The Province of Utrecht

From the point of view of the history of painting, Utrecht is the town which stands most isolated from the other places in the United Provinces. The basic reason for this was not geographical—Utrecht is nearer to Amsterdam than Delft, The Hague, Rotterdam or Dordrecht—but the fact that the town remained predominately Catholic in religious outlook. This affected both the types of pictures painted and their style.

Of all the towns in the northern Netherlands, Utrecht seems to have suffered least from the iconoclasts, and even in the seventeenth century was totally dominated by the church. The predominance of church buildings can easily be seen in Saenredam's famous *View of Utrecht* where the town seems to be made up of two churches close together, both of them dominated by the colossal cathedral tower. It is possible to gain some idea of painting in Utrecht in the sixteenth century, owing to the survival of a considerable proportion of Jan van Scorel's work (much of which is still in the museums of the town). On his return from Rome in 1524 following the death of his papal patron, Scorel spent the rest of his career in Utrecht apart from two years (1527–9) in Haarlem. His Italianate and rather exaggerated style dominated painting in Utrecht because he was such an influential teacher. He was quite capable of painting a large altarpiece—an example survives in the City Art Gallery, Birmingham. He also painted a large number of group portraits, which were not to be as influential in Utrecht as the single one he painted for Haarlem. In the seventeenth century there seems to have been little group-portrait painting in Utrecht, quite unlike the situation in Haarlem.

The dominant painter of the generation following Jan van Scorel, apart from his own pupil Maerten Jacobsz. van Heemskerck, was the Antwerp-trained Joos de Beer (d. Utrecht 1591). He had studied under Frans Floris at Antwerp and brought with him northwards an Ant-

werp style of painting figures in exaggerated poses and bright colours. In the last years of the sixteenth century, indeed until the truce of 1609, there was no real certainty that the northern Netherlands would become separated from the south, and although in Haarlem a nascent specifically Dutch tradition has been pointed out, the painters of Utrecht give no such clues. Joos de Beer, whose pictures are today very rare, had two important pupils, Joachim Wtewael and Abraham Bloemaert. It was these two painters who were to be the most important painters in Utrecht for almost 50 years. Bloemaert's position was particularly powerful as he was an active teacher and kept a large studio. In continuing the style that they had learned from de Beer and adding just a little of their own character, Wtewael and Bloemaert gave Utrecht in the last years of the sixteenth century a distinctly international feeling. Their art was probably influenced by and was certainly quite close to the international mannerist style practised by Bartholomeus Spranger at the Prague court of the Emperor Rudolf II, and there are even certain affinities with the minor painters active in France who are known as the second school of Fontainebleau.

By about 1600 the situation was superficially rather similar to that in Haarlem, where Cornelis van Haarlem occupied the same dominant position as Wtewael and Bloemaert in Utrecht. But Utrecht was to witness a very different course of events than those which turned Haarlem into the liveliest and most inventive artistic centre outside Amsterdam. It was the art of Italy, and later of France, which was to give the Utrecht painters their peculiar character and make their style quite incompatible with that practised in other places.

The first painter of importance to arrive from Italy was Hendrick TERBRUGGHEN in 1614—he had been born in about 1588 in the province of Overijssel and had been in Italy since 1604. Unfortunately the first date which appears on any of his pictures is 1619, and therefore it is not possible to tell whether he had any immediate impact.

In 1619 Roelant Savery arrived, bringing with him another Flemish type of painting—this time of flowers, animals and birds. Like Ambrosius Bosschaert his art was to some extent derived from the Flemish painter Jan (Velvet) Brueghel, but he painted in a broader manner, often

with a delicious sense of humour. He favoured the subject of *Orpheus Charming the Animals* very much (Utrecht, Centraal Museum), painting many different versions of the composition, in which the animals and birds often appear almost human in their facial expressions. He also painted several extraordinarily elaborate still-life pictures of flowers which are a cross between the precision of Bosschaert and the sumptuousness of Jan Brueghel. A particularly good example is in the Centraal Museum at Utrecht.

There was also, as might be expected, a respectable tradition of portrait-painting in the town. The most important painter of this type was undoubtedly Paulus Moreelse (1571–1638), whose accurate portraits belong to the school founded in Delft by Michiel Jansz. van Mierevelt. His style was meticulous, and he left out no detail of the lace collars and cuffs which his sitters usually wore. Wtewael, too, was an accomplished portrait painter, as is seen in his *Self-Portrait* of 1601 (Utrecht, Centraal Museum).

There is in this pattern of painting little indication that the year 1620 was to be a kind of *annus mirabilis* in the history of painting in Utrecht. This was the year of the return from Italy of Gerrit van Honthorst and Dirck van BABUREN and a sudden burst of activity by Terbrugghen. These three painters have been labelled the Utrecht Caravaggists because their style included dramatic lighting effects from Caravaggio, who had died ten years before.

Why these three painters should have chosen to paint in more or less the same manner and why they should all three have descended on Utrecht at once remains a mystery. After their arrival, however, painting in Utrecht was completely transformed. Wtewael and Bloemaert remained oblivious, but a whole group of minor painters like Johannes Moreelse (d. 1634) and Jan van BIJLERT latched onto the newly fashionable style.

The precise relationship of the three painters, Terbrugghen, Baburen, and especially Honthorst, to Caravaggio himself is a problem of considerable complexity. Caravaggio had died in 1610 on his return to Italy after four intensely productive years in Sicily and Malta; therefore only his earlier work was available for study and copying in Rome by the three Dutch painters. What seems to have affected them just as much, if not more, was the painting of Caravaggio's

Italian followers, especially the large number of still-disputed pictures associated with Bartolomeo Manfredi.

Most of Caravaggio's lighting effects are produced by hidden light sources, but Honthorst's pictures, in his Italian period at least, reveal the origins of their illumination. He was fascinated by candlelight and firelight. This also interested Terbrugghen, who on occasion produced good effects involving artificial light. The painter closest in style to Caravaggio himself was Baburen, particularly in composition—his *Deposition* (Rome, San Pietro in Montorio, version in Utrecht, Centraal Museum) is derived from Caravaggio's *Entombment* in the Vatican.

The 1620s were a period of almost frenetic activity in Utrecht. Baburen died in 1624 and Honthorst left in 1628; Terbrugghen died in the following year. Bijlert was in Italy between 1621 and 1624 and returned full of Caravaggesque ideas. The dominant painter throughout this crucial period was therefore Ter-brugghen, who painted an immense variety of subject matter. What he really liked were bagpipe players, singers and prostitutes, but he was also capable of painting large-scale religious pictures, which, like those of Caravaggio himself, have an intensity of experience which is quite unexpected in a painter who wallowed in the painting of vulgar subjects. Terbrugghen also had a very personal technique which was reflected, not in the next generation of Utrecht painters (on whom he had no influence) but on the youthful Vermeer. Indeed, Vermeer's early religious pictures, especially the Edinburgh *Christ in the House of Martha and Mary*, are quite similar in handling to those of Terbrugghen. Vermeer also must have owned *The Procuress* (Boston, Museum of Fine Arts) by Baburen, as it appears twice in the backgrounds of his pictures—in his own *Concert* (Boston, Isabella Stewart Gardner Museum) and also in the *Lady Seated at the Virginals* (London, National Gallery).

Below: Jacob de Heusch's The Waterfall, *dated 1693. It is curious that the great tradition of landscape painting in seventeenth-century Holland should end with competent and polished pastiches of French classical painting, as seen in this work. So complete was the assimilation that a specialist is often required to distinguish between products of the two schools. (Utrecht, Centraal Museum)*

Right: Hendrick ten Oever's Evening Landscape with a Distant View of Zwolle, *dated 1675. Ten Oever has achieved a sense of calm and detachment which is unique in Dutch painting of the seventeenth century. No other artist was as bold in the treatment of the distant silhouette of the little town or as free with the poses of the bathers enjoying the evening light and warmth. (Edinburgh, University, lent to National Gallery of Scotland)*

Terbrugghen also, later in the 1620s, began to lighten his palette. In this he could have been following Honthorst, who had already begun to abandon his strong light-and-shadow manner as early as 1624. Many of Terbrugghen's later pictures begin to take on bland tones, as in his *Jacob and Laban* (London, National Gallery).

After such a burst of activity it might be expected that, if patterns in the other towns are anything to go by, Utrecht would have settled down to a long period of conventional painting, portraiture, still life and genre, without too many more upsets. After all, Wtewael lived on, doggedly painting in an unchanged style, until 1638 and Bloemaert, incredibly, until 1651.

There were, of course, quite a number of conventional painters whose activity is often overlooked. One of these was the prolific Joost Cornelisz. Droochsloot (1586–1666), whose early pictures are rather grand panoramas of Utrecht but who soon settled down to painting a great number of small village scenes. He is seen painting one of them in his *Self-Portrait*. In comparison to the other categories, landscape painting languished. One of the best landscape artists was Gisbert Gillisz. Hondecoeter (1604–1653) who was responsible for a relatively small number of rather leafy Flemish-inspired landscapes. From Antwerp itself was Adam

Willaerts (Antwerp 1577–Utrecht 1664). He arrived in 1611 and painted many beautifully executed sea and coast scenes, often with religious or historical subject-matter. A good example is *Christ Preaching from a Ship on the Sea of Galilee* in the Bowes Museum, Barnard Castle, County Durham.

Italy later sent back yet another wave of young painters. The first to arrive was Cornelis van POELENBURGH in 1627; he spent the next 40 years specializing in his own type of small, meticulous Italian-ate landscapes, often with religious or allegorical figures. He was not particularly interested in elaborate effects of light and hardly changed his style during the long years that he was in Utrecht, obviously satisfying the demands of his patrons. The next important arrival was Jan Both in about 1641, and he brought with him a whole new type of art which became so popular everywhere—not only in Utrecht—that it is difficult now to realize the impact that it must have had on the decidedly unromantic temper of the existing Utrecht tradition of painting.

Both's landscapes rely for their effect on carefully balanced trees and distant hills, all bathed in a transparent golden tone usually seen at the time of the setting sun after a long, hot day. Aelbert Cuyp almost certainly drew his own style from that of Both, giving up his van Goyen-oriented art. It is possible that Cuyp

simply visited Utrecht from Dordrecht, which was not far distant, although no such journey is in fact documented. Both's manner is also sometimes seen in the Haarlem-based Nicolaes Berchem, and he certainly had a strong influence on the next generation of Utrecht painters, in particular Jan Baptist WEENIX. Both himself was not a totally original painter; he merely imported a certain style at a time when it suddenly became popular. His chief source of inspiration was the Frenchman working in Rome, Claude Lorrain (1600–1682). Both did not actually copy Claude's compositions but imitated the golden glow of some of them and, like Claude, preferred a formal and slightly artificial way of composing the trees.

One of Both's chief Utrecht imitators was Willem de Heusch (1618–1692), who had returned from Italy at about the same time as Both himself. His nephew Jacob de Heusch (1656–1701) developed an entirely different style of painting, a style which was to dominate the last years of the century in Utrecht. It was a curious end to a long and vital tradition, bearing in mind that Utrecht did not have the commercial prosperity of Haarlem. Jacob de Heusch based his style almost exclusively on a French landscape-painter living in Rome, Gaspard Poussin, the brother-in-law of Nicolas Poussin. Unlike Both, whose style, however derivative, is personal, de Heusch produced beautiful pastiches with a high degree of technical competence, as in the *Landscape with a Waterfall* (Utrecht, Centraal Museum). De Heusch was obviously satisfying the demand for painting in the French manner which seems to have been prevalent all over the country after the French invasion of 1672. In his art all originality has finally evaporated, leaving only technical perfection.

Overijssel and the other Provinces

With the possible exception of Deventer, where Terborch spent most of his active career, the other towns in the remoter parts of Holland itself and in the other provinces have little real importance. Some of them remained so isolated, from an artistic point of view, that a talented artist like Hendrick AVERCAMP working in Kampen remained quite oblivious to the other types of painting around him.

Amersfoort, which although near Amsterdam was in the province of Utrecht, looked towards Utrecht for its style of painting. Matthias STOMER was born there about 1600, and although he probably received his training in Utrecht he spent most of his career in Italy, painting, especially in his last years in Sicily, in a Caravaggesque style which had long since gone out of fashion. Paulus BOR also came from Amersfoort and was born at about the same time as Stomer. His painting style stands half-way between the Utrecht Caravaggists and the Haarlem classicists, an interesting example of a painter in a small town being influenced by two quite opposing styles and at the same time ignoring the developments in nearby Amsterdam.

Later in the century the still-life painter Matthias WITHOOS worked in Amersfoort. For some reason in 1672 he moved to Hoorn, which was right in the north of Holland, and there he spent the rest of his long life, painting elaborate still-life pictures of plants and animals. These were rather close in style to the painter from Nijmegen, Otto Marseus van Schreick (Nijmegen c. 1619–Amsterdam 1678).

A whole host of towns and even villages could be mentioned which saw the activity of one or more painters, or whose church or castle was constantly recorded by visiting painters. Nijmegen was a favourite spot as the castle stood romantically above the water and inspired masterpieces by both Aelbert Cuyp and Jan van Goyen. The church of St Cunera at Rhenen was another favourite both with Jan van Goyen and Pieter Saenredam. Breda, that troubled town near the border with the Spanish Netherlands, saw a brief visit in 1619 by the flower painter Ambrosius Bosschaert. Abraham van Beyeren spent three years in Gouda from 1675 onwards. Gorkum, apart from being the birthplace of Abraham Bloemaert, was the place where Hendrick VERSCHURING spent his whole career. Overschie, as well as being painted by Jan van Goyen (London, National Gallery) was the place where Jan van Beyeren spent the last 12 years of his life from 1675 onwards. This list could be extended almost indefinitely as almost every place in the United Provinces can boast some connection with one or more painters. There seems little logical reason why some of them, like Middelburg, should have been so favoured when Nijmegen saw so little artistic activity.

The predominantly rural province of Overijssel, which was quite unlike the densely populated parts of the central area of Holland, had only three towns of consequence—Kampen, Zwolle and Deventer. Artistically these towns were to some extent interdependent. Hendrick Terbrugghen was born somewhere in Overijssel, probably in 1588, and his set of *Four Evangelists* is still in the town hall at Deventer. But in the early part of the century the centre of activity was Kampen, where Hendrick Avercamp spent most of his active career. Avercamp's pictures hark back to the tradition of sixteenth-century Netherlandish painting and bear little relation to the developments in Amsterdam or Haarlem at the time. Instead, they achieve a distinctly local flavour by his inclusion of the town walls or distant views of the town itself in many of his ice scenes. But Kampen must have been too small to support a large number of painters. Although Terborch worked there in about 1650, it was Deventer, the largest of the three towns, which attracted him.

The town of Zwolle, birthplace of Terborch, produced a local painter of significance who has often been left out of general books on Dutch art because he made little contribution to the development of painting. His name was Hendrick ten Oever (1639–1716). He specialized in landscape paintings which have often been confused with those of other painters whose work they do not in fact resemble. His best surviving picture is the *Evening Landscape with a Distant View of Zwolle*; it is evidence of the high quality of painting which could be achieved in a remote place by a painter whose name is hardly known outside the walls of the Provincaal Overijssels Museum of his native town. The painting is quite unlike other Dutch landscapes of the period and is the product of the artist's unusual powers of observation. The silhouette of Zwolle appears on the horizon—fantastic, elaborate and almost as if it has been dreamed or remembered rather than observed on the spot. The whole picture is a harmony of purple shadows and golden evening light. The naked bathers seen emerging from the water in the foreground seem to emphasize the unconventional nature of ten Oever's vision. There is none of the genteel orderliness of Aelbert Cuyp, but a passionate observation of the evening light transforming the landscape near a small town.

Gerard Terborch
The Suitor's Visit
Canvas 80 × 75 cm (31½ × 29⅝ in)
Unsigned. Probably painted in the 1650s.
WASHINGTON, National Gallery of Art
Terborch liked to paint intimate situations of this type. The visitor is expected—he has just doffed his hat and is in the process of making an elaborate bow. In the background a woman is making music, giving an atmosphere of relaxation and pleasure. As is usual in this type of courtly genre picture, Terborch has concentrated an enormous amount of skill and effort in the painting of the woman's silk dress.

The picture was given to the gallery in 1937 by Andrew Mellon as part of the foundation gift.

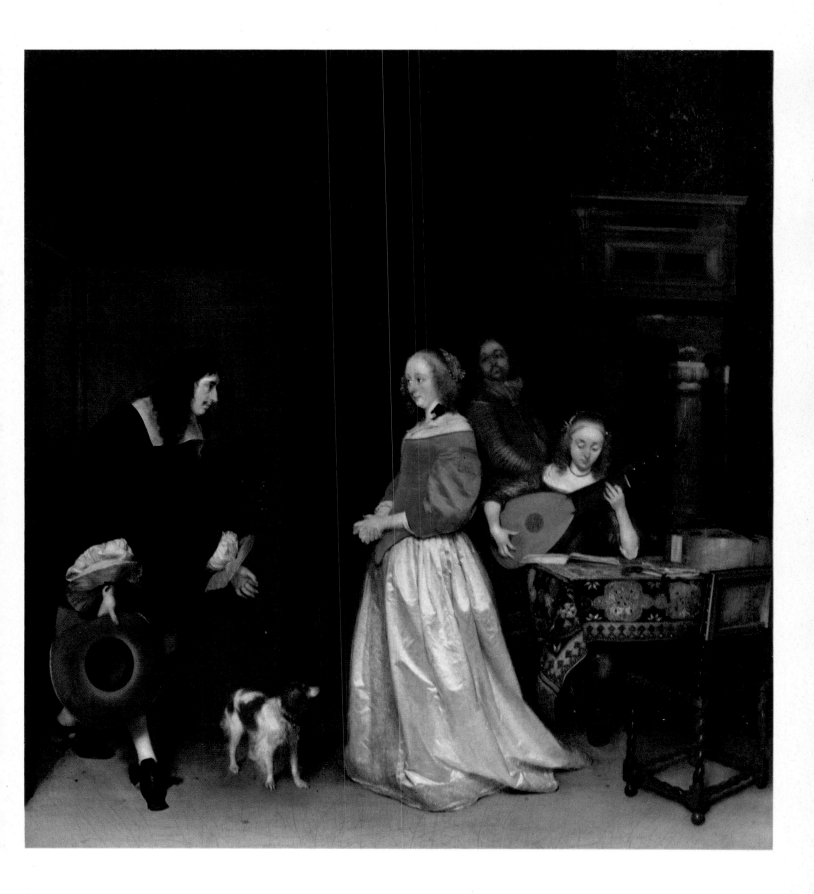

The Deventer of Gerard Terborch must have been quite a contrast to the Zwolle of ten Oever. The town was painted by Hobbema in one of his rare topographical views, and he produced, typically, an impression of leafy charm with the spires of the church just appearing among the trees. This is a good example of a painter imposing a totally personal vision on a particular scene in the interests of achieving a pleasant picture.

It is not often realized that Terborch spent most of his life in the relative isolation of Deventer, so 'townified' are his genre pictures. They epitomize the calm and ordered way of life of the Dutch middle classes in an urban environment. Somehow the bustling streets of Amsterdam are imagined outside the houses where his satin-dressed ladies are making music. The style of painting, too, is quite reminiscent of the Leiden-trained but Amsterdam-based Gabriel Metsu. A possible explanation for this is that the people in the country town wanted, apart from their insatiable demand for portraiture from Terborch, depictions of a way of life to which they aspired rather than experienced. At the same time the middle classes of Amsterdam demanded the idyllic country landscapes of Hobbema.

Further north from Deventer were the provinces of Drenthe, Groningen and Friesland and in these areas there was relatively little artistic activity, even compared with Overijssel. Nevertheless each town supported one or two painters, especially Leeuwarden, which was on the other side of the Zuider Zee from Amsterdam.

There are some artists who cannot be categorized into one place, because they moved so often or because their careers were so shadowy that modern scholarship cannot pin them down to a particular area. The most important of the painters who continually travelled were Jan Steen, Jan Porcellis (Ghent 1584–Soutermonde 1632) and the elusive Hercules Seghers. Both Porcellis and Seghers, perhaps because they travelled so much, were to be very influential in their respective genres of seascape and landscape painting. Segher's career remains largely a mystery but his influence on Rembrandt, especially in the brooding and empty mood of his landscapes, was very important, and Seghers occupies a significant place in the development of landscape painting.

Porcellis, too, was influential. Although born in Ghent, he spent most of

his active career in the north, moving from place to place and finally to Soutermonde near Leiden. Pictures from his hand are rare—a typical example is the *Seascape with a Storm* which seems like a reaction against the intricacies of Vroom. His pictures are always virtually monochrome, and their style was too personal to be widely imitated. Instead, important seascape painters like Simon de Vlieger took over where Porcellis left off, building on his fragile and atmospheric mood to produce their own personal styles, again quite different from that of Vroom. Jan Steen, too, was restless and never really identified himself with one place, although for instance his period in Haarlem in the 1660s was influential on minor painters there like Cornelis Dusart. Although Steen has always been famous (and sometimes ridiculed) for such complex scenes of ribaldry as *The Egg Dance* (London, Wellington Museum), there are many different aspects to his art. In such pictures as the *Archangel Raphael struggling with the Devil* the result is laughable, and there is now no way of telling whether it represents a quite serious attempt to paint a religious allegory or whether it was intended as a joke, like his pictures of quack doctors. Steen is now undergoing a process of rehabilitation, and can be seen as a subtle moralizer on the foibles of his age rather than a vulgarian who could not keep off the bottle.

Above: Jan Porcellis's Stormy Sea, *dated 1629. This is a famous and much-reproduced example of the artist's very personal style. Even on this tiny scale the picture is restless and angular, with a poetic interest in the mood of the sea rather than in topographical accuracy. The bare sky and monochrome palette add to the feeling of unease. (Munich, Alte Pinakothek)*

Right: Jan Steen's The Archangel Raphael and the Devil. *In this picture, probably painted in the 1660s, Steen's imagination is brilliantly seen. Few Dutch pictures at this period were painted purely from the imagination. In this incident from the apocryphal story of Tobit, Steen's devil is quite different from the large-scale images of Hieronymus Bosch and the sixteenth-century tradition. (The Hague, Bredius Museum)*

Amsterdam's Artistic Growth and Triumph

Amsterdam achieved its commercial preeminence among Dutch towns only in the seventeenth century; the sixteenth-century background contains no special characteristics which single out the city as an important place from an artistic point of view. Haarlem, Leiden and Utrecht were all more important as centres of painting. The chief painter was Pieter Aertsen, the sad fate of whose pictures during the iconoclastic crisis has already been referred to. Earlier, there had been the active portrait and religious painter Jacob Cornelis van Oostsanen (d. Amsterdam 1533).

By some accident of history Amsterdam has preserved (in the Historisch Museum there) an unusually large number of late sixteenth-century group portraits of militia companies and governors. Their stern faces are a lasting witness to the severity of temperament which turned Amsterdam into one of the busiest ports of Northern Europe—Antwerp was the chief rival, but the closing of the river Scheldt by the Dutch meant that Antwerp's pre-eminent position was gradually usurped by that of Amsterdam.

The chief painter of group portraits in Amsterdam in the sixteenth century was Dirck Barentsz. (1534–1592). He continued the tradition begun by Scorel, but had none of Scorel's ability to sense the real character of his sitters—although his portraits are quite convincing as physical representations. Barentsz. was too insipid a painter to leave active pupils.

Pieter Lastman was born in Amsterdam in about 1583, and he rapidly developed into the town's leading painter. For an academic painter to assume such importance is quite consistent with the trends in the places already discussed, but Lastman never really had the stature of a Cornelis van Haarlem or an Abraham Bloemaert. He was, however, highly influential in one direction which has earned him a place in art-history books—the fact that for about a year he was the teacher of the young Rembrandt. This was in about 1625, when Rembrandt was only 19. Lastman exerted a dominating influence on the impressionable young man. The few surviving pictures by Rembrandt which date from during or just after his period with Lastman are harsh in colour and frankly unpleasant, as they exaggerate Lastman's bright colour and dense and thick handling of paint. This is nowhere better seen than in the recently discovered *Baptism of the Eunuch* (Utrecht, Rijksmuseum Het Catharijnconvent) of 1626, which is even more intense in colour than in the other very early pictures like the *Stoning of Stephen* of 1625 in Lyons.

After his year with Lastman, Rembrandt returned immediately to Leiden. There, his style was to change with enormous rapidity during his period with Jan Lievens. When he returned to Amsterdam in 1632, almost everything he had learned from Lastman had already been purged from his style.

A group of painters were born in Amsterdam at the turn of the sixteenth century, and some of them painted in a rather similar style. They are Pieter Codde (born 1599), Willem Duyster (born in about 1599), and Pieter QUAST (born 1605/6). All three painted large numbers of 'merry-company' or guard-room scenes of the type familiar from Haarlem from the entourage of Frans Hals.

The real origins of this type of painting are still in dispute; they have to be sought in the work of a painter whose pictures are supremely rare—only ten of them exist. This was Willem Buytewech (c. 1591/2–Rotterdam 1624). His pictures are always of the same type of subjects—merry companies and drinking scenes—and they are always rather light in tone and bright in colour. He worked in Haarlem for a short time, but there are no traces in his art of the monochromatic treatment which was to become so

popular in Haarlem with Dirck Hals. Buytewech's *Interior* (The Hague, Bredius Museum) appears very individualistic, like the landscapes of Seghers. The last five years of his short life were spent in Rotterdam. His importance, if it is really importance, lies in his approach to the subject; his scenes of revelry may have been intended as a kind of protest against the licentiousness of the young.

Lastman exerted a certain influence on his contemporaries, for instance on the brothers Jan (c. 1583/4–1631) and Jacob Pynas (c. 1585–after 1650), whose work, difficult to tell apart, was basically similar to that of Lastman. The most important common influence on all three, and later on Rembrandt himself, was that of the German painter Adam Elsheimer, who had died young in Rome in 1610. Only 30 or so pictures, all of them miniature in scale, survive from his hand. His enormous influence can be ascribed to his manager/publisher, the Dutchman Hendrick Goudt, who engraved a number of Elsheimer's compositions, both landscapes and subject pictures. This initiated a whole school of painting small landscapes—some of them were directly in imitation of Elsheimer himself, and others were more loosely associated with him. In Lastman's little *Flight into Egypt* (Rotterdam, Boymans-van Beuningen Museum) the miniature style and way of painting both the figures and the trees are obviously indebted to Elsheimer. Rembrandt's own interest in Elsheimer could have come through this channel as well as from Seghers, as Rembrandt owned and then reworked an etching plate by Seghers which was a copy of a Goudt engraving after Elsheimer.

The arrival of Rembrandt from Leiden in 1632 can be seen (with historical hindsight) to be the most significant single event for the subsequent character of painting in Amsterdam. Without Rembrandt and his overwhelming effect on a whole host of pupils, trained at every period of his life, the history of painting in Amsterdam would be very much thinner.

Rembrandt was the most imaginative and versatile painter of the whole century. Almost everything he did was an innovation or a reworking of an old tradition and its transformation into something quite new. His actual development in his Leiden period had been prodigious, as is seen in his very moving *Self-Portrait in his Studio* of about 1628, where the

dramatic lighting and self-confident technique make it his first masterpiece.

The great turning-point in his career was the painting in 1632 of the celebrated *Anatomy Lesson of Dr Tulp*. It was a specific commission and remains quite untypical of his style in these years, when he was concentrating on small religious pictures and portraiture. The artist was required to paint a scene which was quite common at the time—the dissection, in the interests of medical research, of the corpse of an executed criminal in public. The Dutch were far more advanced in the field of medical enquiry than most other nations of Europe, and there was a tradition of painting such public demonstrations of anatomy. Rembrandt was only 26 when he painted this very complex picture, and the slight awkwardness in the arrangement of the figures was soon to disappear from his work. What he learned in the intervening years was put to good use in the *Night Watch* of exactly ten years later.

In so many of the books devoted to Rembrandt, the constantly disputed problems of chronology, identification of sitters and the provenance of the pictures have led to the neglect of one of the most important aspects of his work—his role as a teacher. His association with Lievens and Dou in Leiden has already been mentioned but it is, for instance, not often realized that his pupil Ferdinand Bol received more commissions for portraits and large decorations than any other painter of his time, Rembrandt included.

Rembrandt had such a strong artistic character that those who worked in his studio came totally under his spell; perhaps even he was not able to tolerate individuality of style around him. This is quite the opposite to the other great teacher of his time, Abraham Bloemaert in Utrecht, none of whose numerous pupils followed their teacher's out-of-date style. Rembrandt's main pupils in the early Amsterdam years were Ferdinand Bol and Gerbrand van de EECKHOUT. The moment Bol left the studio he went his own way, but Eeckhout continued to use Rembrandt's style of the 1640s right until the end of his career.

The late 1640s and early 1650s were among the most inventive years of Rembrandt's career. At this stage he was, after the troubles which the failure of the *Night Watch* had brought him, very much less of a public figure than before. His pictures of this time rarely contain the

Johannes Hackaert
A Wooded Landscape with Hunters (The Avenue of Birch Trees)
Canvas 66.5 × 53.5 cm (26¼ × 21⅛ in)
Unsigned. Probably painted in the 1660s.
AMSTERDAM, Rijksmuseum
This is the best-known example of Hackaert's woodland scenes and one of the most elaborate. In order to achieve the feeling of dense woodland with the curving line of trees, there has been an enormous amount of careful arranging of the disposition of the tree-trunks. Indeed, such a picture is a tour de force of its type and is so simply and beautifully painted that it allows the spectator to forget the enormous amount of work and observation that went into it. The figures were painted by Adriaen van de Velde, who often collaborated with other artists as he was so good at integrating his figures into other people's landscapes. The picture was acquired by the museum at the G. van der Pot sale at Rotterdam in 1808.

depth of those of his last years, but such outright masterpieces as the Berlin *Man with a Golden Helmet* and the Frick *Polish Rider* date from this time. It was this type of picture, controlled but atmospheric, which must have inspired Rembrandt's most brilliant pupil, Carel Fabritius. The little *Head of an Old Man* (Liverpool, Walker Art Gallery) could almost have been painted by Rembrandt about 1650. Among the more minor pupils were Willem Drost (c. 1630–Dordrecht 1687), who specialized in rather broadly painted portraits and genre scenes, Gerrit Willemsz. Horst (1612–1655), a rather shadowy figure who painted in a style closer to that of Flinck than Rembrandt himself, and the competent but rather staid portrait painter Jacob Adamsz. Backer (1608–1651). Much more important was Nicolaes Maes, who soon abandoned what he had learned from Rembrandt on his return to Dordrecht and pursued an independent course, making a significant contribution to the development of genre painting.

The chief imitator of Rembrandt's much more personal late style was Aert de Gelder, who took back with him to Dordrecht many of Rembrandt's mannerisms, including impasted paint and soft, rich colour. He continued to paint in this style right until his death in 1727, and of all the pupils his pictures were the ones most often confused with Rembrandt himself in the eighteenth and nineteenth centuries.

Newspaper headlines are occasionally made when an important picture by Rembrandt is attacked as a later imitation or the work of a pupil. Contrary to what is sometimes believed, there are a limited number of pictures by Rembrandt whose histories are documented. The *Anatomy Lesson of Dr Tulp*, the *Night Watch* and the *Syndics* are all in this category, and it is possible to construct round them a limited canon of works which have never been the object of serious doubts.

It is also possible to establish a canon of authentic pictures by each of the major

Above: Rembrandt's Anatomy Lesson of Dr Tulp, *dated 1632. This is one of the most important pictures of its period—Rembrandt's first large commission in Amsterdam. The young artist succeeded in giving the figures a strong presence, helped by the fact that they are almost life-size, and the picture set Rembrandt on the road to his early success. (The Hague, Mauritshuis)*

pupils. Quite a number of Bol's pictures are documented. Eeckhout signed much of his work, and Lievens did on occasion. It is therefore possible to gain a distinct idea of the character of most of these painters and their relationship to the major stages in Rembrandt's career. The battle between scholars and connoisseurs rages over a group of pictures which many Rembrandt authorities label anonymous, like the celebrated *Mill* (Washington, National Gallery of Art), or attribute to a relatively insignificant pupil like Jan VICTORS, as in the case of the *Angel Ascending in the Flames of Manoah's Sacrifice* (Dresden, Gemäldegalierie).

In default of the discovery of a cache of new documents giving some insight into Rembrandt's studio practice, there is at present no satisfactory way out of the impasse. It is sufficient to emphasize that Rembrandt, being impulsive and inventive, is not in the least predictable and is therefore what connoisseurs call 'uneven'. On the other hand some of his pupils were occasionally able to paint a masterpiece; hence the confusion. This is also true of several other Dutch painters. Hobbema, for instance, was remarkably even and very predictable until he suddenly painted the *Avenue at Middelharnis* (page 115). Adriaen van de Velde's *Farm* in Berlin (page 195), too, is a masterpiece which transcends completely the very orderly mentality of its creator. In such pictures as Karel Du Jardin's *Diamant* (page 87) and Samuel van Hoogstraten's *View down a Corridor* (page 124), a single isolated work raises the art of a minor painter to the highest level of achievement.

In contrast to the intense and increasing activity of Rembrandt, the other painters active in Amsterdam in the 1630s appear unimaginative. No other painting approaches Rembrandt's huge *Blinding of Samson* (Frankfurt, Städelsches Kunstinstitut) of 1636 either in daringness of composition or sheer emotional impact. Instead, a different sort of art became very much in demand.

In 1633 Bartholomeus BREENBERGH returned from Italy to Amsterdam, bringing with him his skill in painting small Italian-inspired landscapes very similar to the type which Cornelis van Poelenburgh imported into Utrecht. The major difference between the two was simply that Poelenburgh introduced religious or mythological incidents into his landscape more often than did Breenbergh. It

was also in the later 1630s that Aert van der NEER began to paint his small ice-scenes and moonlit pieces, which were to continue hardly changed for some 40 years.

In 1637 Jan Miensz. Molenaer and his wife Judith Leyster arrived from Haarlem and they worked in Amsterdam for some ten years, having brought with them their fully developed style of genre painting. This meant that there were a number of Haarlem-inspired painters all working in Amsterdam at the time, especially the highly talented Pieter Codde, who in fact was called in to complete the one group-portrait commission which Frans Hals was asked to do for Amsterdam and which he left unfinished (Amsterdam, Rijksmuseum).

Judith Leyster was more adventurous than her husband and started to paint a number of pictures with artificial light effects, which may be the cause of speculation about her relationship, both personal and stylistic, with Rembrandt. It is quite likely that such night scenes—and they occur occasionally in Rembrandt's work—had a common source in Utrecht. But the influence of a painter like Terbrugghen was never direct, and by this time Caravaggism in the Utrecht style was quite out of fashion.

Perhaps the return to Haarlem in 1648 of Leyster and Molenaer was significant. They may not have found the ever-increasing demand for pictures in a new style to their liking and preferred to return to Haarlem, where their by now rather out-of-date genre pictures were still appreciated.

The most important picture painted in Amsterdam in the 1640s was Rembrandt's *Night Watch* of 1642. It is one of Rembrandt's bravest achievements. Never before had a Dutchman produced such an elaborate, well-balanced, brilliantly lit composition of so many figures. It had relatively little influence on other painters for the simple reason that they were not capable of imitating it or learning from it.

The 1640s saw the arrival from Italy of a whole younger generation of landscapists. The most important and influential of all the Italianate landscapists was Jan Both, who preferred to remain in Utrecht, where he had considerable influence. But the new generation—both Poelenburgh and Breenbergh were older —which came to Amsterdam in the 1640s were very successful. The chief figures

were Jan ASSELIJN, Adam PIJNACKER and Johannes LINGELBACH. Of the three Pijnacker was the most inventive and Lingelbach the most conventional. But all three have in common an unmistakable golden glow and the use of foreign elements like mountains or classical ruins in their landscapes. Jan Asselijn has been overshadowed by Pijnacker, but his pictures are the most carefully observed of the Italian scenes, as in the delightful *Ruined Bridge* (Barnsley, Cannon Hall, William Harvey Bequest). In Pijnacker there is always an imaginative element, even in the treatment of vegetation, which is quite often a bizarre hybrid of turnip tops and rhubarb leaves which are given a delicate bluish tinge, contrasting beautifully with the yellow light and porcelain-blue sky.

Although there was no real tradition of landscape painting in Amsterdam—one looks in vain for a Jan van Goyen, a Salomon van Ruysdael or an Esias van de Velde—it was in the realm of seascape painting that Amsterdam assumed great significance. In the other towns the seascape painters of importance had been Vroom in Haarlem and the elusive and rare Jan Porcellis, who never stayed in one place for very long. The arrival of Simon de Vlieger in the 1640s heralded a quite unexpected development in this field. By 1650 a high point had been reached which was more or less maintained, unlike some of the other genres, right until the end of the century —Ludolf BAKHUIZEN, a master of the seascape, died in 1708.

Simon de Vlieger spent the 1640s in Amsterdam before moving to nearby Weesp for the last three years of his life. The younger generation of painters were not directly influenced by de Vlieger's delicate handling and monochrome colour schemes. De Vlieger observed shipping very carefully, but his style was quite the opposite from the equally observant Jan van de Cappelle, who preferred to build up his compositions of boats in great pyramids and always placed them in calm water. There is no real precedent for the mature art of Jan van de Cappelle. Jan van Goyen had painted many choppy seas, but van de Cappelle stands as an isolated genius who also had very little influence on his contemporaries.

The opposite type of seascape painting, that of storms, had rather different exponents. Such extravagances had been favoured by Vroom and had been taken

up by Porcellis, but the two painters who favoured this particular style were Ludolf Bakhuyzen and Willem van de Velde the Younger. Both these painters, along with Hendrick DUBBELS, were expert at the painting of calm waters. They differed from Jan van de Cappelle because they preferred to isolate each boat in the calm water, while at the same time observing the minutiae of the rigging and flags. The result in these pictures is an inexplicable sense of calm and well-being, which raises a few of Willem van de Velde's best works to the level of great paintings. Bakhuizen was the storm-painter *par excellence*, and his shipwrecks and choppy seas often have a genuinely observed feeling. Willem van de Velde the Younger was capable of even greater dramas with scudding clouds and extravagant waves (page 198).

All these trends, both in seascape painting and landscape, represent the forward-looking painters. It must not be forgotten that most of the really successful painters of the period were the ones who, year in and year out, received all the important commissions, either for elaborate public decorations (which were few) or large group portraits. The most successful in Amsterdam, apart from Bol, was Bartholomeus van der HELST, whose large painting of the *Celebration of the Treaty of Münster* in 1648 (page 189) represents the official type of painting. The reputation of Helst was far above that of Rembrandt, especially after Rembrandt had painted the *Night Watch,* which had not enhanced his reputation. Nowadays, of course, the position is exactly reversed, but there are signs that modern scholars are beginning to make a proper assessment of Helst's significance in terms of the Amsterdam of his time.

The 1650s saw a continual increase in the number of painters active in Amsterdam, most of them arriving already trained from other places. There was a corresponding increase in quality, but nothing which quite anticipates the dazzling achievements of the 1660s. By the 1650s Rembrandt was well in the background—he was forced to sell, for financial reasons, his large house and move to a very much smaller one, and he went bankrupt in 1656. His pupil Bol received all the best commissions, but in his private world Rembrandt achieved some of his most moving work—the paintings of his mistress Hendrickje, of his son Titus, and the purest expression

of his art in this troubled period, the Frick Collection *Polish Rider.*

The 1650s saw the arrival of a second wave of landscapists, while one native artist, Philips Koninck, reached his maturity. Koninck was highly individual and talented, and the relatively modest impact which his pictures make today is perhaps caused by the fact that he was such a specialist. Basically, he only painted flat landscapes with the horizon approximately across the centre of the picture. Only on close inspection are their subtlety and sensitivity realized. Their style is derived from Hercules Seghers, but with increased breadth.

In 1655 Allart van Everdingen arrived, bringing with him his austere landscape style of fir-trees, torrents and rocks, all of which he had observed in Scandinavia. The success of Koninck and Everdingen paved the way for the enormous expansion of landscape painting in the 1660s under the aegis of the great Jacob van Ruisdael.

There was also yet another wave of Italianate landscape painting in the 1650s. Du Jardin spent the years 1652–6 in Amsterdam and then returned in 1659, staying until 1675. He was less strictly Italianate than many of the other painters and tended towards a type of landscape which is neither Italian nor Dutch, rather close to Berchem's type.

The obscure but talented Govert CAMPHUYSEN arrived in 1650, and from his picture in the Wallace Collection (page 73) it is possible to see that he was capable of painting a well-observed picture which is something more than a literal record of a farmyard; it has a poetic quality usually associated with far greater painters than he. Paulus Potter also spent the last two years of his short and restless career in Amsterdam (1652–4), and from time to time his pictures are suffused with the fashionable golden light, as in his *Orpheus Charming the Animals* (Amsterdam, Rijksmuseum).

Even at this point there was no special Amsterdam style, as there was a Haarlem or Delft style. Many different painters had arrived from many places bringing with them many styles and ideas. Apart from the academic painters (Bol, Helst, Backer) there were several main streams running concurrently at the end of the 1650s. There was that of Rembrandt and his followers. There were the Italianizing landscapists (Asselijn, Lingelbach, Du Jardin). Then there were the seascape

Rembrandt
Passion series no. 1: The Raising of the Cross
Canvas 96.2 × 72.2 cm (37¾ × 28⅜ in)
Unsigned. Painted no later than 1636 and probably c. 1633
MUNICH, Alte Pinakothek
This and the picture on page 163 are the first two of the five surviving pictures representing scenes from the Passion. They were painted by Rembrandt over a period of years in the 1630s for the stadholder Prince Frederick Henry of Orange. The agent for the commission was Constantin Huygens. The direct composition with the aggressive diagonal of the cross and the elaborate and dramatic lighting shows how rapidly Rembrandt had developed. Rembrandt mentioned the picture in his letter to Constantin Huygens in February 1636 and it must therefore have been completed by then.

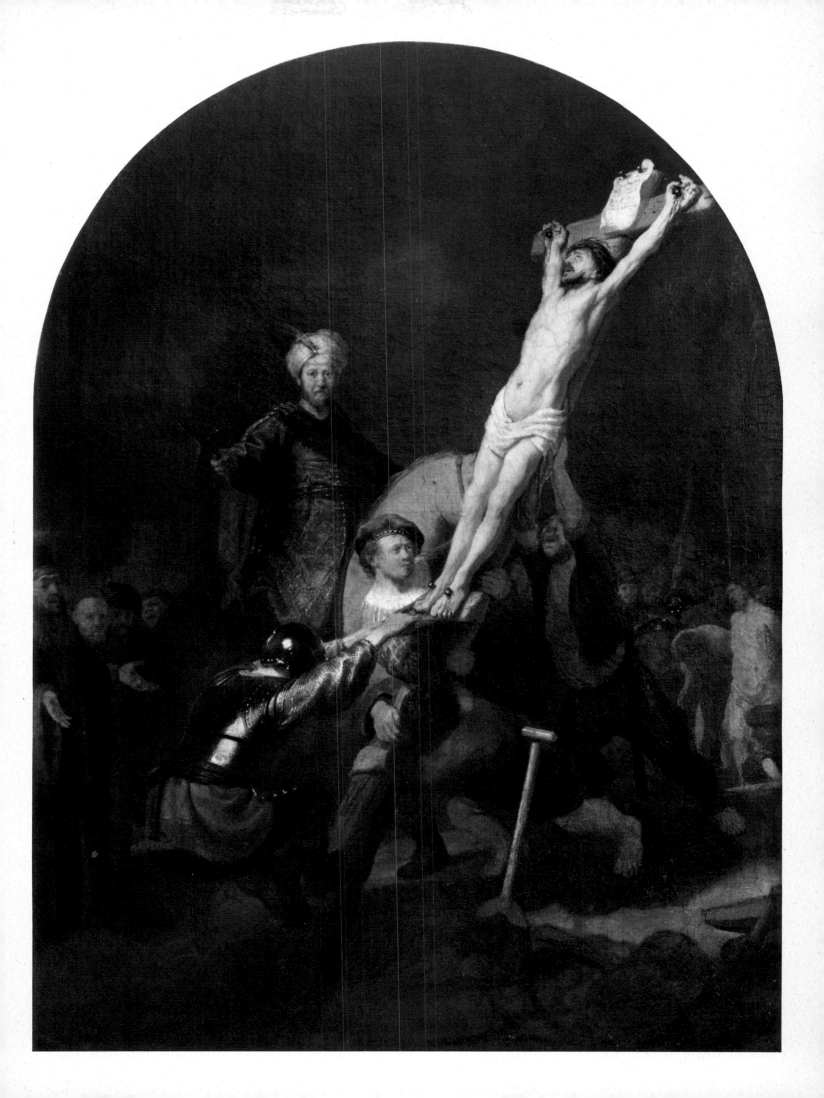

painters and the growing interest in landscape painting.

The city was poised on the edge of a creative torrent which was to have far-reaching results. First, Rembrandt entered a final productive phase and secured two important commissions, the decoration for the town hall (fragment in Stockholm, Nationalmuseum) and the large group-portrait of the Syndics (page 169). Secondly, a whole group of genre painters arrived, either Leiden-trained (Metsu) or from Delft (Pieter de Hoogh). Thirdly, contact with Haarlem increased so much that the creative force of that town was drawn towards Amsterdam by the arrival of the young Jacob van Ruisdael. All this was grafted onto the existing trends which made Amsterdam, for a brief moment in the 1660s, one of the most active centres of painting which had ever existed in Europe.

The sheer variety of creativity in Amsterdam in the 1660s defies classification. Even when Haarlem or Delft were at their heights—Haarlem in the earlier part of the century and Delft in the 1660s—there was never such a concentration of talent or such a host of minor painters in one place.

Over all this was Rembrandt. He was isolated and temperamental. He refused to follow the tastes of his time, but in 1660 he was commissioned to paint one of the large decorations for the newly constructed town hall. The old town hall—gothic, rambling and inconvenient—had been burned down (see Saenredam's picture on page 179 for its state immediately before the fire). The new building towered over all, even dwarfing the gothic Nieuwe Kerk (see Jan van der Heyden's view, page 113). Rembrandt rose to the occasion and painted one of his greatest pictures. This was the *Conspiracy of Claudius Civilis*. The whole composition is known from Rembrandt's drawing in the Graphische Sammlung, Munich. The picture occupied the whole of the end wall of the main hall of the building. The idea was to depict an incident from the very distant past in an attempt to provide the new republic with a history which in fact it did not have. Rembrandt's picture was taken down almost as soon as it had been hung, because, it is said, he wished to retouch it. What is more important is the fact that it was never put back; a mutilated fragment of the central part later ended up in Stockholm (Nationalmuseum).

Rembrandt's last years were not entirely a story of public failure. He was commissioned in 1661 to paint a group-portrait of the *Syndics of the Clothworkers' Guild* (page 169), rather like Hals in his old age was commissioned to paint his magnificent portrait of the *Regentesses of the Old Men's Almshouse at Haarlem* (page 109). Rembrandt produced in this sober masterpiece a summing-up of his official style of painting, and displayed that in his declining years he had lost none of his ability to create a formal composition and to infuse it with his own brilliant analysis of character.

Privately, he was also undergoing a frenzy of activity. He produced several deeply moving self-portraits and a series of pictures of his ailing son Titus. These late masterpieces did not have any public significance. As far as is known they were not sold, and they had no influence on Rembrandt's contemporaries. Indeed, it was only in the nineteenth century that *The Jewish Bride* (page 168) was 'discovered', and only then did this phase of his career assume any importance in the eyes of critics.

Rembrandt trained one genre painter of great ability, Nicolaes Maes, but he spent the 1660s in Dordrecht. At the same time several other genre painters, trained in quite different traditions, arrived in Amsterdam about 1660, and there they either developed or continued their own styles, and raised the standards of genre pictures to new heights of both technique and invention. On the other hand the most skilled painter of them all, Pieter de Hoogh, changed his style radically on his arrival from Delft. Instead of painting pale courtyard scenes or intimate interiors, he turned to a much more atmospheric, shadowy and freely painted style. This must have been caused by a very different clientele than the one he had in Delft. Much greater freedom of brushwork must have been appreciated in Amsterdam rather than in Delft; after all, the Amsterdam connoisseurs had long been accustomed to Rembrandt and his pupils and were used to seeing the pictures of the best Venetian masters, including Titian, sold at auction. Admirers of meticulous brushwork, even nowadays, find Pieter de Hoogh's Amsterdam period vapid compared to the works he produced earlier in Delft.

Gabriel Metsu, the other important genre painter who arrived in Amsterdam, was trained, or rather indoctrinated, into the technical severities of the Leiden school; he stuck to his meticulous technique at a time when many other painters were moving towards a freer approach. In this he was followed by the best townscape painter the century produced, Jan van der Heyden. He spent his whole active career in Amsterdam but travelled widely to places as far afield as Cologne and Brussels, recording them with the same fidelity as he did the streets of Amsterdam. Some of his best pictures were of local scenes, like the *View of the Town Hall* (page 113), and he used the same brilliantly meticulous technique for townscape as Metsu did for genre. The result can perhaps be criticized too easily by those accustomed to looking at the late works of Rembrandt. But what is often forgotten about Jan van der Heyden, especially by those who deride his endless bricks and ivy leaves, is his beautiful treatment of light and atmosphere. In his *View of the Huis ten Bosch* much of the building is in shadow, but every detail is still observed and carefully muted.

The work of Emanuel de Witte, the church interior and genre painter, lies half-way between the meticulous style of Jan van der Heyden and the moodiness of de Hoogh's Amsterdam style. In comparison with the Delft church-interior painter Hendrick van Vliet, de Witte's

Right: Jacob van Ruisdael's View on the Amstel looking towards Amsterdam, *probably painted between 1675 and 1680. Although this is an accurate view of the edge of the great city, it reflects Ruisdael's preoccupation with the open air and cloudy skies. Much of the city was laid out in the middle years of the century on a system of regular canals which survives to this day, and the vast extent of the growing city is hinted at in the distant towers and spires. Amsterdam's informal and commercial nature is emphasized in this picture, in contrast with the rigid splendour of Paris or Rome. (Cambridge, Fitzwilliam Museum)*

work appears freely painted; in fact, his pictures were very carefully made and are almost always of imaginary places. He was interested in the fall of light on pillars, creating great pools of shadow in these vast church interiors.

All these painters, important though they were, are pushed into the background by Jacob van Ruisdael, who had arrived from Haarlem in 1657. Even though he suffered a certain critical neglect in the middle years of the twentieth century, Ruisdael is still without doubt the greatest Dutch landscape painter. Sadly, his excellences are all too easily forgotten by those in search of charm. Ruisdael's work is never pretty and never cheerful. The skies in Ruisdael's pictures are always brooding, and if emotion can be put into landscape painting at all it was Ruisdael who succeeded in putting it there. There is almost a feeling of depression in the *Jewish Cemetery* (page 173), so intense is the painting of the oncoming (or is it departing?) storm.

A comparison with Rembrandt's landscapes is instructive. Rembrandt made many landscape drawings of the countryside round Amsterdam, whereas Ruisdael appears to have made very few, but Rembrandt executed relatively few landscape paintings. They are at once romantic and dramatic. Shafts of sunlight break through storm-clouds, and vast distances are suggested in the backgrounds. By contrast, Ruisdael is very matter-of-fact and ordinary. Rembrandt had, in fact, stopped painting landscapes by the 1660s and Ruisdael steadfastly took no notice of his type of art. Out of his prosaic material he created, not a poetic vision, but a perfectly honest vision of reality.

Occasionally Ruisdael's pictures are topographical, as in the *View of Amsterdam*. Ruisdael was not interested in the urban grandeur or bustle; we have Jan van der Heyden for that. Instead, he gives an impression of the importance of shipping in the daily life of the city around the wide river Amstel.

Ruisdael had quite a number of imitators, both in Haarlem and Amsterdam, but he had one outstanding pupil, Meyndert Hobbema. As a pupil he imitated his master quite convincingly; he then changed his style very slightly—just enough to remove the austerity and grandeur of Ruisdael and to substitute prettiness and charm. The result was very much more picturesque and there is almost always, except in the *Avenue at Middelharnis* (page 115), a certain saccharine quality in Hobbema's pictures. His woodland glades, rustic cottages and castle ruins became very popular with eighteenth-century collectors.

After a decade of such intensity in Amsterdam a decline was inevitable, but it was surprisingly rapid. By 1680 almost all the great painters were dead and a very different sort of art was fashionable. Leiden, The Hague and Rotterdam continued to be centres of activity, and Amsterdam's pre-eminence vanished just as suddenly as it had appeared. The French invasion of 1672 caused a great amount of disruption to commerce and consequently limited the amount of cash available for the purchase of pictures. Then there was the unaccountable change in taste. People suddenly became more exacting about standards of craftsmanship. By craftsmanship they meant manual dexterity and minute brushwork. The last years of the century are dominated, all over the country, by the success stories of Caspar Netscher, Godfried Schalcken, Adriaen van der Werff and Eglon van der Neer. The delicate interpretations of a Jan van Goyen or the robustness of a mature Rembrandt portrait were quite out of fashion.

The Unanswered Questions

This enquiry has concentrated on two main aspects of Dutch painting—the main differences between the towns and the stylistic changes which took place in each of them, and their relationships to and independence from one another. Attempts to produce a carefully argued sequence of reasons why the century abounded with so many painters have been futile. For example, Protestantism has often been seen as one of the driving forces behind Dutch art. The good devout burghers, in not allowing religious pictures, could thus appreciate portraits of themselves or landscapes. But the fact that Catholic Utrecht was one of the most productive towns outside Amsterdam, even if it did not produce a great painter, utterly disproves this theory.

Then there is the problem of literature. In recent years one of the fashions of scholarly enquiry has been to trace the literary sources of many pictures. Paulus Potter's cows and Adriaen van Ostade's peasants have mercifully refused to reveal what poem may have inspired them. Some mythological painting was of course based on the Classical authors, but painters, once they had consulted their text, still had to imagine the scene they wanted to depict, or else look at some other painter's interpretation of the same story. Thus the scholar may exclaim in

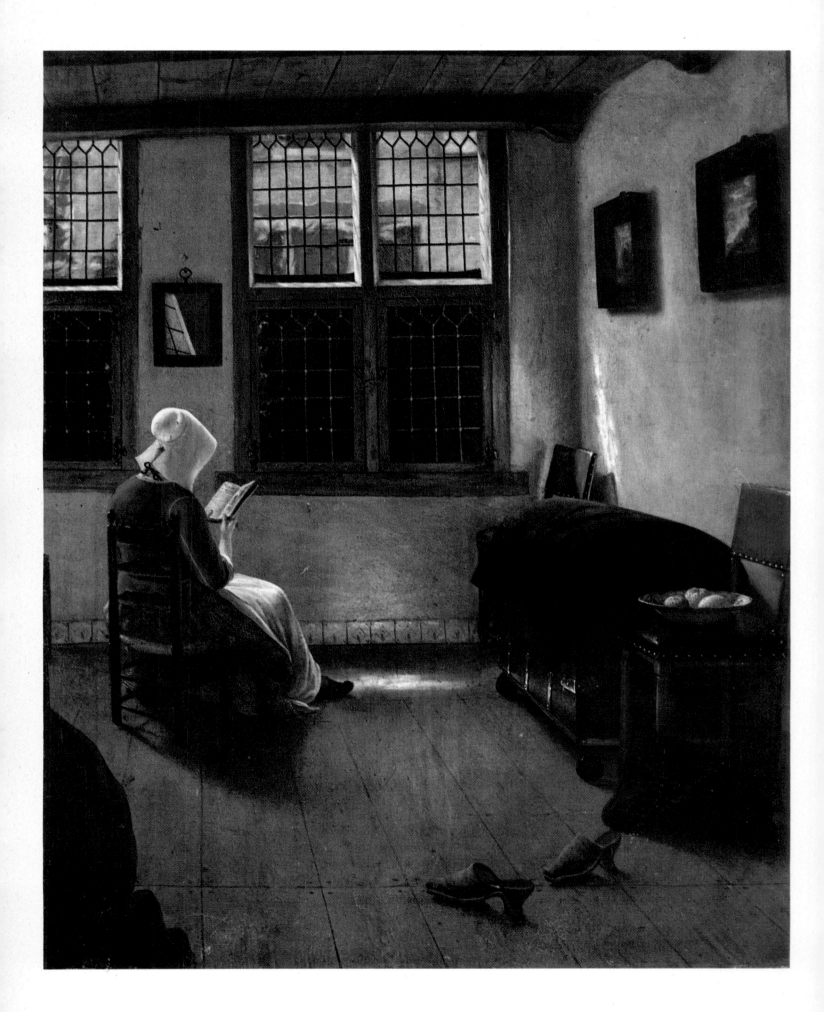

Pieter Elinga Janssens
Interior with a Woman reading
Canvas 75.5 × 63.5 cm (29¾ × 25 in)
Unsigned. Generally dated in the 1670s.
MUNICH, Alte Pinakothek
There is a curious sense of detachment from the scene which is quite different from Pieter de Hoogh, although the actual elements in the picture, in particular the figure, are quite similar to his work. On the other hand, the type of room is familiar from the work of Vermeer (with the exception of the floor, which in Vermeer's art almost always has tiles). It is difficult to know whether the shoes left so conspicuously in the foreground have any significance. The same problem appears in Samuel van Hoogstraten's picture, in the Louvre, of an empty room which also has a pair of slippers lying on the floor.
Janssens's picture was acquired for the Munich collection from a dealer in Mannheim in 1791.

glee if he finds a picture whose subject is taken from a poem by Vondel, but nevertheless the subject is not the reason why painting flourished.

Rather more to the point is the question of commercial wealth. Abundance of money was the reason why people were able to afford pictures, but not the reason why they were painted. The patron must have interfered to some extent, particularly in the manner he or she was to be dressed when appearing in a portrait. But no amount of reasoning can explain why the late works of Hals and Rembrandt stand obstinately outside their time as some of the greatest paintings man has produced.

Then there is the equally complex problem of subject matter. Many pictures probably had extra, unwritten meanings for contemporaries, and many of these have been lost today. A scene of merry-making by Dirck Hals or Willem Duyster could, if the spectator wished it, be interpreted as a warning against licentiousness or gluttony. The Protestant sections of society were constantly being exhorted from the pulpit to live moral and ordered lives. Similarly, ladies opening letters from their lovers are sometimes shown with seascape pictures hanging on the wall of their rooms. These could be taken as symbolizing the uncertainties of the ship of life caught in a storm.

When the subject matter of a painter of Rembrandt's stature is examined, he defies generalization. He painted every type of subject as his curiosity was insatiable. He must have been very familiar with the Bible, especially with the Old Testament, as he painted many obscure incidents. In fact there is rather more religious painting in seventeenth century Dutch art than is usually thought. Almost all of it, except that of Utrecht (which favoured lives of saints in the Catholic tradition), is based on a direct illustration of Bible stories.

The convenience with which Dutch seventeenth century painting breaks down into categories has often been the cause of misunderstanding. The compartments of still life, flower painting, landscape, portraiture and so on lend themselves to specific studies which tend to ignore the fact that a large number of painters who specialized in one category also excelled in others. Examples are infinite—a town view by Hobbema (London, National Gallery), a still life by

Jan van der Heyden (The Hague, Mauritshuis), a seascape by Emanuel de Witte (Amsterdam, Rijksmuseum)—all these and many others emphasize the dangers of generalization. On the other hand it took a very long time for a painter to learn to be proficient in any one area, so exacting were the standards. In the painting of still life this was especially so; flowers seem to have been a particularly difficult area and attracted more specialists than the other genres. But for the very talented it was still possible to change one category of subject matter for another.

Some painters, on the other hand, never changed. As far as is known Jan van Goyen never painted anything but landscapes, but even the single-minded Saenredam did both interior and exterior views of his beloved churches and also painted a few scenes of Rome when he was there. But the most specialized was still flower painting. This, perhaps, has been the cause of miserable neglect, even by 'enlightened' twentieth-century historians and critics. No great Dutch painter ever painted flowers, except the specialists in this genre. The extreme rarity of paintings by the great Ambrosius Bosschaert and the curious lack of important flower pictures in many of the larger collections of Dutch pictures (the London National Gallery and the Louvre being two conspicuous examples) has perhaps increased this unjust oblivion. Neither can the great flower painters be accused of mere imitation of nature with a small brush. They composed their flowers very carefully, balancing them and juxtaposing them to achieve the maximum effect. Bosschaert's robust flowers form a pattern of their own; those of Jan Davidsz. de Heem are much more nervous, as he is preoccupied with their silhouettes and twisting stems. The historian of flower painting is also hampered by the fact that once the genre had matured by about 1630 there were very few stylistic changes later. There was no Rembrandt of flower painting who loosened up the style once and for all. Instead, if anything, the genre became even more meticulous under Rachel RUYSCH and culminated in the *tours de force* of minuteness of Jan van Huysum and Jan van Os in the eighteenth century. A good example of a minor painter who has been overlooked is Jacob van Walscapelle; his *Flower Piece* has all the meticulousness of the genre during the later part of the century.

Other masters of still-life painting, too, are easy to overlook. One of the greatest was Willem Kalf, who worked in Amsterdam from the 1650s onwards. He loosened the style and conceptions of the austere Haarlem school of Pieter Claesz. and Willem Claesz. Heda. He added a sombre tonality and richness of texture which gives his best pictures an air of mystery of a Rembrandtesque type, transferred from the human face to the intricacies of a half-peeled lemon.

Genre painting, too, was not just confined to drunken banalities or ladies peeling parsnips but had an infinite variety of approach. The two 'low-life' genre painters, Adrian van Ostade and Jan Steen, were quite predictable, as were the middle-class genre painters like Terborch, Maes, Metsu and Frans van Mieris. But this is to reckon without such eccentric painters as Michiel Sweerts. There is no precedent for his child with tears running down its face (Rotterdam, Boymans-van Beuningen Museum) or the naked model in the studio (Haarlem, Frans Hals Museum).

The same is true of landscape. Adriaen van de Velde's *Farm* is his one perfect picture. Vermeer's *View of Delft* is perhaps too well known for its uniqueness to be obvious. Hobbema's *Avenue* stands outside its own time, untypical both of Hobbema and of the 1680s in Amsterdam. There are always those exceptions which make enquiry worthwhile.

It has already been said that the Dutch were not in the slightest interested in writing about their art. Pictures were there to be looked at, or they were owned as symbols of wealth. With the signal exceptions of the Oranjezaal at the Huis ten Bosch and the decoration of the new town hall of Amsterdam, pictures emphatically did not serve the purpose of the glorification of a political or religious idea. Occasionally they had an allegorical meaning, but this is relatively rare. A touching example is Pieter Post's *Ladder of Life with the Last Judgement*, where the allegory is so clearly stated as to need no explanation.

The exact extent of literacy among the Dutch merchant classes is difficult to know, but the visual process of looking at and appreciating a Paulus Potter or an Aelbert Cuyp did not demand an extensive knowledge of literature, either classical or contemporary. This is less true of the Haarlem Mannerists, whose erudi-

tion, left over from the sixteenth century, may have been one of the contributing reasons for their decline in popularity in the middle years of the seventeenth century.

It cannot be emphasized too much, however, that many painters who are esteemed today were little known in their time, or even, in the instance of Vermeer, ignored. Instead, the official portraitists of the Leiden school of *fijnschilders* had all the patronage and became wealthy in their lifetimes. It was they who attracted foreign patrons. It was typical of that great connoisseur of Italian painting, Charles I of England, to invite Honthorst to London to paint his portrait when he could have chosen Rembrandt or indeed many other portrait painters of greater talent than Honthorst. Therefore when standing in front of Aelbert Cuyp's *Sunset Landscape*, it has to be remembered that this evocation of the last rays of the sun by one of the supreme painters of light was painted in the relative isolation of Dordrecht, quite apart from the mainstream of official commissions.

The Decline of Dutch Painting

Historical hindsight allows the date of the decline in Dutch painting to be put about 1680, but this is an entirely modern view. Houbraken, writing in 1720, had no such pessimism. He regarded Adriaen van der Werff as the greatest Dutch painter in the

way that Vasari saw Michelangelo as the greatest Italian artist. Most people over the last 400 years, even if they do not personally like Michelangelo, have tended to agree with Vasari's main point that with Michelangelo—painter, sculptor, architect, poet—a very high point of development had been achieved. Houbraken, on the other hand, has fared much worse than Vasari because nobody today can quite tolerate Adriaen van der Werff's being placed above Hals, Rembrandt, Ruisdael and several dozen other painters. But the reaction to Houbraken's ideas has gone too far, especially in the recent past, and late painters like Eglon van der Neer, Netscher and Schalcken deserve to be better appreciated.

This last-mentioned group of painters did not give their contemporaries the slightest cause for concern that painting was in decline at all. An exquisitely painted interior by Netscher must have made the work of a Duyster or a Dirck Hals of 50 years before look old-fashioned, coarse and crude. Houbraken was only expressing a generally held view that art had gone from strength to strength. At no time before had Dutch painters enjoyed such international prestige. Their pictures were collected by all the courts of Europe and painters were sometimes, like Adriaen van der Werff, in the permanent service of a foreign court. The late portraits of Maes and Netscher must have made the direct approach of a Hals or a Rembrandt look

Left: Pieter Post's The Ladder of Life with the Last Judgement, *probably painted in the 1650s. As in most Dutch paintings of the period, when an allegory is intended it is made explicit. Man's rise and fall are here depicted with deadly accuracy, and in the background under the arch is his fate on the last day. (Cleve, Municipal Museum)*

Below: Johann Zoffany's Sir Lawrence Dundas and his Grandson in the Library at 19 Arlington Street, London. *This interesting picture shows the way in which Dutch paintings were hung in about 1769 or 1770. The superb work by Jan van der Cappelle over the chimney piece is still in the Dundas family collection. It is flanked by various Italianate landscapes and one small seascape. Some genre pictures are just visible on the right. (Aske Hall, Yorkshire, The Marquess of Zetland)*

almost amateur; this is why the period 1675–1725 was a period of relative neglect of the very painters who are now considered to be great.

The Dutch Republic also, at the time of the increased internationalism of its painters, gained enormously in prestige and importance. The stadholder was the ruler of England, Scotland and the whole of the expanding British overseas possessions during the period 1689–1702. In spite of many economic problems the Dutch emerged triumphant from the War of the Spanish Succession and were accorded the honour of having the peace signed at Utrecht in 1713. This marked the humiliation of the aged Louis XIV on the one hand and the real termination of Dutch creativity in painting on the other. The younger generation seems not to have been inventive enough to experiment with new ideas, but demanded slavish imitations of the old standards.

Changing Patterns of Taste

The eighteenth-century history of Dutch painting has been neglected. It was characterized by a continuation of technical competence combined with a singular lack of imagination. It is as if the variety of the previous century had inhibited painters; patrons were easily satisfied by the clever imitations of the younger members of the van Mieris family. But if the eighteenth century was a barren period creatively, it was also the great age of collecting.

Only those who have seen one of the rare surviving late seventeenth- or early eighteenth-century collections will realize how out-of-keeping with our own ideas they are. The historian, too, finds himself bewildered because the quality of the pictures seems to vary so much. A visit to the small rooms and corridors of the still-intact collection of the Counts von

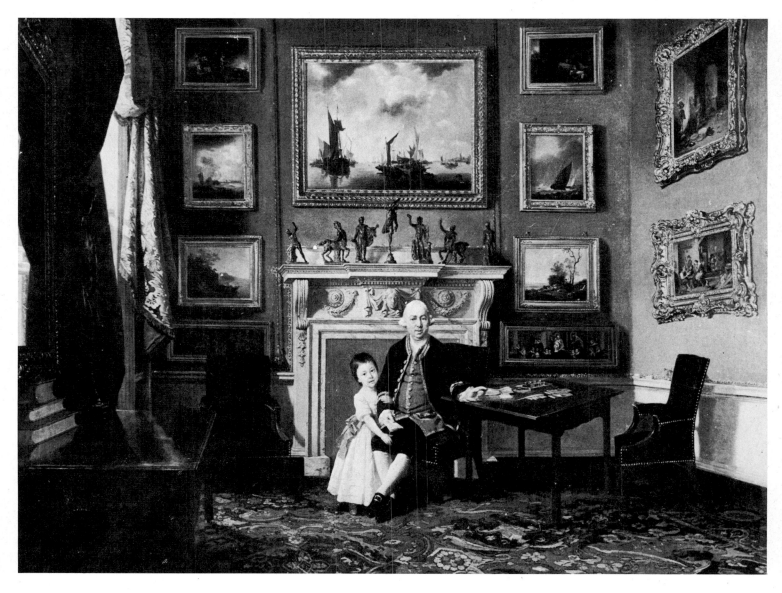

Schönborn at Pommersfelden, or a careful look at the Dutch pictures in the ducal collection in the gallery at Brunswick, illustrates very clearly these different standards. Inferior pictures from his last period by Cornelis van Haarlem hang with dark canvases by Wtewael. Small and not always good examples of the Italianate landscapists jostle with important large mythologies by Lastman.

Another curious aspect of these early collections of Dutch pictures is the fact that there is nearly always a break in the history of each picture. Rare indeed are the paintings which can be traced directly from the artist himself through a series of different owners down to the present day. Rembrandt's *Night Watch* and his *Anatomy Lesson of Dr Tulp* have unbroken histories, but by contrast not a single Vermeer can be traced right back to his lifetime. Even with such exceptional collections as those of Brunswick or Pommersfelden there is nearly always at least a 50-year gap in the history of each picture. Such collections, and also that of the elector palatine at Düsseldorf, most of whose collection is now in the Pinakothek at Munich, were part of a new wave of appreciation which was quite broad in its spectrum. The Italianate landscapists, the Haarlem mannerists, some aspects of Rembrandt (especially his early period) were all collected with enthusiasm. What was not appreciated was the work of Hobbema, Cuyp and all painters who used free brushwork, especially the late works of Rembrandt and late Hals.

In the case of Rembrandt, the neglect of his late period was so widespread that many of those paintings which are now so famous, including the *Jewish Bride*, only came to light in the nineteenth century. Vermeer suffered equal neglect; apart from the Brunswick picture, only two others were recorded in collections before 1750, not counting those which occasionally appeared at auctions only to return to oblivion after a brief appearance.

The electoral and ducal collections of the German states were the most important to be made in the first half of the eighteenth century, and the fact that most of them have survived more-or-less intact gives that country its present-day pre-eminence in Dutch pictures. In the second half of the century the chief centre of activity shifted to France, and to some extent England. The other great collector was Sophia of Anhalt-Zerbst (Catherine the Great of Russia), who took with her from her native German state a taste for Dutch pictures which turned her palace, The Hermitage, into the largest collection of Dutch pictures ever put together by one person. She bought *en bloc* both from England and France, and her collection was so well balanced in all the best masters that only Vermeer was lacking.

The French themselves collected an enormous number of Dutch genre pictures and landscapes, but this is no longer obvious. The Revolution of 1789 caused such a disruption to French collections that only one remained intact, the confiscated Royal Collection, the nucleus of the present-day collection in the Louvre. English collectors benefitted enormously from the French Revolution as large numbers of high-quality pictures were sent over for sale. There had been a growing interest in Dutch pictures in the second half of the eighteenth century. Reynolds, for instance, owned several important Rembrandts even though he publicly denounced him in his *Discourses*. Few of the important English collections of this period survive, and only in the Royal Collection can the breadth of such taste be appreciated. Significant omissions are rare; they are basically the Dutch Mannerists (both Haarlem and Utrecht, although there is an important picture by Terbrugghen). There is also a lack of interest in the realistic landscapists like Jan van Goyen.

In the early years of the nineteenth century England became the dealing shop of Europe. One dealer, John Smith, compiled his incredible work *A Catalogue Raisonné of the Work of the most Eminent Dutch, Flemish and French Painters* (London 1829–36) which charted the movements of many thousands of Dutch paintings.

Taste is difficult to define, and changes in it are even more elusive to chart. Jan Both, Berchem and the other Italianate landscapists certainly achieved their high-water mark of adulation in the early nineteenth century, but this was simply a slight exaggeration of the eighteenth-century admiration for them. The early nineteenth-century collectors did not differ radically from their predecessors. They were, after all, buying and selling the same pictures. But there were some changes: early pictures by Rembrandt were sold for enormous prices, but there was a gradual appreciation of his middle period. Critics tried their hardest to shake the self-satisfied attitudes of rich collectors, without success. Constable himself advised a collector to burn his collection of Berchems, as to sell them would only spread the mischief of their bad influence. Ruskin fulminated against the whole Dutch school, describing Hobbema's pictures as niggling and Backhuizen's sky as 'a volume of manufactory smoke'.

The real change in attitudes began about 1860 from a quite unexpected source. By then most of the really great cabinets of Dutch paintings had been formed. The Wallace Collection was almost complete, as were the collections bequeathed to Montpellier, Lille, Cambridge and Glasgow. It was now the turn of the small private collector, or the large museums with active purchasing policies (Brussels, London and Berlin). The most influential critic was undoubtedly Thoré-Bürger, who wrote an important book on Dutch museums in the 1850s and in 1866 produced the first ever, and still valid, study of Vermeer. He initiated a period of reappraisal of Dutch art and attempted to balance the Italianizing element with the more realistic painters. In this he was followed by Eugène Fromentin, who in 1876 wrote his *Maîtres d'Autrefois*, praising Ruisdael and Potter in memorable passages. He had a blind spot for Vermeer, whom he hardly mentioned, and he did not like Hals's late group-portraits at Haarlem, but his appreciation of Ruisdael was masterly and his open-mindedness refreshing.

Just as collectors in the early part of the nineteenth century followed the taste of their predecessors, so the twentieth century has accepted the standards of Thoré-Bürger and Fromentin. Most of the collections formed in Europe just before or just after 1900 paid homage to these two great critics. The Beit collection near Dublin, still intact, contained supreme works by Ruisdael, Hobbema, Metsu and Vermeer, but no pictures by Berchem or Both.

No single collector after Catherine the Great had the resources to represent every aspect of Dutch painting. Some museums, notably the National Gallery in London, were the fortunate recipients of several different collections, which ensured a better balance than would otherwise be the case. Wilhelm von Bode saw to it that the collection in Berlin was second to none in its representation of Rem-

brandt and quite academically correct in the careful choice of a good example of most of the minor masters. Sadly, the brave attempts of Thoré-Bürger and Fromentin to make people aware of the greatness of Ruisdael or the charm of Potter gave them blind spots in other directions. Until the vast proliferation of art history in the last 30 years, the number of serious studies available was surprisingly little. Cornelis Hosftede de Groot brought up-to-date and added new painters to Smith's catalogue in the early years of the century, but there was no real critical reappraisal of the whole field.

An attempt was made in Utrecht as late as 1965 to rehabilitate the Italianizing landscapists. The exhibition there made them academically respectable again, but Asselijn, Berchem, and Both are not yet on the same level of general appreciation as Hobbema or Ruisdael.

Another factor, neglected to a surprising extent by many European critics, has been the important part which America has played in the appreciation and collecting of Dutch painting in the last hundred years. European collectors often turned to past traditions and were rarely able, unless they had the courage and perception of a Thoré-Bürger, to make great changes. American collectors started with no such inhibitions. The newly rich acquired a taste for art and bought extensively in Europe even before 1900, although after that date there was a great increase in the volume of pictures bought. This was partly precipitated by the upheavals of the First World War, when many important pictures came on the market. No less than 13 of Vermeer's 36 or so surviving pictures found their way to America. In 1870 the Louvre in Paris bought its first and only Vermeer, and exactly 12 years later the Metropolitan Museum in New York was bequeathed an important picture by that master.

Much has been said about American millionaires not knowing what they were buying, but the fact remains that most of the collections of Dutch pictures made in this period in America were of the highest quality. There was a particular appreciation of Rembrandt, except for his early period. Frans Hals was acquired with great discrimination, especially by Taft of Cincinnati, and both Hobbema and Ruisdael were superbly represented in most collections. Many of the minor painters were ignored, except by John C.

Johnson of Philadelphia, who built up a representative collection of the smaller masters although he seems to have been reluctant to buy important pictures by Cuyp or Hobbema.

From what has been said already it would appear that the Dutch themselves have played very little part in the appreciation and collecting of their own art. This is not quite true, but statistically speaking relatively little remains in the country of origin. There are more Cuyps in Washington than Dordrecht, more early Rembrandts in Kassel than Leiden, more single portraits by Hals in Cincinnati than Haarlem, and so on. The reasons for this are several. First, in the eighteenth century, which was a period of stability and peace for the Dutch Republic, Amsterdam became an important centre for the buying and selling of pictures and many were consequently exported. Then came the terrible upheavals of the Napoleonic period, when many important pictures were removed to Paris and many private collections forced onto the market. So great were the upheavals that only one collection of importance with an unbroken history from the seventeenth century survives, the Mauritshuis in The Hague. In that collection, although many important acquisitions have been made—Vermeer's *View of Delft* in 1822—it is possible to study the portraits by Mierevelt and Honthorst of the Orange family.

Most of the great collections in Dutch museums are of nineteenth- or twentieth-century origin, except for those places where pictures have remained since they were painted. These include the eight group-portraits by Hals at Haarlem, the group-portraits at Alkmaar, and the many minor pictures scattered still in the almshouses and smaller museums of the country. Most of the major Dutch museums, Rotterdam and the Rijksmuseum in Amsterdam being the best examples, represent a deliberate and successful attempt to reconstruct the diversity of the past. Some painters are not always represented by their best, Cuyp and Hobbema in particular. But the largest existing collection of Dutch pictures is the Rijksmuseum of Amsterdam, the fruit of a century and a half of collecting and not the product of a great private collection subsequently made public like Leningrad, Munich, Vienna, Brunswick, Kassel, Schwerin and many others.

Present-day attitudes towards Dutch painting are not as free from prejudice as many people would like to think. A broad view over the whole area is hardly possible because of the sheer quantity of pictures produced. A devotee of mannerist art, quite at home with the naked contortions of a Wtewael or a Bloemaert, might find a flat landscape by Philips Koninck dull indeed. The admirers of the broad brushwork of Frans Hals or the late works of Rembrandt would probably have no feeling for the finesse of a Metsu.

Contrary to what is thought, the whole spectrum of Dutch painting is not well-explored. Only about half the painters in this book have been properly catalogued, and it is wrong of the critic to generalize about this or that master because, as has already been demonstrated, they were sometimes capable of producing high-quality pictures far above their normal standards.

The non-specialist is likely also to be bewildered by some 200 Dutch pictures hanging in one gallery, especially as they are likely to be by 100 different painters. There are often good examples of a minor painter hanging next to an inferior work by a great painter, or an unusually good selection of one artist, which may engender admiration—unless there are too many white horses by Wouwermans (as at Dulwich) or too much dead game by both Weenixes (as in the Wallace Collection). How can even the specialist hope to arrive at a balanced view when confronted with collections like this?

The only remedy is to try to look without prejudice. It is easy to read about the excellences or faults of a particular painter's style, but very much more difficult to stand in front of a picture and appreciate it on its own level. Dutch pictures make few intellectual demands on the spectator. But they do demand a sharp eye. A few seconds in front of an Adriaen van Ostade may convince the spectator that he does not like peasant banalities, and he will then pass onto the bourgeois banalities of a Metsu. But this is not the way that Dutch pictures were meant to be seen. They were cherished by their owners and looked at again and again, much in the way it is possible to re-read a favourite author. It is in this mood of careful looking that the enquiry into and appreciation of this, the most productive period of painting in the history of art, should be undertaken.

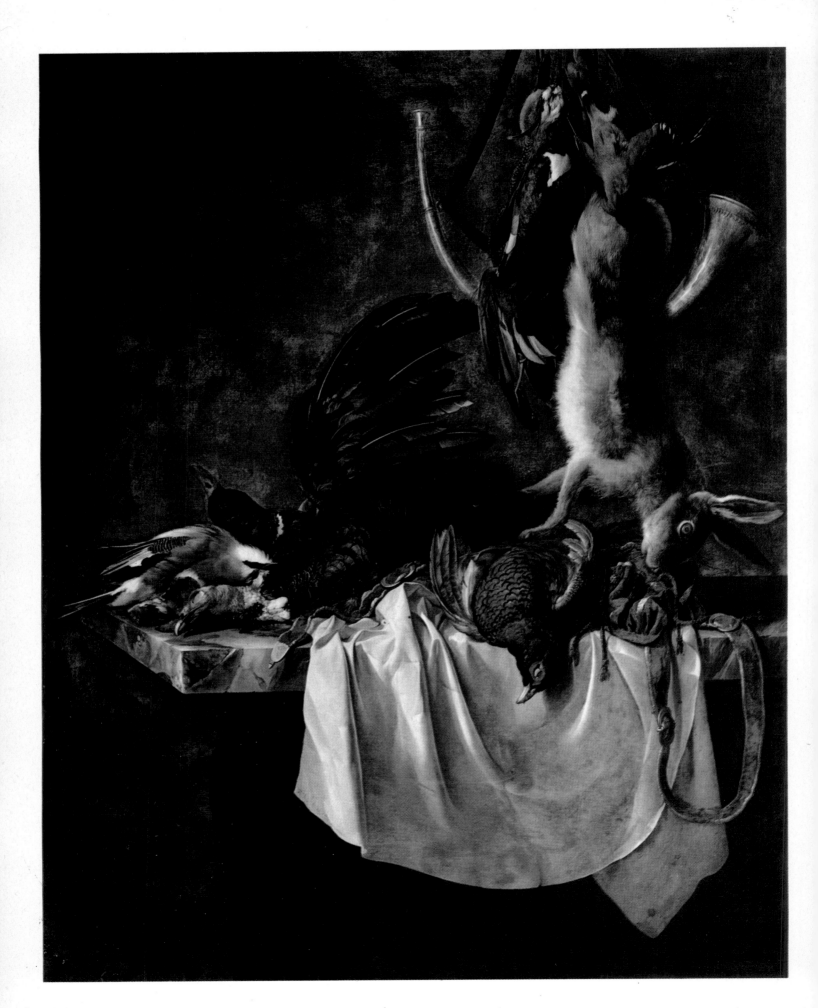

The Artists

In the following section, the full range and fascination of Dutch seventeenth-century painting are revealed in the lives and work of more than 100 masters. The biographies of the artists have been compiled where possible from the standard reference books, details of which are given in the Bibliography. Where a catalogue raisonée exists, the list of public collections in which each artist's work can be seen has been compiled from the catalogue. Unless otherwise noted, the name of a town indicates that the picture is in the main gallery there; asterisks indicate especially good examples. In the dimensions of paintings, height precedes width. Where possible, notes on the history of each painting illustrated are included in the captions; the occasional inequality of information is due to different standards of cataloguing and to the fact that some artists have been studied over a long period while others have been neglected.

Still Life with Dead Game
Canvas 126 × 99 cm (50¾ × 39 in) Signed and dated on the tablecloth: W.v. Aelst 1652.
FLORENCE, Galleria Pitti
This picture was almost certainly painted when the artist was court painter to Ferdinando II de' Medici, Grand Duke of Tuscany, for it has remained (along with its pendant, Still Life with Kitchen Utensils) *in the Pitti Gallery ever since. In this, as in many other pictures of this type, van Aelst has preferred a cool colour scheme where the background and the perfectly painted white tablecloth play an important part in the picture. The aristocratic love of hunting in the seventeenth century, which prevailed all over Europe, gave plenty of scope for specialists like van Aelst to record the daily amusements of their patrons. It was pictures like this which were to be influential in the eighteenth century, especially on the French still-life painter Chardin.*

Willem van AELST
Delft 1627—Amsterdam (?) after 1683

Throughout his lifetime, van Aelst had a wide reputation as a flower painter. Nevertheless, his pictures show great sensitivity in the painting of fruit as well. He became a member of the painters' guild at Delft in 1643 but left the town two years later. He then worked in France, where there was considerable demand for the skills of Dutch artists, and later he was in the service of the Grand Duke of Tuscany at Florence. In 1657 he returned to Amsterdam, where he seems to have spent the rest of his life. His flowers are executed in a brightly coloured and transparent manner, and he also painted a number of pictures of dead game, especially for his Italian patron. His pictures are relatively common.

Ajaccio; Amsterdam; Antwerp (Musée des Beaux-Arts, Musée Mayer van den Bergh); Basle; Brussels; Berlin; Brighton; Budapest; Cambridge; Cherbourg; Copenhagen; Dublin; Florence (Pitti); Glasgow; The Hague; Hamburg; Kassel; Karlsruhe; Leeds; Leipzig; Leningrad; Oxford; Paris; Poitiers; Rotterdam; Stockholm; Toulouse; Valenciennes; San Francisco; Schwerin; Warsaw.

Nocturnal Fishing Scene
Canvas 59 × 49 cm (23¼ × 19¾ in) Signed
in monogram. Probably painted after the
artist's return from Italy in 1647.
COPENHAGEN, Statens Museum for
Kunst
*This style of painting is unusually realistic for
Asselijn, who normally preferred a more
romanticized and Italianate type of landscape.
Nocturnal scenes were surprisingly popular,
and they were not always limited to specialists
like Aert van der Neer. Here the feeling of
atmosphere is heightened by the bands of clouds
which catch the moonlight. The actual fishing
plays a relatively unimportant part in the
composition and seems to be added to what is,
in effect, a nocturnal landscape. Hendrick
Goudt's prints after Adam Elsheimer's nocturnal
scenes had a great influence on Dutch painters
throughout the seventeenth century and it seems
reasonable to suppose that even here the source
is ultimately Elsheimer.*

Jan ASSELIJN
Diemen (near Amsterdam) or Dieppe (?) after 1610—Amsterdam 1652

Asselijn is one of the least appreciated of the group of painters who
specialized in Italian landscapes. Nicolaes BERCHEM, Karel DU JARDIN and
Jan BOTH are now very much better-known. Asselijn's pictures tend to be
more subtle and less adventurous in their treatment of light than those of
either Du Jardin or Berchem in his Italian mood. However, Asselijn favoured
both unusual compositions and subject matter. His Italian ruins are often
romantically overgrown with creeping plants.

The artist was recorded in Amsterdam in 1634, although his place and
date of birth are still uncertain. He then travelled through France to Italy
and went as far as Rome. In 1644 he must have been on his way back; he
was recorded in Lyons, which at that time was an important stopping place
for artists who were making the journey to or from Italy. The city was rich
enough for the painters to have no difficulty in finding clients for their
pictures. By 1647 Asselijn was back in Amsterdam.

Town by a Frozen River with Figures Skating

Panel 77.5 × 132 cm (30½ × 52 in) Signed on the right of the wall of the wooden barn: HENRICUS. AV.
AMSTERDAM, Rijksmuseum

All Avercamp's ice scenes have a special charm and appeal because of their unusual and sensitive colour schemes. He immediately creates the feeling of intense cold on the frozen water and contrasts this with the pinkish glow which he gives the buildings which are always present in the sides and backgrounds of his pictures. This picture is also a good example of the way in which the artist carefully balanced his compositions in a conventional manner, making sure that, in spite of an enormous number of small details, the picture holds together coherently. The picture's date is uncertain but it is likely to come from the artist's maturity.

Formerly in the G. de Clerq collection, Amsterdam, the painting was acquired by the Rijksmuseum in 1897 with the aid of the Rembrandt Society.

By a curious paradox his most famous picture is not a landscape but the *Enraged Swan* in the Rijksmuseum, Amsterdam, which, in its bold treatment, is quite unlike his other work. Bartholomeus BREENBERGH and Cornelis van POELENBURGH were Asselijn's chief sources of inspiration, but his essentially derivative style must not allow his honest qualities to be forgotten—his ability to compose pictures and to observe, however modestly, the fall of evening light.

Amiens; Amsterdam★; Angers; Ascott (Buckinghamshire); Auckland (New Zealand); Barnsley; Berlin; Bremen; Brunswick; Brussels; Budapest; Caen; Cambridge; Cardiff; Copenhagen; Dijon; Dresden; Edinburgh (National Gallery, Royal Scottish Academy); Florence (Pitti); Gray; The Hague; Karlsruhe; Kassel; Leipzig; Leningrad; Montpellier; Munich; Nîmes; Paris; San Francisco; Schwerin★; Toronto; Vienna (Academy); Warsaw; Worcester (Massachusetts); Wroclaw.

Hendrick Berentsz. AVERCAMP
Amsterdam 1585—Kampen 1634

Avercamp worked most of his life in the relative isolation of Kampen in the province of Overijssel. There he painted a small group of pictures which have delighted the twentieth century because they reflect the style of Pieter Brueghel the Elder, the great Flemish painter of the previous century.

Avercamp belonged to the tradition which Brueghel initiated—the painting of peasant life as it really was with the addition of an acute wit. Avercamp

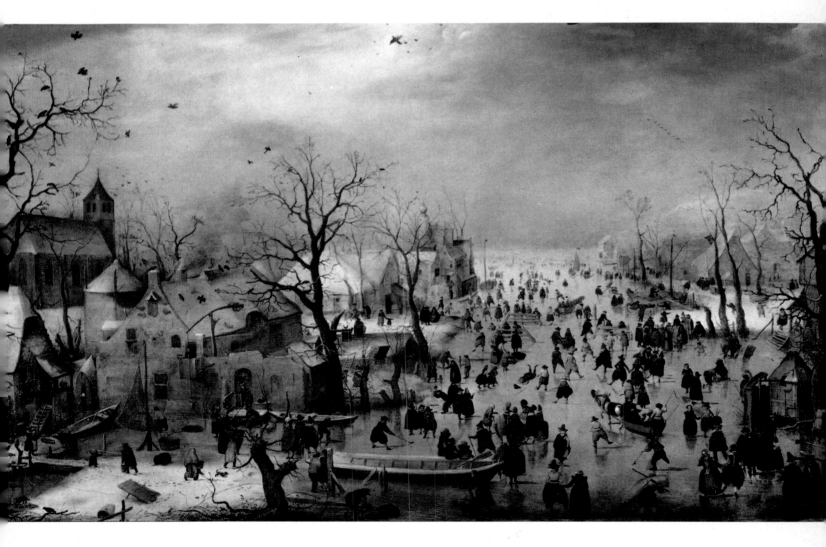

only painted his peasants on the ice; all his pictures depict them skating, talking, arguing, or just standing around on bitter cold days. His compositions are always carefully framed by bare trees and pinkish buildings. Like the pictures of Brueghel before him, his pictures can be read detail by detail and each incident enjoyed.

In his lifetime and shortly after Avercamp was much imitated both by his nephew Berent Pietersz. Avercamp (1612–79) and by Arent Arentsz. (called Cabel) (1685/6—before October 1635).

Amsterdam★; Bergen; Budapest; Cologne; Dessau; Dublin; Edinburgh; The Hague; Hanover; Geneva; Genoa (Palazzo Rosso); London; Malibu (California); Manchester; Mannheim; Oslo; Philadelphia; Rotterdam; Sarasota (Florida); St Louis; Schwerin; Toledo (Ohio); Vienna; Washington; Worms.

Dirck van BABUREN
Utrecht (?) c. 1594/5—Utrecht 1624

Baburen is the least known of the three artists active in Utrecht in the 1620s who practised a style imported from Italy which was basically derived from Caravaggio and his Italian followers.

As a young man Baburen studied at Utrecht under the competent academic artist Paulus Moreelse (1571–1638), who was himself to flirt with the Caravaggesque idiom. Baburen then spent eight years (c. 1612–1620) in Rome. The pictures painted during his stay there are almost totally dependent on Caravaggio. His *Deposition* in the church of San Pietro in Montorio in Rome is a pastiche of Caravaggio's own prototype which was then in St Peter's (now in the Pinacoteca Vaticana). On his return to Utrecht, Baburen shared a studio with the more inventive Terbrugghen and he developed a more individual style. This enabled him to paint a brilliantly coarse *Procuress* (in the Boston Museum of Fine Arts) which VERMEER depicted twice in the backgrounds to his pictures: it appears in the London *Lady seated at the Virginals* and in the *Concert* in the Isabella Stewart Gardner Museum, Boston.

Amsterdam; Bamberg; Berlin (Schloss Grunewald); Boston; Brussels; Greenville (South Carolina); Halberstadt; Leningrad; Mainz; Oslo; Paris (Musée Marmottan); Rome (Galleria Borghese, San Pietro in Montorio★); Utrecht★; Vienna; Weert; Wiesbaden; Würzburg; York.

Roman Charity: Cimon and Pero
Canvas 127.6 × 151.1 cm (50¼ × 59½ in)
Unsigned. Painted soon after the artist's return to Utrecht in 1620.
YORK, City Art Gallery
This is a good example of how Baburen derived his whole way of seeing from that of Caravaggio, and then gave it his own particular brand of coarseness. The whole is boldly painted with broad areas of tone which, on close inspection, appear harsh and unsubtle. This is not a simple low-life scene but a famous story from antiquity: Cimon was condemned to death by starvation in prison but was saved by the regular visits of his daughter Pero who gave him suck on each visit. The subject was very popular in the early seventeenth century; another version of this very composition is in the Accademia di San Fernando, Madrid, where it is attributed to the Flemish artist Jan Janssens.
Baburen's painting was given to the museum in 1955 by F. D. Lycett Green.

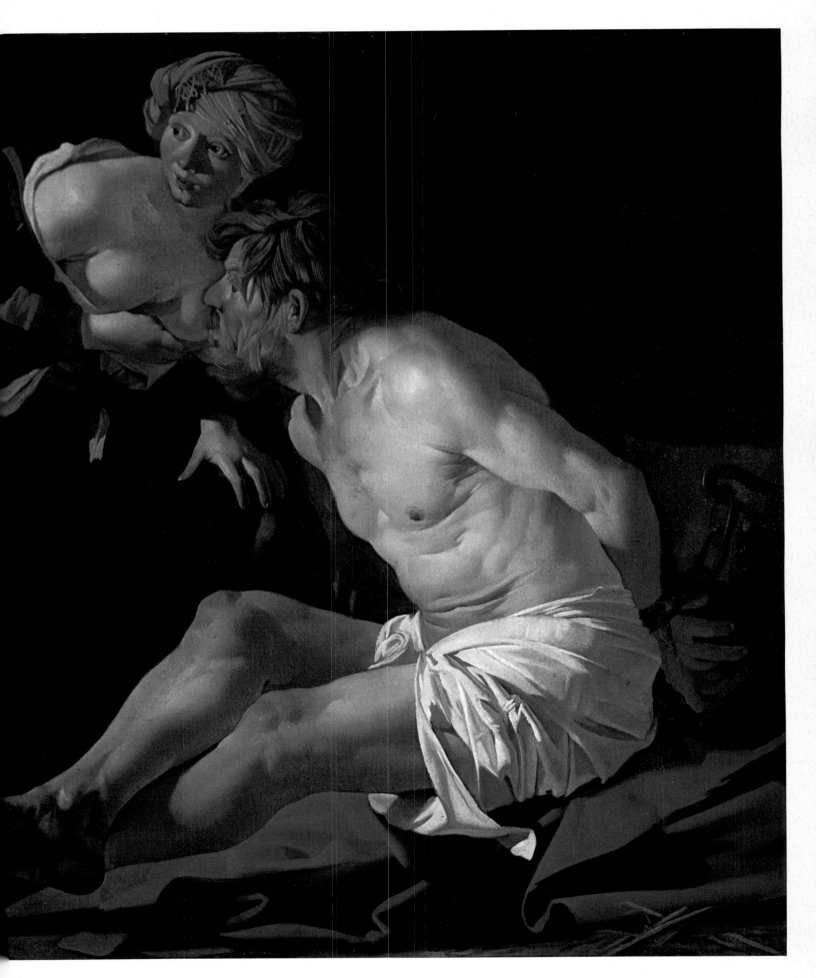

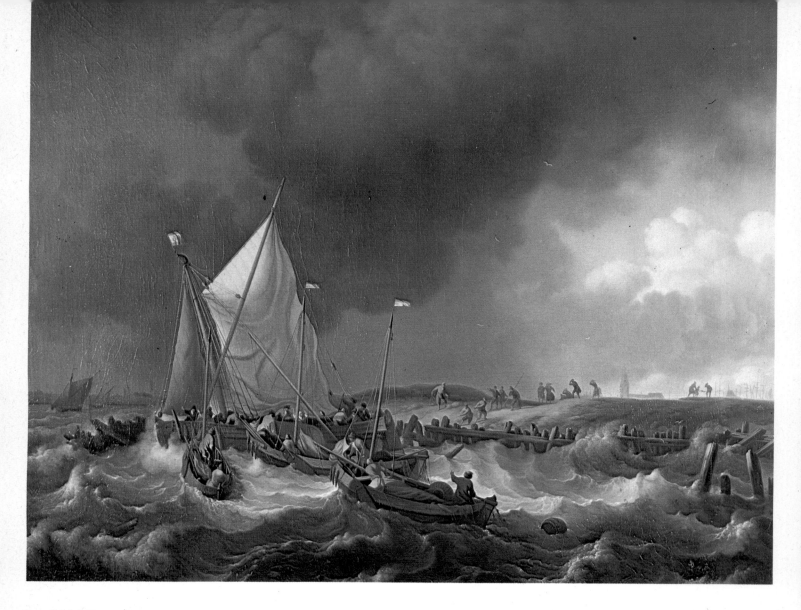

Ludolf BAKHUIZEN
Emden 1631—Amsterdam 1708

Although today connoisseurs prefer the monumental calm or exciting storms of Willem van de VELDE the Younger, Bakhuizen was the most appreciated seascape painter of his time. He was born in the Free Imperial City of Emden, which was very close to the Dutch border, but moved to Amsterdam as a young man by c. 1649/50. He was to remain there for the rest of his life. He was taught the art of painting by Allart van EVERDINGEN and Hendrick DUBBELS, from both of whom he must have learned his obvious skill. But Bakhuizen must have rejected his masters' sense of variety and concentrated exclusively on choppy seas, which brought him dazzling success. A few of his early pictures show calmer waters, but they are not up to Dubbels's standard. He was patronized by many of the German courts and his output was immense, rivalling the Willem van de Veldes, father and son.

Aachen; Amsterdam (Rijksmuseum, Scheepvaart Museum); Bamberg; Barnsley; Bath (Victoria Art Gallery); Bordeaux; Boston; Brunswick; Brussels; Calais; Cape Town; Cologne; Copenhagen; Dresden; Dublin; Edinburgh; Florence (Pitti); The Hague (Bredius Museum, Mauritshuis); Hamburg; Hull; Karlsruhe; La Fère; La Rochelle; Le Havre; Leipzig; Leningrad; Lille; London (Dulwich, Greenwich, National Gallery, Victoria and Albert Museum, Wallace Collection, Wellington Museum); Lyons; Magdeburg; Manchester; Meiningen; Munich; Nantes; Nîmes; Norwich; Oldenburg; Paris (Musée de la Marine, Louvre); Petworth (Sussex); Philadelphia (Johnson Collection); Polesden Lacey (Surrey); Riga; Rotterdam; Sarasota (Florida); Schwerin*; Stuttgart; Turin; Utrecht; Vienna (Academy, Kunsthistorisches Museum).

Seascape: Boats in a Storm
Canvas 62 × 79 cm (24½ × 31 in) Signed on the back of a boat. Dated on a floating plank: 1696
DULWICH, Alleyn's College of God's Gift
It seems likely that Bakhuizen derived this type of storm picture from Willem van de Velde the Younger, who was his chief rival in Amsterdam. However, Bakhuizen usually toned down the storm a little from the appalling drama of an endangered ship as seen in the picture recently acquired by the Birmingham City Art Gallery. This is a particularly impressive example of Bakhuizen's ability to paint a choppy sea with small boats struggling to their moorings while trying to avoid being dashed against the jetty. The sky is inky black (this annoyed Ruskin, who likened such skies to 'a volume of manufactory smoke') and the whole picture is slightly exaggerated: it is less well-observed than a similar work by van de Velde would have been.

The picture was bequeathed, along with most of the rest of the collection, to the gallery in 1811 by Sir Peter Francis Bourgeois.

Adriaen Cornelisz. BEELDEMAKER

Rotterdam 1618—The Hague 1709

The Hunter
Canvas 185.5 × 224 cm (73 × 84½ in)
Signed and dated on the gun: A. C.
Beeldemaeker A° 1653
AMSTERDAM, Rijksmuseum
*This picture appears very much more Flemish
than Dutch. This is especially true in the
treatment of the animals, which is very close to
that of Snyders or Fyt. The composition, too,
is very concentrated in a manner more familiar
in Italian paintings of the period—the main
figure forms a pyramid in the centre. Yet the
artist has given a remarkable feeling of eagerness
and energy as the hunter hurries forward
surrounded by his dogs, which are looking in
all directions in search of something to chase.*

*The picture was bought by the museum in
1882 at the sale of W. Gruyter, Amsterdam.*

Considering the obvious quality of the picture in the Rijksmuseum which
is reproduced here, surprisingly little is known about this artist, who seems
to have specialized in hunting scenes and animals. The artist's native Rotterdam
was relatively close to the border with Spanish-dominated Flanders, and he
can hardly have been unaware of the prevailing trends at Antwerp. Thus his
pictures, especially in the treatment of the animals, seem to be derived from
the Flemish painters Frans Snyders (1579–1657) and Jan Fyt (1611–61). While
still young Beeldemaker seems to have moved northwards to Leiden and
then settled in The Hague (which was close by) from 1676 until his death, the
date of which is still unknown. He is a good example of an artist who has
been obscured by a lack of subsequent interest in his pictures.

Amsterdam; Béziers; Clermont-Ferrand; The Hague (Gemeentemuseum, Mauritshuis);
Leiden; Mirande; Paris; Sheffield; Vienna (Academy); Wroclaw.

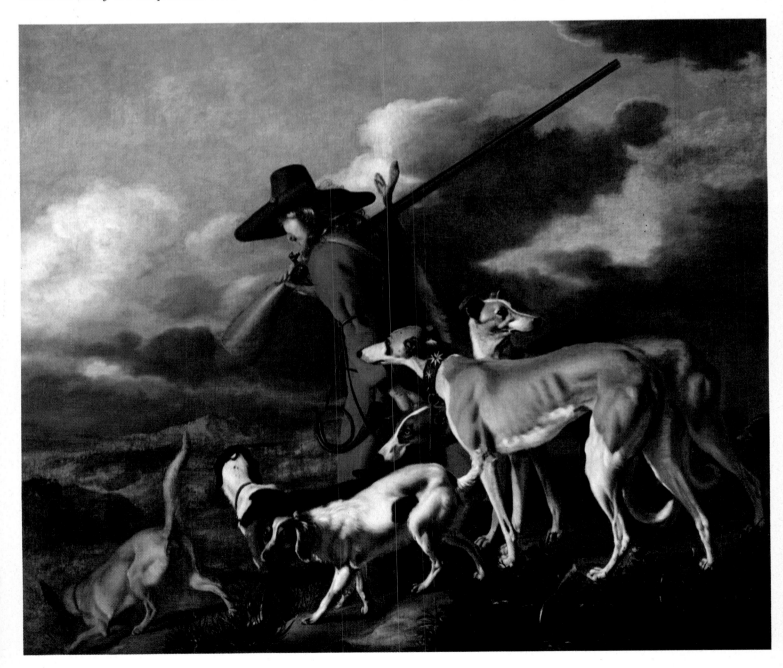

Landscape with a Man and a Youth Ploughing

Canvas 38 × 51 cm (15 × 20¼ in) Signed at the bottom left of centre: cBerghem.
Probably painted in the 1650s.
LONDON, National Gallery

There is no such thing as a typical painting by Berchem; he constantly changed his mood and style. All his pictures have a vaguely artificial quality. He had no interest in exact truth to nature such as Paulus Potter, for instance, can show us in his backgrounds. Yet Berchem had a capacity for the realistic treatment of incidental events in his pictures. Here there is the feeling that the oxen are being especially recalcitrant as they negotiate the slight incline. The artist could not resist putting a vexed look on the face of one of the oxen, with the result that the picture can be enjoyed at the level of the simple anecdote. At the same time the porcelain-blue sky and beautifully observed bushes give the whole the attraction which made Berchem so popular for two centuries.

This picture's history is especially interesting as it belonged to the French eighteenth-century painter François Boucher. The picture was bequeathed to the gallery by Wynn Ellis in 1876.

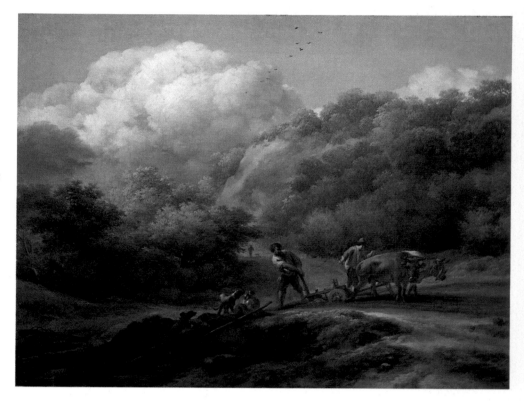

Nicolaes Pietersz. BERCHEM
Haarlem 1620—Amsterdam 1683

One of the most influential artists of his generation, Berchem was born at a time of great artistic activity in Haarlem. He was the son of the brilliant still-life painter Pieter CLAESZ. Writing a century later, Arnold Houbraken stated that he studied under Jan van GOYEN, Nicolaes Moyaert (1592–1655) and Pieter de GREBBER. In the early 1640s Berchem accompanied his cousin Jan Baptist WEENIX to Rome. On his return it is more or less certain that he was active in Haarlem, and he did not settle in Amsterdam until 1677.

It is hardly surprising, therefore, that Berchem's style is difficult to pinpoint; he was capable of assimilating the characteristics of the artists around him. His pictures—mostly landscapes with figures—are always highly finished and vaguely Italianate in their inspiration. His figures, in which he excelled, usually have highly coloured draperies and his skies often have a perfect porcelain-like blue quite alien in character to the real skies over his native Haarlem. Berchem's pictures were especially prized in the eighteenth century and by c. 1800 he was considered, along with Gerard DOU, to be one of the best Dutch painters. Berchem had an enormous number of pupils including Pieter de HOOGH, Jacob OCHTERVELT, and Karel DU JARDIN.

Amsterdam★; Antwerp; Ascott (Buckinghamshire); Aschaffenburg; Augsburg; Bamberg; Barnsley; Basle; Belfast; Bergamo; Berlin; Blackburn; Bolton; Bordeaux; Bremen; Bristol; Brodick Castle (Arran); Brunswick; Brussels; Budapest; Cambridge; Coblenz; Darmstadt; Delft; Dresden★; Dublin; Dunkirk; Düsseldorf; Edinburgh (University); Frankfurt; Ghent; Glasgow; Haarlem; The Hague; Hamburg; Hanover; Hartford (Connecticut); Heidelberg; Karlsruhe; Kassel; La Fère; Leipzig; Leningrad★; London (Dulwich, National Gallery★, Wallace Collection★); Lyons; Malibu (California); Mannheim; Montpellier; Munich; Nantes; Narbonne; New York; Nice; Nîmes; Oberlin (Ohio); Oldenburg; Oxford; Paris (Louvre, Petit Palais); Pau; Philadelphia (Johnson Collection); Plymouth; Potsdam; Prague; Quimper; Riga; Rotterdam; Rouen; Saint Etienne; Schwerin; Sibiu; Southend-on-Sea; Speyer; Stockholm; Tatton Park (Cheshire); Turin; Valenciennes; Vienna (Academy, Kunsthistorisches Museum); Waddesdon Manor (Buckinghamshire); Warsaw; Würzburg; York.

Gerrit Adriaensz. BERCKHEYDE

Haarlem 1638—Haarlem 1698

Berckheyde's career was relatively uneventful and his pictures, although almost invariably of a high standard, are often repetitive. He specialized exclusively in views of The Hague, Haarlem and Amsterdam, often preferring to repeat the same view with a few variations. Yet Berckheyde had a wonderful clarity of vision, an understanding of architectural perspective, a feeling for sunlight and an ability to make an agreeable composition which lift him above the level of a simple topographer.

He seems to have spent most of his life in his native Haarlem living with his elder brother Job, who was also a painter. The only change was a

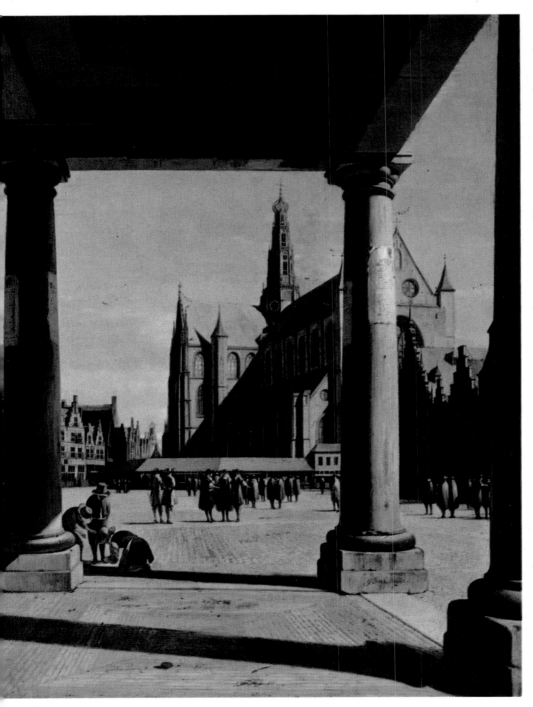

The West Front and North Transept of the Groote Kerk at Haarlem seen from the Colonnade of the Town Hall
Panel 40.2 × 32.7 cm. (15⅞ × 12⅞ in)
Signed and dated at the base of the middle column: G. Berck Heyde 1674.
CAMBRIDGE, Fitzwilliam Museum
This is one of a pair of pictures; the other, which is in the same collection, shows the newly built town hall of Amsterdam with part of the Nieuwe Kerk. It seems to have been the artist's practice to paint his pictures in pairs of this type although, because they represent different towns, there has been a tendency for them to have been parted over the years. The artist's sense of composition is well illustrated in this picture; he has produced a careful balance between the symmetrical columns of the town hall and the church, which is seen from a picturesque angle. From this viewpoint the scene is little changed today.

This picture was bequeathed to the museum by its founder, Viscount Fitzwilliam, in 1816.

visit to Heidelberg to the court of the Elector Palatine where he painted several views of the town—one of them is in the museum there.

Occasionally Berckheyde painted church interiors and again, although conventional, they achieve the high standard of Hendrick van VLIET, Emanuel de WITTE and other church interior specialists. A particularly good example, *The Interior of the Grote Kerk, Haarlem*, is in the National Gallery, London.

Amsterdam (Historisch Museum, Rijksmuseum); Antwerp; Arnhem; Basle; Berlin (Schloss Grunewald); Boston; Brussels★; Budapest; Cambridge★; Copenhagen; Detroit; Douai; Dresden; Florence (Uffizi); Frankfurt; Gothenburg; Haarlem; The Hague (Gemeente-museum, Mauritshuis); Hamburg; Hartford (Connecticut); Heidelberg; Karlsruhe; Koblenz; Leipzig; Leningrad; London; Lyons; Melbourne; Montpellier; Paris (Louvre, Petit Palais); Philadelphia (Johnson Collection); Raleigh (North Carolina); Rotterdam; San Francisco; Schwerin; Sibiu; Springfield (Massachusetts); Stockholm; Strasbourg; Venice (Cà d'Oro); Vienna (Academy).

Abraham van BEYEREN
The Hague 1620/1—Overschie 1690

Beyeren has always been well known as the most important specialist painter of the banquet piece. Most of his pictures show the heaped-up ingredients of a banquet, the most exciting delicacies and the most elaborate silver. As a contrast to this he occasionally painted rather severe grey seascapes, somewhat in the manner of Jacob van RUISDAEL but lighter in tone.

He seems to have spent most of his long life moving from place to place; presumably he saturated the market for banquet pieces in each town and then moved on to find new clients. He became a member of the painters' guild at The Hague in 1640 after having been in Leiden the previous year. His moves were then as follows: Delft 1657, The Hague 1663, Amsterdam 1669, Alkmaar 1674, Gouda 1675. Finally in 1678 he moved to Overschie near Rotterdam, where he remained for the rest of his life. He was a prolific artist and his pictures are always of a high technical standard.

One of the neglected aspects of his art is his occasional treatment of the fish still-life. Pictures of this type have never been popular outside their country of origin; however, van Beyeren gave the glistening fish laid out on platters a kind of silvery poetry which raises them to the level of any other branch of still-life painting. A good example of this type of picture is in the Ward Collection of Dutch still-life pictures in the Ashmolean Museum, Oxford.

Amiens; Amsterdam; Antwerp; Brussels; Budapest; Cape Town; Champaigne/Urbana (Illinois); Cleveland; Copenhagen; Dayton (Ohio); Detroit; Dundee; Ghent; Glasgow (Art Gallery, Burrell Collection); Haarlem; The Hague; Hamburg; Hanover; Leipzig; Leningrad; Lille; London (Greenwich); Manchester; Minneapolis; Moscow; Munich; New York; Otterlo; Oxford; Philadelphia (Johnson Collection); Rotterdam (Boymans-van Beuningen Museum, Vorm Foundation); San Francisco; Schwerin; Stockholm; Toledo (Ohio); Vienna (Academy, Kunsthistorisches Museum); Warsaw; Worcester (Massa-chusetts); York.

Still Life: Fruit and a Lobster
Canvas 99 × 89 cm (39 × 35 in) Signed in monogram on the edge of the table: AVB f.
BRUSSELS, Musée Royal des Beaux-Arts
As is usual with Beyeren, this picture is an incredibly complicated display of luxuries piled up to symbolize wealth. Many pictures of this type include objects like skulls and inscribed parchments which were intended as symbols of vanity with moral overtones. On the whole, Beyeren seems to have avoided these in his pictures. Beyeren never became facile and all his lobsters, peaches half cut-open, grapes and oriental porcelain are painted with extreme care and a genuine feeling for their character. The lobster in particular is well-painted and sets the predominately warm tone of the whole painting. The date of this picture is uncertain as the artist changed his style little during his long career.

The painting was acquired by the museum on the Paris art market in 1886.

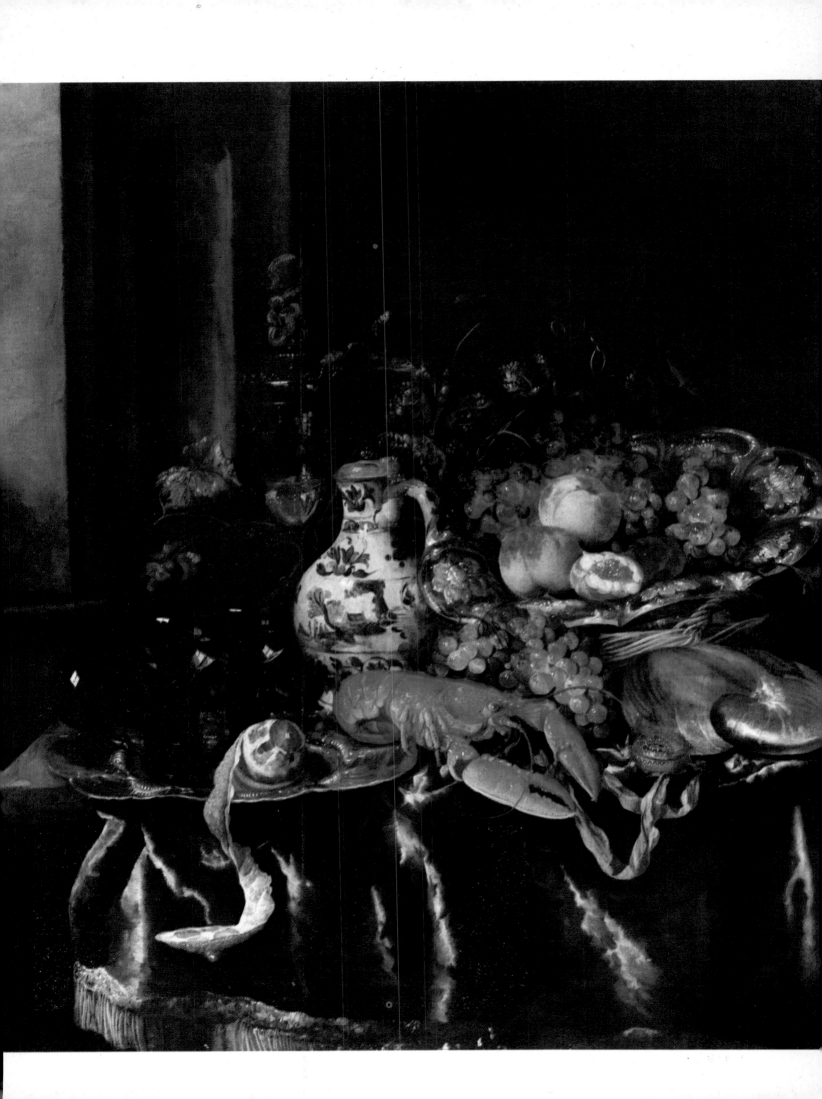

Abraham BLOEMAERT
Gorkum 1564—Utrecht 1651

Bloemaert was one of the most important artists in the whole field of painting in the last years of the sixteenth century and the first half of the seventeenth century. His reputation is now obscured because the type of picture he painted is out of fashion. This has meant that Bloemaert's position as the chief teacher in Utrecht for two generations has been forgotten. He taught his four sons, all of whom were painters of ability who more or less imitated their father, and also Jan van BIJLERT, Jan BOTH and Cornelis van POELENBURGH.

Bloemaert spent his early years in several different places and had many different formative influences; these made him very versatile. His first master was the conventional Utrecht painter Joos de Beer, who also taught Joachim WTEWAEL. Bloemaert then visited Paris during the years 1580–3 and studied under the Antwerp artist Hieronymus Francken. He then returned to Utrecht, where he spent the rest of his life except for brief visits to Amsterdam.

It is a curious paradox that Bloemaert's style, apart from a few concessions to the Caravaggesque craze in the 1620s, remained doggedly mannerist right

The Flutist
Canvas 69 × 57.5 cm (27¼ × 22¾ in) Signed and dated at the right near the top:
A. Bloemaert. fe. 1621.
UTRECHT, Centraal Museum
This is one of Bloemaert's most successful pictures. Significantly dated 1621, the year after Baburen's return from Rome, bringing with him to Utrecht a new wave of Caravaggio's influence, this picture represents Bloemaert's attempt to keep up with the new trend. This he did by the simple expedient of giving his figure a direct frontal pose and by using artificial light. But the actual treatment has none of Caravaggio's deliberate coarseness, which so shocked many Italian patrons. Instead Bloemaert's flutist is cool and elegant. The artist soon returned to painting his more usual elaborate compositions and the Flutist is an exceptional example of his work.

The picture was acquired by the museum in 1928.

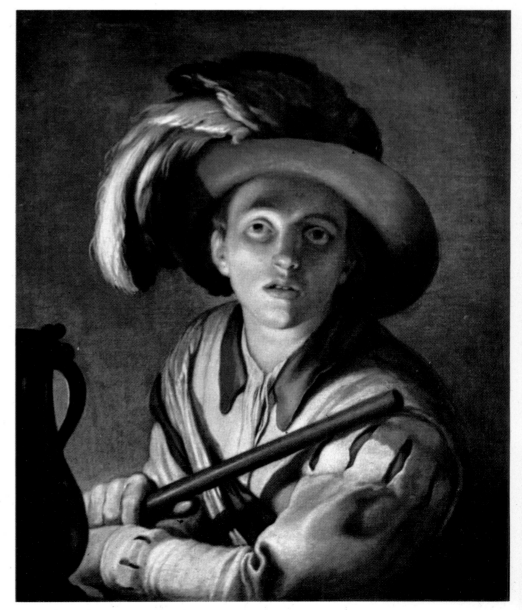

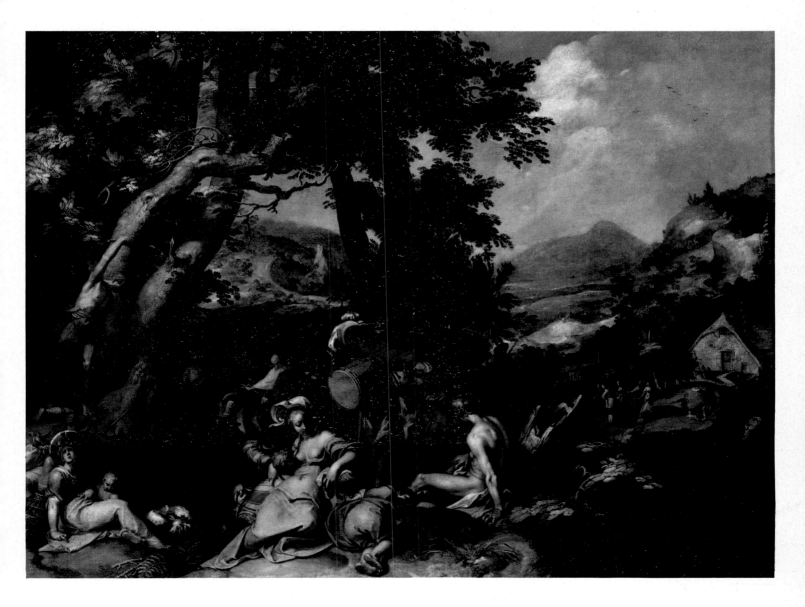

The Preaching of St John the Baptist
Canvas 139 × 188 cm (54¾ × 74 in) Signed
right centre: A. Bloemmaert.
Probably painted in the early years of the
seventeenth century.
AMSTERDAM, Rijksmuseum
*The painter's ability to integrate the complex
group of figures into an equally complex
landscape is impressive. In a perverse way the
picture's real subject is obscured. St John the
Baptist is seen preaching in the shadows at the
left. Quite a number of the figures, even those
who are close to him, are paying no attention
to what is being said. Bloemaert's grasp of a
picturesque landscape was to secure his
reputation for two centuries. Unlike so many of
the paintings of his mannerist contemporaries,
his pictures are not piece-by-piece assemblages
of different elements without a consideration of
the whole.*

*The picture was formerly in collections in
Medemblik and Hoorn but was acquired by the
museum on the London art market in 1950.*

until his death, while he seems to have encouraged newer trends in all his
pupils. Thus in the painting of Jan Both it is difficult to detect Bloemaert's
influence at all. Although Bloemaert's pictures conform to a general mannerist
style in vogue in the last years of the sixteenth century, they are on the whole
more moderate in their contortions than those of Wtewael or CORNELIS van
Haarlem. He often preferred to put his brightly coloured figures into
picturesque landscape settings. Indeed, his landscapes are important for two
reasons: firstly he developed a complex form of picturesque landscape in
which the subject is of little importance (a good example of this is the
Prodigal Son of about 1600 in the museum at Leamington Spa, Warwickshire);
secondly his landscapes had an enormous influence in eighteenth-century
France, especially on François Boucher. During his lifetime and long after
many of Bloemaert's compositions were engraved, and his '*Drawing Book*',
which was a manual for students, ran through several editions.

Aachen; Amsterdam; Aschaffenburg; Baltimore (Walters Art Gallery); Barnard Castle;
Berlin (Schloss Grunewald); Brunswick; Brussels; Copenhagen; Frankfurt; Gateshead;
Göttingen; Graz; Grenoble; Haarlem; The Hague; Hamburg; Hanover; Indianapolis;
Jacksonville (Florida); Karlsruhe; Kassel; Leamington Spa★; Leningrad; London (Black-
heath); Lübek; Malibu (California); Minneapolis; Munich; Nancy; Nantes; New York;
Nuremberg★; Ottawa; Paris; Potsdam; Richmond (Ham House); Rome (Galleria Spada);
Rotterdam; Salzburg; Stockholm; Stuttgart; Toledo (Ohio); Utrecht★; Vienna; Wroclaw.

Portrait of an Unknown Man
Canvas 87.5 × 72.5 cm (34½ × 28½ in)
Unsigned. Probably painted in the
mid-1640s.
MUNICH, Alte Pinakothek
*This was long thought to be a self-portrait, but
the picture bears little resemblance to an
engraved self-portrait of Bol which is dated
1645. The confusion which surrounded this
picture was increased by the fact that it was for
a very long time considered to be by Rembrandt.
It is easy to see how this came about, because
the composition is derived from Rembrandt's
Self-Portrait of 1640 which is in the National
Gallery, London. To make matters worse,
Rembrandt's picture itself has been doubted.
Thus it is a good example of the complete
failure of scholars and connoisseurs to agree over
a Rembrandtesque painting which does not
happen to be signed. The picture's pendant,
A Portrait of a Woman, is also at Munich
but it has attracted less attention.*

*Both paintings were in the Electoral Gallery
at Düsseldorf in the eighteenth century and were
transferred to Munich in the early nineteenth
century.*

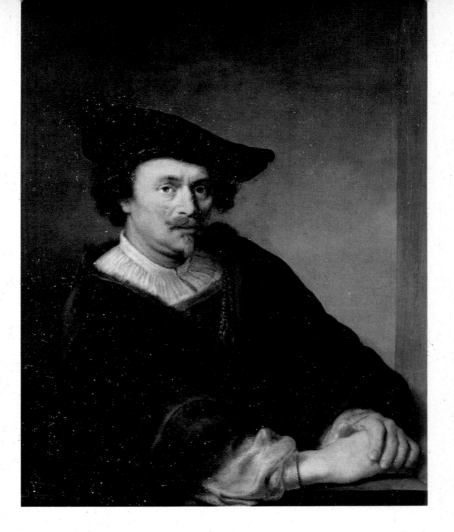

Ferdinand BOL
Dordrecht 1616—Amsterdam 1680

In recent years pictures attributed to Ferdinand Bol have been those which are
not thought to be good enough to be by REMBRANDT. This happened to
Rembrandt's *Falconer* (in the collection of the Duke of Westminster). In fact
Bol's career was one of great success in his own lifetime and his contemporaries
never confused him with Rembrandt. His early life was spent in Dordrecht;
after 1635 he arrived in Amsterdam to work in Rembrandt's studio. At this
time Rembrandt was going through one of his most productive phases which
was to culminate in the *Night Watch* of 1642. Bol's contemporary fame rested
not on his Rembrandtesque manner but on the fact that he was able to
fulfil official commissions both for portraiture and history painting with great
efficiency. He received the honour of being asked to paint a large mythological
picture for the Burgomaster's room in the New Town Hall of Amsterdam.

Bol's reputation is a little clouded today, as his large mythologies are not
appreciated and his portraits are thought to be close to Rembrandt in manner
but without that master's insight into human character.

Amsterdam (Historisch Museum, Rijksmuseum, Scheepvaart Museum); Antwerp;
Baltimore; Basle; Berlin (East); Boston; Brunswick; Brussels; Cincinnati; Copenhagen;
Danzig; Dayton (Ohio); Dordrecht; Dresden; Dublin; Frankfurt; Gouda; Graz; The
Hague; Hoorn; Houston (Texas); Indianapolis; Ithaca (New York); Leiden; Leipzig; Le
Mans; Leningrad; Le Puy; London (Blackheath, Greenwich, Kenwood, National Gallery,
Wallace Collection); Los Angeles; Meiningen; Miami Beach (Florida); Munich; New York;
Oslo; Paris; Ponce (Puerto Rico); Potsdam; Raleigh (North Carolina); Riom; Roosendaal;
Rotterdam; San Francisco; Schwerin; Springfield (Massachusetts); Stockholm; Toledo
(Ohio); Vienna; Warsaw; Worcester (Massachusetts).

Paulus BOR

Amersfoort (?) c. 1600 (?)—Amersfoort 1669

Bor deserves to be better studied as so few of his pictures are at present known and they are all of good quality. He had a successful career and gained important commissions which included part of the decoration of the Huis Hanselaersdijk for Prince Frederick Henry in 1638.

The artist spent some three years in Italy (c. 1620–23) where he stayed in Rome. He was thus able to assimilate not only the general Caravaggesque idiom but also some of the polish which Orazio Gentileschi always gave to his work. Bor then returned to Amersfoort, where he probably spent the rest of his career. The special quality of his painting is the mysterious facial expressions which he gives to his otherwise quite conventional pictures. He adopted a style which is familiar from artists like Jan van BIJLERT. He has remained, for historians and connoisseurs alike, an independant spirit.

Amersfoort; Amsterdam; Groningen; Jacksonville (Florida); Liverpool; New York*; Rotterdam; Utrecht*.

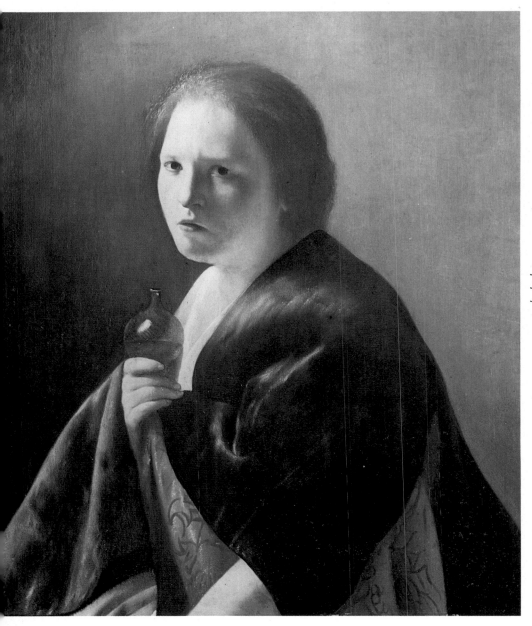

A Woman as the Magdalen
Panel 65.5 × 60.8 cm (25⅞ × 24 in)
Unsigned. Probably painted in the late 1630s.
LIVERPOOL, Walker Art Gallery
Bor achieved popularity in his lifetime as a result of the high finish he gave to his work, which appealed to his aristocratic patrons. Indeed it is not inconceivable that the young Vermeer responded to just this type of picture when he was painting the Girl with the Pearl Eardrop which is in the Hague. The tradition of depicting portrait sitters as the Magdalen is a long one. The most famous example is the picture in the Rijksmuseum, Amsterdam, by the sixteenth-century artist Jan van Scorel (see introduction for a discussion of his importance). Traditionally the Magdalen brought an alabaster box of ointment and annointed Christ's feet with it. Here she has the worried look found in all Bor's pictures, which elevates it from the general level of religious painting practised all over the United Provinces in the middle years of the century.

The picture was acquired by the museum on the London art market in 1952.

Ambrosius BOSSCHAERT
Antwerp 1573 — The Hague 1621

Only a few details of Bosschaert's life are known, and they add little to an understanding of his very special type of flower painting. He must have left Antwerp when quite young, as he was over the border in Middelburg during the period c. 1593–1613.

Although trained in Antwerp—and indeed his pictures always betray his Flemish upbringing—Bosschaert can be said to have had a decisive influence on still-life painting in the Netherlands. His own style was largely based on that of the Antwerp artist Jan (Velvet) Brueghel (1568–1625), and Bosschaert's intense pre-occupation with highly finished treatments of individual flowers in a vase set a standard which took a long time to surpass. His pictures are surprisingly rare and are much sought-after by present-day collectors.

Amsterdam; Cambridge; Copenhagen; Cleveland (Ohio); Detroit; Frankfurt (Historisches Museum); The Hague (Bredius Museum, Mauritshuis★); Oxford; Söfdeborg Castle (Sweden); Stockholm (Hallwylska Museet, Nationalmuseum); Tours; Vienna.

Still Life: A Vase of Flowers at a Window
Copper 28 × 23 cm (11 × 9⅛ in) Signed in monogram: AB.
AMSTERDAM, formerly Wetzlar Collection

In the United Provinces, flower painting was relatively rare in the early part of the century and there were few Dutch specialists. This particular way of putting the flowers on a window-sill with a landscape background was not taken up by other Dutch flower specialists; they preferred a plain and usually dark background which served to enhance the colour and form of each flower.

In this picture Bosschaert has chosen roses and mayflowers instead of his more usual tulips, irises and fritillary. Such a picture must have been composed from carefully made studies of each flower as the individual flowers, and even the shells, appear in other pictures. Clearly, he did not draw each one afresh for each new picture. The artist's style changed little and therefore this painting could have been produced at any time during the early part of the seventeenth century.

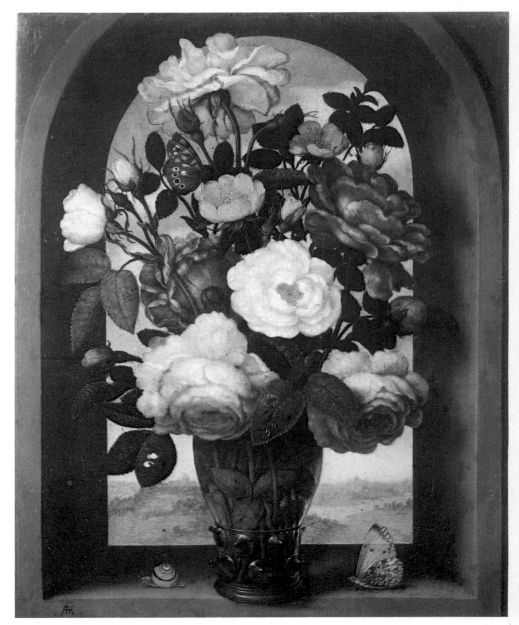

Alpine Landscape with a Fir Tree
Panel 42.5 × 61 cm (16¾ × 21 in) Unsigned.
Generally dated in the late 1640s.
DETROIT, The Detroit Institute of Arts
This is one of Both's most exciting pictures because he has abandoned his usual convention of the careful balance of trees to right and left. Instead he has produced a picture which gives a wonderful sense of place. It seems that Both must have been moved by the Alps, which he would have crossed on his return to Utrecht from Italy. The fir tree (centre left) plays an important part in the composition as it forms a strong diagonal against the heavy slope of the mountains from right to left. Mountain scenes were, of course, popular with many Dutch artists and the tradition reaches well back into the sixteenth century. Nevertheless, there is the feeling that Both observed with passion this impressive scene.

The painting was given to the museum by T. E. Scripps in 1889.

Jan BOTH
Utrecht c. 1615 (?)—Utrecht 1652

Both's pictures enjoyed an enormous reputation in the late eighteenth and early nineteenth centuries on account of their gentle Italian light and careful compositions. It is perhaps not generally realized that in the context of Dutch painting Both was an innovator; he was the first artist to perfect this particular type of picturesque, almost romantic, view of the Italian countryside. His pictures are almost always bathed in a golden light which he must have derived from Claude Lorraine. Both's early career has not been satisfactorily explained but he was probably a pupil of Abraham BLOEMAERT at Utrecht in the 1620s. He then left for Italy with his brother Andries Both, and they were both in Rome in 1635. He was still there in 1641 and then returned to Utrecht, where he spent the rest of his short career. Both dated very few of his pictures and his style developed little.

Amsterdam; Antwerp; Arles; Barnsley; Baroda (India); Basle; Belfast; Boston; Brussels; Budapest; Cambridge; Copenhagen; Detroit★; Dijon; Dresden; Dublin; Düsseldorf; Edinburgh; Florence (Pitti); Frankfurt; Glasgow; The Hague; Indianapolis; Karlsruhe; Kassel; La Fère; Leipzig; Leningrad; London (Dulwich★, National Gallery, Victoria and Albert Museum, Wallace Collection); Madrid; Minneapolis; Montpellier; Munich★; Naples; Nîmes; Nottingham; Oxford; Paris (Louvre, Petit Palais); Petworth (Sussex); Ponce (Puerto Rico); Poznan; Prague; Pushkin (Russia); Rome (Galleria Nazionale); Rotterdam; Rouen; Schwerin; Stockholm (Nationalmuseum, University); Toledo (Ohio); Vienna (Academy, Kunsthistorisches Museum); Warsaw; Worms.

Leonaert BRAMER
Delft 1596—Delft 1674

Bramer was an individualist and his style of painting does not fit into the established pattern of the Delft painters like VERMEER and Pieter de HOOGH. It is not easy to work out how he arrived at the idea of small, dark subject pictures where the figures are barely visible in the shadows. He left Delft in 1614 and, after having passed through France, arrived in Rome c. 1618. There he would have been able to study the small pictures of the German painter Adam Elsheimer, who had died in 1610. But unlike most of his contemporary Dutch artists he seems to have learned little from the contact with Italy. In 1628 Bramer returned to Delft, where he spent the rest of his career, never changing his style and never lightening his palette. It is quite difficult to imagine what Bramer and Vermeer thought of one another as they both spent their lives working in a town which was about a mile from side to side.

Amsterdam; Augsburg; Basle; Birmingham (City Art Gallery); Bordeaux; Brunswick; Cambrai; Copenhagen; Delft; Florence (Uffizi); Gotha; The Hague (Bredius Museum); Hamburg; Hanover; Hartford (Connecticut); Karlsruhe; Leipzig; Leningrad; Madrid; New York; Oldenburg; Philadelphia (Johnson Collection); Potsdam; Rome (Capitoline Museum); Salzburg; Sibiu; Stockholm; Turin; Vienna; Warsaw; Würzburg.

Scene of Sorcery
Copper panel 27 × 36 cm (10½ × 14 in)
Unsigned. Probably painted in the early 1630s.
BORDEAUX, Musée des Beaux-Arts
A picture of this subject is unusual in Bramer's work, although the actual handling of the paint is quite typical. Such scenes of sorcery were much more popular in Catholic Flanders; perhaps such fantasies were not well received by the Protestant sections of Dutch society. Significantly the evil-doings are clearly pagan and are not set, as the Flemish Hendrick van Steenwyck set his (in the picture in the Maidstone Museum), in a building which is obviously a church. Bramer had a vivid imagination in evolving this scene of demons, devils and gremlins indulging in foul practices and the casting of spells. All this is taking place in Stygian gloom lit only by pin-points of yellow light.

The picture was bequeathed to the museum in 1900 by M. Poison and it is only in recent years that the attribution to Bramer has emerged. It is now generally accepted.

Bartholomeus BREENBERGH

Deventer 1599—Amsterdam 1657

River Landscape with St Peter and St John

Copper panel 23 × 32 cm (9 × 12½ in)
Signed in monogram: BBf. Probably painted in Italy in the 1620s.
KASSEL, Staatliche Gemäldegalerie

It is typical of the artists of Breenbergh's generation to subordinate the subject matter of the picture to the treatment of the landscape. As is usual there is an interest in the ruins of antiquity which dotted the countryside around Rome even more than at the present time. It became the fashion to paint and draw these ruins, and many of his pictures include them.

The picture was first mentioned in 1752 in the collection of Landgrave Wilhelm VIII of Hesse-Cassel, who had bought it in that year from a collection in the Hague. The picture was removed to Paris by the Napoleonic troops in 1806 and returned to Kassel in 1815. The fact that such a small picture was thought worth removing gives some idea of the esteem in which Breenbergh was held at that time.

Breenbergh's art is saved from being pedestrian and from being overshadowed by that of the more inventive Cornelis van POELENBURGH by his superb technique. Almost all his pictures are of Italian landscapes which are small in format and have a highly finished surface and a cool colour scheme. Such pictures were immensely popular in seventeenth-century cabinets of painting.

His career appears to have been uneventful and little is known about him. He may have studied under Abraham BLOEMAERT in Utrecht and he was certainly at Amsterdam in 1619. He spent a long period in Rome (c. 1620–c. 1633) and then returned to the United Provinces, staying in Amsterdam for the rest of his life. One of the chief influences on his art, as it is on that of Cornelis van Poelenburgh, is the painting of the older Flemish artist Paul Bril (1554–1626), who was the real innovator in Rome of the small, highly finished Italianate landscape.

Abbeville; Amsterdam; Angers; Antwerp; Avignon; Bamberg; Birmingham (Barber Institute); Bordeaux; Brest; Cambridge; Chicago; Copenhagen; Dublin; Florence (Uffizi★); Frankfurt; Grenoble; The Hague; Hanover; Karlsruhe; Kassel★; Leeds; Leningrad; London (Dulwich, National Gallery, Wellington Museum); Malibu (California); Nantes; Oldenburg; Oxford; Paris; Richmond (Ham House); Schwerin; Stockholm; Strasbourg; Toledo (Ohio); Vienna (Academy); Warsaw; Würzburg.

Jan van BIJLERT (Bylert)

Utrecht 1597—Utrecht 1671

Although he is best known as a Caravaggesque artist, by far the largest part of Bijlert's art was not in this idiom. He was in Italy c. 1621–24, that is, at a time when Gerrit van HONTHORST, Dirck van BABUREN and Hendrick TERBRUGGHEN had already left. He picked up a number of the then fashionable mannerisms derived from Caravaggio and on his return to Utrecht began to repeat them.

He worked for 47 years after his return from Italy, painting religious and mythological pictures which are highly polished. The understated influence here seems to be the Utrecht painter Paulus Moreelse (1571–1638) rather than the all-powerful Abraham BLOEMAERT. His output was large but his pictures are relatively rare today.

Amsterdam; Antwerp; Belfast; Brunswick; Budapest; Cardiff; Copenhagen; Dijon (Musée Magnin); Greenville (South Carolina); Hanover; Indianapolis; Kassel; Konigsberg; Leipzig; Leningrad; London; Lyons; Marseilles; Metz; Moscow; Orléans; Prague; Riom; Rotterdam; Saint Germain-en-Laye; Saumur; Sibiu; Sydney; Turin; Wellesley College (Massachusetts); Wroclaw.

St Matthew the Apostle and the Angel

Canvas 94 × 78 cm (37 × 30¾ in)
Formerly signed top right; only part of the J.F. is now visible as the picture has been cut across the top. Probably painted in the 1630s.
BELFAST, Ulster Museum

This is one of a set of four evangelists, now dispersed, which were sold together at Christie's in 1926. One of them, the St John, is now in the Centraal Museum, Utrecht. This is a good example of Bijlert's post-Caravaggesque phase where his style of painting became much more polished. The picture's subject is interesting as it is the same as the famous Rembrandt in the Louvre where he used his son Titus as a model for the angel. But Bijlert's down-to-earth approach prevents him from giving the angel the slightest air of mystery; instead we have one of self-satisfaction.

The picture was acquired by the museum on the London art market in 1968.

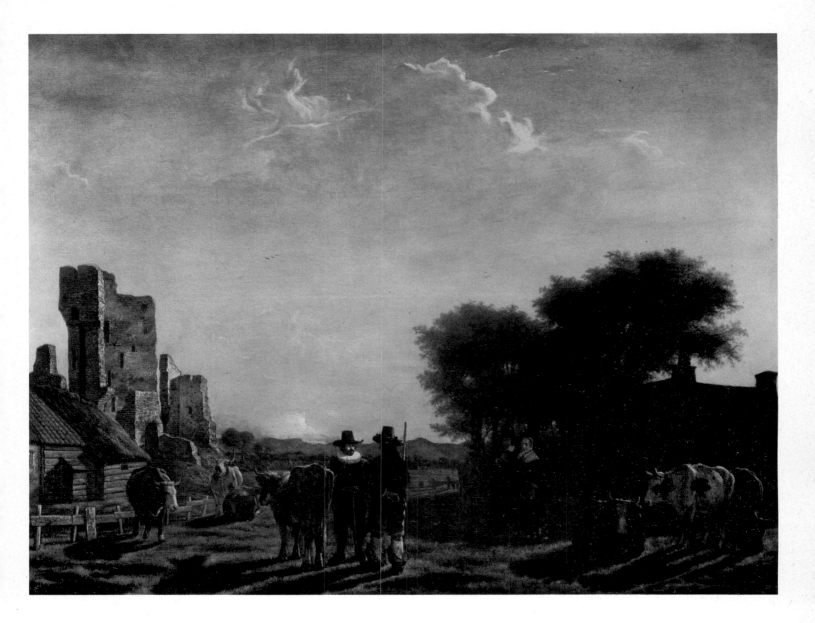

Landscape with Figures (A Farm at Sunset)

Panel 84 × 115 cm (33¼ × 45⅜ in) Signed on the fence to the left: G. Camphuijsen. Probably painted in the late 1660s or early 1670s.

LONDON, Wallace Collection

This is generally thought to be the artist's masterpiece, painted during his final years at Amsterdam. At a first glance the picture seems a little obvious—a few figures, a ruin at the left balanced by a few trees to the right. But what raises it above the ordinary is the astonishing treatment of the light. It is not simply a golden glow derived from the Italianizing efforts of Jan Both or Nicolaes Berchem. It is a brilliantly observed study of that wan yellow which, on some evenings, etches every object as the shadows reach their fullest length before the sun finally disappears. Such atmospheric unity is rare in the whole of Dutch painting in the century.

The picture was bequeathed to the nation in 1897 as part of the Wallace Collection.

Govert Dircksz. CAMPHUYSEN

Dokkum c. 1623/4—Amsterdam 1672

Camphuysen is a painter whose reputation is still obscure, as his pictures have continually been attributed both to Paulus POTTER and Aelbert CUYP. The artist's youth was spent in Amsterdam, but in 1652 he made a surprising move to Sweden, which was at that time a dominant force in European affairs. Three years later Camphuysen had become court painter to Charles X and it is unfortunate that few pictures can be attributed to his Swedish period. He returned to Amsterdam in 1663 and spent the rest of his life there. It is generally thought that his best paintings are those produced in the last years in Amsterdam, although the picture at Lille, plausibly identified as Willem II of Orange (1606–50) out hunting, shows that Camphuysen's whole career deserves reassessment. His pictures often contain elements derived from both Cuyp and Potter, but he composes them in an entirely different way and favours a pale tonality with few or lightly defined shadows.

Amsterdam; Aschaffenburg; Brussels; Cologne; Copenhagen; Grenoble; Gripsholm (Sweden); Kassel; Leipzig; Leningrad; Lille★; London (Dulwich, Wallace Collection★); Philadelphia (Johnson Collection); Rotterdam; Utrecht; York.

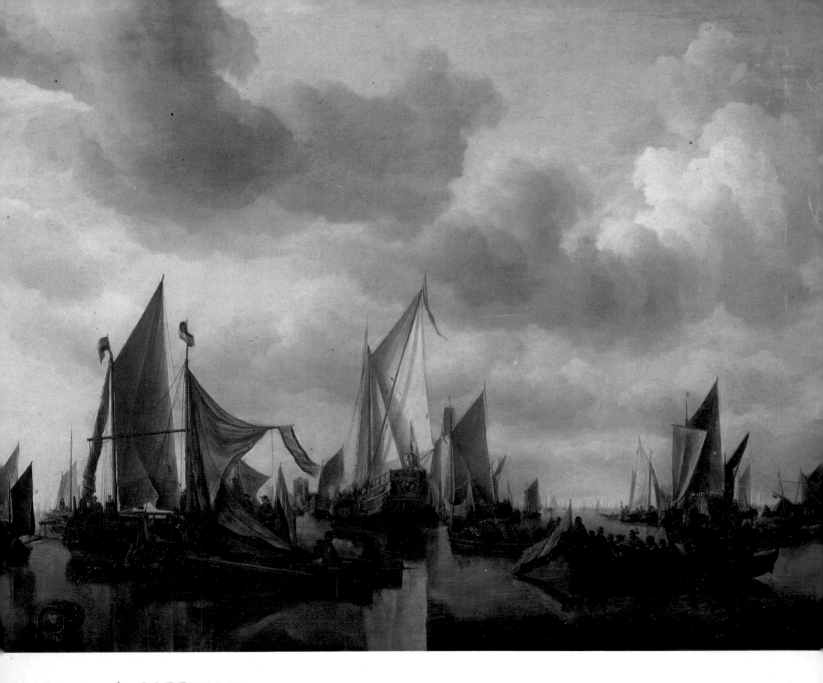

Jan van de CAPPELLE

Amsterdam 1626—Amsterdam 1679

It seems that Cappelle was extremely active in his father's dye works; in addition, he was a passionate collector of seascape paintings and drawings— he had several thousands of them. Thus his paintings are very rare; painting must have been for him a part-time activity. He specialized in seascapes, almost all of them calm, and he only ventured into one other type of painting— the winter scene. They are more or less like the winter scenes of his Amsterdam contemporary Aert van der NEER, although Cappelle preferred a slightly heavier fall of snow. It could be argued that Cappelle's particular brand of balance and calm puts him above almost all the other seascape painters. He eliminates trivia in the search for the precise relationships between the silhouettes of the sails. The best collection of his pictures is in the National Gallery, London.

Amsterdam; Antwerp; Barnsley; Birmingham (Barber Institute); Brussels; Chicago; Cologne; Dublin; Enschede; The Hague; Leipzig; London (Greenwich, Kenwood, National Gallery★); Luxembourg; Manchester; New York; Ottawa; Rochester (New York); Rotterdam; Stockholm; Toledo (Ohio); Upton House (Warwickshire); Utrecht; Vienna; Zurich.

Seascape: A Calm
Canvas 111 × 144 cm (43¾ × 56¾ in)
Signed lower right towards the centre: J.v. Capelle. Probably painted in the mid-1660s.
ROTTERDAM, Boymans-van Beuningen Museum
This is an example of a picture where the artist's preoccupation with arranging the silhouettes of the sails has produced the atmosphere of a fantasy. He rejected the clear palette of so many of the other seascape painters and preferred to use rather muddy greens and browns and some yellow. This makes his best pictures seem as if moss is growing on the surface of the boats just afloat in a stagnant sea. The boats are so crowded together that the sea itself plays a very small part in the picture. Like the landscapes of Jacob van Ruisdael, Cappelle's picture requires a lot of effort before it is realized that an exquisite mood has been distilled.

The painting was acquired by the museum in 1939.

Pieter CLAESZ.

Burgsteinfurt (Westphalia) 1597/8—Haarlem 1660

Still Life: Bread, Fruit and Glass
Panel 64 × 82 cm (25¼ × 32¼ in) Signed in
monogram and dated lower right: PC
A° 1647.
AMSTERDAM, Rijksmuseum
*The actual ingredients in Claesz.'s breakfast
pieces hardly vary—the same white tablecloth,
glass and half-peeled lemon. Furthermore, they
always seem halfway between a real breakfast
table casually left and a carefully composed
still-life designed to display the artist's
brilliance. Certainly white tablecloths are
regarded by painters as one of the great trials of
their skill. Claesz. seems to have achieved it
effortlessly. He was brilliant at painting glass;
here the stem is of the elaborate sort which
makes it slightly out of place at a humble
breakfast.*

*The picture was acquired by the museum in
1900 from a collection in Groningen.*

In recent years, Claesz. has been very much admired by connoiseurs and
collectors as the best painter of unpretentious still lifes. Almost all the surviving
pictures by Claesz. are still-lifes, and by far the largest part of these are the
almost completely monochrome breakfast pieces. It is interesting to speculate
on what it was in Haarlem which caused almost all the painters to tone down
their colours in whatever genre they were working and produce the austere
style of the 1620s. This is in direct contrast to the Caravaggesque extravagances
of Utrecht. Claesz.'s career is completely obscure—his birthplace, Burgstein-
furt, was some 30 miles from the Dutch border and he moved to Haarlem
by 1617. He was the father of Nicolaes Pietersz. who later adopted the name
of BERCHEM.

Amsterdam; Berlin; Boston; Bristol; Brussels; Budapest; Cambridge; Chicago;
Copenhagen; Dresden; Dublin; Haarlem; The Hague; Hamburg; Indianapolis; Kansas
City; Karlsruhe; Kassel; Leipzig; Leningrad; London; Madrid; Malibu (California);
Minneapolis; Munich; Nantes; New York; Otterlo; Oxford; Paris; Philadelphia;
Poughkeepsie; Prague; Rotterdam; St Louis; Stockholm (Hallwylska Museet, National-
museum); Strasbourg; Toledo (Ohio); Utrecht; Vienna; Würzburg.

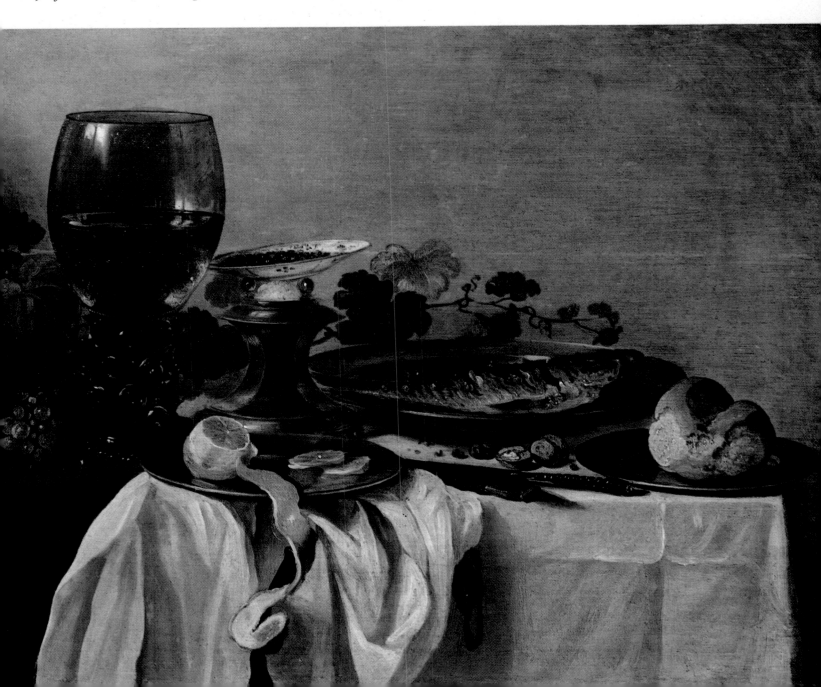

The Smoker (An Allegory of Contentment with Little?)

Panel 46 × 34 cm (18 × 13½ in) Signed in monogram: CP. Probably painted in the mid-1630s.

LILLE, Palais des Beaux-Arts

Codde's picture has been interpreted, along with one by Jan Davidsz. de Heem of a similar subject (now in the Ashmolean Museum, Oxford), as an allegory of contentment with little. An objection could be raised: the sitter does not seem to be particularly happy. The symbolism in the picture is supposed to be revealed by the fact that, to be happy, the man needs books as well as a table and a chair. Whatever the precise meaning, Codde has painted an exceptional picture from the point of view of technique. The bare wall in the background is worthy of Vermeer while the young man's awkward pose is reminiscent of a similarly awkward sitter by Hals—the Willem van Heythuysen *at Brussels (page 108).*

The picture was bequeathed to the museum by Antoine Brasseur in 1885.

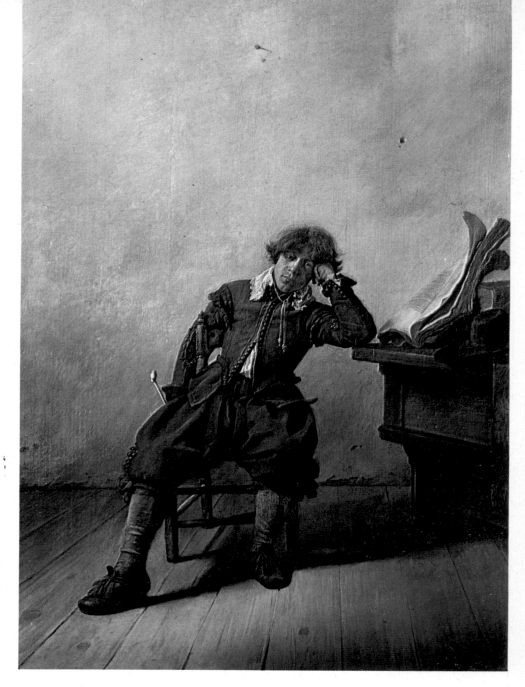

Pieter Jacobsz. CODDE
Amsterdam 1599—Amsterdam 1678

Almost all Codde's surviving pictures are portraits or genre pieces. Although he spent his whole life in Amsterdam, the chief influence on his art was that of Fran HALS who spent most of his career in nearby Haarlem. Codde employed a more precise brushwork than did Hals and his small pictures of groups of figures in a room are often similar to those of Hendrick Gerritsz. POT and Willem DUYSTER.

Perhaps Codde's greatest charm lies in his sense of humour. In the *Portrait of a Woman in an Interior* of 1625 in the National Gallery, London, there is a cat poised to chase a large mouse (or rat).

Aix-en-Provence; Amsterdam; Bordeaux; Bristol; Chicago; Copenhagen; Dresden; Dublin; Geneva; Ghent; Göttingen; Haarlem; The Hague; Hanover; Karlsruhe; Leipzig; Leningrad; Lille; London; New York; Nottingham; Oxford; Paris (Louvre, Musée Jacquemart-André, Petit Palais); Philadelphia (Johnson Collection); Prague; Quimper; Rome (Galleria Borghese); Rotterdam; St. Etienne; Speyer; Stockholm; Strasbourg; Stuttgart; Vienna (Academy); Warsaw; Würzburg.

Adriaen COORTE

Places and dates of birth and death unknown. Working in Middelburg c. 1685–c. 1707

The very modesty of Coorte's pictures has led them to be overlooked. His reputation has not been helped by the fact that no information has turned up about his career; his period of activity has been reconstructed from the dates on his pictures. All his surviving work is of still life, which is limited to the depiction of shells, gooseberries, red currants, medlars, peaches and asparagus. Occasionally and unexpectedly he paints a butterfly hovering over the isolated elements in his pictures. It is possible that these butterflies—usually of the prosaic Cabbage White variety—may have some allegorical significance. Transcience and the mutability of all things are the usual interpretations given to their presence. His works are always small and carefully painted. The Middelburg of his time was relatively isolated and his personal way of seeing cannot have been popular elsewhere. He has been forgotten for three centuries.

Antwerp; Amsterdam; Cambridge; Dordrecht; The Hague (Gemeentemuseum); Leningrad; Middleburg; Oxford; Paris; Rotterdam; Zierikzee.

Still Life: A Bundle of Asparagus

Canvas 29.8 × 22.8 cm (11¾ × 9 in)
Signed and dated lower centre: A. Coorte 1703.
CAMBRIDGE, Fitzwilliam Museum
Like all the artist's very limited surviving output, this picture's charm lies in the utterly simple way he has treated the subject. The lowly bundle of asparagus is perched rather uneasily on the edge of whatever it is he always put his still-life objects on. It seems to be a kind of stone ledge rather than the edge of a table. The monotony of the bundle is only relieved by one of the spears which has not grown straight. Only after a long hard look is it realized that Coorte saw more in a single object than many of the painters of grand banquet pieces, who were concerned with the grandeur of the effect rather than the precise character of an asparagus stalk.

CORNELIS Cornelisz. van Haarlem

Haarlem 1562—Haarlem 1638

In the story of official academic art, Cornelis van Haarlem was the most important artist of his time. He was the chief painter of the Haarlem academy, which had been founded in the mid-1580s by Carel van Mander. Cornelis also had the advantage of foreign training. According to van Mander he travelled from 1577 to 1583, visiting Rouen and Antwerp, although in fact his art owes little to either French or Flemish painting of the period.

From the 1580s onwards he received almost every important official commission in Haarlem for nearly two generations. He painted two large group portraits—the second one (1599) was to form the basis for the composition of Frans HALS's first group portrait. He painted in 1591 a colossal *Massacre of the Innocents* (Haarlem, Frans Hals Museum) and two years later an equally enormous *Marriage of Peleus and Thetis* (Haarlem, Frans Hals Museum) for the town hall at Haarlem.

Cornelis's art was basically Italian-oriented, although he never went to Italy; his brilliantly coloured draperies and rounded forms are derived from mid-sixteenth-century Italian models. He was particularly good at integrating a large number of figures into an elaborate composition.

An Allegorical Portrait of the Haarlem Conchologist Jan Govaertsen

Canvas 176 × 233.5 cm (69½ × 92 in)
Signed in monogram and dated: CH 1605
LACOCK ABBEY (Wiltshire) National Trust

This complex allegory presumably refers to the sitter's many interests. Govaertsen's portrait was also painted by Hendrick Goltzius (lent to the Boymans-van Beuningen Museum, Rotterdam, by a private collector) and as both pictures show him surrounded by sea shells it is clear that he was a leading exponent of the craze for conchology. The artist's ability to contrast the ideal and the real is well seen in this picture. He has not flinched from the sitter's double chin, made all the more obvious by the idealized bearded man playing the lute in the foreground which is worthy of an Italian painter. Significantly, this picture was executed the year after the publication of van Mander's Schilderboek. Perhaps Cornelis had been reading van Mander's didactic poetry and this caused him to introduce so many allusions to science, architecture and music. The picture was in the collection at Lacock by about 1750.

The Corruption of the World before the Flood

Panel 112 × 155 cm (44 × 61 in) Signed in monogram and dated on the stone on which the musician at the centre is seated: CvH 1615.

TOULOUSE, Musée des Augustins

There is the feeling that the artist enjoyed painting this scene of debauchery explaining in every detail why there had to be a Flood. He was able to get away with such a subject by alluding to the Old Testament. As long as painters kept their religious subject-matter strictly to the Bible and avoided the depiction of saints, their work does not seem to have raised objections from the Protestant church.

This picture's history is especially interesting as it belonged to the celebrated picture gallery of the Duke of Brunswick-Wolfenbüttel at Brunswick, from which it was removed, along with the rest of the collection, by the Napoleonic troops in 1808. In 1812 it was sent to Toulouse by the French authorities and when the Brunswick pictures were returned in 1815 this painting was overlooked.

Cornelis had many pupils, some of whom—like Gerrit Pietersz. Sweelinck, who was the brother of the Haarlem composer Jan Sweelinck—limited themselves to the imitation of their master. He also taught Pieter LASTMAN for a time, and his reputation was such that it caused Dr Bredius to remark that when the young Rembrandt went to Amsterdam to study under Pieter Lastman he chose the second most important painter in the country. Thus the first 30 years of the century in Haarlem were still dominated by Cornelis's outdated style. His pictures changed but little; he painted them slightly smaller and reduced the brightness of his colours to conform with the growing taste for monochrome. To modern eyes his endless nudes seen from the rear, limited in their number of poses, seem mawkish. But to connoisseurs of painting for 200 years a picture by Cornelis van Haarlem was an essential part of any respectable cabinet of pictures.

Antwerp; Amsterdam★; Baltimore; Berlin (Schloss Grunewald); Bonn; Bordeaux; Brunswick; Brussels; Budapest; Caen; Cambridge; Copenhagen; Darmstadt; Dessau; Dresden; Douai, Frankfurt; Fort Worth (Texas); Geneva; Gothenburg; Haarlem★; Hamburg; Hanover; Hartford (Connecticut); Karlsruhe; Kiel; Konigsberg; Lacock Abbey (Wiltshire); Leningrad; Lille; Linköping; London (National Gallery, Victoria and Albert Museum); Madrid; Mainz; Nuremberg; Ottawa; Oxford; Philadelphia; Potsdam; Prague; Quimper; Rotterdam; Schwerin; Sibiu; Stockholm; Toulouse; Troyes; Utrecht; Valenciennes; Vienna; Warsaw; Würzburg.

Aelbert CUYP
Dordrecht 1620—Dordrecht 1691

In the last 50 years, Cuyp has occupied an invidious position in the context of Dutch seventeenth-century painting because his very virtues have led him to be over-esteemed. He occupies a minor position in the development of painting in the seventeenth century as he worked all his life in the relative isolation of his native Dordrecht. His earliest pictures are delightful essays in the manner of van GOYEN, the major difference being that Cuyp preferred a slightly more cheerful palette and paid greater attention to detail.

It is not quite clear what caused Cuyp to change his style so radically from his early manner, but it has been assumed to have been the influence of the newly fashionable Italian-style landscapes painted in Utrecht in the 1640s following the return of Jan BOTH from Italy. Cuyp, however, did not slavishly imitate; he soon evolved his own very special style. This frequently included the much-abused cows which he used as compositional props to frame his perfectly balanced distances, which are so often punctuated by the unfinished Gothic tower of the Grote Kerk at Dordrecht.

Cuyp responded to nature more than his detractors are prepared to admit, and a proportion of his pictures contain no cows at all. The artist's interest in the depiction of atmosphere went a long way beyond a limp imitation of Italian-type light—which of course he had never seen. This is best revealed in his seascapes. They usually depict rather square-looking boats becalmed. They have none of the elegance of those of Jan van de CAPPELLE, but they are made appealing by the fall of light. The result is a special feeling of calm which permeates almost all Cuyp's pictures; only occasionally is the calm disturbed by a hunter about to shoot a bird.

Cavaliers and Hunters in a Landscape
Canvas 120 × 171.5 cm (47⅜ × 67½ in)
Signed lower right: A. cuyp. Probably painted in the 1660s.
WASHINGTON, National Gallery of Art
There is a complete contrast to the solid quality of the Large Dort. Here Cuyp has changed the mood completely by painting a vast open landscape with plenty of action. In fact, there is far more going on than a glance would suggest. At the extreme right the herdsmen and their cattle are engaging the attention of the two passers-by on horseback, while at the left there is a hunter at full gallop. From the point of view of composition Cuyp was quite daring: almost half the picture is devoted to the golden sky which he painted with infinite nuances of tone.

The picture was given to the gallery in 1942 by Joseph Widener of Elkins Park, Philadelphia.

A Distant View of Dordrecht with a Milkmaid, Four Cows and other Figures (The Large Dort)

Canvas 157 × 197 cm (62 × 77½ in) Signed lower right A. cuÿp. Probably painted c. 1650.
LONDON, National Gallery

This is one of the artist's most ambitious pictures, both in scale and the complexity of the composition. It is built up in a series of layers. The nearest to the spectator is the undergrowth of brambles and those mysterious cabbage-like leaves which also appear in the work of Adam Pijnacker. Then come the cows and figures, which are carefully related both to the foreground and the immensely complex distance, which is, of course, Dordrecht. The whole is bathed in the artist's beloved golden glow and the result is the epitome of prosaic contentment.

The earliest record of this once-famous picture is in 1810, when it was brought to England. There it changed hands several times until it was bequeathed to the gallery by Wynn Ellis in 1876.

As is so often found with painters who did not pursue an official career of academic success and royal or state patronage, details about the artist's life are scant indeed. He was the son of the Dordrecht portrait painter Jacob Gerritsz. Cuyp (1594–1652), and indeed a few portraits have been attributed to Aelbert himself. His life was probably uneventful and the most adventurous thing he ever did was to paint a few ducks and hens.

Cuyp could well be described as the archetypal provincial painter. He did not make the move to Amsterdam, and the only evidence that he left Dordrecht at all is the fact that his pictures sometimes take other places as their subject, for instance Nijmegen. It is sad that this humble and inscrutable man should have enjoyed such adulation in the eighteenth and nineteenth centuries and should have had such criticism heaped upon him in the twentieth.

Aachen; Aix-en-Provence; Amiens; Amsterdam; Anglesey Abbey (Cambridgeshire); Ascott (Buckinghamshire★); Aschaffenburg; Augsburg; Barnsley; Basle; Berlin; Besançon; Birmingham (Barber Institute); Brunswick; Budapest; Caen; Cambridge; Cape Town; Cardiff; Cleveland (Ohio); Cologne; Copenhagen; Darmstadt; Dessau; Dordrecht; Douai; Edinburgh; Essen; Frankfurt; Genoa (Palazzo Bianco); Glasgow; Gotha; Haarlem; The Hague (Bredius Museum★, Mauritshuis); Indianapolis; Innsbruck; Jerusalem; Kassel; Leipzig; Leningrad; London (Dulwich★, Kenwood, National Gallery★, Wallace Collection★); Los Angeles; Mainz; Manchester; Minneapolis; Montpellier; Munich; New York (Metropolitan Museum, Frick Collection); Oxford; Paris (Louvre, Petit Palais); Petworth (Sussex); Philadelphia (Johnson Collection); Polesden Lacey (Surrey); Prague; Rotterdam; St Louis (Washington University); Salzburg; San Diego; Sarasota (Florida); Strasbourg; Toledo (Ohio); Toronto; Venice (Museo Correr); Vienna; Waddesdon Manor (Buckinghamshire)★; Washington (Corcoran Gallery, National Gallery); Weimar; Wroclaw; Wuppertal.

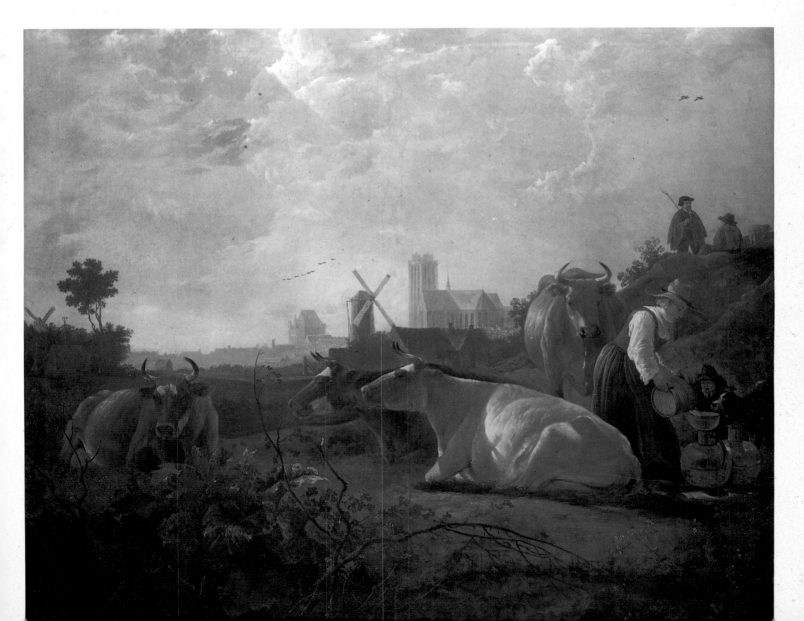

Arent (?) DIEPRAAM

Rotterdam 1622?—Rotterdam 1670?

The only information to come to light so far about this artist is the fact that there is a small group of pictures of peasant interiors, all signed A. Diepraam, which are dated between 1648 and 1668. There are records in Rotterdam of a painter named Arent Diepraam who was born in 1622 and died in 1670, and he has been presumed to have created the pictures. The style of the paintings is, however, strictly Flemish in its origin and is based on a familiarity with the paintings of Adriaen Brouwer (1606?–38), part of whose career was spent in Amsterdam. Diepraam lacked Brouwer's depth of penetration while successfully imitating his lively handling and thin, transparent paint.

Amsterdam; Douai; Guéret; The Hague (Bredius Museum); Karlsruhe; Leningrad; Lille; London; Mainz; Perth; Philadelphia (Johnson Collection); Schwerin; Vienna (Academy).

Interior of a Tavern: Boors Smoking and Drinking
Canvas 46 × 52 cm (18 × 20½ in) Signed and dated: A. Diepraem 1665.
AMSTERDAM, Rijksmuseum
Perhaps the main difference between this picture and Brouwer's treatment of the same subject is the heightened colour scheme. The boors are accurately observed but they lack any real penetration of character. It has to be remembered that this type of 'low life' picture enjoyed enormous popularity in the middle years of the century with those classes who could afford to collect works of art. They thought it becoming to collect representations of the way of life of the peasantry, and it was only later in the century that the genteel interior overtook this type of picture in popularity. The picture was acquired by the museum in 1892.

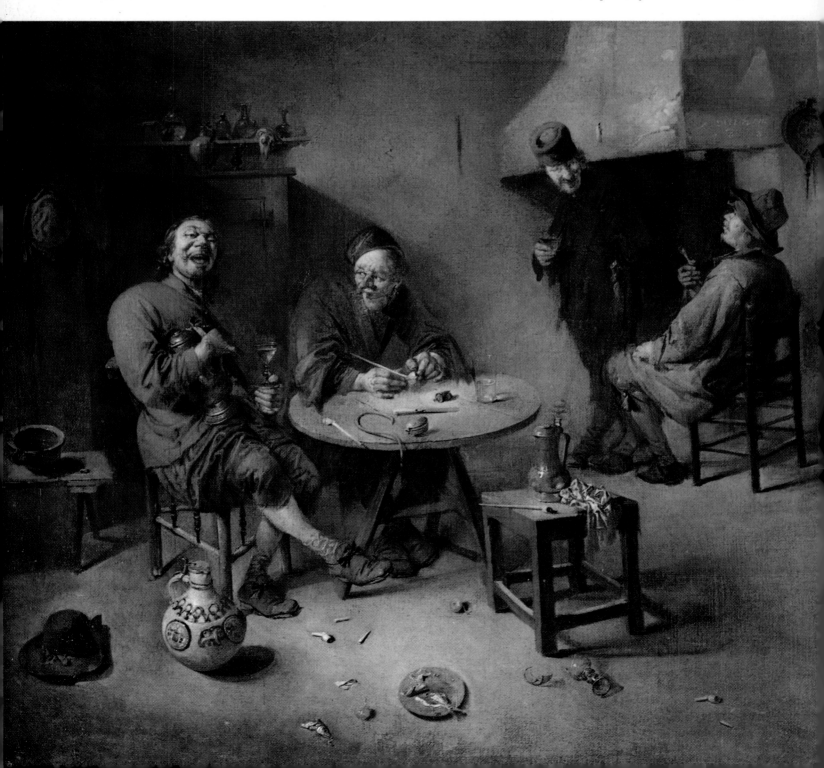

**A Distant View of Dordrecht with a
Milkmaid, Four Cows and other
Figures (The Large Dort)**

Canvas 157 × 197 cm (62 × 77½ in) Signed
lower right A. cuÿp. Probably painted
c. 1650.

LONDON, National Gallery

*This is one of the artist's most ambitious
pictures, both in scale and the complexity of the
composition. It is built up in a series of layers.
The nearest to the spectator is the undergrowth
of brambles and those mysterious cabbage-like
leaves which also appear in the work of Adam
Pijnacker. Then come the cows and figures,
which are carefully related both to the
foreground and the immensely complex distance,
which is, of course, Dordrecht. The whole is
bathed in the artist's beloved golden glow and
the result is the epitome of prosaic contentment.*

*The earliest record of this once-famous
picture is in 1810, when it was brought to
England. There it changed hands several times
until it was bequeathed to the gallery by Wynn
Ellis in 1876.*

As is so often found with painters who did not pursue an official career
of academic success and royal or state patronage, details about the artist's life
are scant indeed. He was the son of the Dordrecht portrait painter Jacob
Gerritsz. Cuyp (1594–1652), and indeed a few portraits have been attributed
to Aelbert himself. His life was probably uneventful and the most adventurous
thing he ever did was to paint a few ducks and hens.

Cuyp could well be described as the archetypal provincial painter. He did
not make the move to Amsterdam, and the only evidence that he left Dordrecht
at all is the fact that his pictures sometimes take other places as their subject,
for instance Nijmegen. It is sad that this humble and inscrutable man
should have enjoyed such adulation in the eighteenth and nineteenth centuries
and should have had such criticism heaped upon him in the twentieth.

Aachen; Aix-en-Provence; Amiens; Amsterdam; Anglesey Abbey (Cambridgeshire);
Ascott (Buckinghamshire★); Aschaffenburg; Augsburg; Barnsley; Basle; Berlin; Besançon;
Birmingham (Barber Institute); Brunswick; Budapest; Caen; Cambridge; Cape Town;
Cardiff; Cleveland (Ohio); Cologne; Copenhagen; Darmstadt; Dessau; Dordrecht; Douai;
Edinburgh; Essen; Frankfurt; Genoa (Palazzo Bianco); Glasgow; Gotha; Haarlem; The
Hague (Bredius Museum★, Mauritshuis); Indianapolis; Innsbruck; Jerusalem; Kassel;
Leipzig; Leningrad; London (Dulwich★, Kenwood, National Gallery★, Wallace Collec-
tion★); Los Angeles; Mainz; Manchester; Minneapolis; Montpellier; Munich; New York
(Metropolitan Museum, Frick Collection); Oxford; Paris (Louvre, Petit Palais); Petworth
(Sussex); Philadelphia (Johnson Collection); Polesden Lacey (Surrey); Prague; Rotterdam;
St Louis (Washington University); Salzburg; San Diego; Sarasota (Florida); Strasbourg;
Toledo (Ohio); Toronto; Venice (Museo Correr); Vienna; Waddesdon Manor (Bucking-
hamshire)★; Washington (Corcoran Gallery, National Gallery); Weimar; Wroclaw;
Wuppertal.

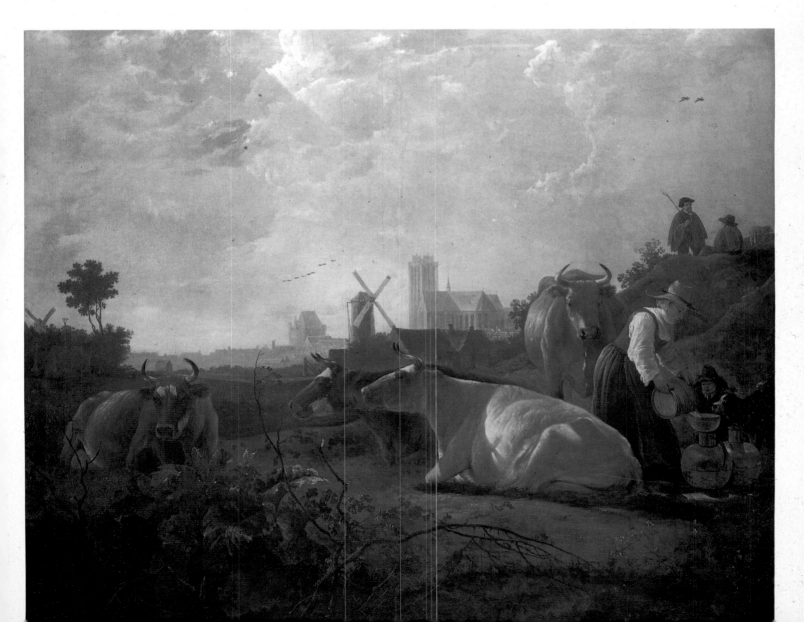

Arent (?) DIEPRAAM

Rotterdam 1622?—Rotterdam 1670?

The only information to come to light so far about this artist is the fact that there is a small group of pictures of peasant interiors, all signed A. Diepraam, which are dated between 1648 and 1668. There are records in Rotterdam of a painter named Arent Diepraam who was born in 1622 and died in 1670, and he has been presumed to have created the pictures. The style of the paintings is, however, strictly Flemish in its origin and is based on a familiarity with the paintings of Adriaen Brouwer (1606?–38), part of whose career was spent in Amsterdam. Diepraam lacked Brouwer's depth of penetration while successfully imitating his lively handling and thin, transparent paint.

Amsterdam; Douai; Guéret; The Hague (Bredius Museum); Karlsruhe; Leningrad; Lille; London; Mainz; Perth; Philadelphia (Johnson Collection); Schwerin; Vienna (Academy).

Interior of a Tavern: Boors Smoking and Drinking

Canvas 46 × 52 cm (18 × 20½ in) Signed and dated: A. Diepraem 1665.
AMSTERDAM, Rijksmuseum
Perhaps the main difference between this picture and Brouwer's treatment of the same subject is the heightened colour scheme. The boors are accurately observed but they lack any real penetration of character. It has to be remembered that this type of 'low life' picture enjoyed enormous popularity in the middle years of the century with those classes who could afford to collect works of art. They thought it becoming to collect representations of the way of life of the peasantry, and it was only later in the century that the genteel interior overtook this type of picture in popularity. The picture was acquired by the museum in 1892.

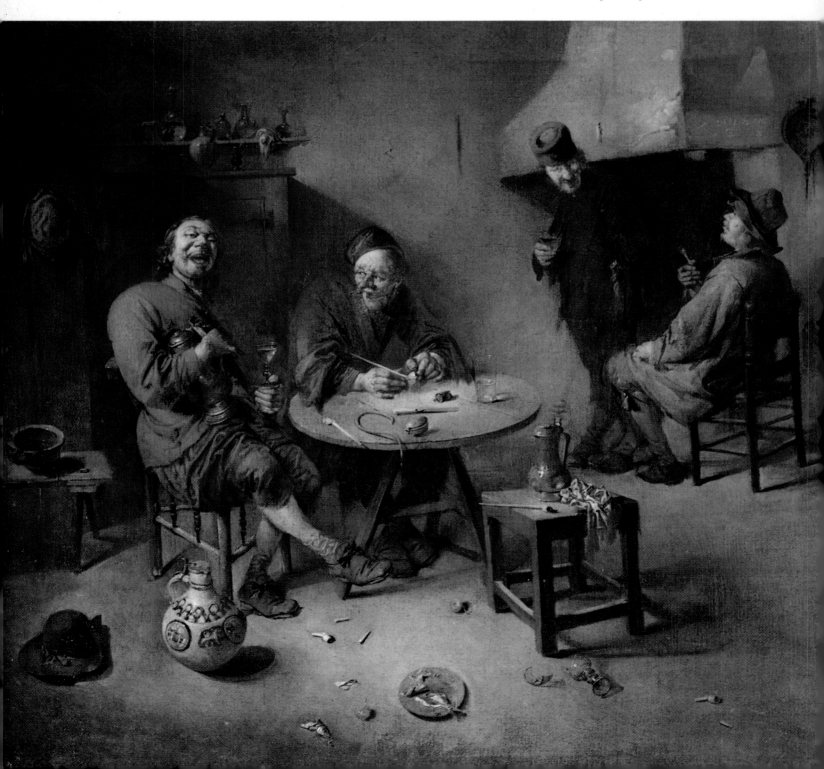

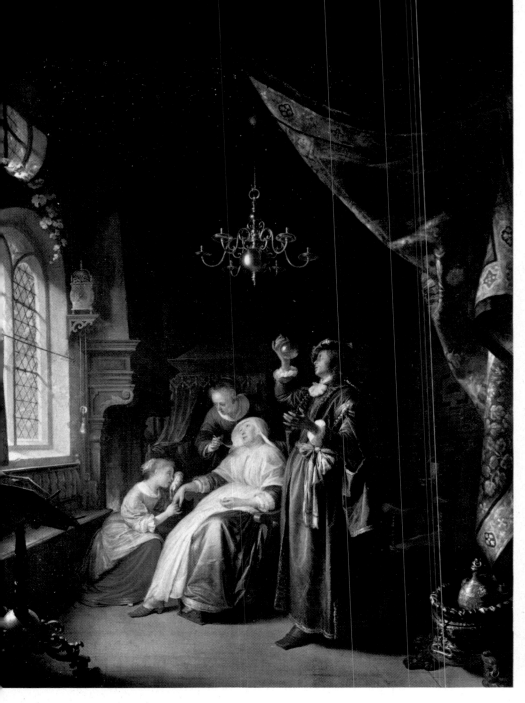

Interior with a Sick Woman, her Urine being examined by a Doctor (The Dropsical Lady)
Panel 83 × 67 cm (32¾ × 26¼ in) Signed and dated on the book at the left: 1663 G. DOV. OVT. 65 JAER.
PARIS, Musée du Louvre

As a perfect master of technique Dou was justly admired by his contemporaries and he has been unjustifiably neglected in recent years. In a picture of this type the technique is perfect but what lies open to question is the sentiment. It is difficult to take the whole picture seriously as it seeks to give charm to an unpleasant incident. The stout lady is genuinely ill and this is not one of the many pictures of imaginary illness brought on by love which were so often painted.

This picture's history is interesting as its fame has ensured that it is well-documented. It was in the cabinet of a certain M. Bye in Leiden in 1665 and was acquired for the colossal sum of 30,000 florins by the Elector Palatine Charles Philip, who in turn gave it to Prince Eugène of Savoy. It remained in the Savoy family in the eighteenth century, first at Vienna and later in the gallery at Turin. In 1798 it was offered by Charles Emmanuel IV of Sardinia to the French occupying forces and it was taken to Paris. In 1815 the picture formally became the property of the Louvre, where its fame has gradually declined ever since.

Gerrit (Gerard) DOU
Leiden 1613—Leiden 1675

Dou occupies a central position in the art of his own time, to a point where it is difficult to over-estimate his importance. His early training was with REMBRANDT before the latter left Leiden c. 1631/2. They collaborated on at least one picture—the *Anna and the Blind Tobit* which is in the National Gallery, London. Dou spent the whole of the rest of his career in his native Leiden and he clearly rejected whatever he may have learned from Rembrandt. Instead he concentrated on small, highly finished pictures of wide-ranging subject manner, of which he was one of the most proficient masters who has ever lived.

His pictures are curiously restrained in their colour scheme; they have to be appreciated by close inspection. Whatever Dou may have known about Rembrandt, HALS and VERMEER, for him their art did not exist. Instead he

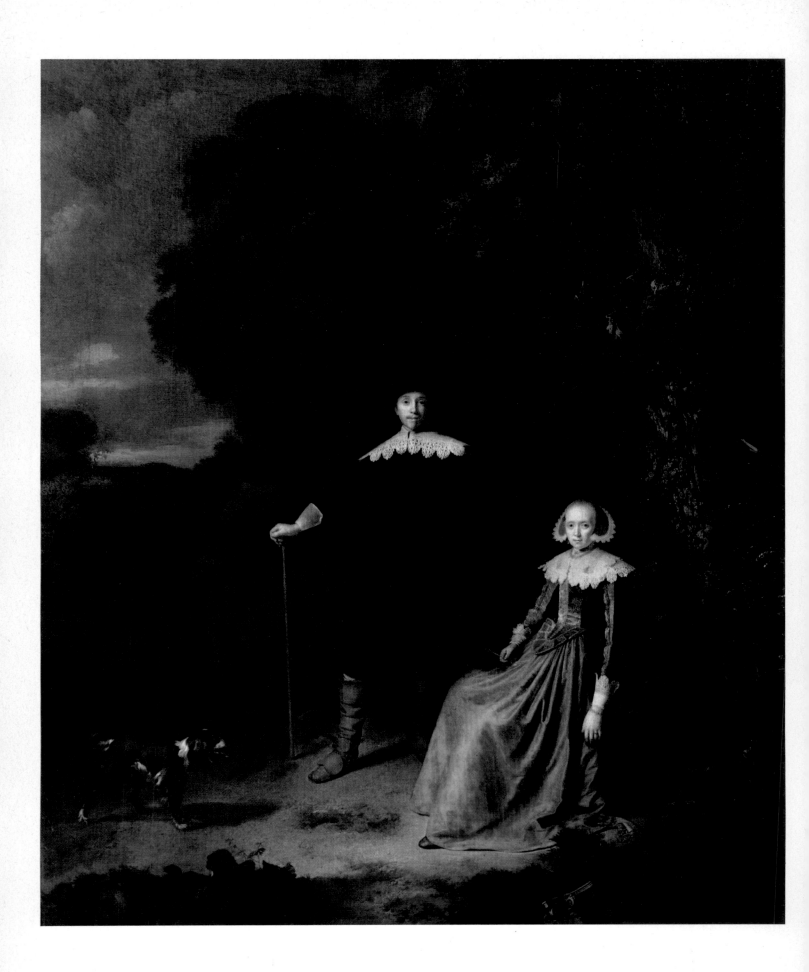

Portrait of a Man and his Wife in a Landscape

Panel 76 × 62.5 cm (30 × 24¾ in) Signed on the capital of the column which bears the artist's portrait: G. Dov. Signed left foreground: Berchem. Probably an early picture.

AMSTERDAM, Rijksmuseum

This is an interesting and by no means rare example of the collaboration between two artists whose style was rather different from one another but who each modified their way of painting in order to produce a perfectly harmonious picture.

Berchem was responsible for the landscape and the dog and Dou for the figures. Berchem has toned down his usually highly coloured landscape to make it more in keeping with Dou's sober tones. The sitters are thought to be Adriaen Wittert van der Aa and his wife Maria Knotter, although this identification is not certain.

The painting was originally in the National Museum in The Hague in 1808 but was later transferred to the Rijksmuseum.

became an enormously important teacher whose influence was to last almost 200 years. He taught Gabriel METSU and Godfried SCHALCKEN, encouraging them towards painting the highly finished pictures which dominated Dutch taste in the eighteenth and early nineteenth centuries.

Obviously Dou has been removed from the pedestal on which the taste of the eighteenth and nineteenth centuries placed him. Minute detail is no longer considered a sound basis on which to assess the merit of a painting. The twentieth century has lost respect for this skill, and Dou's controlling position in Leiden is too easily forgotten by modern historians seeking to justify their preference for less influential painters. It has often been suggested, not unreasonably, that Dou's *Lady at the Virginals* (in the Dulwich Gallery) is the source of inspiration for Vermeer's *Lady seated at the Virginals* (in the National Gallery, London), which was probably painted some ten years later than Dou's work.

Dou covered a wide range of subject matter, from religious work to most of the different aspects of genre painting. One of his most elaborate and significant pictures is the *Quack* of 1652 (Rotterdam, Boymans-van Beuningen Museum), which shows a group of people being taken in by the nonsense of the smooth-talking charlatan. The picture is as full of incident as one by Jan STEEN, even down to such normally unmentionable daily events as a mother wiping clean her child's bottom. Dou himself leers into the picture as a spectator through the window.

Dou's religious pictures have the same meticulous technique and small scale; a typical example is the *Hermit* (Amsterdam, Rijksmuseum), where there is almost a sense of humour in the old man's facial expression.

It was Dou's technique which was to form the basis for the Leiden school of *fijnschilders* or fine painters. His influence was strongest on the van MIERIS dynasty, who often painted more elaborate and highly coloured compositions than did Dou himself. But they always remained faithful to the perfectly polished surface in which every detail was included with the utmost respect.

Amsterdam★; Aschaffenburg; Berlin; Boston; Brunswick; Budapest; Cambridge; Cheltenham; Cincinnati; Cologne; Copenhagen; Cracow; Danzig; Dessau; Dresden★; Düsseldorf; Florence (Uffizi); Frankfurt; Gotha; The Hague (Bredius Museum, Mauritshuis); Hamburg; Kansas City; Karlsruhe; Kassel; Leiden; Leningrad★; London (Dulwich★, National Gallery, Wallace Collection); Luxembourg; Manchester; Munich★; Oldenburg; Prague; Riga; Rotterdam; Salzburg; Schwerin★; Sibiu; Speyer; Stockholm; Turin; Vienna; Waddesdon Manor (Buckinghamshire); Warsaw; Washington; Williamstown (Massachusetts); Wroclaw; Würzburg; York.

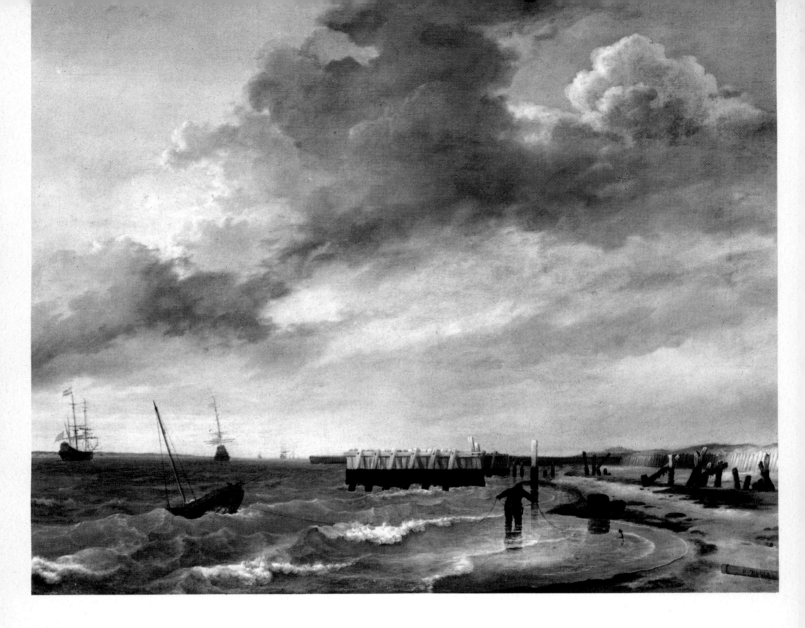

Hendrick DUBBELS

Amsterdam 1620/1—Amsterdam 1676

Hendrick Dubbels occupies an awkward place in the development of Dutch seascape painting as no scholar has decided whether he was an imitator or an innovator. The perfect example of his serene seascape painting, the *Dutch Yacht and other Vessels becalmed near the Shore*, in the National Gallery, London, was for long attributed to Jan van de CAPPELLE, but it has been pointed out that it is very much closer in style to Willem van de VELDE the Younger. It could well be that Dubbels was influenced by Jan van de Cappelle and it would not be fair to assume that his pictures were all derived from van de Velde, who was some twelve years his junior.

Very little is known of Dubbel's career. He is recorded several times in Amsterdam, where he was a shopkeeper as well as a painter. He was made bankrupt in 1665.

Relatively few of Dubbel's pictures seem to be signed. This is probably the cause of his unjust neglect, as his pictures can so easily be attributed to other painters.

Amsterdam; Bonn; Cape Town; Copenhagen; Dunkirk; Florence (Pitti); Kassel; La Fère; London (Greenwich, National Gallery); Madrid; Paris; Philadelphia (Johnson Collection); Rotterdam; Schwerin; Stockholm; Strasbourg.

Beach Scene
Canvas 69 × 86 cm (27⅛ × 33¼ in) Signed on a stake: Dubbels.
FLORENCE, Galleria Pitti
This seemingly simple and empty beach scene is in fact full of subtlety of atmosphere. The few gentle waves breaking on the flat beach with a jetty and open sky are a carefully calculated piece of understatement. The contrast with Jan van de Cappelle, for example, could hardly be more dramatic. The latter was trying to achieve a monumental composition using boats and the sea while Dubbels was pursuing the opposite course, producing an open, natural effect. Dubbels's pictures are difficult to date as they all resemble each other.
The picture was bought by Ferdinando III of Lorraine in 1823 from the dealer Artaria of Mannheim. It has been in the Pitti Gallery ever since.

Italian Landscape (Le Diamant)
Panel 20.5 × 27 cm (8⅛ × 10⅝ in) Signed
lower right: K. DU IARDIN. Probably
painted c. 1652 as the artist executed an
etching of a similar composition in that
year.
CAMBRIDGE, Fitzwilliam Museum
*This is one of the very best surviving Italian
landscapes painted by a Dutchman. In the
eighteenth century it was considered so precious
that it became known as 'The Diamond'. The
picture is a true landscape as there is very little
incident. The artist must have been moved by
the purity of the light and atmosphere; he
distilled his experience into this miniscule
object which has a feeling of great breadth and
distance.*

Karel DU JARDIN
Amsterdam 1621/2 (?)—Venice 1678

Although most of Du Jardin's pictures are Italian landscapes in the manner
of Nicolaes BERCHEM, who is believed to have been his master, his art shows
a wide variety of subject matter and technique. He also painted a few large
pictures like the *Conversion of Saul* (in the National Gallery, London) but these
lack the precision and concentration of his small-scale pictures. There are also
a few excellent portraits, most of which depict a young man. Although the
sitters differ, almost all of them have at one time been described as self-
portraits.

Du Jardin did not make any contribution to the development of the Italianate
landscape which was evolved by Jan BOTH and continued by Berchem, but

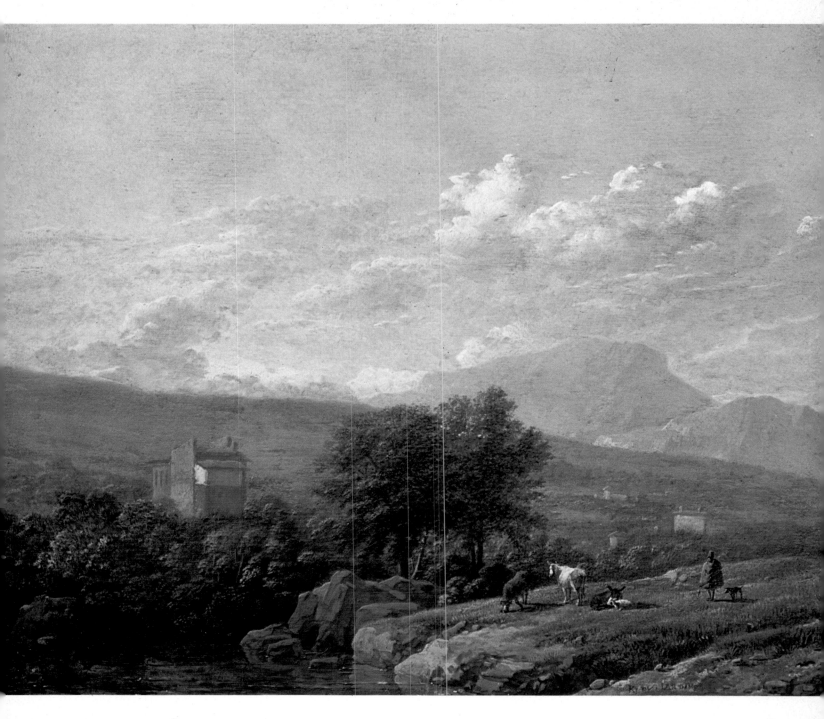

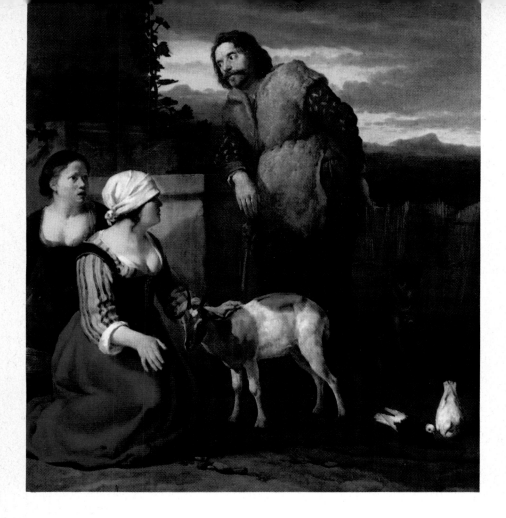

Italian Landscape with Figures (The Sick Goat)
Canvas 84.5 × 73.2 cm (33¼ × 28¾ in)
Signed lower right: K. IARDIN fec.
Probably painted in the 1660s.
MUNICH, Alte Pinakothek
In direct contrast to 'Le Diamant' this picture shows the artist's preoccupation with anecdote. Sentimentality about animals was obviously prevalent in the seventeenth century and the artist has made his point forcibly. The sick animal appears pathetic and cannot fail to arouse the spectator's sympathy. The landscape background is typical of the artist and he rarely excluded a distant Italian view from his pictures.

This picture was first recorded in an Amsterdam sale in 1789 and was then in the gallery at Mannheim before being transferred to Munich.

he practised the genre with a skill and perfection which make him outstanding in the group. He was also good at painting animals and occasionally his pictures come close to those of Paulus POTTER.

Jan Both concentrated on the general effect of his landscapes, which are meant to be viewed as a whole, but Du Jardin preferred his pictures to be read at close quarters. The atmosphere has a milky quality rather than the golden glow used by most of his contemporaries.

His career was complex and is best summarized as follows: Rome before 1650; Amsterdam 1650; Lyons; Amsterdam 1652; The Hague 1656; Amsterdam 1659; Rome 1675; Venice 1678. His pictures show remarkably little evidence of these continuous moves and, without dates on them, they are remarkably difficult to pin-point to a particular time in his career.

Aix-en-Provence; Amsterdam; Annecy; Antwerp; Arnhem; Bamberg; Baroda (India); Basle; Bayreuth; Berlin; Birmingham (Barber Institute); Bristol; Brunswick; Budapest; Cambridge★; Cologne; Copenhagen; Detroit; Dresden; Dublin; Edinburgh; Eindhoven; Gotha; The Hague; Hanover; Karlsruhe; Kassel; La Fère; Leningrad; Lille; London (Dulwich, National Gallery★, Wallace Collection); Lyons; Montpellier; Munich; New Haven (Connecticut); Oxford; Paris; Philadelphia (Johnson Collection); Potsdam; Prague; Riga; Rotterdam; Salzburg; Schwerin; Stockholm; Turin; Vienna (Academy, Kunsthistorisches Museum); Warsaw; Wroclaw; York.

DUTCH School

There are many paintings surviving which cannot in the present state of knowledge be given a satisfactory attribution. Quite often curators and collectors in front of a picture of high quality feel the necessity to give it an attribution, even though there may be no sound reason for it. The picture reproduced here is an outstanding example of a masterpiece without a name.

Portrait of an Unknown Man
Canvas 73 × 59.5 cm (28¾ × 23½ in)
Unsigned and undated.
BRUSSELS, Musée Royal des Beaux-Arts
This picture has been attributed to many different painters of importance. Its author still remains unidentified. In the early twentieth century the most popular attribution was to Vermeer, which now seems surprising but was based on the ideas of Thoré-Bürger, the discoverer of Vermeer, who saw him as a painter influenced by Rembrandt. This picture is influenced by Rembrandt's portrait style of about 1650. The painter has taken over Rembrandt's brooding quality, deep penetration of character, and elimination of detail. There is a similar picture in the Szépmüvészeti Museum at Budapest which depicts an Unknown Woman. It, too, was unsatisfactorily attributed to Vermeer and it may be that the two pictures are by the same hand.

The Unknown Man was acquired by the museum in Paris in 1900. In the 1949 catalogue it was attributed to Carel Fabritius, and currently it is attributed to Nicolaes Maes.

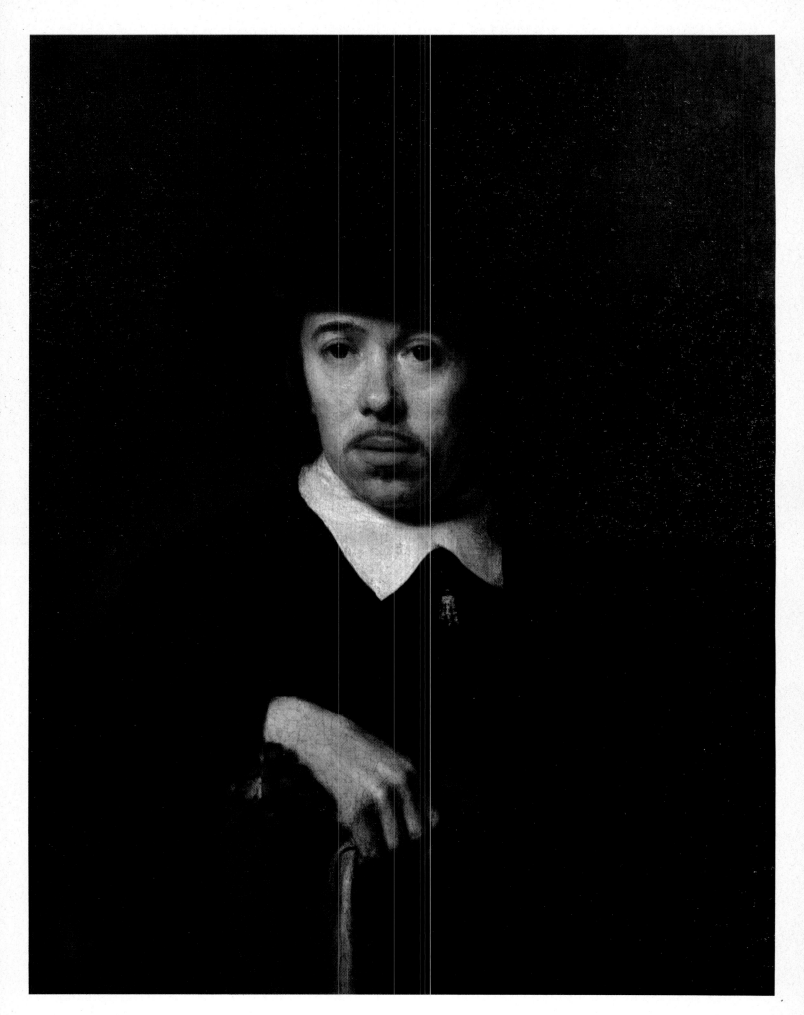

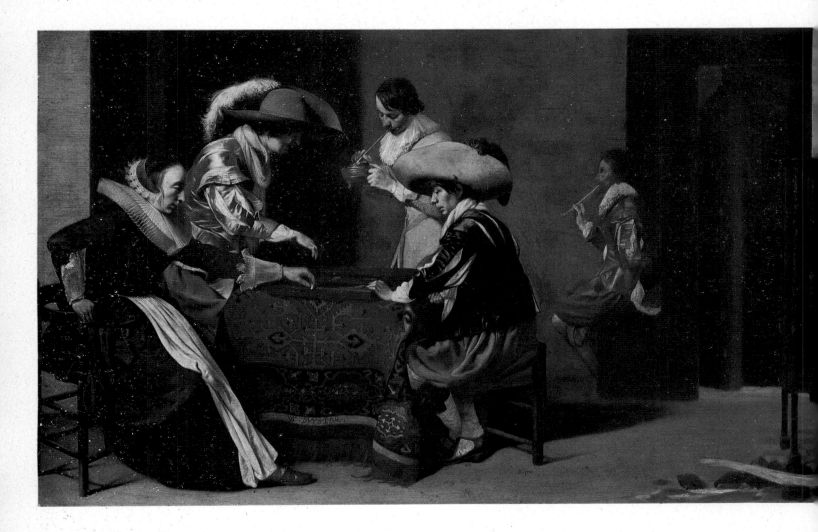

Willem Cornelisz. DUYSTER

Amsterdam 1598—Amsterdam 1635

There is little record of the events of Duyster's life or his artistic training. It has been assumed that he was trained by Pieter CODDE, whose influence is discernable in his work. Duyster concentrated exclusively on small interior scenes with well-dressed people, sometimes including soldiers. No satisfactory explanation has yet been given as to why this type of picture was in vogue in the 1620s and 1630s, especially in Haarlem and Amsterdam, and why it gave way to an increased taste for 'low life' in the middle years of the century.

Amsterdam; Basle; Berlin (Schloss Grunewald); Copenhagen; Douai; Dublin; Haarlem; The Hague; Hamburg; Leipzig; Leningrad*; London (National Gallery, Wellington Museum); Lyons; Paris; Philadelphia (Johnson Collection); Rotterdam; Stockholm; Schwerin; Upton House (Warwickshire); Warsaw.

Gerbrand Jansz. van den EECKHOUT

Amsterdam 1621—Amsterdam 1674

Eeckhout was one of REMBRANDT's many pupils, but the precise period which he spent in the master's studio is unknown. It could well have been in the 1640s as most of Eeckhout's pictures are based on Rembrandt's style of that decade.

In common with so many of Rembrandt's pupils, Eeckhout has never attracted much critical attention as a painter in his own right. His compositions

Interior with a Man and a Woman playing Tric-Trac and Three Other Men
Panel 37.6 × 57 cm (14¾ × 22½ in) Signed on the border of the rug on the table: WC DVYSTER. Probably painted in the late 1620s.
LONDON, National Gallery
It is typical of Duyster to introduce a slight element of exaggeration into his genre scenes. There is something not quite real in the extravagant hats worn or in the pose of the man at the right. The characters are restless and humourless. The soldiers and their ladies may be having a jolly time, but this is not communicated to the spectator. It has to be remembered that games were very much frowned upon by the stricter sections of Dutch society, although this does not seem to have prevented a large number of artists depicting such subjects.
The picture is thought to have been in England in the early eighteenth century. It was bought by the National Gallery in 1893.

The Infant Samuel brought by Hannah to Eli

Canvas 110 × 135 cm (43¾ × 53⅛ in)
Signed lower left corner: G. V. Eekhout.
Probably painted in the 1650s.
OXFORD, Ashmolean Museum

The sombre tones of this picture show the influence of Rembrandt, although the way of painting and observing the faces is individual and not directly derived from Rembrandt himself. There is an especial clarity and crispness in the way the infant Samuel has been treated. The child is fashionably dressed and is being presented to the aged Eli for instruction. But the artist was unable to relate the figures to one another in a convincing manner: Hannah kneels awkwardly, and her gaze is not quite towards either Samuel or Eli as might be expected.

The picture was given to the museum by Sir George Leon, Bt. in 1945.

are sometimes a little uneasy, but he was, in fact, a painter of ability. His work included portraits, guard-room scenes and other interiors, and biblical and historical paintings.

Eeckhout never imitated Rembrandt's later style with its increased impasto but preferred to paint in a relatively detailed manner, often with the addition of rather heavy shadows. Most of his pictures are signed and on the whole his style is, unlike those of so many of Rembrandt's pupils, easy to recognize, relying on sombre tones and carefully modelled figures. His career was uneventful; he seems never to have left Amsterdam, where he also had a successful portrait practice.

Amsterdam; Avignon; Bayeux; Berlin; Bonn; Boston; Bremen; Brunswick; Cardiff; Castres; Copenhagen; Dresden; Dublin; Glasgow (Burrell); Greenville (South Carolina); Grenoble; Haarlem; The Hague (Bredius Museum, Gemeentemuseum); Hamburg; Hartford (Connecticut); Indianapolis; Kassel; Kremsier (Czechoslovakia); Leipzig; Leningrad; London; Milan; Moscow; Munich; Nantes; New York; Oxford; Paris; Potsdam; Prague; Raleigh (North Carolina); Rotterdam; Salzburg; San Francisco; Strasbourg; Stockholm; Stuttgart; Toledo (Ohio); Verviers (Switzerland); Warsaw; Worcester (Massachusetts); Würzburg.

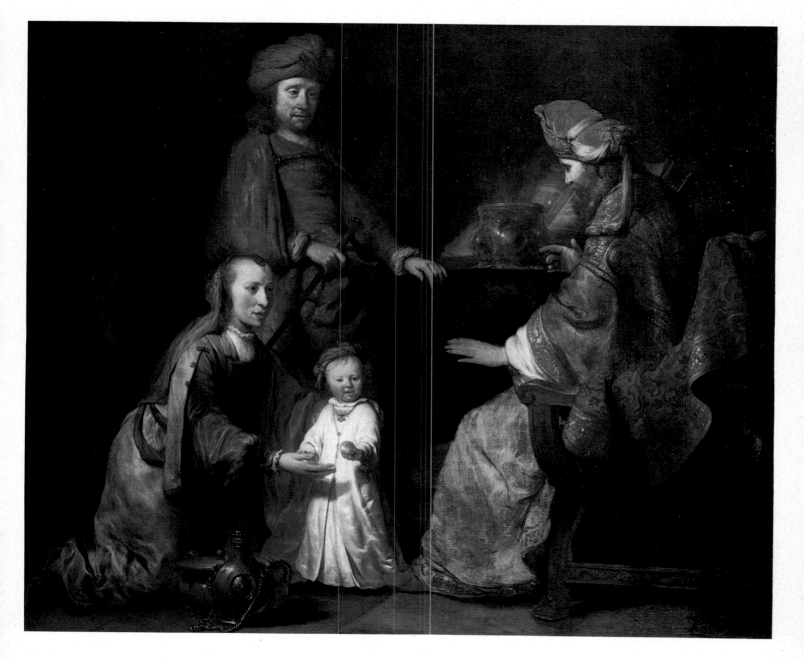

Allart Pietersz. van EVERDINGEN

Alkmaar 1621—Amsterdam 1675

Everdingen's significant contribution to the development of landscape painting is obscured by the fact that his innovations were so successfully taken up in the next generation by Jacob van RUISDAEL. Thus Everdingen is easily overlooked as the pioneer of painting dark mountainous landscapes.

It is not known what inspired him to leave his native Alkmaar and visit Scandinavia. He was recorded back in Haarlem, where he had been a pupil of Pieter de MOLIJN, in 1645. The inspiration of fjords and fantastically shaped rocks never left the artist, and he had a beautifully cool palette which matched the mood of his subject matter. Almost all his surviving pictures are of Scandinavian landscapes with fir-trees and torrents. In contrast to some of those of Jacob van Ruisdael they never have allegorical significance.

After leaving Haarlem in 1655 he spent the rest of his life in Amsterdam. His elder brother, Cesar van EVERDINGEN, was also a successful painter who worked in a very different style.

Alkmaar; Amiens; Arnhem; Amsterdam★; Aschaffenburg; Barnard Castle; Bordeaux; Brunswick; Budapest★; Caen; Cambridge; Cleveland; Cologne; Copenhagen; Chantilly; Dresden; Dunkirk; Düsseldorf; Frankfurt; Gothenburg; Haarlem; The Hague; Hamburg★; Hanover; Kassel; Karlsruhe; Leeuwarden; Leipzig; Leningrad; Lille; London (National Gallery, Victoria and Albert Museum); Lyons; Mainz; Minneapolis; Nancy; New London (Connecticut); Oldenburg; Paris (Louvre, Petit Palais); Philadelphia (Johnson Collection); Prague; Rotterdam; Rouen; Speyer; Stockholm; Strasbourg; Vienna; Warsaw.

Norwegian Landscape
Panel 43.8 × 56 cm (17¼ × 22 in) Signed and dated on the rocks in the centre: A VERDINGEN fe. 1656.
CAMBRIDGE, Fitzwilliam Museum
In this dramatic and sombre landscape the artist has caught perfectly the feeling of the far north. The strange rock-formations were caused by glaciation. They must have fascinated the artist and impressed his clients; a Dutchman who had not travelled would never have seen a hill, so flat is the country. Everdingen's colour schemes with their dominant blues and greens are especially beautiful.

The picture was bequeathed to the museum along with a large collection of Dutch and Flemish pictures by Daniel Mesman in 1834.

Woman with a Brazier (An Allegory of Winter)
Canvas 91.4 × 71 cm (36 × 28 in)
Unsigned. Probably painted in the 1650s although Everdingen's pictures are difficult to date precisely.
SOUTHAMPTON, Art Gallery
This picture is now much better known following its recent exhibition at the National Gallery, London. It is generally thought to have belonged to a now-lost set of four seasons. Such sets of pictures were popular in Utrecht in the 1620s and generally pairs of landscapes showing summer and winter scenes were designed as allegories of the seasons. Everdingen's originality is seen in the exquisite rose colour of the woman's dress and her gentle, almost sultry expression. The picture belonged to the connoisseur and dealer Vitale Bloch, who, apart from writing on Sweerts, Vermeer and Georges de La Tour, did much to rehabilitate this type of art.

The picture was acquired by the museum through the Chipperfield Bequest in 1937.

Cesar Pietersz. (Bovetius) van EVERDINGEN
Alkmaar c. 1617—Alkmaar 1678

In common with so many forgotten or underestimated artists, Cesar van Everdingen (he sometimes signed himself 'Bovetius' as well) occupied an important place in the art of his own time. The century-long refusal of critics and connoisseurs to look at his type of art shows signs of coming to an end.

Everdingen was a superb technician, not only with minute detail, but with his ability to paint portraits, mythological and allegorical pictures in a crisp and polished style. The source of his art is probably the Haarlem manner-ists—he imitated the polish of CORNELIS van Haarlem and his pictures are sometimes quite close in style to those of the Haarlem painter Pieter de GREBBER; together they are the chief painters of mythological and religious subjects in Haarlem in the middle years of the century.

Most of his career was spent in Alkmaar, although in the 1640s he was in Haarlem. He received the important commission to decorate part of the Huis ten Bosch near The Hague. In 1657 he was back in Alkmaar, where he remained, except for a visit to Amsterdam in 1661. His younger brother was Allart van EVERDINGEN.

Alkmaar★; Amsterdam; Barnsley; Brunswick; Cape Town; Haarlem; Leiden; Polesden Lacey (Surrey); Rouen; St Louis; Southampton; Strasbourg.

Barent Pietersz. FABRITIUS
Midden Beemster 1624—Amsterdam 1673

Like so many of the painters who derived their style from REMBRANDT, Barent Fabritius is an elusive painter whose pictures are difficult to attribute if they are not signed. The position is further complicated by the fact that Barent seems to have been influenced by his elder brother Carel FABRITIUS, who died in the explosion at Delft in 1654 at the age of 32. It is not known, however, whether Barent was with Carel in Delft in the early 1650s, and some regard their similarities as having the common source of Rembrandt.

Both brothers were born in the small town of Midden Beemster. Barent was in Amsterdam in the 1640s, although he still resided in his native town. He was in Leiden in 1656 and returned to Midden Beemster in 1665/6. The last few years of his life were spent in Amsterdam.

He painted many different types of pictures—portraits, genre and religious pieces, the subject matter of most of them being familiar from Rembrandt.

Amsterdam; Arras; Bagnères-de-Bigorre; Bayonne; Bergamo; Berlin; Boston; Brunswick; Cambridge; Chicago; Copenhagen; Dallas (Texas); Darmstadt; Frankfurt; Haarlem; Hartford (Connecticut); Hull; Innsbruck; Kassel; Leningrad; London; Munich; Nîmes; Rotterdam; San Francisco; Stockholm; Strasbourg; Turin; Vienna (Academy); York.

The Dismissal of Hagar
Canvas 112 × 145.5 cm (44 × 57¼ in)
Unsigned. Probably painted in the 1650s.
KINGSTON UPON HULL, Ferens Art Gallery
It is possible to see similarities with both Rembrandt and Carel Fabritius in this picture. The light palette and sharp edges are reminiscent of Carel. On the other hand, the facial types and attempted subtlety of emotion derive from Rembrandt. Each individual face is perfectly observed, but the artist has not succeeded in relating the figures to each other in the way Rembrandt would have done. Nevertheless the work is carefully composed and the central figure is particularly well painted. The picture was bought by the museum in 1961.

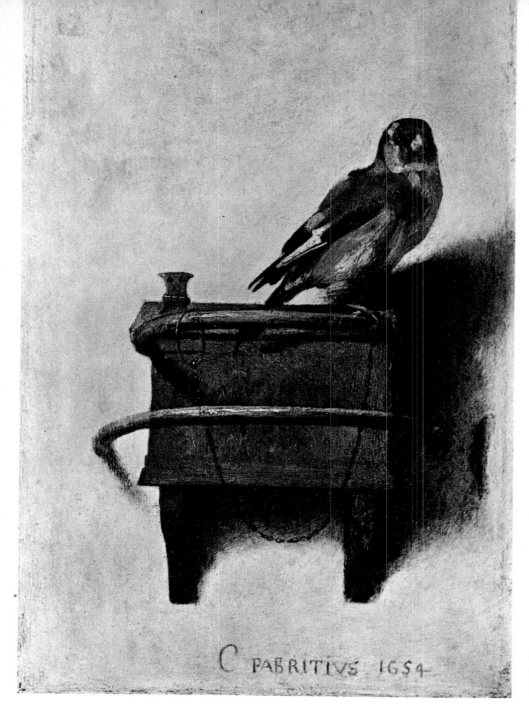

The Gold Finch
Panel 33.5 × 22.8 cm (13¼ × 9 in) Signed
and dated lower centre: C. FABRITIVS
1654.
THE HAGUE, Mauritshuis
*This small and brilliantly observed bird is
considered to be Fabritius's masterpiece. It has
often been compared to Vermeer, although the
handling of the paint and the way of seeing
are totally different. It has been suggested that
the picture formed part of a small shutter which
would have covered a more important painting
and that this was a trompe l'oeil and not an
individual picture at all.*

*In the nineteenth century the picture was in
the Duc d'Arenberg's collection in Brussels,
which also contained the Vermeer Portrait of a
Girl which is now in an American private
collection. The picture was then in the
collection of the critic Thoré-Bürger who was
responsible for the rediscovery of Vermeer. It
was acquired by the Mauritshuis in 1896.*

Carel Pietersz. FABRITIUS
Midden Beemster 1622—Delft 1654

Carel Fabritius was a great painter who died young—in the explosion of the
powder magazine in Delft in 1654—and whose pictures are too rare to
perpetuate his reputation. He became a pupil of REMBRANDT at an early age
and it could be argued that he was the most original painter Rembrandt ever
had in his studio. Fabritius appreciated Rembrandt's analytical approach to
human character and interpreted it in his own quiet way instead of just
imitating the outward bravado of brushwork.

Fabritius has also occupied a peculiar position in the context of the painting
style in Delft in the 1650s. This is caused by the fact that the rediscoverer of
VERMEER, Thoré-Bürger, who owned Fabritius's *Gold Finch*, saw Fabritius
as a link between Rembrandt and Vermeer. This has led most subsequent
writers to see Fabritius as a forerunner of Vermeer and not as a painter in his
own right. Indeed, Fabritius was already dead when Vermeer signed and

Self-Portrait (?)
Canvas 62.5 × 51 cm (24½ × 20 in) Signed
lower right: C. . . Probably painted
c. 1652–4.
MUNICH, Alte Pinakothek
*Only three portraits of young men by
Fabritius survive—the other two are at
Rotterdam and the National Gallery, London.
All three have at some point been considered to
be self-portraits, although it is by no means
certain that they represent the same man.
Certainly the introspective character of this
young man has the air of a self-portrait but
that could be said of the other two as well.
As in all Fabritius's work there is an avoidance
of strong contrasts, and in its quiet intensity
this portrait can rival most of Rembrandt's
pictures of this type.*
 *The picture was originally in the
Fürstbischöflichen Galerie at Würzburg.*

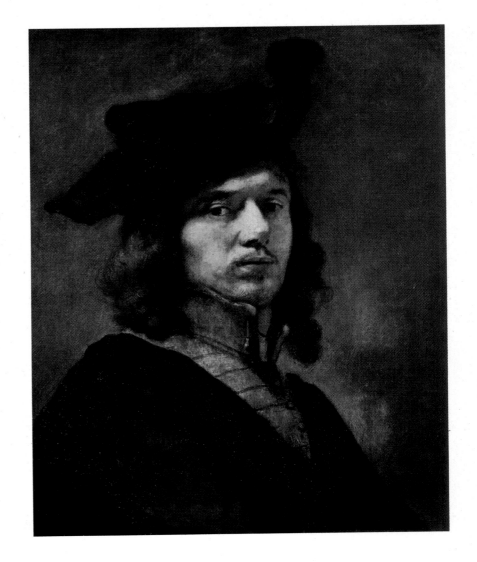

dated his first pictures and they are all more or less derived from Utrecht artists like Hendrick TERBRUGGHEN rather than Fabritius.

Considering how little survives there is a great variety of subject matter and approach in Fabritius's painting. It ranges from the tiny perspective *View of Delft* in the National Gallery, London, to the sleeping sentry or soldier seen against a perfectly painted black wall in the museum at Schwerin. He also painted a small group of heads of old men (in Groningen, Liverpool and The Hague) which almost anticipate Rembrandt's last manner when he also painted so many heads of old men.

Fabritius's palette was richer and softer than that of Vermeer. He preferred very gentle tonal contrasts with no one colour dominating in the way that Vermeer so often used blue or yellow. The details of Fabritius's life are confusing; like his brother Barent he seems to have been in Amsterdam often while continuing to live in Midden Beemster. He was certainly in Delft by 1651 and became a member of the guild there in the following year. His death in the explosion two years later robbed the town of Delft and the whole of Dutch art of one of its greatest painters.

Amsterdam; Groningen★; The Hague★; Liverpool; London; Munich; Paris; Rotterdam; Schwerin; Warsaw.

Aert de GELDER
Dordrecht 1645—Dordrecht 1727

Esther adorned by her Maids
Canvas 139.4 × 163.3 cm (54¾ × 64¼ in)
Signed and dated lower right: Aert de
Gelder 1684.
MUNICH, Alte Pinakothek
*The subject is presumably taken from the book
of Esther, Chapter 2, where it is explained
that the women have to be purified for a year
before being presented to Ahasuerus. This
picture possibly depicts the moment when
Esther is being adorned in preparation for
presentation to the king. If the painting were
not in fact dated it could be placed on
stylistic grounds some 20 years earlier. The
artist's delight in texture is especially obvious
here in the treatment of Esther's dress, which
has a particularly varied combination of rich
materials.*

 *In keeping with the artist's reputation in the
eighteenth century the picture was recorded in
an Amsterdam sale in 1749; it was then in
the gallery at Mannheim. In 1799 it was
transferred to Munich.*

Because Aert de Gelder carried his Rembrandtesque style of painting right
into the eighteenth century he stands out as an exception in his time (which
generally reacted against REMBRANDT's type of pictures). At a first glance Aert
de Gelder's pictures seem like weak interpretations of the religious and
mythological subjects familiar from the last two decades of Rembrandt's
career. On closer inspection they are seen to have enormous vitality and are
painted with a much wider range of colours than Rembrandt himself used.
He often employed lilac and lemon yellow, which give his pictures a shimmer-
ing effect in spite of their generally dark tones.

 Aert de Gelder spent most of his life in his native Dordrecht, where he
worked in the studio of Samuel van HOOGSTRATEN. He was in Rembrandt's
studio in Amsterdam c. 1661 and soon returned to Dordrecht, where he
remained for the rest of his life. In the eighteenth and nineteenth centuries
his pictures were often confused with those of Rembrandt himself.

Aachen; Amiens; Amsterdam; Aschaffenburg; Berlin; Birmingham (Barber Institute);
Boston; Brighton; Budapest; Cambridge; Chicago; Copenhagen; Dordrecht; Dresden;
Dunkirk; Frankfurt; The Hague; Hanover; Leipzig; Leningrad; London (Dulwich);
Malibu (California); Melbourne; Munich; Paris; Potsdam; Prague; Rotterdam; Vienna
(Academy, Kunsthistorisches Museum).

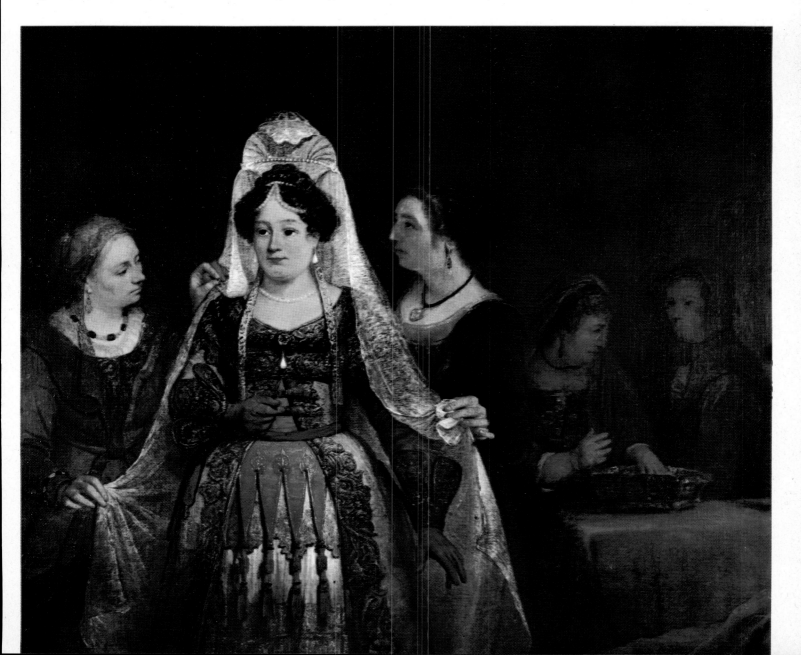

Hendrick GOLTZIUS

Mühlbrecht (near Venlo) 1558—Haarlem 1617

The reputation of Goltzius is based on his eminence as an engraver; he was the most distinguished artist in this medium of the whole sixteenth century, Lucas van Leyden excepted. In his last years his sight began to fail and he started to paint in oil as this was less exacting. His painting style was very much out of date—Goltzius had been, as an engraver, one of the leading teachers in Carel van MANDER's Haarlem academy after his return from Italy in 1591. His lack of inventiveness and backward-looking style could be ascribed to the fact that he could not forget the compositions of those painters, especially CORNELIS van Haarlem, whose work he had so often engraved. It is difficult to imagine that he painted his *Venus and Adonis* only two years before Frans HALS was to paint his first great group portrait, the *Militia Company of St George* (page 104).

Amsterdam; Basle; Douai; Haarlem; Leningrad; Munich; Nantes; Paris; Providence (Rhode Island); Sibiu; Strasbourg; Turin; Utrecht.

Venus and Adonis
Canvas 114 × 191 cm (45 × 75¼ in) Signed in monogram and dated on the ledge of rock at the right: HG 1614.
MUNICH, Alte Pinakothek
This is a perfect example of the all-pervading official style of painting practised in Haarlem right into the third and even fourth decade of the seventeenth century. There is nothing to suggest that it was not painted c. 1580, so stereotyped had the images become. There are some elements, especially the way in which the landscape background is handled, which suggest that Goltzius had been looking at the Flemish painter Jan (Velvet) Brueghel (1568–1625). Bearing in mind the problem of his eyesight it is possible to excuse Goltzius's peculiarly heavy way of painting warm-toned flesh. His skill as the greatest engraver of his time in Northern Europe is apparent in the confident way that he composed his pictures.

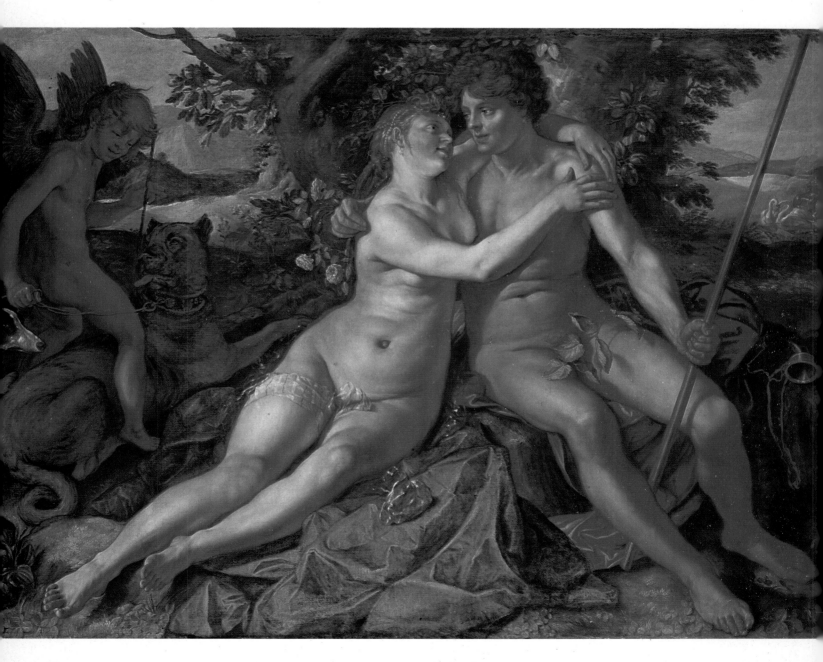

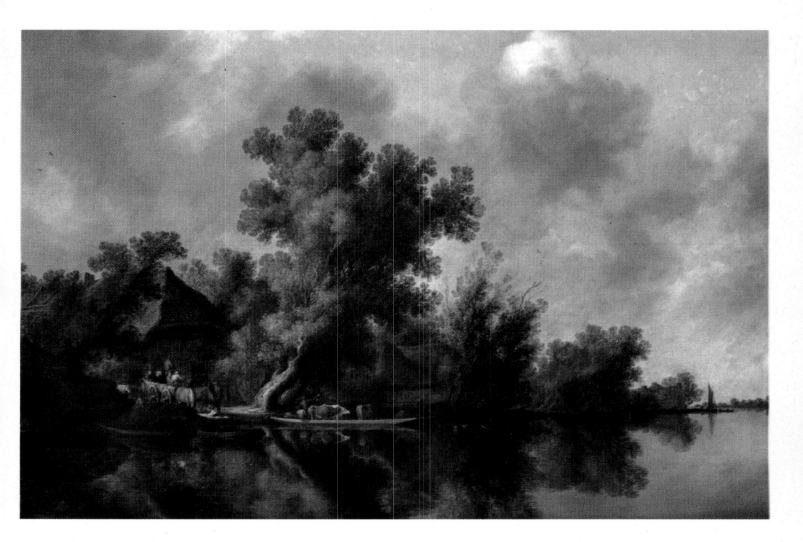

River Landscape
Panel 39.5 × 60 cm (15½ × 23½ in) Signed
and dated on the boat: VGOYEN 1636.
MUNICH, Alte Pinakothek
*This picture is very close in style to those of
Salomon van Ruysdael. Only in the handling
of the leaves on the trees is the difference
discernible—and then only to a specialist.
The two artists also used very similar colour
schemes in the 1620s and 1630s, although there
is usually a little less brown in Salomon's
pictures. Van Goyen has concentrated on the
picturesque elements in the hamlet by the side
of the river. The church spire in the distance
has not been identified. The date of this picture
indicates that it was painted right at the end of
this particular phase in his career.*

*The picture was formerly in the
Fürstbischöflichen Galerie, Würzburg, before
being transferred to Munich.*

Jan Josephsz. van GOYEN
Leiden 1596—The Hague 1656

Van Goyen's exquisite and fragile style of painting seascapes, river scenes and
landscapes led him to be neglected for 200 years after his death, when a more
finished type of picture was preferred. Now the situation is reversed: his open
skies and lightly suggested trees and buildings are much prized by connoisseurs.

Van Goyen was born in Leiden and spent his early life there, being
apprenticed, as was the young Rembrandt a few years later, to Isaac Nicolai
van Swanenburgh. About 1616 he spent a crucial year in nearby Haarlem as
a pupil of Esaias van de Velde, and this painter's influence was to remain for
the rest of van Goyen's life. He then spent the 1620s back in Leiden and in the
early 1630s moved to The Hague. He must, however, have revisited Haarlem,
as in 1634 he was recorded in the house of Isaac van Ruisdael, who was the
brother of Salomon van RUYSDAEL. He spent the rest of his life in The Hague
and in 1651 received the important commission to paint a panoramic view of
the town which was to be placed in the Burgomaster's room in the Town Hall.

Van Goyen's development as an artist is relatively easy to follow, as a
sufficiently large number of his pictures are signed and dated. His very earliest
pictures are highly coloured and very close in style to those of Esaias van de
Velde. He soon abandoned this manner and in the 1620s started to paint a
large number of river scenes in cool colours, exactly like his Haarlem
contemporaries Salomon van Ruysdael and Pieter de MOLIJN. In the late

1630s and 1640s his style changed again and approached a complete mono-chrome. The colour of the wooden panel or the prepared ground dominates the picture and each element is lightly sketched in, allowing the ground to show through.

Though spending most of his mature career living permanently in The Hague, painting in a manner typical of Haarlem, he seems to have been an in-satiable traveller. A large number of his landscapes have identifiable topograph-ical elements in them, and most Dutch towns and even villages appear in one or more of his pictures. They are rarely topographically accurate in the strict sense of the word, but the individual buildings are usually easy to recognize. The town which he painted most frequently was Dordrecht, where the cathedral can be seen at a distance from over the water.

Van Goyen was enormously prolific. Clearly his small, quickly executed pictures did not take long to paint, as minute detail was suggested rather than painstakingly filled in. Nevertheless his rapid brushwork was never facile. All

Landscape with Two Oaks
Canvas 88.5 × 110.5 (34¾ × 43½ in)
Signed in monogram and dated lower centre: IVG 1641.
AMSTERDAM, Rijksmuseum
Only five years separate this and the previous picture and it is easy to see what a change had come over the artist. He had become much broader in his conception of landscapes. Most of his early pictures avoid a vast panorama. Here the composition is reminiscent of Rembrandt's etching of the Three Trees which is dated two years later. In both, the mass of the trees serves to emphasize the enormous distance. This is one of van Goyen's best pictures—he has suggested the damp air and the fall of cool yellow light by the simplest of means. The painting was bequeathed to the Rijksmuseum in 1870 by L. Dupper Wzn., of Dordrecht.

Imaginary Landscape with some Buildings from Leiden

Panel 39.8 × 59.5 cm (15¾ × 23¼ in) Signed in monogram and dated lower right: VG 1643.

MUNICH, Alte Pinakothek

By no stretch of the imagination can this picture be said to represent the actual site of Leiden. Instead the artist has taken the large main church there, St Pancras, whose silhouette resembles that of St Bavo at Haarlem, and used it as the central motif in this picturesque and delicately painted landscape. The outlines of the spires against the sky are particularly subtle and the touches of paint are laid on in a much lighter way than in the previous two pictures. This is a good example of his monochrome style of the 1640s.

Like the River Landscape the picture was formerly in the Fürstbischöflichen Galerie at Würzburg.

his authentic pictures have a marvellous feeling for nature. They are rarely anecdotal. His human figures are usually adjuncts to the composition to give atmosphere. Van Goyen had a large number of now largely anonymous imitators and followers. All over the western world, where there are collections of Dutch pictures, there are slight and inferior landscapes painted in imitation of van Goyen.

Aachen; Amiens; Amsterdam★; Antwerp (Museé des Beaux-Arts, Museum Ridde Smidt van Gelder); Aschaffenburg; Baltimore (Museum of Art, Walters Art Gallery); Bamberg; Basle; Berlin★; Berne; Birmingham (Barber Institute, City Art Gallery); Besançon; Bonn; Bordeaux; Boston; Brunswick; Bruges; Brno; Brussels; Budapest; Bucharest; Caen; Cambridge; Cambridge (Massachusetts); Cape Town; Carcassonne; Châteauroux; Cincinnatti; Cleveland; Cologne; Copenhagen; Cracow; Dordrecht; Dresden; Dublin; Düsseldorf; Edinburgh; Eindhoven; Enschede★; Epinal; Frankfurt★; Geneva; Glasgow; Gothenburg; Göttingen; Gotha; The Hague (Bredius Museum, Gemeentemuseum, Mauritshuis); Haarlem; Hamburg; Hanover; Hartford (Connecticut); Heidelberg; Hoorn; Innsbruck; Ipswich; Jerusalem; Karlsruhe; Konigsberg; Leiden; Leipzig★; Leningrad★; Lille; Linköping; Linz; Liverpool; London (Greenwich, National Gallery, Victoria and Albèrt Museum); Los Angeles; Lyons; Maastricht; Madrid; Mainz; Manchester; Manchester (New Hampshire); Mannheim; Milan; Montpellier; Mora (Sweden); Moscow; Munich; Nancy; New York; Nijmegen; Northampton (Massachusetts); Norwich; Oberlin (Ohio); Oslo; Ottawa; Otterlo; Oxford; Paris (Musée Jacquemart-André, Louvre, Petit Palais); Perm (Russia); Petworth (Sussex); Polesden Lacey (Surrey); Portsmouth; Poznan; Prague; Pretoria; Princeton; Rotterdam (Willem van der Vorm Foundation, Boymans-van Beuningen Museum); Rouen; St Gallen; San Francisco; Schwerin; Sheffield; Springfield; Stockholm (Nationalmuseum, Hallwylsk Museet); Strasbourg; Stuttgart; Toledo (Ohio); Toronto; Tours; Upton House (Warwickshire); Utrecht; Vienna (Academy, Kunsthistorisches Museum); Warsaw; Worcester (Massachusetts); Worms; Wroclaw; Wuppertal; Würzburg; York; Zurich.

Pieter Fransz. de GREBBER

Haarlem c. 1600—Haarlem c. 1652/3

Because de Grebber was so eclectic an artist his pictures have almost always been confused with the painters whom he so successfully imitated. He painted in the manner used by Salomon de Bray (1597–1664), Cesar van EVERDINGEN and Salomon Koninck (1609–1656). In spite of this, many of his pictures are of a high standard. He preferred a delicate tonality for his religious and mythological pictures, often using quiet browns, greys and a certain rose colour. His career in Haarlem was uneventful; he became a member of the painters' guild in 1632. He was commissioned along with Cesar van Everdingen and Gerrit van HONTHORST to assist in the decoration of the Huis ten Bosch at The Hague. Later in life he did not change his style and was obviously able to find a market for his rather bland pictures. This situation is very similar to the latter part of Jan van BIJLERT's career.

Amsterdam; Bonn; Bordeaux; Budapest; Caen; Ghent; Haarlem (Frans Hals Museum, Bisschoppelijk Museum); Hanover; Kassel; Leiden; Leipzig; Leningrad; London (Courtauld Institute); Malibu; Manchester; Paris; Riom; Schwerin; Stockholm; Stuttgart; Tourcoing; Turin.

Lamentation over the Dead Christ
Canvas 164 × 174 cm (64½ × 68½ in)
Signed and dated on the rock at left:
P. DG A 1640.
AMSTERDAM, Rijksmuseum
Even though Haarlem was a predominantly Protestant town, there still seems to have been a demand for this type of picture. The painter has, however, kept to the essentials of the story and has not embellished it with elaborate symbols, as was often done in Italy. In style the picture owes something to the Utrecht Caravaggists, especially Baburen, and this is combined with reminiscences of Haarlem painters of the previous generation like Cornelis.

The picture has been on loan to the Rijksmuseum since 1889.

The Fête in the Park
Panel 78 × 137 cm (30¾ × 54 in) Signed
and dated on the balustrade at the left:
D Hals 1627.
AMSTERDAM, Rijksmuseum
*The brilliant colour of this elaborate picture is
unusual for Dirck Hals, who preferred almost
monochrome tones. The enormous range of
colour, which fits the subject, could well have
been derived from the Haarlem mannerists,
most of whose pictures were highly coloured
whatever the subject. There is great variety of
incident in the picture, including such exotic
elements as the monkey in the background.
Frans Hals himself executed a Fête picture on
similar lines to this, but unfortunately it was
destroyed in Berlin at the end of the last war.*

*This picture was bought by the museum
from a collection in Delft in 1899.*

Dirck HALS
Haarlem 1591—Haarlem 1656

The art of Dirck Hals has always been overshadowed by that of his great elder
brother, Frans. Nevertheless in his own way he was an innovator in
Haarlem, where he spent much of his career, of a type of genre painting which
was to become very popular, especially in the 1620s and 1630s. His interior
scenes painted in pale colours are often similar to his short-lived Rotterdam
contemporary Willem Buytewech (1591/2–1624). Both painters specialized in
interior scenes which almost always have some form of jollification. Because
he lacked his brother's insight into human character Dirck Hals's pictures are
almost always genuinely cheerful and never analyze the real character of the
human being concealed by the laughter. His masterpiece is, however, of a
melancholy subject quite untypical of him. It depicts a woman alone in a bare
room in the act of tearing up a letter, and is in the picture gallery at
Mainz.

Dirck Hals himself is the best known of the Hals family after his brother
Frans. One of his nephews—the son of Frans—was Harmen Hals (Haarlem
1611–1669), who specialized in peasant interiors. These were painted in a style
similar to that of his father, whose pupil he was, but few of his pictures
survive today.

Amiens; Amsterdam; Brunswick; Copenhagen; Dortmund; Frankfurt; Haarlem;
Hamburg; Hanover; Leipzig; Leningrad; Lille; London; Louisville (Kentucky); Mainz★;
Nottingham; Oldenburg; Oxford; Paris; Perpignan; Philadelphia (Johnson Collection);
Quimper; Rotterdam; Stockholm; Stuttgart; Vienna (Academy, Kunsthistorisches
Museum); Williamstown (Massachusetts); Wroclaw.

Frans HALS
Antwerp (?) c. 1580 (?)—Haarlem 1666

Frans Hals has become a household name over the last 100 years as the creator of the *Laughing Cavalier*. For many reasons this type of fame is unfortunate. The prestige of the picture is perhaps today in decline, and nothing else in Hals's work has taken its place in the popular imagination. Thus Hals is now seen as lagging behind somewhat in the trio of great artists of the period; REMBRANDT and VERMEER are now pre-eminent.

Any historical analysis of Hals's position in the Dutch seventeenth century places him in a position of great importance in his time as the creator of the most spendid, in size and colour, of the group portraits of the first half of the century. As a portraitist of individual sitters he had many clients and was easily as successful as Rembrandt in this field. Therefore, although the latter part of his career, like that of Rembrandt, was clouded with poverty, Hals must not be seen as a misunderstood and misanthropic genius.

The known facts about his life are tantalizingly few. It is not even known where he was born, but it is certain that his family came from Malines, which is between Brussels and Antwerp; he may in fact have been born in Antwerp. But the first known fact is that he was in Haarlem by 1591, as in that year his younger brother Dirck, who was also destined to become a painter, was baptized there. The whole of the rest of Hals's long life was spent in Haarlem. Thus his active painting career, which seems to start in about 1610, spans the next 55 years of the seventeenth century.

Hals was apprenticed to Carel van Mander (1548–1606), an obvious choice as he was the leading teacher in Haarlem at the time. It is not possible, however, to detect anything but the most generalized influence from van Mander in Hals's work as he developed his own style of painting very rapidly. Indeed, unlike Rembrandt, who went forward in great spurts of invention,

Banquet of the Officers of the St George Militia Company, Haarlem, 1616
Canvas 175 × 324 cm (69 × 127½ in)
Unsigned. Dated on the arm of the chair at the left: 1616.
HAARLEM, Frans Hals Museum
This is the first of the great series of group portraits of militia companies of which five still survive at Haarlem, the sixth being in the Rijksmuseum, Amsterdam. Although the whole picture appears fresh, direct and unacademic the composition is derived, with only slight modifications, from the Militia Group Portrait of 1599 by Cornelis van Haarlem. (Unfortunately this picture has long been in the reserves of the Frans Hals Museum). Cornelis's influence, however, ends with the composition. Hals gave the tradition of group-portrait painting an immense boost when he painted the figures quite naturally, in conversation, eating, drinking or enjoying a chat. With one gesture he swept away the artificiality of all the previous portraits of this type. It is interesting to note that the still life on the table, even at this early date, appears reminiscent of the Haarlem still-life painter Pieter Claesz. although he was not yet active.

The picture was transferred from the headquarters of the St George Milita Company, Haarlem, to the Frans Hals Museum in 1862.

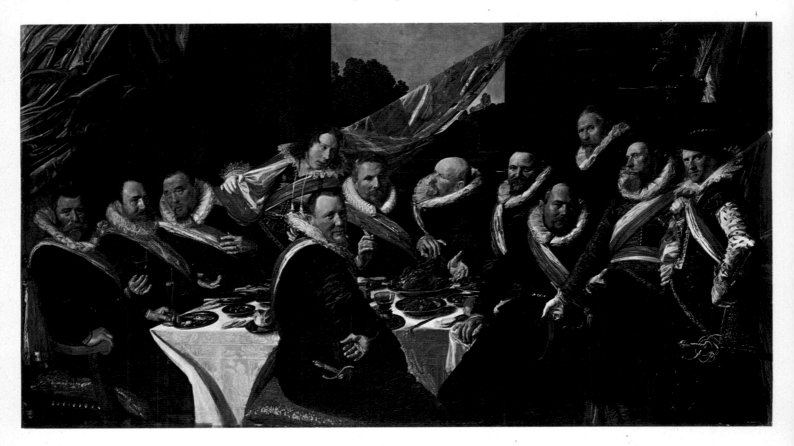

The Laughing Cavalier
Canvas 86 × 69 cm (33¾ × 27 in)
Unsigned. Dated upper right: AETA.
SVAE 26 A° 1624.
LONDON, Wallace Collection
It is quite clear that this handsome young man is not laughing; the association grew up in the nineteenth century from the idea that his eyes were laughing. Even though the picture has been over-exposed for generations it remains as one of the best single portraits from Hals's early maturity. The sitter is unknown; he has the same lively expression and brilliantly painted clothes already familiar from the militia company portrait of 1616.

The first record of this famous work was on the art market in The Hague in 1776 and it was frequently sold on the Dutch market until 1822, when it became part of the Pourtalès collection, Paris. It was acquired by Lord Hertford in 1865 at the Pourtalès sale for the enormous sum of 51,000 francs. It was bequeathed to the nation along with the rest of the collection by Lady Wallace in 1897.

Hals's development was relatively slow once he had evolved his style. He moved from painting bright, rather brittle portraits through a more sober period in middle life and ended up making a final distillation, when he was over 80, of all that he had learned from a lifetime of searching out the character behind people's faces.

Only some 200 or so individual portraits survive from his hand and a variety of controversies rage about some of them. The question has often been asked: how it is that a painter of such obvious facility should have left behind him such a relatively small corpus of work after such a long career? In fact it is often forgotten that in five of the militia-group portraits at Haarlem there are over 80 individual portraits, each one a brilliant piece of observation. The earliest of these group portraits is dated 1616 and the changes which take place in the intervening years are relatively subtle. Indeed as the five pictures hang in the same room now they show a unity of style and colour which might indicate that Hals reserved a special manner for these pictures which so obviously pleased his patrons.

Hals differed from his contemporaries in several ways. Firstly he seems to have been exclusively a portrait painter. There are odd exceptions in his work, notably the two *Evangelists* discovered in recent years in the State Museum of Odessa. Also, a certain number of his pictures come into the genre category although they are most often single figures like *Malle Babbe* in Berlin or the *Gypsy Girl* in the Louvre. Secondly Hals is quite apart from his contemporaries in his way of seeing: it was based on a reliance on his own vision and not on a respect for tradition. Most Dutch seventeenth-century portraiture naturally corresponds to the norm of a life-like but formal face, black dress, white ruff and plain background. Many thousands of surviving pictures fit into this category. Indeed superficially Hal's work resembles it, but there are important differences.

His powers of observation were such that, although favouring smiles and laughter, he often saw through that veneer of humour and recorded the uncertainties of temperament of so many of his sitters. His technique of painting was also unique, although this is not immediately obvious. He seems to have painted directly onto the canvas without preparation and does not appear to have built up the paint in layers as did Rembrandt. He laid on, especially in the faces and hands, areas of opaque paint which on close inspection appear almost like a mosaic. From a short distance the observation of form and tone values is so perfectly observed that the whole picture appears to jump to life in a manner which makes so many contemporary portraits, however well painted, appear stiff, formal and almost doll-like.

It is true that many people find Hals's sitters uninteresting. Often we do not know their names or the identifications remain dubious. The pot-bellies and plump cheeks of dozens of over-fed militiamen are not easily seen as the material for a poetic, or indeed dignified, approach to painting. In direct contrast to Hals, Rembrandt painted poverty, and to modern taste that is excusable. Hals too often recorded the self-satisfied, and although Rembrandt himself did paint a large number of formal portraits they do not dominate his work as they do Hals's.

However, as Hals grew older he grew ever more perceptive of people. Quite often he painted small portraits which have a curiously intimate quality. For example the well-dressed lady in the small picture at Christ Church, Oxford, is painted with enormous bravura but the laughter has gone and has been replaced by a feeling of unease. The middle-aged lady is unhappy about something, but we are not permitted to know what it is.

The most significant act of Hals's career took place right at the end of his life. This was the painting c. 1664/5, when he was well over 80, of the two group portraits of the Regents and Regentesses of the Old Men's Almshouse at Haarlem. It has now been proved that Hals was not, in fact, an inmate of the poorhouse, but that owing to his dire poverty he was given a small allowance by the town of Haarlem.

These two great pictures did not please Eugène Fromentin, the French critic, but his comments on them are worth quoting as examples of critical but perceptive writing: 'The Regent on the right with his red stockings, which we can see above his garter, is a priceless morsel to a painter, but you will no longer find any consistent drawing or construction. The heads are fore-shortened; the hands do not exist if we look for their form and articulations. Touch, if indeed there be any, is flung carelessly, almost at random, and no longer means anything. This absence of all rendering, these failings of the brush, he makes up for by tone which gives a semblance of being to that which is no more. Everything fails him—clearness of vision, certainty of hand.' In the twentieth century it is precisely these 'failings' which have caused

The Gypsy Girl
Panel 57 × 52 cm (22½ × 20 in) Unsigned. Probably painted c. 1630.
PARIS, Musée du Louvre
This is one of the most famous examples of Hals's genre style. On this small scale it is easy to see his direct way of laying on the paint with the suggestion of detail by the merest flick of the brush, as is the case with the hair in this picture. In the context of Dutch seventeenth-century painting as a whole, pictures of this type are comparatively rare. Most genre subjects contain more than one figure. The picture, although probably painted from life, cannot be considered to be a portrait in the strict sense of the word as it would not have been intended for the sitter.

The picture was recorded as having been sold in Paris in 1782 and it was bequeathed to the Louvre as part of the enormous collection of Dr Lacaze in 1869.

Overleaf:
Portrait of Willem van Heythuyzen
Panel 46.5 × 37.5 (18¼ × 14¾) Signed in monogram lower right: FH. Probably painted in the late 1630s.
BRUSSELS, Musée Royal des Beaux-Arts
This small picture is one of Hals's most analytical portraits. Its contrast with the portrait of the same sitter dated c. 1625 which is now in the Alte Pinakothek, Munich, could not be greater. The fact that the sitter has been depicted leaning back on his chair creates a tremendous feeling of instability which is in keeping with his quizzical expression and the uneasy way in which he is bending his sword. The painting is almost monochrome in colour and the rapid brushstrokes seem to shimmer all the more as the grain of the panel shows through. Willem van Heythuyzen was a wealthy Haarlem merchant who endowed a home for old people (the Hofje van Heythuyzen), whose property the picture remained.

The picture was acquired by the museum from the Hofje in 1870.

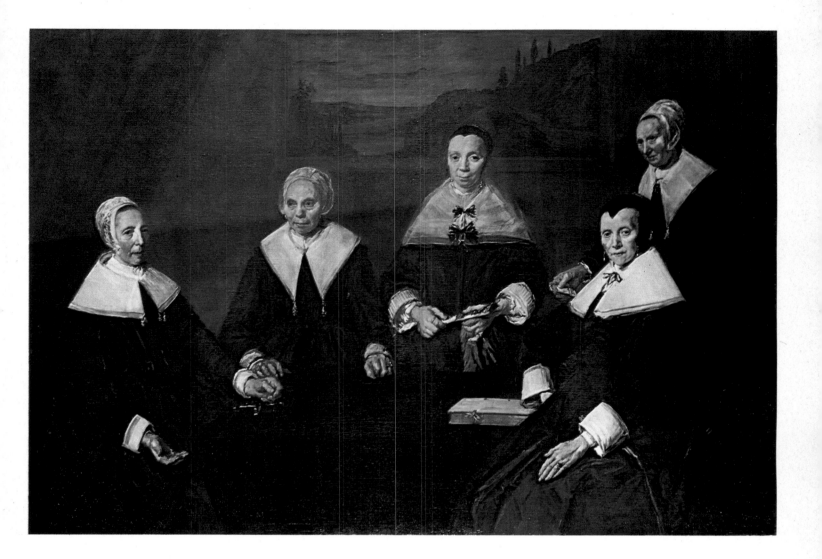

Hals's late style to be so much admired.

The effect of these two group portraits is overwhelming. They are painted with a light touch and very free brushwork which make it appear as if the lace collars are in movement. Yet the figures themselves are static. It is as if they have been frozen, not in a hieratic way, but caught as the camera catches a precise instant. In his analysis of character Hals was not as merciless as has sometimes been suggested. Reproductions of isolated heads from these two pictures tend to emphasize the caricature-like feeling of each one, as if he hated all those stuffy old governors. But in front of the pictures this is emphatically not the case. He observed unerringly the faces of those responsible for public charity in a manner which may embarrass the spectator if he is unused to truth in portraiture.

Amiens; Amsterdam★; Antwerp; Baltimore (Museum of Art); Berlin★; Birmingham (Barber Institute); Boston; Brooklyn; Brussels★; Budapest; Cambridge; Cambridge (Massachusetts); Champaigne/Urbana; Chicago; Cincinnati (Museum; Taft Museum★); Cleveland; Cologne; Copenhagen; Detroit; Dijon; Dresden; Dublin; Düsseldorf; Edinburgh; Eindhoven; Fort Worth (Texas); Frankfurt; Ghent; Haarlem (Bisschoppelijk Museum, Frans Hals Museum★); The Hague; Hartford (Connecticut); Houston; Hull; Kansas City; Kassel; Leipzig; Leningrad; London (Kenwood, National Gallery, Wallace Collection★); Merion (Pennsylvania); Munich; New Haven (Connecticut); New York (Frick Collection, Metropolitan Museum); Odessa (U.S.S.R.); Ottawa; Oxford (Christ Church); Paris (Museé Jacquemart-André, Louvre★); Pittsburgh; Prague; Rochester (New York); Rotterdam; San Diego (Fine Art Society, Timken Gallery); São Paolo; Sarasota; Schwerin; St Louis; Stettin; Stockholm; Stuttgart; Toronto; Washington (Corcoran, National Gallery★).

The Regentesses of the Old Men's Almshouse, Haarlem

Canvas 170.5 × 249 cm (67⅛ × 98⅜ in) Unsigned. Probably painted c. 1664/5. HAARLEM, Frans Hals Museum

It has often been suggested that Hals attacked his sitters in this picture, reducing them to a pathetic row of old women whom he obviously hated. This is, of course, over-interpretation. No august body of this type would ever have permitted such an insult. The picture appears to moralize simply because of Hals's powers of observation; this is what makes it a masterpiece. Hals looked at the character of each sitter and recorded—not each line as Gerard Dou would have done—but an impression of their faces. In reproduction the picture may appear awkward, but in old age bones become brittle and the joints stiff; Hals is merely recording the exact way in which people of advanced years sit.

The picture was in the Old Men's Almshouse until 1862 when it was transferred to the Frans Hals Museum.

Willem Claesz. HEDA
Haarlem 1594—Haarlem 1680

Still Life (The Dessert)
Panel 44 × 56 cm (17¼ × 22 in) Signed and
dated 1637.
PARIS, Musée du Louvre
*In a picture of this type there is a curious
balance between the casual—the feeling that the
table has just been left after a good meal—and
the necessity of making a well-balanced
composition. Thus there is a calculated disorder
which has given the artist the excuse to lavish
his skill on the depiction of the enormous
variety of texture. But in comparison with
Pieter Claesz., who interlocked each element so
beautifully, each object appears slightly
awkward in relation to the others. The picture
had arrived in the Louvre by 1815.*

Heda's numerous still-life pictures are very close in style to those of Pieter
CLAESZ., whose contemporary he was in Haarlem. Heda is mentioned in the
records of the Haarlem guild of painters from 1631 onwards but apart from
this fact very little is known about his life. The main difference between the
two painters is that Heda preferred a slightly more complicated composition.
It has been pointed out that in the 1640s Heda moved towards the richer
style of Willem KALF, whose elaborate manner was becoming fashionable.
Heda had one important pupil—his son Gerrit Heda—and a large number of
obscure painters imitated his style in the middle years of the seventeenth
century.

Heda's pictures are now much sought-after as examples of a pure style of
still-life painting which epitomizes an honest and down-to-earth way of life.

Amsterdam; Antwerp (Musée Mayer van den Bergh); Bonn; Boston; Brunswick; Budapest;
Cadiz; Cologne; Dresden; Dublin; Frankfurt; Ghent; Haarlem; Hamburg; Hanover;
Karlsruhe; Leipzig; Leningrad; Madrid (Prado, Academia di San Fernando); Moscow;
Oxford; Paris; Philadelphia (Johnson Collection); Rotterdam; Saint-Etienne; Schwerin;
Warsaw; Worcester (Massachusetts); Vienna (Academy, Kunsthistorisches Museum).

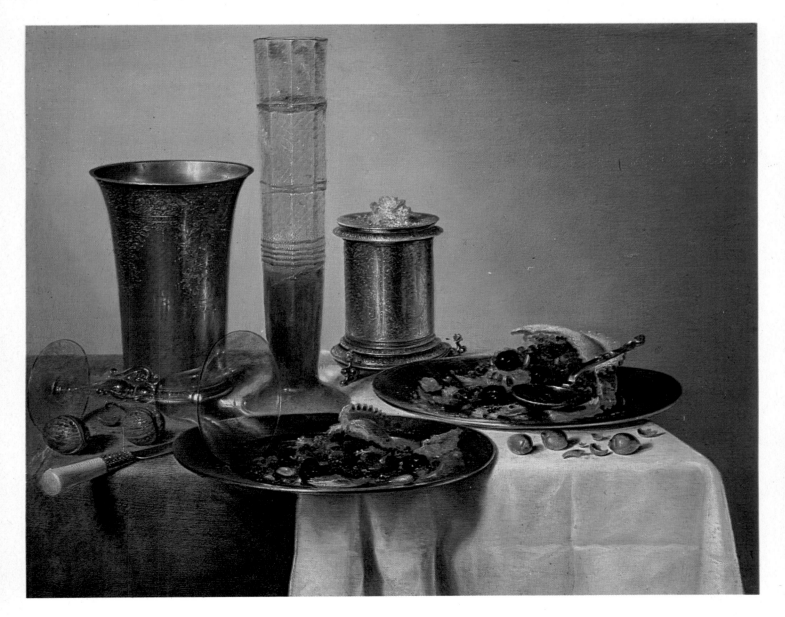

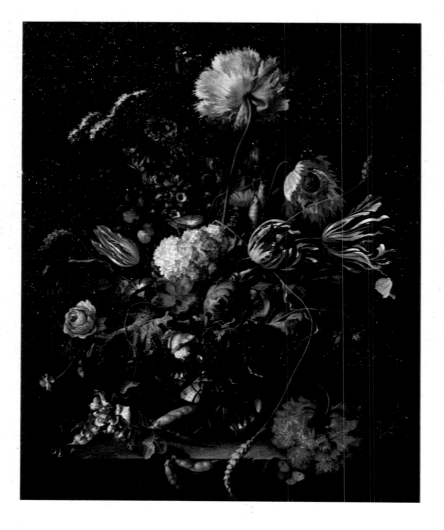

Still Life: A Vase of Flowers
Canvas 69.6 × 56.5 cm (27⅞ × 22¼ in)
Signed on the parapet lower left: J.D.
Heem f. Probably painted during the
artist's Antwerp period.
WASHINGTON, National Gallery of Art
(Mellon Collection)
*This picture is a dazzling example of de
Heem's mastery of flower painting. The
moment is high summer, with tulips and
carnations extravagantly placed in the vase.
This composition appears very different from
the careful balance of Ambrosius Bosschaert.
The painter has exaggerated the real forms of
the flowers to produce a restless and picturesque
composition.*

*The picture was acquired by the museum
through the Andrew W. Mellon Fund in 1961.*

Jan Davidsz. de HEEM
Utrecht 1606—Antwerp 1683/4

Jan Davidsz. de Heem's career is unusual among those of the thousands of
painters recorded as active in the seventeenth century in the United Provinces:
he left his native Utrecht for Antwerp before he was 30 and spent the rest
of his life there. However, his style of painting, which had evolved before he
left the North, changed little while he was in Flanders; he brought a Dutch
influence to Antwerp, where he was to have considerable importance. Thus
within a generation the wheel had come full circle. Ambrosius BOSSCHAERT
had begun in Antwerp under the influence of Jan (Velvet) Brueghel
(1568–1625) and had then brought his style to Utrecht where he finally settled.
De Heem took the influence back to Antwerp and then, late in life, spent the
years 1669–72 back in the North while Antwerp was under French occupation.

All de Heem's still-life pictures, in which he specialized, combine precision
and opulence. Even the work of Abraham van BEYEREN appears slightly
coarse in comparison.

Amsterdam; Arnhem; Aschaffenburg; Birmingham (Barber Institute); Bordeaux;
Budapest; Brunswick; Brussels; Cambridge; Chaâlis; Cheltenham; Cologne; Copenhagen;
Dresden; Dublin; Edinburgh; Frankfurt; Ghent; Glasgow (Art Gallery, Burrell Collection);
The Hague (Bredius Museum); Hamburg; Kassel; Leipzig; Leningrad; Lille; London
(Wallace Collection); Lyons; Madrid; Manchester; Melbourne; Munich; New York;
Oberlin (Ohio); Ottawa; Oxford; Paris; Philadelphia (Johnson Collection); Richmond
(Virginia); Rotterdam; Salzburg; Schwerin; Sibiu; Southampton; Speyer; Stockholm;
Strasbourg; Toledo (Ohio); Turin; Utrecht; Vienna (Academy, Kunsthistorisches
Museum); Warsaw; Washington.

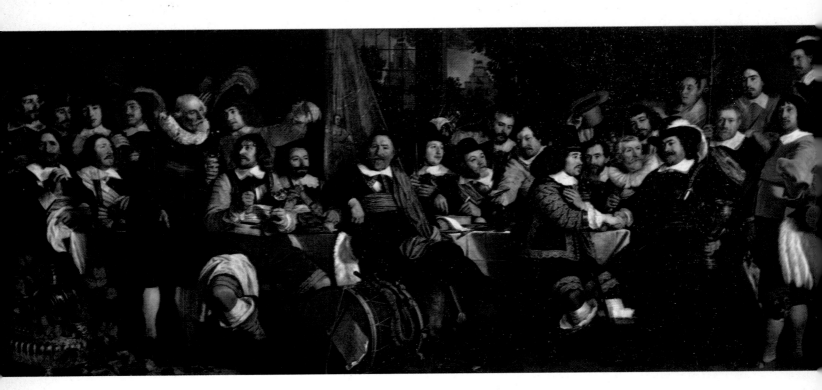

Bartholomeus van der HELST

Haarlem 1613 (?)—Amsterdam 1670

At an early age van der Helst left his native Haarlem and moved to Amsterdam, where he pursued one of the most brilliantly successful careers of his generation. His style of painting was a carefully balanced mixture of a stiff, formal approach—he took his sitters very seriously—and a dazzling brushwork which gives a real-life appearance to every texture. His sitters did not have to put up with the idiosyncracies of the genius of Rembrandt or Hals; they could go instead to the predictable and competent van der Helst. A reappraisal of his art is due; his pictures have been little collected in the English-speaking world and most of his best pictures remain in the Netherlands. He never left Amsterdam and it seems that he had some effect on the portrait painting style of both Ferdinand BOL and Govaert FLINCK who toned down their Rembrandtesque manner in favour of Helst's more fashionable approach.

A typical and beautiful example of his more informal style of painting is the double portrait in the Boymans-van Beuningen Museum, Rotterdam. The artist succeeded in combining in this picture an informal approach to the sitter with a brilliant depiction of the textures of their clothes—the satin of the woman's dress being an exceptional example.

Amsterdam★; Brunswick; Budapest; Cambridge; Copenhagen; Dijon (Musée Magnin); Dresden; Florence (Uffizi); Frankfurt; Glasgow; Hamburg; Hull; Karlsruhe; Kassel; Leipzig; Leningrad; Lille; London (National Gallery, Wallace Collection); Lyons; Malibu (California); Minneapolis; Munich; New York; Paris; Pau; Philadelphia (Johnson Collection); Poznan; Rheims; Rotterdam★; Schwerin; Southend-on-Sea; Stuttgart; Swansea; Utrecht; Vienna; Warsaw.

Banquet of the Civic Guard of Amsterdam on June 18th in the Large Hall of the St Jorisdoelen in Celebration of the Conclusion of the Treaty of Munster

Canvas 232 × 547 cm (91½ × 216 in)
Signed and dated lower centre:
Bartholomeus Van der Helst fecit A° 1648.
AMSTERDAM, Rijksmuseum
This is one of the artist's most important pictures. Its scale rivals Rembrandt's Night Watch *and it is easy to see why Helst was so popular. He was able to catch a likeness without penetrating too deeply into the character behind, performing the function of a modern society photographer. He was also able to achieve an atmosphere of tremendous jollity as befitted the momentous occasion: at last all the nations of Europe had officially recognized the existence of the Dutch Republic.*

The picture was originally in the 'Doelen' or Hall of the Cross-Bowmen and was later transferred to the large hall of the Court Martial in Amsterdam (Rembrandt's Night Watch *was there as well); it has been lent to the Rijksmuseum since 1808.*

View of the Dam at Amsterdam with part of the Nieuwe Kerk and the Town Hall (detail)

Panel 68 × 55 cm (26¾ × 21¾ in) Signed on the shed of the weighing house (Waag): V Heyde. Probably painted in the late 1660s.

AMSTERDAM, Historisch Museum (lent by Rijksmuseum)

When this picture was painted the town hall must have been recently completed. Its predecessor had been burned down and the replacement was a source of immense pride to the town, as it was built on a scale normally reserved for royal palaces in the rest of Europe. As is usual with van der Heyden, the minute detail is subordinated to the picture's atmospheric unity and the buildings are greyish in the cool light. It has been suggested that the figures in the painting are by Adriaen van der Velde.

Jan Jansz. van der HEYDEN
Gorkum 1637—Amsterdam 1712

Van der Heyden deserves to be considered the best Dutch painter of townscapes of the seventeenth century. His pictures are a continuous source of wonder: how is it that so much detail, especially bricks, cobblestones and ivy leaves, could be included on so small a scale without destroying the unity of the picture? Van der Heyden could be accused of being a mere topographer— after leaving his native Gorkum for Amsterdam at the age of 13, he travelled extensively and he painted towns all over the United Provinces, made many views of Brussels and frequently painted Cologne. He favoured town views with picturesque elements like the colossal unfinished cathedral of Cologne. Late in life he painted a few landscapes and tended to include more and more trees in his compositions. There are also a few still-life pictures surviving from his hand. As might be expected, they are meticulously painted and rather austere in their colour schemes.

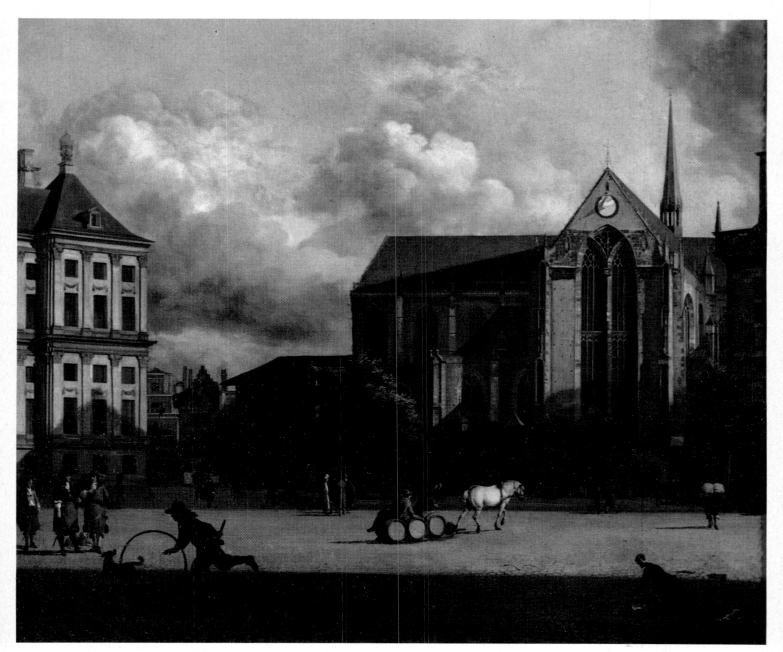

His treatment of light is exceptional. He avoids the obvious effects of a golden glow, preferring a limpid pale light which can be seen to advantage in the *Approach to the Town of Veere* which is in the British Royal Collection. Even though van der Heyden had a large output of incredibly highly finished pictures, he found time to devote considerable efforts to experiments with improvements in street lighting and fire-fighting in Amsterdam.

Amsterdam★; Ascott (Buckinghamshire); Barnsley; Basle; Berlin; Brunswick; Bristol; Budapest; Cincinnati; Detroit; Dortmund; Dresden; Düsseldorf; Edinburgh; Enschede; Florence (Uffizi); Frankfurt; The Hague; Hamburg; Innsbruck; Karlsruhe; Kassel; Leipzig; Leningrad; London (Dulwich, National Gallery★, Wallace Collection, Wellington Museum★); Los Angeles; Luxembourg; Manchester; Montpellier; Moscow; Munich; New York; Oslo; Paris; Petworth (Sussex); Philadelphia (Johnson Collection); Polesden Lacey (Surrey); Richmond (Virginia); Rotterdam; Schwerin; Upton House (Warwickshire); Vienna (Academy); Waddesdon Manor (Buckinghamshire)★; Washington; Worcester (Massachusetts); Zurich.

View in Delft with the Oude Kerk
Panel 44 × 53.3 cm (17¼ × 21 in) Signed and dated above the doorway, left: V Heyden 1675.
OSLO, Nasjonalgalleriet
This picture has all van der Heyden's clarity of tone and forms a contrast to Vermeer's View of Delft *which in the final analysis appears very much more a product of the imagination—a quality which van der Heyden lacked altogether. The tower of the Oude Kerk stands cold and erect (although in fact it leans a little). The slightly unnerving quality of the tower is completely avoided by van de Heyden and yet it is revealed in the* View in Delft *by Daniel Vosmaer which is in the Stedelijk Museum 'Het Prinsenhof' at Delft.*

The Avenue at Middelharnis

Canvas 103.5 × 141 cm (40¾ × 55½ in)
Signed and dated bottom towards the
right: M: hobbema 1689.
LONDON, National Gallery
*This picture has been one of the most popular
of all Dutch landscapes for several generations
and its consequent over-exposure makes it
difficult to recognize as the masterpiece that it
is. It could be described as the culmination of
the whole school of Dutch landscape painting.
What persuaded Hobbema to abandon his
wooded landscape painting and paint this open
panorama we shall never know, but its
topographical accuracy makes it likely that it
was painted for a specific patron. The painting
of formal avenues of this type is not unknown;
one of the best is Cuyp's Avenue near
Dordrecht which is in the Wallace Collection.
In Hobbema's Avenue there is a feeling of
space cleverly defined by the avenue of trees
against the flat meadows.*

*This painting remained at Middelharnis,
first in a private collection and then in the
town hall, until 1822. By 1834 it was in the
collection of Robert Peel and was bought by the
National Gallery in 1871.*

Meyndert Lubbertsz. HOBBEMA

Amsterdam 1638—Amsterdam 1709

'Oh Hobbema, my dear Hobbema, how I have loved you' were reputed to be the dying words of Old Crome, the great Norwich landscape painter of the early nineteenth century. Apart from the *Avenue at Middelharnis* in the National Gallery, London, which is still famous, the reason for the reverence formerly accorded Hobbema is no longer clear. It may be that his sentimental approach to landscape appealed to English taste in the eighteenth and nineteenth centuries, and that in the present century connoiseurs have not looked for charm in the types of pictures they have esteemed.

If any Dutch landscapes could be described as sentimental they are Hobbema's. He succeeded in prettifying everything, offering delightful peeps of woodland glades, ruins or cottages embowered in trees or just the alternating light and shadow of a spring or early summer day.

At an early age Hobbema was apprenticed to the great Jacob van RUISDAEL, whose style he seems to have assimilated with ease. Quite a few of Hobbema's early pictures are only distinguishable from those of his master by a tendency to be slightly more cheerful. He lacked Ruisdael's melancholy. Yet the detached dignity of the *Avenue* must have been in Hobbema's mind from the early years with Ruisdael.

Hobbema's present position is very similar to that of Aelbert CUYP; over-praise has led to neglect. Even if it is justifiable to relegate him from the second to the third rank of Dutch painters on grounds of taste, it must not be forgotten that after Jacob van Ruisdael's death in 1682 Hobbema was the most important landscape painter left in Amsterdam. Hobbema's pictures are comparatively rare and in his later years his output seems to have declined. Indeed, after 1668 he had a virtually full-time job as one of the wine-gaugers from the Amsterdam Octroi or customs office.

Amsterdam; Antwerp; Ascott (Buckinghamshire); Augsburg; Berlin★; Brussels★; Budapest; Cambridge; Cape Town; Chicago★; Cleveland (Ohio); Copenhagen; Darmstadt; Detroit; Dresden; Dublin; Edinburgh; Frankfurt; Gray; Grenoble; The Hague; Indianapolis; Kansas City; Leipzig; Leningrad; London (Dulwich, National Gallery★, Wallace Collection★); Melbourne; Minneapolis; Munich; New York (Frick Collection, Metropolitan Museum); Norwich; Oberlin (Ohio); Ottawa; Paris (Louvre, Petit Palais, Musée des Arts Decoratifs); Petworth (Sussex); Richmond (Virginia); Rotterdam; Schwerin; Toledo (Ohio); Vienna; Washington★; Williamstown (Massachusetts).

Wooded Landscape (The Haarlem Wood)

Canvas 96 × 129 cm (37¾ × 50¾ in) Signed and dated bottom left: M. Hobbema f. 1663.

BRUSSELS, Musée Royal des Beaux-Arts
This picture was painted when Hobbema was still heavily under the influence of Jacob Ruisdael and had not yet evolved the lighter palette and cool blue skies which typify so much of his later work. Such a picture appears composed rather than observed: each element is true to nature but the manner in which they are arranged is artificial. Like so many of his pictures, this seemingly empty landscape is in fact full of small figures which are beautifully integrated into their surroundings. The picture was bought by the museum in 1874.

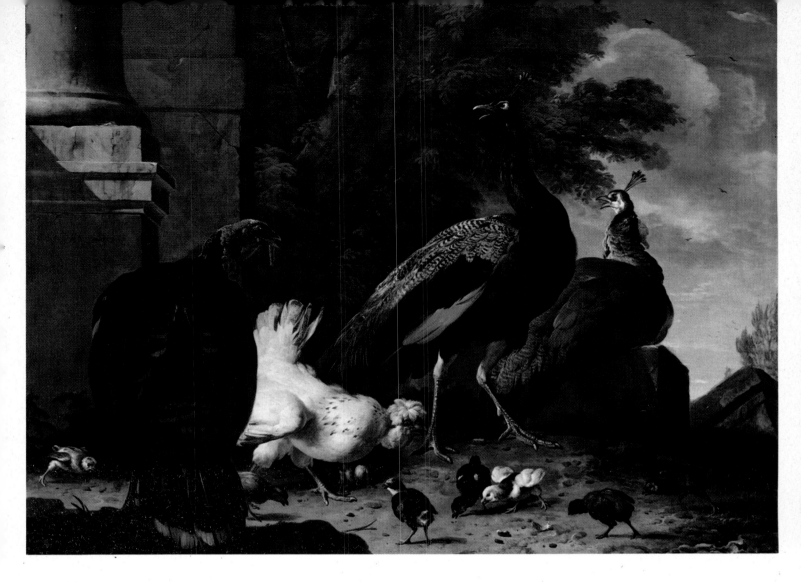

Hens, Chickens, Peacocks and a Turkey

Canvas 134 × 174.5 cm (52¾ × 69 in)
Signed on the column at the left: M d
Hondecoeter. Undated.
AMSTERDAM, Rijksmuseum
Hondecoeter has a sharp eye for the differing temperaments of birds. The benevolent stupidity of the turkey, the hen fussing over her chickens and the haughty but brainless peacocks are all depicted with tremendous accuracy. In order to give the picture pretensions and make it appeal to collectors of the grander sort of art, Hondecoeter introduced a classical column which gives the picture a vaguely Italianate character. Although this picture is of exceptional quality a satisfactory chronology of Hondecoeter's work has not been worked out and it cannot be accurately dated.

The picture formed part of the enormous and important van der Hoop collection which was bequeathed to the city of Amsterdam in 1854. It has been lent to the Rijksmuseum since 1885.

Melchior de HONDECOETER
Utrecht 1636—Amsterdam 1695

Hondecoeter was the most successful Dutch painter of hens, chickens, ducks, turkeys, geese and exotic birds. The very nature of his subject matter has let to a certain critical neglect in recent years, yet his work was collected and taken seriously in his own time and in the eighteenth and nineteenth centuries. His pictures are found in most of the great European picture galleries. His career, as might be expected, seems to have been uneventful. He was recorded in The Hague in 1659, but by 1653 he had moved to Amsterdam, where he spent the rest of his life. There are various influences on his art, the most important being that of his uncle Jan Baptist WEENIX. Most of Hondecoeter's pictures are of good quality, well painted and often charming in their humour—but his influence was catastrophic. Numerous miserable imitations were made, and his influence was responsible for the farmyard banalities which disfigure many a collection and also harm the reputation of this underestimated painter.

Amiens; Amsterdam★; Antwerp; Arnhem; Boston; Brunswick; Brussels; Caen; Cambrai; Cardiff; Chantilly; Cheltenham; Copenhagen; Cracow; Dresden; Dyrham Park (Gloucestershire)★; Florence (Pitti); Gateshead; Ghent; Glasgow; Gothenburg; The Hague; Kassel; Hamburg; Hartford (Connecticut); Karlsruhe; Leipzig; Leningrad; Lille; London (National Gallery, Wallace Collection); Lyons; Manchester; Melbourne; Montpellier; Munich; New York; Nîmes; Nottingham; Orléans; Paris (Louvre, Petit Palais, Musée des Arts Decoratifs); Philadelphia (Museum of Art, Johnson Collection); Rotterdam; Saint-Brieuc; Salzburg; Santa Barbara (University); Schwerin; Stockholm; Stuttgart; Toledo (Ohio); Tournai; Troyes; Upton (Warwickshire); Utrecht; Vienna (Academy, Kunsthistorisches Museum); Warsaw; Würzburg; York.

Gerrit van HONTHORST (Gherardo della Notte)
Utrecht 1590—Utrecht 1656

Honthorst occupies an important position in Dutch painting for two reasons. First, he was the leading exponent of the Caravaggesque style and imported it into the North. Secondly, he pursued a successful career as a court portraitist and decorator. This second part of his career has in fact been overlooked in recent years by the decision of the author of the most important work on the artist to exclude his activity as a portrait painter.

In terms of quality it has to be admitted that Honthorst's earliest pictures, executed while he was in Italy, are by far his best. Yet his later work, bland and uninspired as it was, became highly prized by Charles I of England and the Stadholder. It must not be forgotten that his reputation was very much greater than that of Rembrandt or Hals as a portrait painter. He was invited to England in 1628 by Charles I, who rewarded him lavishly for his work. Honthorst's portrait of the king is in the National Portrait Gallery, London. He also worked extensively for the Stadholder in The Hague, taking part in the decoration of the residences of Rijswijk and Honselaersdijk. He also helped decorate the Oranjezaal at the Huis ten Bosch. (Cesar van EVERDINGEN and other painters were also involved).

Nativity
Canvas 138 × 204 cm (54¼ × 80¼ in)
Unsigned; Probably painted c. 1620.
FLORENCE, Galleria degli Uffizi
Although Honthorst's Italian period pictures owe a direct debt to Caravaggio, this picture seems to be inspired much more by earlier Italian pictures like Correggio's Notte *at Dresden. It was Correggio who caused the light to emanate from the Christ Child himself rather than from any other source. Such effects were never used by Caravaggio. Also derived from the Italian Renaissance is the serenity and calm of the scene. Indeed, Honthorst rarely imitated the brutality of Caravaggio's subject matter.*

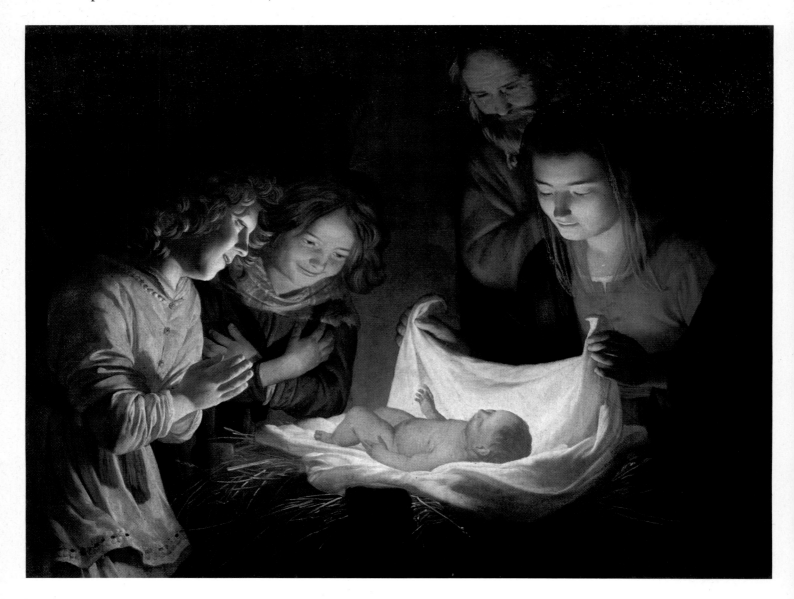

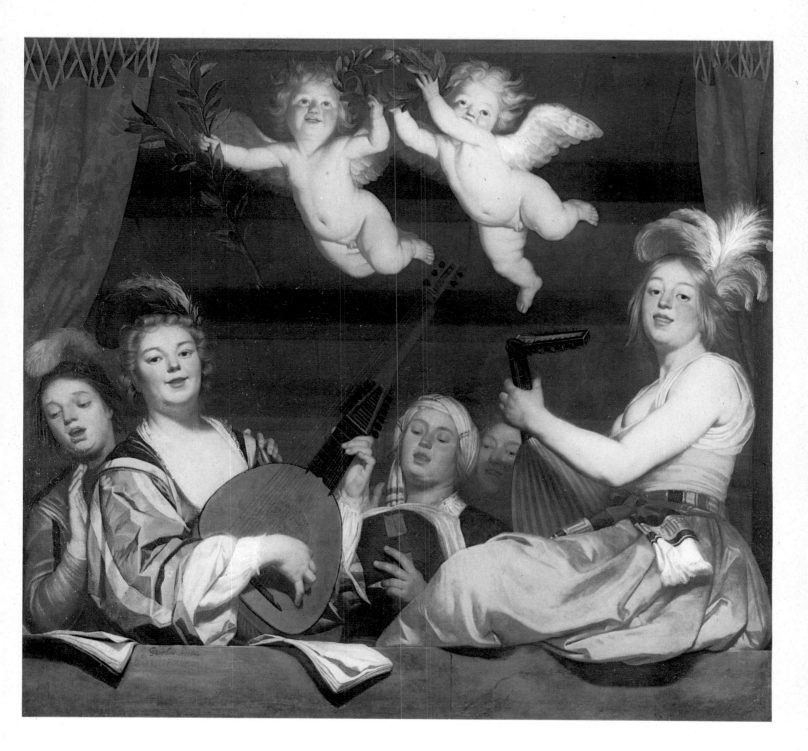

The Concert
Canvas 168 × 178 cm (66 × 70 in) Signed
and dated on the balustrade at the left:
G. Honthorst fe. 1624.
PARIS, Musée du Louvre
*Although this picture was painted only four
years after Honthorst had left Italy, it shows
how rapidly he abandoned his tenebrist style and
adopted a more classicizing manner.*

*The picture was in the collection of the
Stadholder Willem V at The Hague in the
eighteenth century. Seized by the French forces
during the Napoleonic occupation and not
returned to The Hague in 1815, the picture has
been in the Louvre ever since.*

Honthorst's modest reputation today poses the serious question: to what
extent are we right to consider that the governments of the day showed bad
taste in preferring Honthorst to Rembrandt? Certainly Honthorst's portraits
are now difficult to appreciate as anything but interesting historical curiosities.

Aberdeen; Albano; Alkmaar; Amsterdam; Angers; Ashdown House (Berkshire); Avignon;
Basle; Bayreuth; Berlin; Brunswick★; Brussels; Budapest; Cleveland (Ohio)★; Cologne;
Copenhagen; Dresden; Drottningholm; Dublin; Florence (Uffizi★); Fontainebleau;
Fredericksborg (Denmark); Ghent (St Bavon); Greenville (South Carolina); Haarlem;
The Hague (Gemeentemuseum); Hamburg; Hanover; Kassel; Krönberg Castle (Denmark);
Leipzig; Leningrad★; Lille; Linköping; London (National Gallery★, National Portrait
Gallery); Lyons; Malibu (California); Montecompatri (San Silvestro); Munich; Ottawa;
Paris; Powys Castle; Rennes★; Rome (Borghese, Santa Maria della Scala, Santa Maria in
Acquiro, Santa Maria della Vittoria); Saint Louis; Salzburg; Schwerin; Seattle; Speyer;
Upton House (Warwickshire); Utrecht★; Vidtsköfle (Sweden).

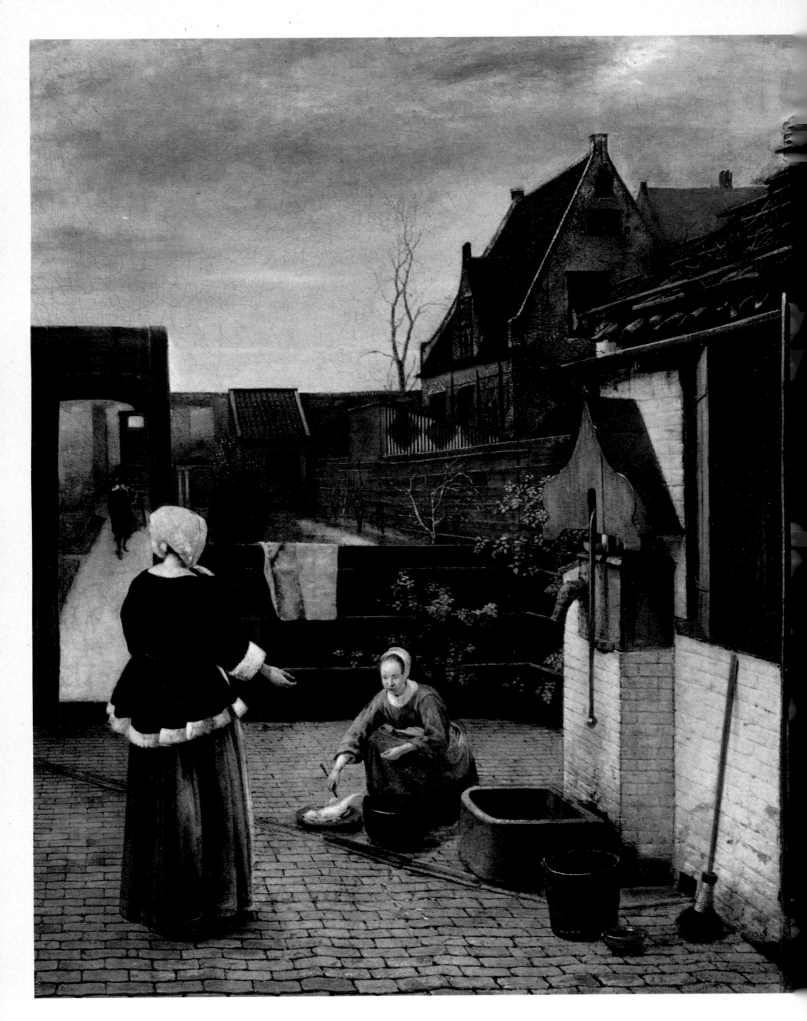

A Woman and her Maid in a Courtyard
Canvas 73.7 × 62 cm (29 × 24⅝ in) Signed
in monogram and dated bottom right:
P.D.H. 166_(?)
LONDON, National Gallery
*De Hoogh has recorded the precise appearance
of the back of a prosperous Delft house, kept
spotlessly clean by endless coats of whitewash
and repeated sweeping and scrubbing of the
yard. Apart from the obvious charm of seeing so
clearly into the past, de Hoogh offers the
spectator more—a picture whose clarity of
composition and unity of tone are worthy of
Vermeer himself.*

*The painting was not recorded until 1833,
when it was on the Amsterdam art market. It
was then in various Paris private collections
until acquired by the National Gallery at a
Paris sale in 1869.*

Overleaf:
**Woman handing a Jug to a Child
(The Pantry)**
Canvas 65 × 60.5 cm (25½ × 23¾ in) Signed
in monogram left foreground P.D.H.
Probably painted c. 1660.
AMSTERDAM, Rijksmuseum
*This is one of de Hoogh's most endearing
pictures because of the delightful sentiment
expressed. The mother is handing the small jug
to the expectant child who is anticipating
something pleasant. The artist's genius for
painting the subtle modulation in an interior
view from one room to another is particularly
obvious here.*

*The picture was in the collection of Pieter
Smeth van Alpen, who also owned Vermeer's
Interior with a Girl interrupted at her
Music in the Frick Collection, New York. It
appeared in the Alphen sale in 1810 and was
acquired by the museum in 1817.*

Page 123:
The Linen Cupboard
Canvas 72.0 × 77.5 cm (28¼ × 30½ in)
Signed and dated on the step: P.D. Hooch
1663.
AMSTERDAM, Rijksmuseum
*This picture is a good example of the change
which came over de Hoogh's style when he
became established in Amsterdam. There was an
obvious taste for increased elegance. By
comparison with Amsterdam, Delft must have
appeared provincial. The artist's mastery of a
simple situation has not been lost; the mistress
of the house is piling into the arms of her maid
a heap of beautifully laundered linen and a
small child is playing on the right.*

*The picture belonged to John Smith, the
author of the* Catalogue of the most eminent
Dutch, French and Flemish Painters *(See
bibliography). It was then in the Six
Collection, Amsterdam and was acquired by the
Rijksmuseum in 1928 with the aid of the
Rembrandt Society.*

Pieter Hendricksz. de HOOGH
Rotterdam 1629—Amsterdam after 1683 (?)

Pieter de Hoogh was one of the greatest painters of genre and also one of
the painters whose historical position is not yet fully understood. Consider-
ing his importance in the development of interior painting, it is tantalizing
that so many of the details of his career are still unknown.

As a young man he may have studied under Nicolaes BERCHEM at Haarlem;
he certainly left Rotterdam in 1654 and established himself in nearby Delft.
It is still not known when he left Delft for Amsterdam, but it was certainly
after 1660. It is not even known when he died; the last dated picture which
survives is of 1684.

It is often conveniently but wrongly assumed that somehow de Hoogh
derived his genre style of painting from VERMEER of Delft. We are captivated
by Vermeer's interiors and slightly bored by the perfect but predictable de
Hoogh.

But in contradiction to this facile view, it is quite clear that in the years
1654– c. 1660 de Hoogh produced a series of masterpieces in Delft of both
courtyard and interior scenes which anticipate the art of Vermeer, who
probably did not start to produce his interior scenes until about 1660. Vermeer's
Procuress in Dresden is dated 1656 and points clearly to the fact that at this
time Vermeer was still dependent on the Utrecht Caravaggists. The point is
made all the more forcefully when it is realized that de Hoogh's *Courtyard
of a House in Delft* is signed and dated 1658. It therefore has to be accepted
that it was de Hoogh who was the originator of this type of painting and that
it was Vermeer who perfected it. This is perhaps an oversimplification, as
there is the further problem of common source material. For instance,
Emanuel de WITTE was in Delft throughout the 1640s and his interiors could
well have had some influence on both Vermeer and de Hoogh.

Apart from the fascinating but unanswered question of how this style was
evolved, it has to be admitted that only in a very few of his pictures did de
Hoogh achieve a standard which was far above that of his contemporaries. His
figures have a feeling of warmth and benevolence and inhabit a calm and
ordered world. After his move to Amsterdam in about 1660 his style changed.
Most writers have said that he declined. He certainly became more elaborate,
more shadowy, but in some of these late pictures, which lack the finesse of
the Delft period, there is an air of mystery which makes them worthy of
reappraisal.

Aix-en-Provence; Amsterdam★; Berlin★; Boston; Budapest; Cincinnati (Taft Museum,
Art Museum); Cleveland; Cologne; Copenhagen; Danzig; Darmstadt; Detroit; Dublin;
Hamburg; Hanover; Indianapolis; Karlsruhe; Leipzig; Leningrad; Lisbon; London
(National Gallery★, Wallace Collection★, Wellington Museum); Magdeburg; Manchester;
Minneapolis; Moscow; New York; Nuremberg; Paris★; Philadelphia (Museum of Art);
Pittsfield (Massachusetts); Polesden Lacey (Surrey); Rome (Corsini); Rotterdam; St Louis;
San Francisco; Stockholm; Strasbourg; Toledo (Ohio); Vienna (Academy, Kunsthistorisches
Museum); Waddesdon Manor (Buckinghamshire)★; Washington (National Gallery★,
Corcoran Gallery); Worcester (Massachusetts).

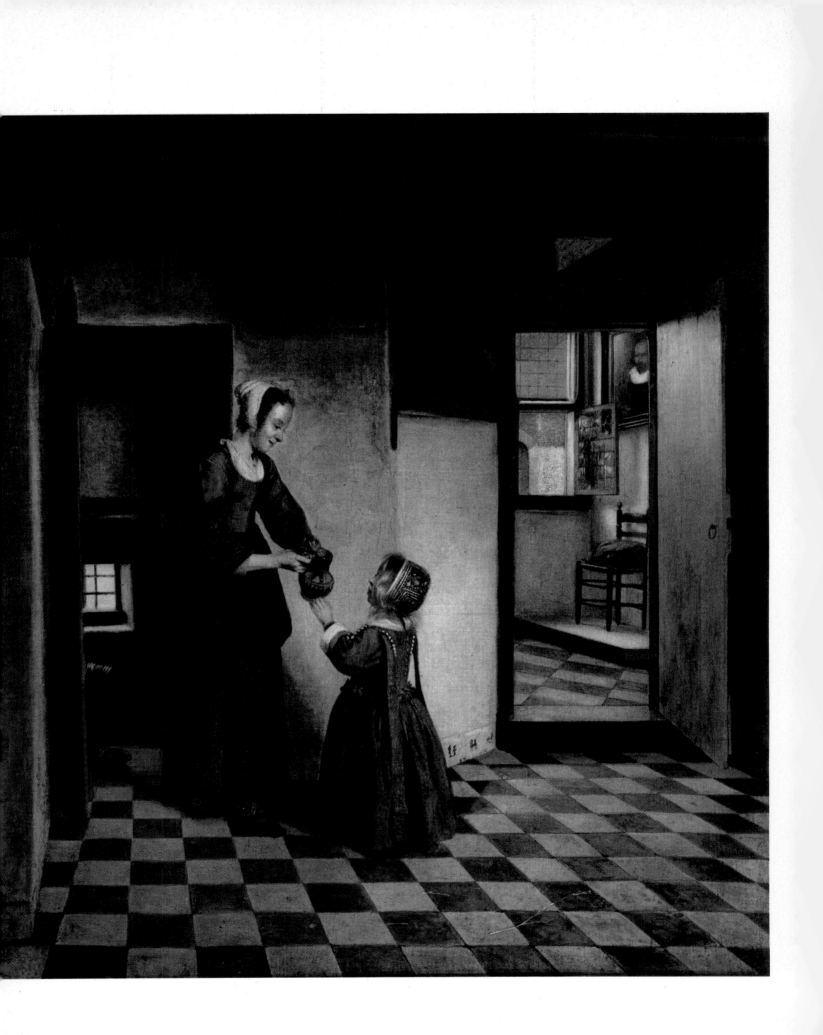

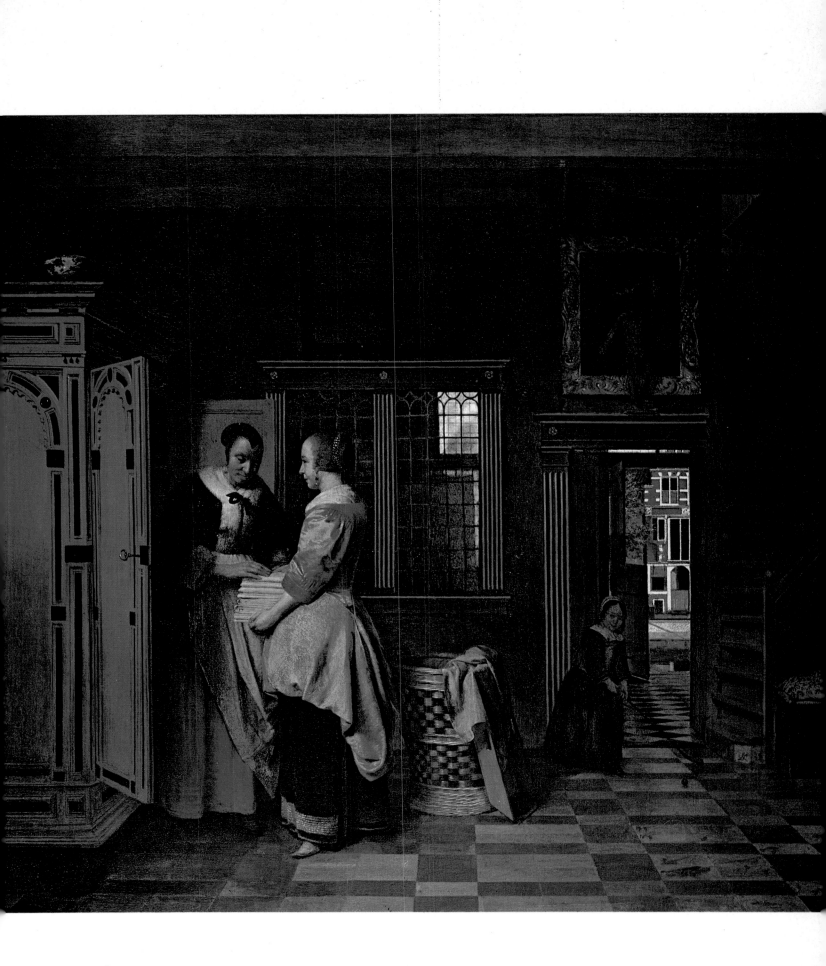

Perspective View down a Corridor
Canvas 260 × 136 cm (104 × 55¾ in)
Signed and dated 1662.
DYRHAM PARK (Gloucestershire)
National Trust
*This picture is generally considered to be the
artist's masterpiece. It is vast in scale and
brilliantly contrived to give the effect of several
rooms in succession. Indeed the fact that there
seems to be no subject at all emphasizes the
trompe l'oeil nature of the work.*

*The painting was acquired by William
Blathwayt (1649?–1717) and placed at the end
of a suite of rooms at Dyrham Park with the
intention of increasing the illusion of length. It
thus remains as one of the few Dutch
seventeenth-century pictures to be certainly in
the place where it was put in the seventeenth
century.*

Samuel Dircksz. van HOOGSTRATEN
Dordrecht 1626—Dordrecht 1678

Hoogstraten's art is uneven in quality but in his own lifetime he was justly
famous for his pictures of perspective views. At the age of 13 in 1640 he
entered Rembrandt's studio in Amsterdam and remained there for several
years. In the early 1650s he visited Vienna and Rome and then spent the latter
half of the 1650s in Dordrecht. In 1662 he was recorded in London and by
1668 he was at The Hague. The last years of his life were, however, spent
back in his native Dordrecht.

His perspective pictures, bold in concept but a little coarse in execution,
show no influence of Rembrandt. Hoogstraten was especially successful in
England, and in the National Gallery, London is his well-known perspective
box. In his last years he wrote a book of art theory, *Inleyding tot de Hooge
Schoole der Schilderkonst,* which was published in the year of his death.

Amsterdam; Coblenz; Detroit; Dordrecht★; Dyrham Park (Gloucestershire)★; Glasgow
(University); The Hague; London★; New York; Prague; Springfield (Massachusetts);
Vienna.

Willem KALF

Rotterdam 1619—Amsterdam 1693

Kalf was one of the greatest Dutch painters of still life, and his art, with its wonderful variety of textures and beautiful objects carefully arranged, is easy to appreciate. Unlike so many other still-life painters he relied on the extreme subtlety of the shadows in the background of his pictures, so that each precious object painted appears to take shape before the spectator's eyes as he approaches the picture. Kalf was particularly sensitive to the various textures seen in a peeled lemon, as well as painting silver, glass and porcelain with consummate skill. He spent the years 1642–6 in Paris and from 1653 onwards he was in Amsterdam, where he spent the rest of his life. His paintings are much sought-after today.

Amiens; Amsterdam; Berlin★; Budapest; Cleveland (Ohio); Cologne; Copenhagen; Dijon; Epinal; Frankfurt; Glasgow; The Hague (Bredius Museum); Hanover; Indianapolis; Karlsruhe; Le Mans★; Leningrad; Le Puy; Lyons; Malibu (California); Manchester; Melbourne; Metz; Montpellier; Munich; New York; Oxford; Paris; Philadelphia (Johnson Collection); Quimper; Rotterdam (Boymans-van Beuningen Museum, Willem van der Vorm Foundation); Rouen; St Louis; Schwerin; Stockholm; Strasbourg; Toulouse; Tours; Valenciennes; Washington.

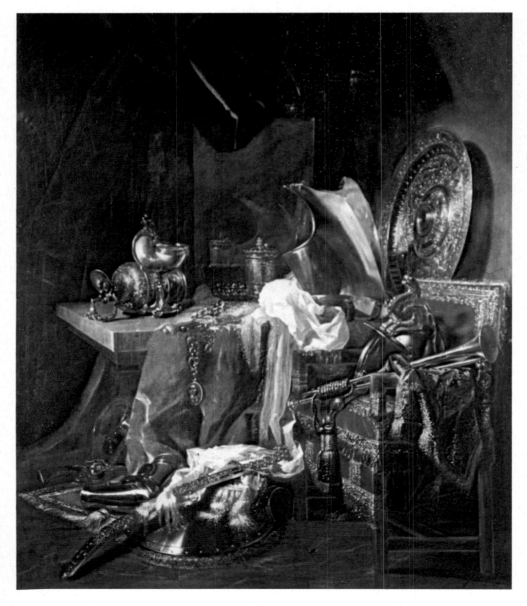

Still Life with Armour

Canvas 200 × 170 cm (78¾ × 67 in)
Formerly stated to have been signed and dated 1643. This is no longer visible. Probably painted c. 1650.
LE MANS, Musée de Tessé
This is Kalf's largest and most elaborate picture. In recent years it has been the subject of much controversy as its authenticity has been doubted by some scholars. Certainly there is no good reason to suppose that it was painted during the artist's French period, but it remains as Kalf's most grandiose and (possibly) allegorical statement. It is unusual for Kalf to paint objects grouped round a theme—here, the accoutrements of war. There is, however, nothing else in the picture which would suggest an allegory of vanity.

The picture was in the collection of the Maréchal de Tessé and was confiscated in 1794 and placed in the Le Mans museum.

Pieter Schout on Horseback
Panel 86 × 69.5 cm (33¾ × 27¼ in) Signed
and dated on the saddle: TDK F. 1660.
AMSTERDAM, Rijksmuseum
*It is just possible that the explanation for the
rarity of this type of picture is the fact that the
Dutch did not think that a man looked elegant
or dignified on horseback. Indeed, in de Keyser's
pictures of this type the character of the sitter
plays a very small part in the whole. At this
stage in his career de Keyser's brushwork had
lost some of the precision found in the Huyghens
portrait of more than 30 years earlier. The
sitter (1640–69) was high bailiff of Hagestein.*
*The picture was bequeathed to the
Rijksmuseum in 1880 by Jhr. J.S.H. van de Poll.*

Constantin Huyghens and his Secretary
Panel 92.4 × 69.3 cm (36¾ × 27¼ in) Signed
and dated on the front of the
chimney-piece: JDK AN 1627.
LONDON, National Gallery
*Without the identification of the sitter this
picture would be a perfect early example of a
genre-type portrait. The fact that the sitter is
Constantin Huyghens increases the picture's
significance: he was instrumental in securing for
Rembrandt the commission from the Stadholder
Prince Frederick Hendrick of Orange for the
Passion series which is in Munich (see
page 163). In addition, Huyghens was one of
the most important men of his generation,
serving several stadholders in succession. Some
of his widely varied interests are indicated in the
picture, notably the musical instruments and
globe. The young man has not been identified
and has been presumed to be a secretary.*
*The picture was bequeathed to the National
Gallery by Richard Simmons in 1847.*

Thomas Hendricksz. de KEYSER
Amsterdam 1596/7—Amsterdam 1667

De Keyser spent his whole career in the painting of portraits in his native
Amsterdam—the town which he presumably never left. His careful style
stands slightly apart from the exciting developments in portrait painting
which he must have witnessed. He cannot have avoided Rembrandt and may
even have known him through Constantin Huyghens, whose portrait he
painted. It is possible to appreciate de Keyser's art on the simple level of an
unpretentious and well-painted portrait. He occasionally painted groups, of
which a good example is in the Toledo (Ohio) Museum of Art.

De Keyser also specialized in, and probably even introduced, the painting
of small equestrian portraits. Equestrian portraiture is curiously rare in Dutch
seventeenth-century painting. This is difficult to explain, bearing in mind the
popularity of animal paintings. Rembrandt himself attempted it only once—
assuming that *The Polish Rider* in the Frick Collection, New York, is not a
portrait—in the large equestrian portrait in the National Gallery, London.

Aix-en-Provence; Amsterdam; Basle; Brussels; Budapest; Châteauroux; Cologne;
Dresden; Frankfurt; Ghent; The Hague (Bredius Museum); Kassel; Leningrad; London★;
Oldenburg; Oxford; Paris; Philadelphia (Johnson Collection); Richmond (Virginia);
Rotterdam; Rouen; Saint-Omer; Schwerin; Toledo (Ohio); Utrecht; Vienna.

Philips Aertsz. KONINCK
Amsterdam 1619—Amsterdam 1688

Koninck is always known as the painter of superficially monotonous flat landscapes with an approximately equal proportion of land to sky. If Arnold Houbraken is to be believed, he was a pupil of Rembrandt for a time. The latter artist can have had little influence on him as the similarities with Rembrandt's landscapes can be traced to a common source: that of Hercules SEGHERS.

Koninck's debt to Seghers is obvious in the way he treats the distances in his landscapes—the flat meadows merge into one another as rivers slowly meander along. The result, although never as poetic as Seghers, is very atmospheric. Koninck seems to have spent most of his career in his native Amsterdam.

Amsterdam; Arnhem; Béziers; Brussels; Cape Town; Copenhagen; Dresden; Florence (Uffizi); Frankfurt; Glasgow (University★); Gothenburg; The Hague (Bredius Museum); Leiden (University); Leningrad; London (National Gallery★, Victoria and Albert Museum); Manchester; Moscow; Munich; Münster; New York; Oslo; Philadelphia; Rotterdam; San Francisco; St Louis; Schwerin; Sibiu; Southampton; Utrecht; Vienna.

Extensive Landscape with a Hawking Party
Canvas 132.5 × 160 cm (52½ × 63⅛ in)
Unsigned. Probably painted in the 1670s.
It has been suggested that the figures are by Johannes Lingelbach.
LONDON, National Gallery
This is a typical example of Koninck's habit of painting flat landscapes seen from an imaginary eminence or high building. This method was initiated by Hercules Seghers. In contrast to Seghers, who usually painted with a brownish palette, Koninck almost always used cool blues and greens which impart a fresh feeling to his pictures. These can but rarely be identified with a particular place and many of them are probably imaginary, although of course they reflect the flat landscape of the United Provinces, especially that of Holland.

By 1850 this picture was in the collection of Sir Robert Peel and it was bought by the National Gallery along with the rest of the Peel collection in 1871.

Pieter van LAER (called Bamboccio)

Haarlem 1592 — Haarlem 1642

An important and influential painter whose career remains obstinately obscure, van Laer must have arrived in Rome sometime before 1625 from his native Haarlem. He is recorded in the city until about 1637 and it is usually surmised that he died about 1642. In his short period of activity in Rome he became a member of the Accademia di San Luca, which was the official Roman academy, and also a member of the Schilderbent, which was the guild for foreign, especially northern, painters working in Rome. He concentrated on small, mostly outdoor genre scenes which immediately became immensely popular, much sought-after, and widely influential. A whole host of painters imitated him. In spite of their fame, van Laer's pictures are rare and difficult to identify today.

Amsterdam; Bremen; Brunswick; Budapest; Florence (Pitti, Uffizi); Gateshead; Hartford (Connecticut); Jacksonville (Florida); Kassel; Leningrad; Le Puy; Oxford (Christ Church); Paris; Rome (Galleria Spada★); Schwerin; Sibiu; Vienna (Academy).

Pieter Pietersz. LASTMAN
Amsterdam 1583—Amsterdam 1633

As a painter, Lastman has been subjected to unjust neglect, for he was the most active representative of the style of painting practised in Amsterdam in the early years of the seventeenth century. In spite of this, however, his real importance lies in his role as a teacher, especially of the young REMBRANDT, who came to him in Amsterdam in the 1620s. According to van Mander, Lastman was himself a pupil of Gerrit Pietersz. Sweelinck, who was a pupil and imitator of CORNELIS van Haarlem. Indeed, most of Lastman's pictures reflect, more or less, the style of the Haarlem mannerists. In technique, however, there was a major difference because he preferred to use much opaque paint and even impasto. It was this technique which was to impress Rembrandt so much—almost all Rembrandt's earliest pictures have a dense and brightly coloured surface which goes one stage further towards a disagreeable extreme than the paintings of Lastman which they imitate.

Lastman spent most of his active career in Amsterdam where he achieved a great reputation. In the early years of the century he visited Rome, where he seems to have been influenced by the German painter Adam Elsheimer—especially in such pictures as the little *Flight into Egypt* in the Boymans-van Beuningen Museum at Rotterdam.

Amsterdam (Historisch Museum, Rembrandthuis, Rijksmuseum); Basle; Berlin; Boulogne-sur-Mer; Bremen; Brunswick; Budapest; Copenhagen; Detroit; Dijon (Musée Magnin); Dublin; Gateshead; Göttingen; The Hague; Hamburg; Karlsruhe; Kassel; Leningrad; London; Moscow; Nantes; Paris; Prague; Providence (Rhode Island); Rotterdam; San Francisco; Stockholm; Stuttgart; Warsaw.

The Dispute between Orestes and Pylades
Panel 83 × 126 cm (32¾ × 49¾ in)
Signed and dated on the altar: Pietro Lastman fecit 1614.
AMSTERDAM, Rijksmuseum
The pendant to this picture, Paul and Barnabas at Lystra (also painted in 1614) is now in the Historisch Museum, Amsterdam. The theme, a particularly obscure subject from classical mythology, is typical of the fashion of the period among academic painters. Orestes and Pylades are deciding who shall sacrifice himself to the gods, while Iphigenia looks on. In 1657 Joachim Oudaen composed an ode on this picture while the pendant was eulogized by the great Dutch poet Joost van den Vondel.

Both pictures remained together until the early nineteenth century, this one being acquired by the museum from a Berlin collection in 1908.

Portrait of an Unknown Man
Panel 70.5 × 54.5 cm (27¾ × 21½ in)
Unsigned. Probably painted in the 1660s.
ROTTERDAM, Boymans-van Beuningen
Museum
*The unknown man has the same introspective
mood as in many of Rembrandt's late portraits
and presumably Levecq was very much
impressed by Rembrandt's final manner—few
other artists seem to have been influenced by
Rembrandt's pictures of the 1660s. The man's
face is treated in a similar manner to
Rembrandt's* Syndics *and almost all Levecq's
surviving pictures correspond to this style.*
 *The painting was acquired by the museum
in 1937.*

Jacob LEVECQ
Dordrecht 1634—Dordrecht 1675

Jacob Levecq belongs to the group of Dordrecht painters who went to
Amsterdam to study under REMBRANDT. But, unlike his contemporaries
Nicolaes MAES and Samuel van HOOGSTRATEN, he remained faithful to the style
he had learned in Rembrandt's studio and painted little else but portraits.
His pictures are very rare and show no development beyond Rembrandt's
style of the 1650s. They often have a brooding quality with strong contrasts
of light and shade and have in the past been confused with works by
Rembrandt himself. Most of his career seems to have been spent in Dordrecht
as his time in Rembrandt's studio in Amsterdam was probably very short.
His impressive portraits have been little appreciated and studied in recent years.
Dordrecht; Hartford (Connecticut); Los Angeles; Polesden Lacey (Surrey); Rotterdam;
Warsaw.

Judith Jansdr. LEYSTER
Haarlem 1609—Heemstede 1660

Judith Leyster has, in the early part of this century, been the source of much romantic speculation; there was a time when many important and even documented pictures by Rembrandt were ascribed to her. She was even believed to be his mistress. Her career was in fact rather complicated. She was probably a pupil of Frans HALS in Haarlem at an early age and he was the most important influence on her style. She married Jan Miensz. MOLENAER in 1636 and, not surprisingly, many of her later genre pictures show the influence of her husband, who himself was often close to Frans Hals. Hence the ease with which the confusion has grown up. Most of her life was spent in Haarlem or in nearby Heemstede although she lived and worked in Amsterdam 1637–48. A study of her art is much needed, as her style is difficult to define easily. Women have been rare in the whole history of painting, and Judith Leyster must have been a remarkable women to achieve such proficiency in this traditionally male preserve.

Amsterdam; Haarlem; Karlsruhe; Leningrad; London; Paris; Philadelphia (Johnson Collection); Rouen; Stockholm*; Washington.

A Boy Playing a Flute
Canvas 73 × 62 cm (28¾ × 24⅜ in)
Signed in monogram JL. Probably painted about 1630.
STOCKHOLM, Nationalmuseum
The stylistic source for this picture is Hals's group-portrait style of the 1620s. However, it would be impossible to mistake this picture for a Hals; it is painted with much less bravura, and the violin almost amounts to an exercise in trompe l'oeil. This could be said to be the artist's best surviving work, full of life and acute observation.

In spite of the monogram, this picture was attributed both to Frans Hals and Jan de Bray at the time of its acquisition by the museum in 1871. It was identified as by Judith Leyster by Hofstede de Groot in 1893.

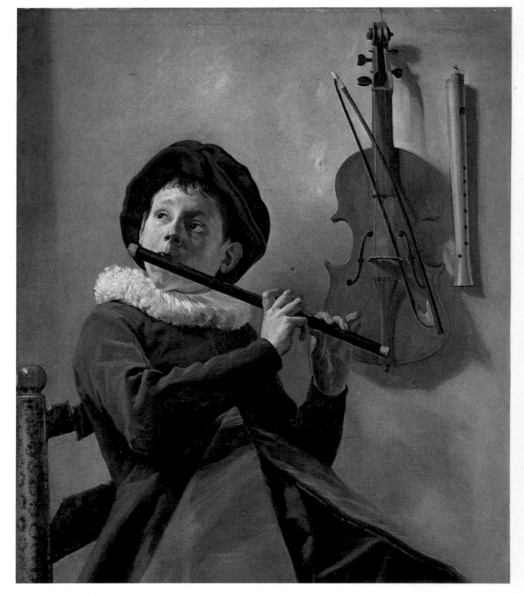

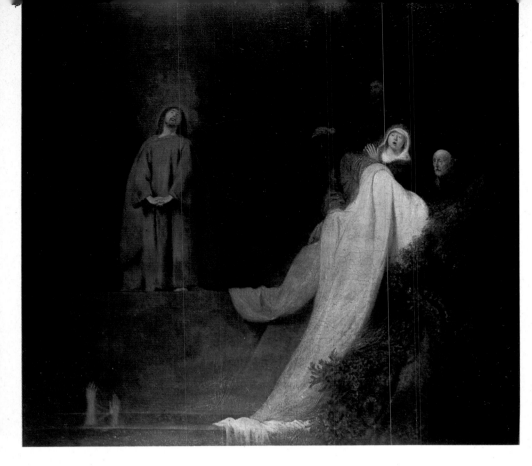

Jan LIEVENS (Lievensz.)

Leiden 1607—Amsterdam 1674

Lievens is a complex artist whose historical importance is undeniable but whose pictures are often difficult to appreciate. Any attempt to reconstruct REMBRANDT's early development has to consider Lieven's position, but as their relationship is not properly documented much remains as speculation. As a young man it is probable that, like Rembrandt, he studied under Pieter LASTMAN at Amsterdam and then returned to Leiden, where he worked in the 1620s. He became the close collaborator of Rembrandt, who was two years his junior, and it is clear that Rembrandt's debt to Lastman virtually disappeared during his time with Lievens. It is thus likely that it was Lievens who influenced Rembrandt and not the other way round. When Rembrandt returned to Amsterdam, Lievens left for Antwerp. He returned briefly to Leiden c. 1639/40, when he painted a large *Scipio Africanus* for the town hall. By 1644 he had returned permanently to the United Provinces and he seems to have divided his time between Amsterdam and The Hague.

Throughout his life Lievens received an enormous number of official commissions, largely portraits and decorative schemes, far more than Rembrandt. The most important was his contribution to the decoration of the new Town Hall at Amsterdam in the 1660s. Present-day taste finds Lieven's eccentric style difficult to appreciate. He was an imaginative artist but his technique lacks finesse and his colour is often dense and lacking in transparency.

Aix-en-Provence; Amsterdam; Bamberg; Besançon; Birmingham (Barber Institute); Bremen; Brighton; Brunswick; Budapest; Chicago; Copenhagen; Douai; Edinburgh; Leiden★; Leipzig; Leningrad; Lille; London; Macon; Mainz; Malibu (California); Nancy; Oldenburg; Ottawa★; Paris; Pau; Philadelphia (Johnson Collection); Potsdam; Rotterdam; Rouen; Salzburg; Schwerin; Vienna (Academy, Kunsthistorisches Museum); Warsaw.

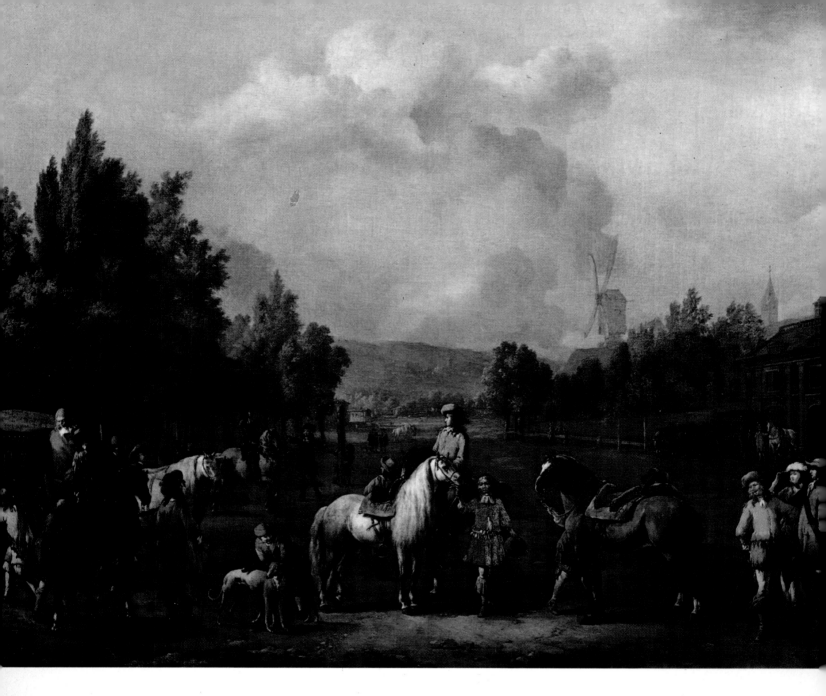

Johannes LINGELBACH

Frankfurt 1622—Amsterdam 1674

Although born in the capital city of the Holy Roman Empire, Lingelbach moved to Amsterdam at an early age and spent most of his life there. He visited France and Italy in the years 1642–50. Lingelbach was an immensely skilled craftsman of both landscapes and figures, but he borrowed his compositions and style from Philips WOUWERMANS. He was also remarkably adept at the painting of figures in other artists' landscapes and he appears as the collaborator of artists as widely different in style as Johannes HACKAERT, Philips KONINCK and Jan WYNANTS. His Italianate landscapes with their gentle light were esteemed in the eighteenth and nineteenth centuries.

Aix-en-Provence; Amsterdam; Aschaffenburg; Bath; Brunswick; Brussels; Copenhagen; Carcassonne; Dijon (Musée Magnin); Douai; Edinburgh; Epinal; Frankfurt; Glasgow; Gouda; Grenoble; Haarlem; Kassel; La Fère: Leeds; Leipzig; Leningrad; Lille; London (Dulwich, National Gallery, Wellington Museum); Malibu (California); Manchester; Minneapolis; Nancy; New York; Nottingham; Paris (Louvre, Petit Palais, Musée Marmottan); Rotterdam; Salzburg; Schwerin; Speyer; Vienna (Academy, Kunsthistorisches Museum); Waddesdon Manor (Buckinghamshire).

The Riding School
Canvas 68 × 82 cm (26⅞ × 32¼ in)
Signed right foreground: J. Lingelbach.
Probably painted in the 1660s.
AMSTERDAM, Rijksmuseum
Pictures of this subject are comparatively rare, although there were obviously many riding schools in the United Provinces. Indeed, except for Thomas de Keyser the Dutch artists seem to have had a higher regard for the cow than the horse. The lightweight charm of this picture, exquisitely painted with a very soft golden light, is typical of Lingelbach, whose pictures never make any demands on the spectator.

The painting was originally in the National Museum at The Hague in 1808 and was later transferred to the Rijksmuseum, where it has been in reserve in recent years.

Nicolaes MAES

Dordrecht 1634—Amsterdam 1693

Maes has always been esteemed as a painter of genre pictures and his Rembrandtesque style is direct and easy to appreciate. His career was relatively uneventful; it is likely that he left his native Dordrecht at an early age to become a pupil of REMBRANDT in the 1650s. He was back in Dordrecht by 1654 where he remained for nearly twenty years. The rest of his life was spent in Amsterdam. His career divides neatly into two parts: the first and most influential was when he specialized in genre painting; the latter part of his career (after 1660) was devoted almost exclusively to the painting of portraits, most of which are on a small scale.

His earliest pictures are difficult to identify and it is only in recent years that the large Rembrandtesque *Christ Blessing the Children* in the National Gallery, London, has been attributed to him. Another problem picture which is of the highest quality, the *Portrait of a Man* in the Manchester City Art Gallery, appears in all Rembrandt monographs up to and including that of Bredius as a work of Rembrandt. It was then attributed (somewhat hesitantly) to Samuel van HOOGSTRATEN and now to Maes himself. These pictures have a quiet melancholy and are close to the mood achieved by the stylistically different Dordrecht painters such as Samuel van Hoogstraten and Jacob LEVECQ.

As soon as Maes returned to Dordrecht, however, his style changed and he began painting beautifully wrought genre scenes of which perhaps the best example is the *Idle Servant* in the National Gallery, London. The date of 1655 on this picture has been the source of much speculation as to the role of Maes in the development of genre painting in that part of the province of Holland. At an identical moment in Delft, which was only a few miles away, Pieter de HOOGH was evolving his own genre style and it is generally agreed that Maes must have had some influence on him, although through lack of dated pictures it is difficult to be precise.

In the *Eavesdropper* in the Dordrecht museum Maes shows an interest in the moral and anecdotal part of the picture and the maid's obvious enjoyment of what she is overhearing. This forms a contrast to the more refined and discreet art of de Hoogh, whose figures are so often seen in simple activity— standing, sitting or sweeping a floor.

By 1660 Maes had given up genre painting altogether and no explanation can be found for this. His portraits are always well-painted, conventional, and were very successful in their time. They also formed the model for most portrait painting for the rest of the century and well into the next one. When burghers required small representations of themselves and their families, it was a Maes-type portrait which they seem most to have admired, and his imitators, too, became highly successful in financial terms.

Amiens; Amsterdam★; Antwerp (Musée des Beaux-Arts, Musée Mayer van den Bergh); Arras; Ascott (Buckinghamshire); Bath; Belfast; Berlin; Birmingham (Barber Institute); Bordeaux; Boston; Brighton; Bristol; Brussels; Budapest; Caen; Carcassonne; Chaâlis; Chicago; Cologne; Copenhagen; Dordrecht★; Douai; Dublin; Evreux; Glasgow (Art Gallery, Burrell Collection, University); Haarlem; The Hague (Gemeentemuseum, Mauritshuis); Hamburg; Hanover; Indianapolis; Karlsruhe; Leamington Spa; Leicester; Leiden; Leningrad; Le Puy; London (National Gallery★, Wellington Museum); Lyons; Madrid (Museo Lazaro Galdiano); Malibu (California); Manchester; Munich; Nancy; Narbonne; New York; Nîmes; Norwich; Oxford; Paris (Louvre, Petit Palais); Perpignan; Philadelphia (Johnson Collection); Poitiers; Quimper; Rennes; Rheims; Rotterdam; St Louis★; Schwerin; Soissons; Southampton; Stuttgart; Toledo (Ohio); Toulouse; Turin; Utrecht; Vienna (Academy, Kunsthistorisches Museum); Warsaw; Washington; Worcester (Massachusetts).

Overleaf:
A Woman leaning out of a Window (The Daydreamer)
Canvas 123 × 96 cm (48½ × 37¾ in)
Signed and dated on the window ledge: N. Mae. Probably painted in the mid-1680s.
AMSTERDAM, Rijksmuseum
The large scale of this picture is perhaps caused by the continuing influence of Rembrandt, who painted several pictures of this type—a good example being the Girl at a Window *of 1645 at Dulwich. Maes here achieves a kind of romantic melancholy, a mood which is usually only found in Rembrandt. An especially charming touch is the apricot branch which winds round the window. All the details are beautifully observed but never obtrusive.*
The picture was acquired by purchase by the museum in 1829.

Page 137:
Mother with her Child in a Cot
Canvas 32.5 × 28 cm (12⅞ × 11 in)
Probably painted c. 1660.
AMSTERDAM, Rijksmuseum
This tiny picture shows the artist's other extreme: a genre scene on a small scale but freely painted with a lot of attention to texture, exactly as Rembrandt would have done. The artist has also introduced the motif of the curtain at the side which occurs both in Vermeer's Lady reading a Letter *at Dresden and in Rembrandt's* Holy Family *at Kassel. Many pictures were in fact covered by curtains which were only opened on special occasions. In Gabriel Metsu's painting* A Lady reading a Letter with her Maid *in Sir Alfred Beit's collection the maid is actually uncovering a seascape picture which is hidden by a curtain.*
The painting was given to the museum in 1961 by Mr. and Mrs. I. de Bruijn-van der Leeuw.

135

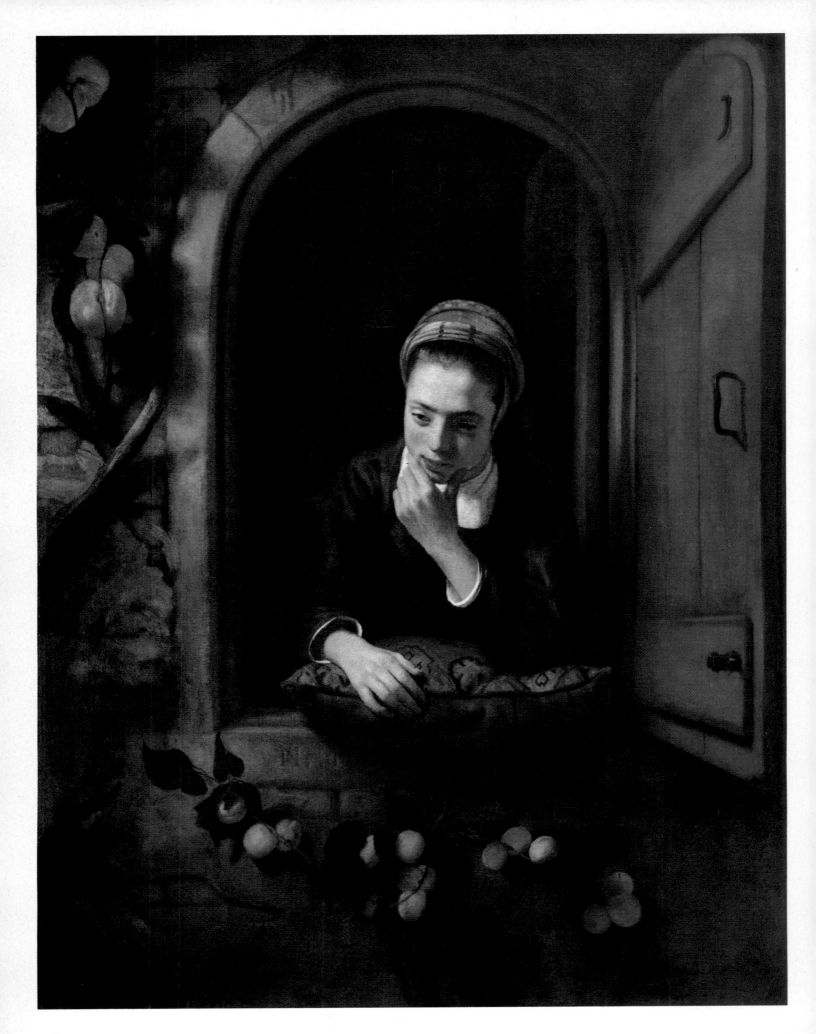

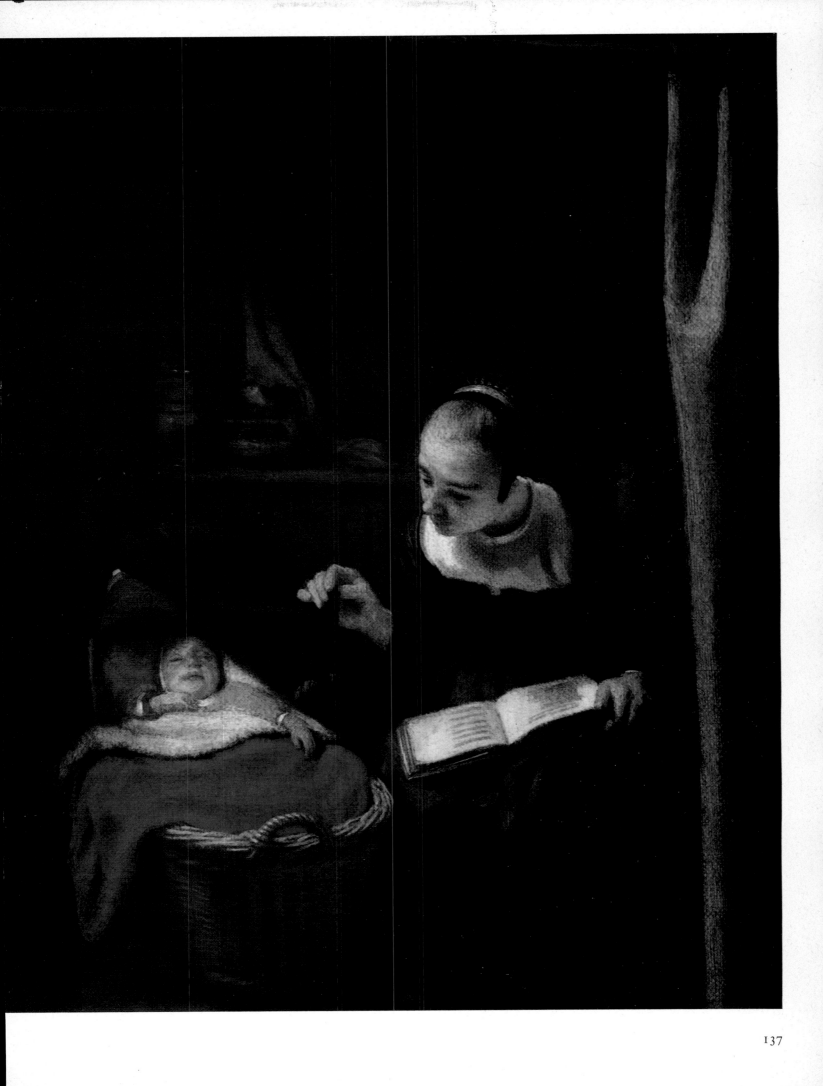

Gabriel METSU

Leiden 1629—Amsterdam 1667

Gerard DOU was reputed to have been Metsu's master, but as most of Metsu's early pictures (painted while he was still in Leiden) are religious or mythological in content it has to be assumed that the young artist reacted violently against the rigours of his master's style. Metsu settled permanently in Amsterdam in 1657 and he seems to have remained there for the rest of his life. Paradoxically, it was in Amsterdam that his style developed, becoming much closer in fact to Dou who remained in Leiden.

An important example of Metsu's early style is the *Christ and the Woman taken in Adultery* of 1653 in the Louvre where the source seems to be REMBRANDT rather than any other artist. Metsu soon gave up painting in this manner and concentrated on meticulously painted genre pictures on a small scale.

Metsu's development was rapid in the 1650s and the question of his relationship to VERMEER, Pieter de HOOGH and Nicolaes MAES has to be asked. There are surprisingly few dated works by Metsu of the crucial period of the 1650s.

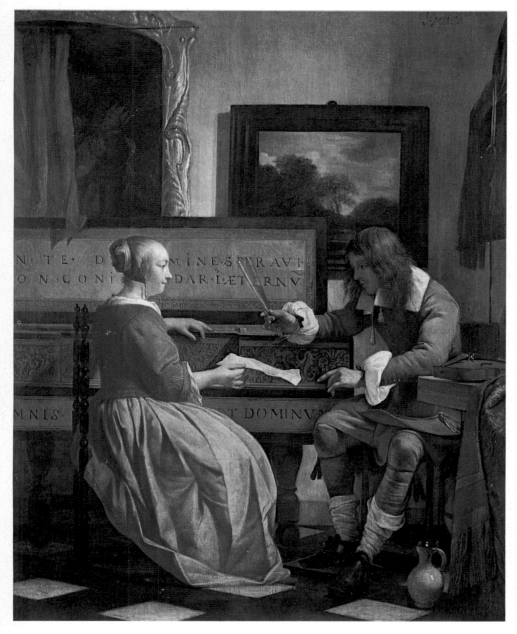

A Man and a Woman seated by a Virginal (The Music Lesson)
Panel 38.4 × 32.2 cm (15⅛ × 12¾ in)
Signed top right: G. Metsu. Probably painted in the late 1650s.
LONDON, National Gallery
Along with the two pictures in the Beit collection this is usually considered to be Metsu's best work. Its date is not certain but it is likely to predate Vermeer's pictures of the same type, the Windsor Music Lesson and the Boston Concert. The mood is very much the same as is found in many of Vermeer's pictures but the technique of painting is completely different; Metsu softened his edges in a manner exactly opposite to that of Vermeer. The virginal, which is elaborately inscribed in Latin with verses from the Psalms, appears again in a much larger picture by Metsu which is in the Willem van der Vorm collection, Rotterdam.

The painting was first certainly recorded in a London sale in 1798. It was in the collection of Sir Robert Peel by 1833 and it was bought by the National Gallery along with the rest of the Peel collection in 1871.

The Sick Child
Canvas 33.2 × 27.2 cm (13 × 10¾ in)
Signed above the map: G. Metsue.
Probably painted c. 1660.
AMSTERDAM, Rijksmuseum
Most of Metsu's pictures depict bourgeois interiors and well-dressed people; this intimate scene is therefore unusual. The attitude of the fractious child is caught with the same care that Metsu usually lavished on fur and velvet. The painting of the Crucifixion in the background has been interpreted as having a moral meaning concerning the charity of the mother who is caring for the sick child, but it may be that this recent interpretation is going too far in the direction of supposing that every such picture must have an extra meaning.

The painting was acquired by the museum in 1928 from a Berlin collection.

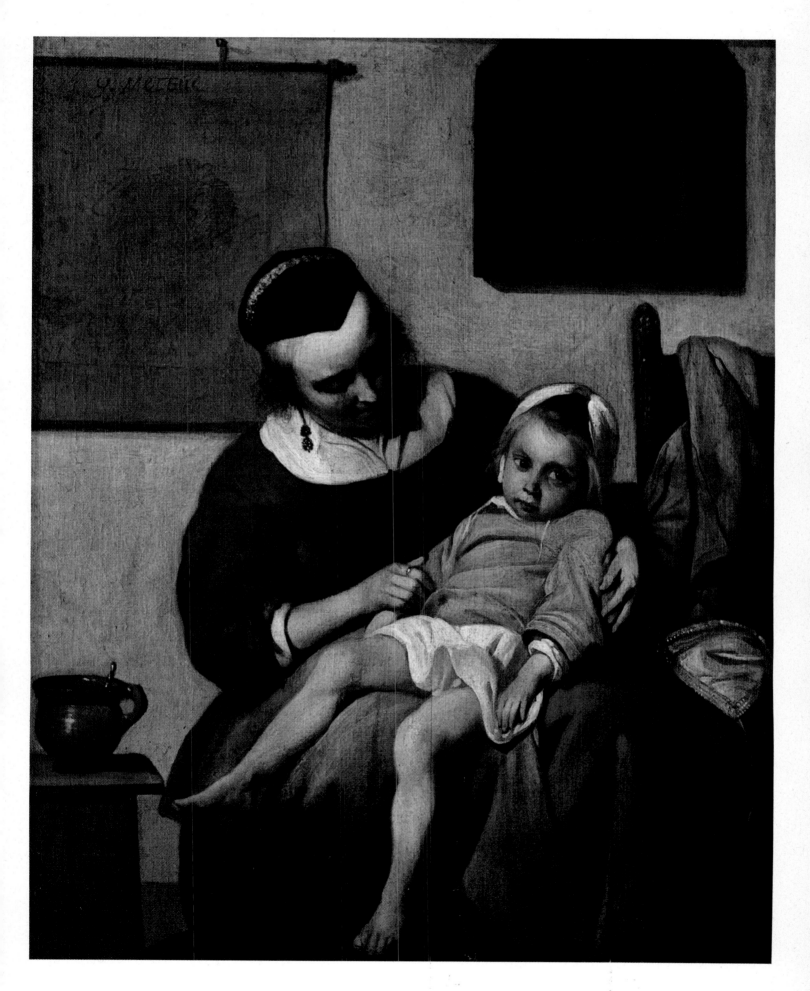

139

There must have been a considerable demand in Amsterdam for small, finely painted pictures of the type which made Dou so successful, and this could well be the reason why de Hoogh was lured from Delft c. 1660 in order to seek his fortune in Amsterdam. Metsu never had de Hoogh's interest in light and his pictures are usually quite gentle in their tonal contrasts. His most celebrated works are the pair in the collection of Sir Alfred Beit at Blessington, Co. Wicklow. In the *Man writing a Letter* he approaches Vermeer in composition. There is an open window with leading, as in the *Lady reading a Letter* by Vermeer at Dresden, and the man's pose and the treatment of the background wall also imply some relationship between the two artists. The pendant, the *Lady reading a Letter with her Maid,* is much more strident in colour and is thinner in texture than Vermeer ever was. It has also been subjected to an interesting interpretation as the maid lifts the curtain to show a seascape which has been seen as symbolizing the ship of life—it is a love letter which the lady is reading.

Aix-en-Provence; Amsterdam★; Berlin; Boston; Brunswick; Brussels; Cheltenham; Cleveland (Ohio); Copenhagen; Dresden; Florence (Uffizi); The Hague; Hamburg; Hanover; Jerusalem; Karlsruhe; Kassel; Leipzig; Leningrad★; London (National Gallery★, Wallace Collection); Los Angeles (Norton Simon Museum); Louisville (Kentucky); Madrid; Montpellier; Moscow; Munich; New York (Frick Collection, Metropolitan Museum); Oxford; Paris (Louvre, Petit Palais); Prague; Rome (Capitoline Museum); Rotterdam (Boymans-van Beuningen Museum, Vorm Foundation); Salzburg; San Diego; San Francisco; Schwerin; Stockholm; Upton House (Warwickshire); Venice (Cà d'Oro); Vienna; Waddesdon Manor (Buckinghamshire); Washington.

Interior Scene (The Intruder)
Panel 67 × 60 cm (26¼ × 23½ in) Signed on the bed: G. Metsu. Probably painted c. 1660.
WASHINGTON, National Gallery of Art (Mellon Collection)
Most of Metsu's interior scenes are much calmer and quieter than this one. Perhaps Metsu was influenced by Jan Steen's boisterous style and decided to paint this amusing subject. The disconcerted look on the lady's face as the smiling cavalier arrives in the room is brilliantly observed. Metsu's continual preoccupation with texture is also visible, especially in the velvet and fur-trimmed garment thrown casually over the chair at the right.

The picture was given by Andrew W. Mellon in 1937 as part of the foundation gift of the National Gallery.

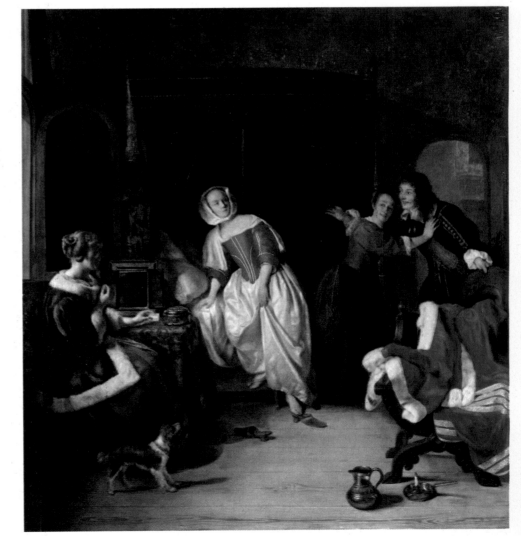

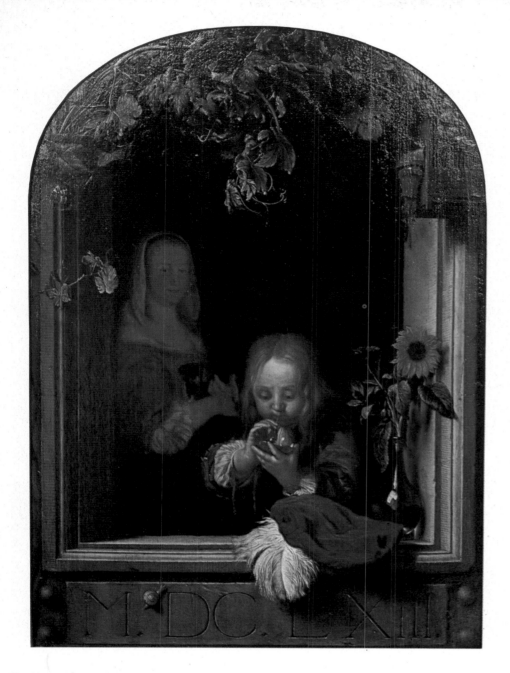

Boy blowing Bubbles at a Window
Canvas 25.2 × 18.4 cm (10 × 7¼ in)
Unsigned. Dated in large letters across the
bottom: MDCLXIII (1663).
BARNSLEY, Cannon Hall
*It was a common conceit of Dutch painters to
place their figures either at a window or leaning
out of it—a good example by Maes can be seen
on page 136. On one level this small panel is a
simple observation of a small boy amusing
himself with the pleasant pastime of blowing
bubbles, while an older woman watches him
from the background. But in the seventeenth
century bubbles were nearly always interpreted as
a symbol of the brevity of life. Each flower
also had a significance, and the large sunflower
in the vase on the window-ledge may also have
some extra meaning. The generally sombre
scheme was derived from Dou, who considered
Frans von Mieris to be his best pupil.*

 *The picture formed part of the collection made
by William Harvey of Barnsley (died 1867)
and it was bequeathed by his nephew in 1917
to form part of the National Loan Collection
Trust. After being on tour for two generations
the pictures were finally deposited on permanent
loan to Barnsley.*

Frans Jansz. van MIERIS the Elder

Leiden 1635—Leiden 1681

Frans van Mieris was the founder of a dynasty of genre and subject painters in
Leiden. He had two sons, Jan (Leiden 1660—Leiden 1690) and Willem van
MIERIS, who followed in his footsteps, and one grandson, Frans van Mieris the
Younger (Leiden 1689—Leiden 1763). Frans van Mieris himself was far from
being the eclectic painter which might be expected of a pupil of Gerard DOU;
instead he evolved his own distinctive style. This owed relatively little to Dou
except from the point of view of technique. He painted many small-scale
genre pictures of a very special type. They were highly finished and
concentrated on intimate subject matter, mostly of the merchant classes. This
type of painting seems to have been popular all over the country in the late
1650s and early 1660s—Nicolaes MAES in Dordrecht, Gerard TERBORCH in
Deventer and Gabriel METSU in Leiden and later in Amsterdam are examples.

Aix-en-Provence; Ajaccio; Amsterdam; Ascott (Buckinghamshire); Barnsley; Bayreuth;
Berlin; Bristol; Cherbourg; Copenhagen; Dresden; Erlangen; Florence (Pitti); Frankfurt;
Glasgow; The Hague; Hamburg; Karlsruhe; Kassel; Leiden; Lille; Leningrad; London
(National Gallery, Wallace Collection); Munich; Paris (Louvre, Petit Palais); Polesden
Lacey (Surrey); Rennes; Schwerin; Sibiu; Turin; Vienna (Academy); York.

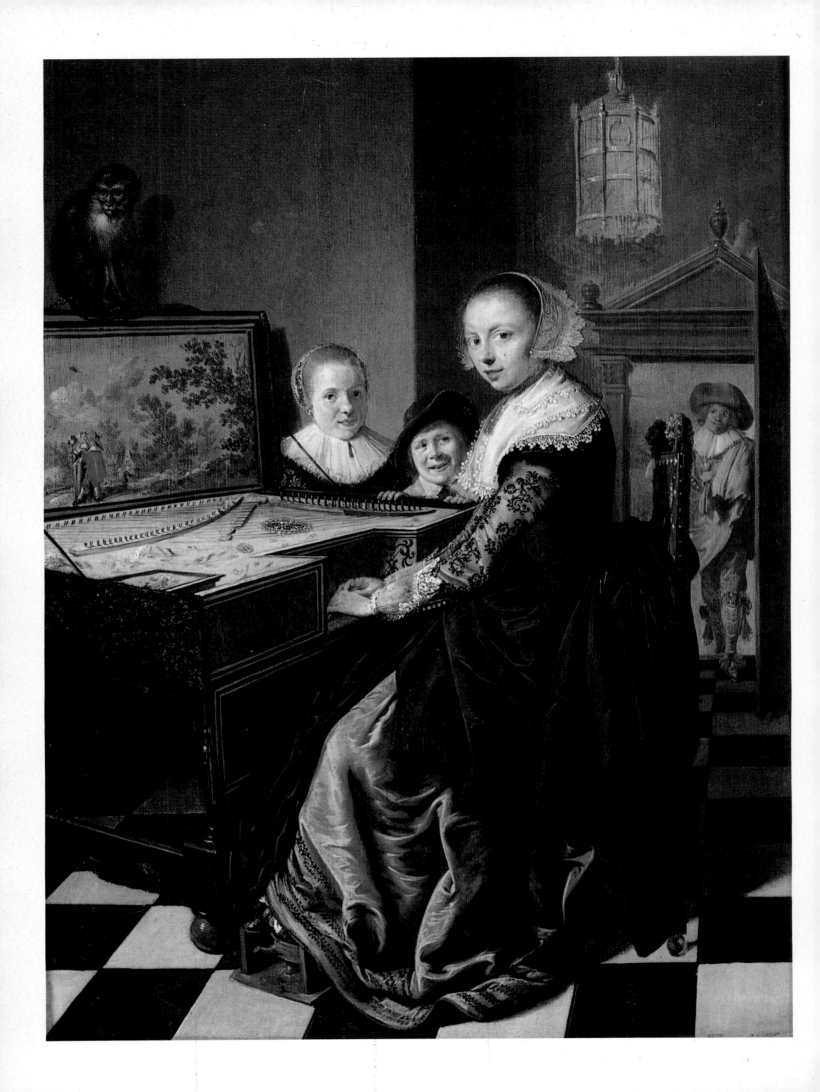

Interior with a Lady at the Virginals
Panel 38.5 × 29.5 cm (15¼ × 11¾ in)
Unsigned. There are illegible traces of an
inscription above the door. Probably
painted c. 1640.
AMSTERDAM, Rijksmuseum
The lady seems at ease, seated at her
instrument; the contrast with Vermeer's austere
treatment of the same subject in the National
Gallery, London, could not be greater. Here the
sitter is full of life and the children are playful.
The picture was formerly thought to be a
portrait of the artist's wife, Judith Leyster, and
her children, but modern scholarship suggests
otherwise.

The picture was in the celebrated van der
Hoop collection which was bequeathed to the
city of Amsterdam in 1854 and lent to the
Rijksmuseum in 1885.

Landscape with Travelling Figures
Panel 39.7 × 55.8 cm (15⅝ × 22 in) Signed
lower left: P mol(y)n. Probably painted in
the 1620s.
MAIDSTONE, Museum and Art Gallery
It was precisely this type of humble picture
which was to have such an influence on the
development of landscape painting in Haarlem.
This simple dunescape, catching perfectly the
lonely quality of the area around Haarlem, is
the distant ancestor of the masterpieces by
Jacob van Ruisdael. Molijn is a perfect example
of an artist whose modest talents allowed other
painters to build on his discoveries and to create
an entirely new style as did Ruisdael some
thirty years later. Jan van Goyen also painted
landscapes with travelling figures.

The picture was bequeathed to the museum
by Thomas Charles in 1855.

Jan Miensz. MOLENAER
Haarlem c. 1609/10—Haarlem 1668

Molenaer concentrated on small genre paintings of high finish and lively
subject matter. The main influence on his work was that of Frans HALS,
although Molenaer never imitated the great painter directly. He spent most
of his life in Haarlem and in 1636 he married the painter Judith LEYSTER, who
was also close to Hals in style. He spent the years 1637–48 in Amsterdam
and after that he lived in Heemstede near Haarlem with his wife. Molenaer's
pictures have often been confused with those of his wife.

Aix-en-Provence; Amsterdam; Bamberg; Barnard Castle; Boston; Bilbao; Bonn;
Bordeaux; Bourges; Bournemouth; Brighton; Brunswick; Brussels; Budapest;
Châteauroux; Cologne; Copenhagen; Cracow; Dijon; Dresden; Dublin; Dunkirk; Epinal;
Florence (Uffizi); Frankfurt; Ghent; Haarlem; The Hague; Indianapolis; Leipzig; London
(National Gallery, Victoria and Albert Museum); Lyons; Manchester; Nantes; Nimes;
Oldenburg; Paris (Louvre, Petit Palais); Philadelphia (Johnson Collection); Poitiers;
Richmond (Virginia); Schwerin; Strasbourg; Vienna; Warsaw.

Pieter de MOLIJN
London 1595—Haarlem 1661

Although he was born in London of Dutch parents, by 1616 Molijn had
become a member of the Haarlem guild of painters and he remained in the
town for the rest of his life. Along with Esaias van de VELDE and Jan van GOYEN,
in his early years Molijn was in the forefront of the painting of open dunescapes.
He was, unfortunately, not very imaginative and his art developed no further,
in marked contrast to van Goyen, who was constantly experimenting with
new approaches. Nevertheless, Molijn's pictures are pleasant and open, and
they catch very well the bleak feeling of the endless sand dunes which protect
Haarlem and the surrounding area from the ravages of the stormy North Sea.

Aix-en-Provence; Amsterdam; Basle; Birmingham (Barber Institute); Berlin; Bonn;
Bremen; Brunswick; Budapest; Cambridge; Cologne; Copenhagen; Florence (Pitti);
Geneva; Gothenburg; Haarlem; The Hague (Bredius Museum); Hanover; Maidstone;
Mainz; Minneapolis; New York; Oldenburg; Poznan; Prague; Quimper; Rotterdam;
Salzburg; Sibiu; Stockholm; Venice (Ca d'Oro); Vienna (Academy).

Aert van der NEER

Amsterdam 1603/4—Amsterdam 1677

Aert van der Neer is beloved of collectors as the perfect painter of both night scenes and skating scenes. He was equally good at both genres and his pictures have the additional attraction of being easily recognizable and not readily confused with the work of other painters. His style hardly changed at all throughout his career, which was mostly spent in Amsterdam, and it is recorded that he became bankrupt in 1662. Little else is known about van der Neer's life.

Although van der Neer's pictures are frankly repetitive, they are often far more subtle than a first glance would suggest. He had great ability in the depiction of trees and water seen under the effect of moonlight, the pre-

River Scene by Moonlight
Canvas 64.8 × 81 cm (25½ × 32 in) Signed. Undated.
LEEDS, City Art Gallery
As in all van der Neer's work of this type, the picture is calm, well-observed and picturesque. He was one of the few painters who could convincingly paint moonlight scenes and many of his pictures therefore have a delicate silvery tone. Seemingly effortless and unfortunately slightly boring when seen in more than two examples together, a picture of this complexity required enormous skill to produce it. The seemingly empty landscape is full of half-hidden figures.

This painting was bought by the museum in 1951.

Winter Scene with Skaters
Canvas 64 × 79 cm (25¼ × 31 in) Signed in
monogram on the left: AV DN. Undated.
AMSTERDAM, Rijksmuseum
*This picture represents the other side of van der
Neer's skill. There is a well-observed feeling of
cold light and shimmering detail as the skaters
move over the ice. Some figures are almost seen
to shiver as the others keep warm by moving.
Snow and ice scenes were very popular and
many artists did a few, as well as specialists like
Hendrick Avercamp and Aert van der Neer.*

*Like so many of the best Dutch pictures in
the Rijksmuseum this work was in the van der
Hoop collection which was bequeathed to the
city of Amsterdam in 1854 and lent to the
Rijksmuseum in 1885.*

dominant colours being dark brown and silver. His ice scenes, too, are full of
sensitivity; the figures are lively and well-observed, in the tradition of
Hendrick AVERCAMP. He also occasionally painted scenes of fires, but these
are much rarer.

It is likely that his son Eglon van der NEER was born in Amsterdam in
1634; Eglon's career and style of painting were to be totally different from
those of his father. Aert van der Neer was much copied both in his
lifetime and in the eighteenth century; copyists seem to have been able to
grasp his highly skilled style of painting moonlit river scenes and produce
the most cunning pastiches. In the eighteenth century the vogue for
romantic landscapes often led painters to imitate van der Neer instead of
creating their own style. Thus—although this is not often realized—van
der Neer can be said to have been one of the most influential Dutch
painters.

Aachen; Amiens; Amsterdam★; Antwerp; Arnhem; Aschaffenburg; Avignon; Barnsley;
Berlin; Brighton; Brunswick; Brussels; Budapest★; Cape Town; Carcassonne; Cologne;
Copenhagen; Cracow; Darmstadt; Detroit; Dordrecht; Dresden; Dublin; Frankfurt; Genoa
(Palazzo Bianco); Glasgow; Gotha; Göttingen; The Hague (Bredius Museum, Mauritshuis);
Hamburg★; Karlsruhe; Kassel; Leeds; Leipzig★; Leningrad; London (Dulwich, National
Gallery, Victoria and Albert Museum, Wallace Collection, Wellington Museum);
Manchester; Montpellier; Munich; New York; Norwich; Nottingham; Oldenburg; Paris
(Louvre, Petit Palais); Philadelphia (Johnson Collection); Polesden Lacey (Surrey); Prague;
Richmond (Virginia); Rotterdam (Boymans-van Beuningen Museum, Vorm Foundation);
Salzburg; Schwerin; Stockholm (Nationalmuseum, University); Vienna; Warsaw;
Worcester (Massachusetts); Würzburg.

Eglon Hendrik van der NEER
Amsterdam 1634—Düsseldorf 1703

In direct contrast to his father AERT VAN DER NEER, Eglon van der Neer's career was remarkably international. According to Arnold Houbraken, at the early age of 19 Eglon was already in the service of the Dutch Governor of the Principality of Orange in the south of France. He then spent much of his time at Rotterdam and in 1679 moved to Brussels, where he remained for ten years. In 1690 he became court painter to the Elector Palatine at Düsseldorf, where he spent the rest of his life. He is one of the chief representatives of the international trend in Dutch art late in the century.

Most of the artist's work consists of small, highly finished genre pieces painted in a polished style which was much appreciated by princely patrons in the last years of the seventeenth century. Although Eglon was famous in his lifetime, today the situation is exactly reversed, and his father's work is much sought after.

Aix-en-Provence; Amsterdam; Antwerp; Augsburg; Barnsley; Béjar (Spain); Boston; Brunswick; Chicago; Copenhagen; Dublin; Florence (Pitti); Glasgow; Hull; Karlsruhe; Leningrad; Lille; London (National Gallery, Wallace Collection, Wellington Museum); Lyons; Montpellier; Munich; Nottingham; Nuremberg; Paris; Prague; Rotterdam; Schwerin; Speyer; Stockholm (University).

Boys playing with a Bird's Nest in a Landscape
Panel 26.5 × 20 cm (10⅜ × 8 in) Unsigned.
NOTTINGHAM, Castle Museum and Art Gallery
The careful recording of this boyish activity and the artist's rather brittle and polished handling must have appealed to the demand for anecdote in pictures. After the middle of the seventeenth century artists tended to paint fewer tavern and barrack-room scenes and concentrate on this altogether more gentle recording of the realities of life. The date of this picture is uncertain as the artist's chronology has not yet been worked out.

The picture was bequeathed to the museum in 1904 by Richard Godson Millns along with 140 other Dutch and English pictures.

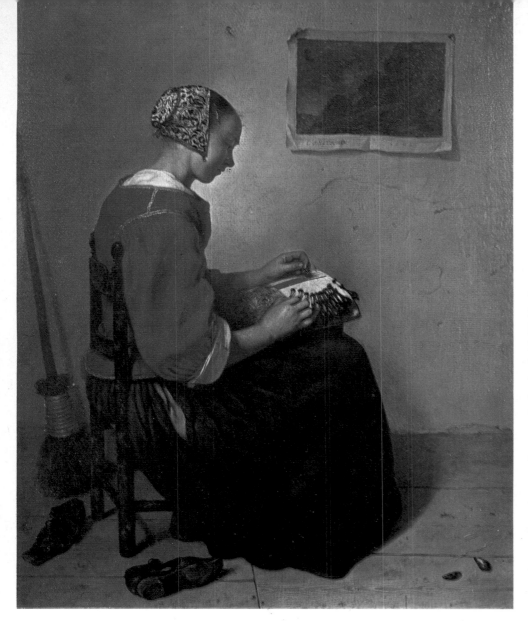

The Lacemaker
Canvas 34 × 28 cm (13½ × 11⅛ in) Signed and dated on the mount of the engraving hanging on the wall: C. Netscher 1664.
LONDON, Wallace Collection
This is Netscher's most famous picture, epitomizing domestic content and industry and painted at exactly the same time as Vermeer's mature masterpieces. Netscher was living at The Hague, some five miles from Delft, and therefore it is even likely that there was some contact between them. Very few of Netscher's other pictures are quite so detached and simple, both in composition and colour scheme. Since the picture's recent cleaning it has emerged much crisper and much closer to Vermeer in style than it formerly appeared under several coats of yellowing varnish.
The painting was first recorded in 1780 and was repeatedly sold until 1807 when it became part of the collection of the 3rd Marquess of Hertford. The picture was bequeathed to the nation in 1897 along with the rest of the collection by Lady Wallace.

Caspar NETSCHER
Heidelberg 1639—The Hague 1684

The place and date of the artist's birth are still in dispute—the early sources disagree. Most of his career was spent in The Hague, although Houbraken notes that as a young man Netscher was a pupil of Gerard TERBORCH at Deventer. This would explain the origins of the style of his portraits, most of which are small and highly finished. They never have Terborch's detached melancholy and this may explain Netscher's success as court painter at The Hague. He also painted a number of carefully finished genre pictures and there is almost a hard-edged realism in the way that some of them are painted. There is no exquisite blurring of the edges as is found in Gabriel METSU; instead each object is minutely detailed in a three-dimensional way.

Amsterdam★; Antwerp (Musée Mayer van den Bergh); Aschaffenburg; Barnsley; Berlin; Boston; Brunswick; Budapest; Chicago; Copenhagen; Darmstadt; Dessau; Dijon; Dresden; Frankfurt; Geneva; Glasgow; Gotha; The Hague (Gemeentemuseum); Hamburg; Hanover; Heidelberg; Karlsruhe; Kassel★; Leipzig; Leningrad; London (National Gallery, National Portrait Gallery, Wallace Collection★, Wellington Museum); Lyons; Manchester; Munich; New York; Nîmes; Paris; Philadelphia (Johnson Collection); Pittsburgh; Potsdam; Quimper; Rotterdam; Salzburg; Schwerin; Sibiu; Speyer; Stockholm; Stettin; Strasbourg; Stuttgart; Turin; Utrecht; Waddesdon Manor (Buckinghamshire).

Jacob OCHTERVELT
Rotterdam 1634—Amsterdam 1682

In common with many minor artists of talent, very little indeed is known of Ochtervelt's career. It is established that by 1655 he was working in Rotterdam, but even without this evidence it could be assumed that he had some knowledge of the Delft school of painting, especially that of Pieter de HOOGH. Indeed, Houbraken notes that Ochtervelt was Nicolaes BERCHEM's pupil at the same time as Pieter de Hoogh. Most of Ochtervelt's relatively few surviving pictures are crisply painted middle-class interiors whose patterns and hard edges sometimes look like caricatures of VERMEER's style. He also liked to set his elaborately dressed figures against an expanse of bare wall and contrasted this with areas of highly concentrated detail such as carpets on tables and beautifully painted silk.

Amsterdam; Antwerp (Musée Mayer van den Bergh); Berlin; Birmingham★; Brunswick; Brussels; Budapest; Chicago; Cologne; Copenhagen; Dublin; Frankfurt; Glasgow; Hamburg; Karlsruhe; Leipzig; Leningrad; London; Manchester★; Pittsburgh; Poznan; Raleigh (North Carolina); Rotterdam; St. Louis; Stockholm; Vienna; Warsaw; York.

Interior: The Music Lesson
Canvas 97 × 76 cm (38¼ × 30¾ in)
Unsigned. Probably painted c. 1670 on grounds of costume.
BIRMINGHAM, City Museum and Art Gallery
This is considered to be one of Ochtervelt's best pictures. The brilliance of the texture of the lady's dress is reminiscent of Terborch but the sparseness of the interior and the man's pose seem derived from pictures like Vermeer's Interior with a Lady and a Gentleman *at Brunswick. Not all Ochtervelt's pictures are up to the standard of this one; so often in Dutch art minor painters produce one or two masterpieces and spend the rest of their lives producing competent but derivative work.*

The painting was in the collection of Ernest Cook of Bath, who, on his death in 1955, directed that his pictures should be dispersed to the museums of England outside London. This one was sent to Birmingham.

The Fish-Seller
Canvas 36.5 × 39.5 cm (14¼ × 15¼ in)
Signed and dated lower centre:
A V Ostade 1672.
AMSTERDAM, Rijksmuseum
*Most Dutch towns and villages were on or near
the sea and fishmarkets must have been a
common sight everywhere. There is the
impression in this picture that it is market day,
as there is much activity on the left-hand side.
Van Ostade had a beautiful sense of composition
and used restrained but not dull colour.*

*This painting was first recorded in an
Amsterdam sale in 1771 and was given to the
museum in 1936 by one of its most generous
twentieth-century benefactors, Sir Henry
Deterding. (He also gave Vermeer's* Little
Street).

Adriaen Jansz. van OSTADE

Haarlem 1610—Haarlem 1685

Adriaen van Ostade created a style of genre painting which could be described
as typically Dutch and has been the source of both ridicule and admiration.
'Beggars, bordellos, children on their pots and worse' sums up his lively art.
He spent his whole career in Haarlem except for a few brief visits to
Amsterdam. He is one of the few Haarlem genre painters who worked
independently of Frans HALS and instead was influenced by the important
Flemish painter Adriaen Brouwer. (d. Antwerp 1636).

Brouwer occupies an awkward position in the history of seventeenth-
century painting as he evolved his style in Flanders, then brought it briefly
to Haarlem, where he worked during the 1620s—probably as a pupil of Frans
Hals. It was on Brouwer's sketchy and powerful style that Adriaen van Ostade

built. He refined it into something altogether more precise; his figures are not violent and do not appear to be under the influence of drugs, as those of Brouwer often do.

Adriaen van Ostade always contrives to make his interiors look messy. Full of people, they are littered with the unswept debris of daily life. Chamber pots sit ostentatiously in his foregrounds and drunken peasants vomit in front of their friends. Quite obviously there was an enormous market for this type of picture for van Ostade was extensively copied and imitated. His brother Isaac (Haarlem 1621—Haarlem 1649) was also a painter of consequence. In his early period he was close in style to Adriaen and then painted several particularly good winter scenes of which a typical example is in the National Gallery, London.

Both painters have been somewhat neglected by writers on Dutch art. Isaac was the more subtle, especially in the handling of open-air effects. Adriaen was at his best in the interior scenes; one of the most outstanding is the *Peasant Family at Home*, which is in the British Royal Collection. Lovingly painted, it forms a delightful (if slightly disconcerting) record of daily life in the 1660s—it is dated 1668. There is a feeling that the home has seen better days; the elaborate lattice window is partly blocked and in a state of decay. The peasant couple with their two small children seem happy in their disarray. There seems to be no moral significance in the picture such as would be found in a Jan STEEN of a similar style—there is no suggestion that the household is dissolute. The couple inhabit a world of bare floors and peeling plaster in a perfectly natural way.

Both brothers deserve to be better known as painters of ability, even if their subject matter, lacking as it does Jan Steen's moralizing qualities, does not appeal to late-twentieth-century taste.

Allentown (Pennsylvania); Amiens; Amsterdam★; Antwerp (Musée des Beaux-Arts, Musée Mayer van den Bergh); Ascott (Buckinghamshire); Augsburg; Barnsley; Bath; Berlin; Boston; Brunswick; Brussels; Budapest; Caen; Cambridge; Chicago; Copenhagen; Dessau; Dresden; Frankfurt; Haarlem★; The Hague (Bredius Museum); Hamburg; Helsinki; Innsbruck; Kassel; Lille; Leipzig; Leningrad★; London (Dulwich, National Gallery, Victoria and Albert Museum, Wallace Collection, Wellington Museum); Madrid; Magdeburg; Manchester; Meiningen; Montpellier; Munich; New York; Otterlo; Oxford; Paris (Louvre,★ Petit Palais); Philadelphia (Johnson Collection); Polesden Lacey (Surrey); Prague; Rotterdam (Boymans-van Beuningen Museum, Vorm Foundation); Salzburg; Schwerin; Speyer; Stockholm (Nationalmuseum, University); Strasbourg; Tourcoing; Vienna (Academy, Kunsthistorisches Museum); Waddesdon Manor (Buckinghamshire); Warsaw; Washington; Wroclaw.

Interior of an Alehouse
Panel 44 × 35.5 cm (17¼ × 14 in) Signed and dated lower right: AV Ostade 1650. AMSTERDAM, Rijksmuseum
In this example of van Ostade's low-life painting the peasants are relatively well-behaved: they are simply getting quietly drunk on ale. The determined old woman in the centre is a particularly memorable image. As in all van Ostade's authentic pictures, the technique is near-perfect. His brushwork is very precise and his colours delicately muted.

The picture was first recorded in the Hendrik Sorgh sale, Amsterdam, 1720. It was acquired by the Rijksmuseum in 1908.

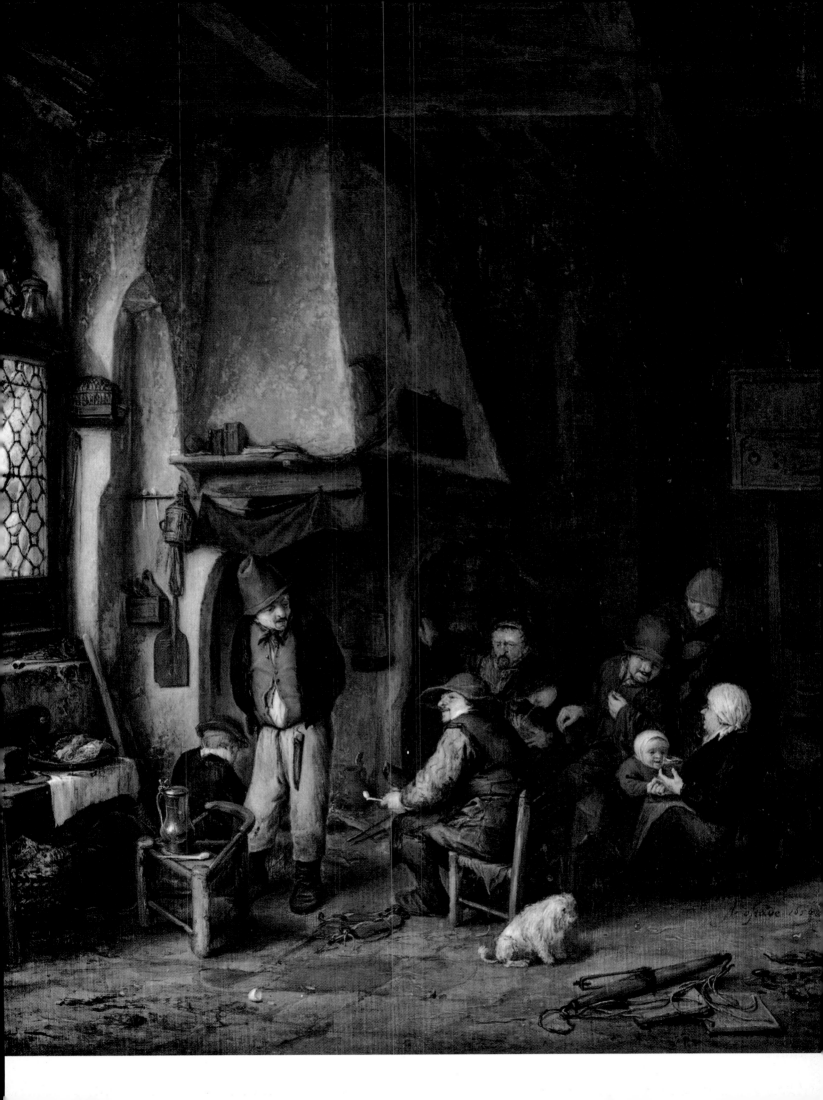

Anthonie PALAMEDESZ.
Delft 1601—Amsterdam 1673

Palamedesz. was a pupil in Delft of Michael Jansz. van Mierevelt (1567–1641), but this portrait painter had little influence on his style. Instead, Palamedes concentrated on genre pieces which were much closer to the Haarlem and Amsterdam painters like Dirck HALS and Pieter CODDE. His pictures are always small in format and highly polished, depicting elegant interiors with well-dressed people making merry, playing music or playing cards. He often used an intense black for his figures which contrasts strongly with the white collars and other accoutrements.

Alençon; Amsterdam; Antwerp; Berlin; Boston; Brunswick; Brussels; Budapest; Cologne; Copenhagen; Douai; Dublin; Dunkirk; Glasgow; Grenoble; Hanover; Karlsruhe; Leiden; Leipzig; Leningrad; Lille; Montauban; Nantes; Nottingham; Paris (Louvre, Petit Palais); Philadelphia (Johnson Collection); Poitiers; Rotterdam; Schwerin; Stockholm; Stuttgart; Vienna; Warsaw.

Cornelis van POELENBURGH
Utrecht 1586 (?)—Utrecht 1667

Poelenburgh spent about ten years in Italy after 1617 and it was there that his style was formed. Unlike so many painters who returned northwards, he hardly changed his style again. Poelenburgh was the most prolific and successful painter of the small, highly finished type of Italianate landscape. More inventive than his contemporary Bartholomeus BREENBERGH, he also differed from the younger generation of Italianate landscape painters like Nicolaes BERCHEM and Jan BOTH because he never expanded his style into larger romantic compositions.

Almost all the artist's early pictures show an unmistakable debt to the art of the German painter Adam Elsheimer (Frankfurt 1579—Rome 1610). This must largely have been through the medium of engravings, as Elsheimer's few pictures were already scattered or in Rubens's collection by the time that Poelenburgh was in Rome. His figures, however, were not derived from Elsheimer; most of his landscapes are peopled with well-rounded men and women bathing or simply resting in the landscape. Even though Poelenburgh and Breenbergh painted very similar subjects, it is these figures which usually give Poelenburgh away.

His pictures were much sought-after in their own time and he was summoned to London by Charles I. Some of his pictures are still in the British Royal Collection. He had many followers, and the classicizing landscapists of the end of the seventeenth century, especially in Utrecht, owed just as large a debt to Poelenburgh as they did to the French landscapists.

Aix-en-Provence; Amiens; Amsterdam; Antwerp; Aschaffenburg; Basle; Bordeaux; Boston; Bourg-en-Bresse; Bristol; Brunswick; Cambridge; Copenhagen; Dijon; Florence (Pitti); Frankfurt; Glasgow; Gray; Hartford (Connecticut); Karlsruhe; Kassel; Leipzig; Leningrad; Libourne; Lille; London (Dulwich, National Gallery, Wellington Museum); Malibu (California); Manchester (Whitworth Institute); Milan; Montpellier; Nantes; Oldenburg; Paris; Rochefort; Schwerin; Sibiu; Stuttgart; Turin; Utrecht*; Vienna (Academy, Kunsthistorisches Museum).

Figures in an Interior
Panel 54 × 88.5 cm (21½ × 35 in) Signed and dated underneath the left hand picture in the background: A. Palamedes 1633.
AMSTERDAM, Rijksmuseum
As this is a merry-making scene depicting the merchant classes, the company is well-behaved and well-dressed. The two seated figures in the centre of the composition are looking out of the picture, almost as if they are conscious of being painted. The seascape paintings on the wall are very close in style to the Flemish painter Jan Porcellis (Ghent c. 1584–Soutermonde 1632) who spent much of his career in the United Provinces painting a simple type of monochromatic seascape which was to be highly influential.

The painting was bought by the Rijksmuseum in 1900.

View of the Campo Vaccino, Rome
Copper 40 × 55 cm (15¾ × 21¾ in)
Unsigned. Dated on the fountain MDCXX (1620).
PARIS, Musée du Louvre
Innumerable pictures of this type were produced in the 1620s by Northern artists resident in Rome, especially by Poelenburgh. There seems to have been an enormous demand for them, both locally and for export back to the North. The ruins of the forum and adjacent buildings had become partly buried with centuries of rubbish and debris so that there was, in effect, a large open space in the centre of the city. The Castel Sant' Angelo is just visible in the background.

This picture, along with its pendant (which also depicts Roman ruins) was confiscated by the French Republic in 1794 from the collection of Catherine de Cossé-Brissac and has remained in the Louvre ever since.

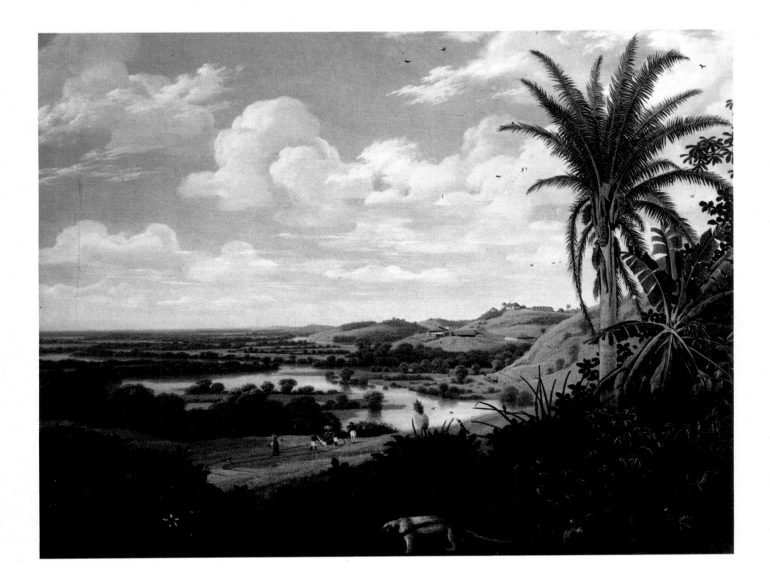

Frans POST

Leiden c. 1612—Haarlem 1680

The artist is known only for his landscapes depicting the topography of Brazil. He accompanied Prince Maurice of Nassau-Siegen to Brazil, part of which was then a Dutch colony, during the years 1637–44. On his return to Haarlem he continued to paint Brazilian scenes, mostly of Dutch trading stations or their immediate environs. The handling of his pictures is often pedestrian but they are highly prized today because of their subject matter. Shorn of the trappings of palm trees and exotic creatures, these works owe much to the contemporary landscape painters in Haarlem with their open skies, low horizons and cool colour schemes. His pictures are relatively rare.

Amsterdam (Rijksmuseum, Scheepvaart Museum); Basle; Berlin; Cologne; Copenhagen; Detroit; Dublin; Düsseldorf; Frankfurt; The Hague; Hartford (Connecticut); Karlsruhe; Liège; Leningrad; Madison (Wisconsin); Mainz; Munich; Nuremberg; Paris; Prague; Richmond (Ham House); Rio de Janeiro; Rotterdam; São Paolo; Sarasota (Florida); Schwerin; Siegen; Washington (Catholic University of America).

Brazilian Landscape with an Ant-Eater
Panel 53 × 69.4 cm (21 × 27½ in) Signed and dated on the trunk of the palm tree: F.POST 1649.
MUNICH, Alte Pinakothek
Painted five years after Post's return from Brazil, the exotic quality of the landscape is limited to the conspicuous palm tree and the ant-eater in the foreground. Otherwise the landscape distance is reminiscent of Philips Koninck, and the hills are like the enlarged sand dunes so popular with the Haarlem painters of the previous generation such as Pieter de Molijn and Jan van Goyen in his early phase. Indeed, it is astonishing that the artist was able to continue painting in this manner for the rest of his career, long after this type of landscape had gone out of fashion.

The picture was in the collection of King Maximilian I of Bavaria in the nineteenth century.

Hendrick Gerritsz. POT
Haarlem before 1585—Amsterdam 1657

Pot probably spent his early years in Haarlem, because he is recorded as having become a member of the Haarlem painters' guild in 1626. He visited London in 1632 (where he painted at the court of Charles I) and in the following year he returned to Haarlem. The last years of his life were, however, spent in Amsterdam.

In spite of a possible early training with van Mander, who was the most influential man on the artistic scene in Haarlem in the last years of the sixteenth century and who had been responsible for the foundation of an academy of painting there, Pot really looked to Frans HALS for his source of inspiration. Many of his delightful small portraits have much of Hals's insight, although they are much less freely painted. His *Portrait of Charles I, Henrietta Maria and Charles, Prince of Wales* forms a record which is perhaps more accurate than the masterpieces by Van Dyck, who imbued his sitters with such aristocratic melancholy. Pot also painted a number of small interior scenes in the manner of Dirck HALS which often show rollicking humour in an austere setting of bare walls and floors. An especially good example is in the National Gallery, London.

The artist's most important picture is the *Group Portrait of the Officers of the Civic Guard of St Adrian at Haarlem* in the Frans Hals Museum, Haarlem. This picture dates from 1630, three years after the same officers had been painted by Frans Hals himself. Although many pictures by Pot survive, they are surprisingly rare in museums.

Aachen; Amsterdam; Berlin; Cambridge; Chantilly; Dresden; Dublin; Ghent; Gouda; Haarlem★; The Hague (Bredius Museum, Mauritshuis); Indianapolis; Le Havre; Leipzig; Leningrad; London (National Gallery, Wallace Collection); Mainz; Malibu (California); New York; Paris (Louvre, Petit Palais); Prague; Rotterdam; Stockholm (Hallwylska Museet).

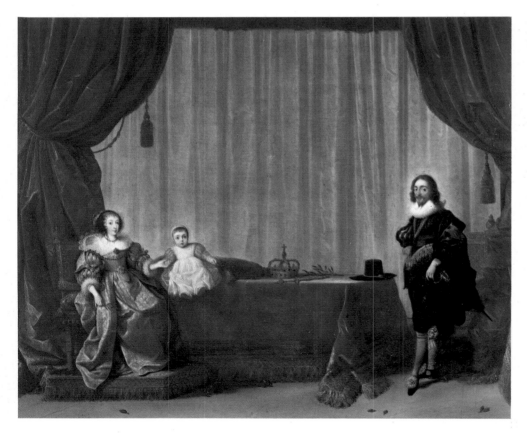

Charles I, Henrietta Maria and Charles, Prince of Wales
Panel 47.3 × 59.8 cm (18⅝ × 23½ in)
Unsigned. Probably painted in 1632.
LONDON, Royal Collection
(reproduced by gracious permission of Her Majesty the Queen)
The historical importance of this painting has been overlooked; it is an example of how Charles I sought out some of the leading artists of his day to give visible form to the theory of the divine right of kings. Unlike Van Dyck, however, Pot favoured small figures against large backgrounds. In 1632 England was at peace; this is symbolized by the olive branch on the table, while the laurels of war lie scattered underfoot.

The painting was acquired in 1814 by George IV, having presumably left the Royal Collection during the Commonwealth.

Paulus POTTER

Enkhuizen 1625—Amsterdam 1654

Although he only lived to the age of 28, Potter made an original contribution to the already established genre of animal painting. He observed directly from nature, and his compositions do not seem to be related to those of other artists. Indeed, his ability as a landscape artist is often ignored as landscape usually forms a subordinate element in his pictures, but his observation of rain-soaked and sunlit distances and the fall of light on trees is only parallelled by Adriaen van der VELDE's celebrated *Farm* at Berlin.

Surprisingly little is known about the artist's life. He was in Delft c. 1646–9 and The Hague 1649–52; the remaining two years of his life were spent in Amsterdam. He seems to have been oblivious to the current artistic trends in the towns in which he lived, preferring his own way of looking at cows and, from time to time, other animals. On rare occasions his pictures show some similarity with those of Karel DU JARDIN, although Potter avoided the Italianate settings in which Du Jardin placed his animals and figures.

Potter's subject matter is confined exclusively to animal painting—cows frightened by an oncoming storm or relaxing on a warm evening. Occasionally the animals form part of a subject picture; a good example is the *Orpheus Charming the Animals* of 1650 in the Rijksmuseum, Amsterdam. As far as can be ascertained the artist did not become famous in his own lifetime. The

The Young Bull
Canvas 235.5 × 339 cm (93 × 133¾ in)
Signed and dated: Paulus Potter F. 1647.
THE HAGUE, Mauritshuis
This is the most famous painting of its type, but it has suffered from over-reproduction and many critics have found difficulty in admiring it. Fromentin, in his Masters of Past Time *(1875), devoted a whole chapter to Potter and concentrated on* The Young Bull *in particular: 'The Bull at the Hague represents him perfectly—charm alone excepted. It is a great study—too great from the common sense point of view, but not too great for the research of which it was the object, nor for the instruction which the painter derived from it.' The artist was only 22 when he painted the picture and, along with Aelbert Cuyp's Large Dort in the National Gallery, London, which also dates from the late 1640s, it must be seen as a triumphant achievement despite the prosaic subject matter. The landscape background, as is often found in his pictures, is freshly and lovingly painted.*

The picture formed part of the celebrated cabinet of Prince William V of Orange (1748–1806) which was to form the basis of the present Mauritshuis.

Two Horses in a Landscape

Panel 23 × 30 cm (9 × 11¾ in) Signed and
dated on the fence: Paulus Potter f. 1649.
AMSTERDAM, Rijksmuseum
*One of Potter's special qualities is that the
horses are seen as part of the landscape and
not just as clever animal studies with a landscape
background. Quite often, Potter's animals have
an expression of surprise or unease on their
faces and this is certainly the case with the
dark brown horse here. It was this type of
painting which was to be most valued by
collectors in the eighteenth and nineteenth
centuries.*

*The picture was bequeathed to the city of
Amsterdam in 1854 by the great collector
A. van der Hoop along with Vermeer's
Lady reading a Letter.*

only evidence which survives about his patrons is Houbraken's remark in 1719
that Potter was persuaded to leave The Hague for Amsterdam by Dr Nicolaes
Tulp. He painted an equestrian portrait of the latter's son in 1653 which is
in the Six Collection, Amsterdam. Some of Potter's pictures have a naughty
sense of humour. An example is the *Young Thief* in the British Royal
Collection, where a child rushing out of a stable is pursued by an angry
dog which is clutching his coat-tails.

Potter must have worked immensely hard in his short life, as he left behind
a relatively large number of paintings. He also made several etchings of
animals which are of very high quality.

Amsterdam★; Berlin; Baroda (India); Brussels; Budapest; Copenhagen; Dijon; Dresden;
Dublin; The Hague★; Hamburg; Innsbruck; Kassel; Leningrad★; London (National
Gallery, Wallace Collection); Lyons; Madrid; Malibu (California); Manchester; Milan;
Montpellier; Munich; Paris★; Rome (Galleria Borghese); Sarasota (Florida); Salzburg;
Schwerin★; Turin; Washington; Warsaw.

Adam PIJNACKER (Pynacker)

Pijnacker (near Delft) 1622—Amsterdam 1673

According to Houbraken, Pijnacker spent some three years in Italy and on grounds of style it would be reasonable to assume this from his work. He also painted a number of pictures of specifically Mediterranean subject matter although they cannot always be precisely identified. Most of Pijnacker's small pictures are quite close in style to those of Jan BOTH, the main difference being that Pijnacker preferred brighter colours and more frequently introduced strong blues, rather in the manner of Nicolaes BERCHEM. In his use of sharp contrasts of light and shade and picturesque, sometimes riotous vegetation, Pijnacker could be said to be the most romantic and imaginative of the Italianate landscape painters. His career was uneventful—the early part of it was spent in Delft and he then moved to Amsterdam, where he spent most of his life.

Aachen; Amiens; Amsterdam; Antwerp; Aschaffenburg; Augsburg; Barnsley; Berlin; Brunswick; Budapest; Cambridge; Copenhagen; Dijon (Musée Magnin); Frankfurt; Gotha; The Hague (Bredius Museum); Hamburg; Hartford (Connecticut); Karlsruhe; Kassel; La Rochelle; Le Mans; Lille; London (Dulwich★, Wallace Collection★); Montpellier; Munich; Nîmes; Nottingham; Paris (Louvre, Musée des Arts Decoratifs); Rotterdam; Stockholm; Vienna (Academy, Kunsthistorisches Museum).

Landscape with Sportsmen
Canvas 137.8 × 198.7 cm (54¼ × 78¼ in)
Signed: A Pynacker. Probably
painted in the 1660s.
DULWICH, Alleyn's College of God's Gift
This is one of Pijnacker's largest and most ambitious compositions. The artist has concentrated on the decorative effect of the picturesquely arranged trees and the almost exaggeratedly bright scheme in which cool yellows and blues predominate. Pictures of this type were to have an enormous influence on the development of romantic landscape painting in the eighteenth century, especially on such French painters as François Boucher.

The painting was bequeathed along with some 400 other pictures to the college in 1811 by Sir Peter Francis Bourgeois.

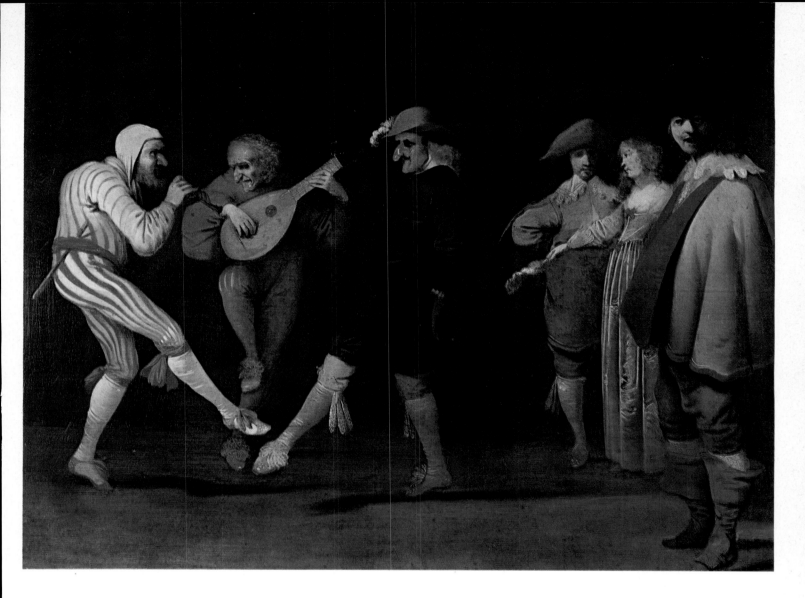

Comedians Dancing
Panel 41 × 55 cm (16 × 21⅝ in)
Signed lower left: ter Quas.
Probably painted about 1630.
PARIS, Musée de la Comedie Francaise
Theatre scenes are relatively rare in Dutch
seventeenth-century painting, although many
different artists occasionally did a picture of this
type. The three actor/dancers on the left are
contrasted with the three spectators on the right.
The cavalier-type figure on the extreme right
staring quizzically out of the picture adopts a
pose favoured by Quast for his single-figure
portraits; a good example is in the National
Gallery, London.
This picture was given to the museum by
Etienne Arago in 1869.

Pieter Jansz. QUAST
Amsterdam 1606—Amsterdam 1647

The reputation of Quast has been obscured by the fact that his excellent little genre scenes have often been confused with those of Pieter CODDE. He specialized almost exclusively in genre scenes, quite often of a bawdy type. His pictures always have a personal element of exaggeration—not just extravagent gestures: his characters are troubled, shy, or downright mischievous. His pictures are usually quiet, even sombre in colour and never have the glitter of those by Jan MOLENAER.

Like so many artists of his type the details of his career are scant. He moved several times; the place of his artistic education is not known. He was recorded in Amsterdam in 1632 and in the following year became a member of the painters' guild at The Hague. By the beginning of 1644 he had returned to Amsterdam, where he spent the last three years of his life.

It has been suggested that he could have seen pictures by the Flemish artist Adriaen Brouwer in Amsterdam, but any such influence cannot explain his very personal interpretation of character. At the present time his pictures are relatively rare; many more probably remain to be discovered masquerading under the names of other artists.

Amsterdam (Rijksmuseum, Theatre Museum); Antwerp (Musée Mayer van den Bergh); Arnhem; Bamberg; Brunswick; Budapest; Dole; Hamburg; Karlsruhe; Kassel; Leipzig; Leningrad; London; Los Angeles; Nîmes; Paris (Musée de la Comedie Française); Vienna; Wroclaw.

159

REMBRANDT Harmensz. van Rijn

Leiden 1606—Amsterdam 1669

Rembrandt is now thought to be the greatest Dutch painter and also one of the greatest painters of all time. His pre-eminent position is, however, a relatively recent one; eighteenth- and nineteenth-century connoisseurs and critics preferred Gerrit DOU and Nicolaes BERCHEM.

The artist's life was relatively uneventful and the all-too-few known facts do little to explain the development of his genius. Born the son of a Leiden mill owner, the young Rembrandt attended the local university in 1620 but in the following year was apprenticed to the now-obscure but then relatively important local artist Jacob Isaacsz. van Swanenburgh (c. 1571–1639?), with whom he remained for three years. In 1624 Rembrandt moved to Amsterdam, where he was apprenticed to the much more fashionable Pieter LASTMAN, but he only remained there for a year and then returned to Leiden.

Several of Rembrandt's earliest pictures owe a clear debt to Lastman, for example the *Stoning of Stephen* which is dated 1624 in the Musée des Beaux-Arts at Lyons. However, it is not Lastman who was the most important formative influence on the young artist but the fact that he shared a studio throughout the latter part of the 1620s in Leiden with Jan LIEVENS. In fact, they seemed to have derived ideas from one another; Rembrandt did not

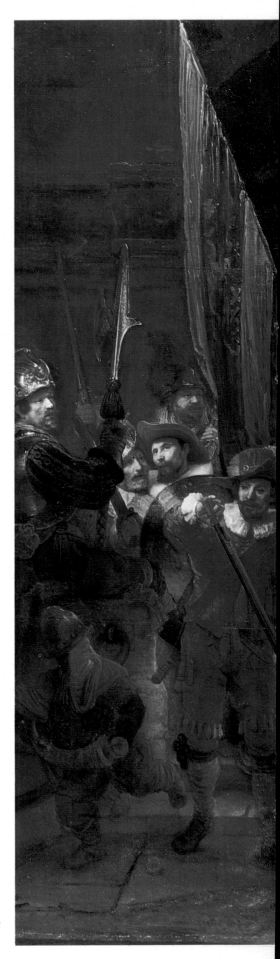

The Militia Company of Captain Frans Banning Cocq and of Lieutenant Willem van Ruytenburgh (The Night Watch)
Canvas 359 × 438 cm (141¼ × 172½ in)
Signed and dated lower left towards the centre: Rembrandt f. 1642.
AMSTERDAM, Rijksmuseum
This is Rembrandt's most complex picture. Celebrated in the Netherlands in the nineteenth and twentieth centuries because of its scale alone, it is easily the grandest picture painted by a Dutchman in the seventeenth century. The title 'Night Watch' is typical of nineteenth-century Romanticism. The scene is neither at night nor are the figures watching. They are in fact coming out of the gate which is visible in the background and there was no suggestion, even before the picture underwent its recent and dramatic cleaning, that it is a night scene. Many people have found the picture difficult to admire, perhaps on account of its enormous variations of lighting, pose and expression. In the eyes of his contemporaries Rembrandt had overstepped himself.

The painting is not in its original state. It has been cut down on all four sides, probably as early as 1715. The evidence for this is the small copy by Gerrit Lundens (London, National Gallery, lent to the Rijksmuseum). The damage was probably inflicted when the picture was moved from the Guildhall of the Arquebusiers in 1715 and transferred to the Court Martial Room of the Old Town Hall, Amsterdam. It has been lent to the Rijksmuseum by the city of Amsterdam since 1808. The picture was subjected to repeated and problematic restorations, especially in the nineteenth century. It was damaged by a vandal in 1975 but has since been repaired.

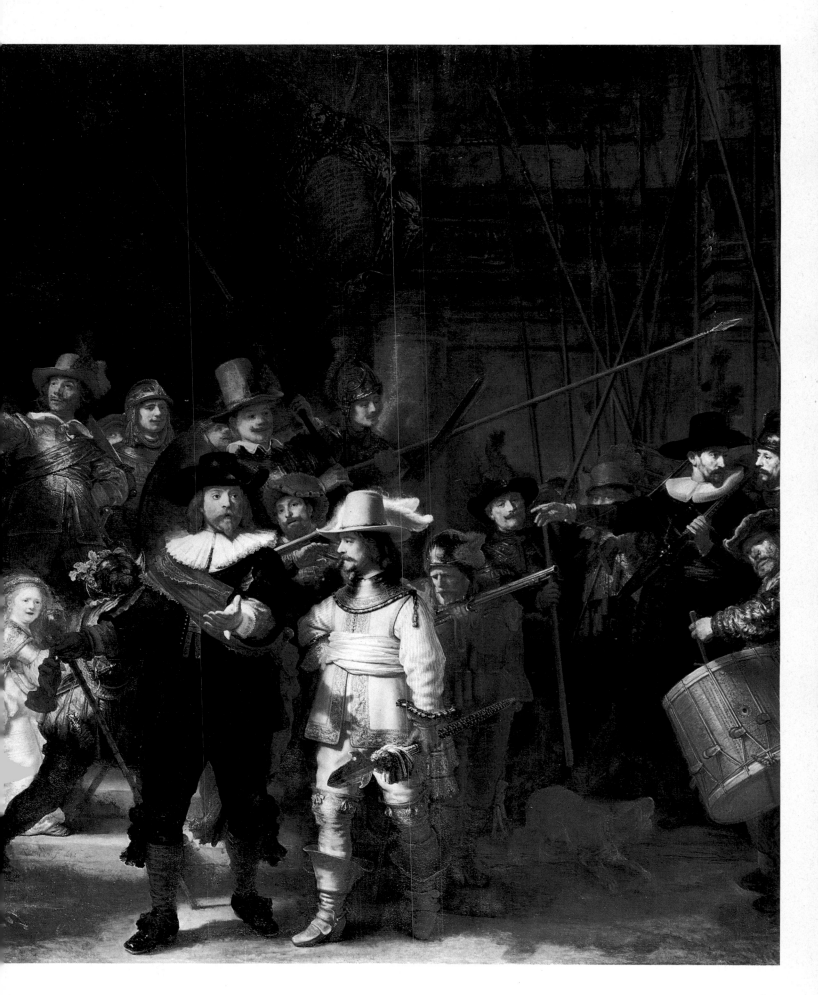

always lead the way. Rembrandt's debt to Lievens is proved by the Los Angeles *Raising of Lazarus* which is related to Jan Lievens's picture of the same subject at Brighton. It was not until 1631 that Rembrandt was to receive his first important commission, for the *Anatomy Lesson of Dr Tulp* which is in the Mauritshuis, The Hague. While the picture is obviously a great step forward for Rembrandt, who had mostly concentrated on small panel pictures of religious and mythological subject matter until this time, the painting of anatomy lessons was a matter of course at the period. More usually, however, the doctor concerned is shown explaining the different parts of the skeleton.

It is quite astonishing how the artist, from the moment that he made the final and decisive move to Amsterdam in 1632, was to be so successful as a society portraitist and a painter of official commissions. His formal portraits of these years are numerous, good examples being the pair of father and son and mother and daughter in the Wallace Collection, London.

Rembrandt's most fruitful relationship was with Constantin Huyghens, who was the secretary to the Stadholder Prince Frederick Henry of Orange. Jan Lievens painted Huyghens's portrait which is at present on loan to the Rijksmuseum, Amsterdam, and it was through Huyghens that Rembrandt received the commission to paint a Passion series of at least five pictures which were to occupy him at intervals during the 1630s. He was also sufficiently esteemed by the Orange household to receive a commission to paint Amelia von Solms, the Stadholder's wife. This picture has in fact been identified recently; it was formerly thought to represent Rembrandt's sister or his wife Saskia.

Rembrandt married Saskia van Uylenborgh in 1634. She was the daughter of a wealthy burgomaster from Leeuwarden in Friesland, and until her untimely death in 1642 she served as a model for a large number of his religious and mythological pictures. She appeared in the guise of *Artemisia* (Madrid, Prado) and Rembrandt also painted several single portraits of her, as well as the memorable double portrait of *The Artist with Saskia on his Knee* (Dresden, Gemäldegalerie).

The 1630s was a period of conspicuous success for the artist and his pictures rarely contain that quality of insight into the human condition of misfortune and sadness which characterizes his later work. Already Rembrandt was a passionate observer of human nature, but he had not yet acquired the skill to take it further. He concentrated on the dramatic, but with a surprising range. The small *Flight into Egypt* in the Musée des Beaux-Arts at Tours has all the feeling of urgency necessary, but what a contrast this is to the enormous *Blinding of Samson* at Frankfurt! In spite of their brutality there is an optimistic and self-assured feeling in almost all the pictures in this period. Only occasionally in the self-portraits, which he did throughout his life, is there a sense of introspection and melancholy which was to strengthen in his maturity and dominate his late years.

Rembrandt's most important painting was the *Night Watch* of 1642. It is now difficult to imagine with hindsight what an impact it must have had on the unsuspecting Amsterdam public. The sitters complained that they had not been given equal prominence. Quite obviously Rembrandt had no intention of painting them in a neat line. But in attempting to produce a feeling of movement in a type of picture which was usually, of necessity, static, he created a picture very close in spirit to the Italian Renaissance. He succeeded in integrating a large number of figures so that they appeared natural and at the same time gave the composition a sense of balance and order exactly as Titian, whom he much admired, would have done.

Passion Series no. 2: The Deposition from the Cross
Panel 89.4 × 65.2 cm (35¼ × 25¾ in)
Falsely signed lower left: C. Rembrandt. f.
Dateable no later than 1636 and probably c. 1633.
MUNICH, Alte Pinakothek
The importance of this series of pictures has perhaps been underestimated. They are the only surviving example by Rembrandt of a religious commission from an important patron in these years. The Orange family were not yet supreme in the government of the country and they were not significant art patrons. Even at this stage the Rembrandt paintings must have seemed eccentric and dramatic. All the pictures in the series are strongly realistic and emotionally intense; to modern eyes this is enhanced by the fact that Rembrandt chose to place himself, in different disguises, at the foot of the cross.

All five of the passion series paintings were mentioned in the inventory of the Noordeinde Palace in The Hague in 1667 but their whereabouts are not recorded in the late seventeenth century. They appeared in an inventory of 1719 of the electoral gallery at Düsseldorf and were transferred to Munich in 1806.

Overleaf:
Christ presented to the People (Ecce Homo)
Paper laid down on canvas 54.5 × 44.5 cm (21½ × 17½ in) Signed and dated underneath the clock, right background: Rembrandt f. 1634.
LONDON, National Gallery
This is one of the few pictures which Rembrandt painted in preparation for an etching. This is presumably the reason for the monochrome; the artist was interested in expression and composition rather than colour. The most striking point about the picture is the way in which he has conveyed the feeling of confusion which must have prevailed at the event. The vast mob and Pilate's uncertainty are made to dominate the scene while the tragic figure of Christ is overwhelmed by the situation. This is also one of the few pictures which can now be identified with the list of Rembrandt's possessions drawn up at the time of his bankruptcy in 1656.

The picture was recorded in many different sales in the nineteenth century and finally became the property of the director of the London National Gallery, Charles Eastlake. It was bequeathed to the gallery by his widow in 1894.

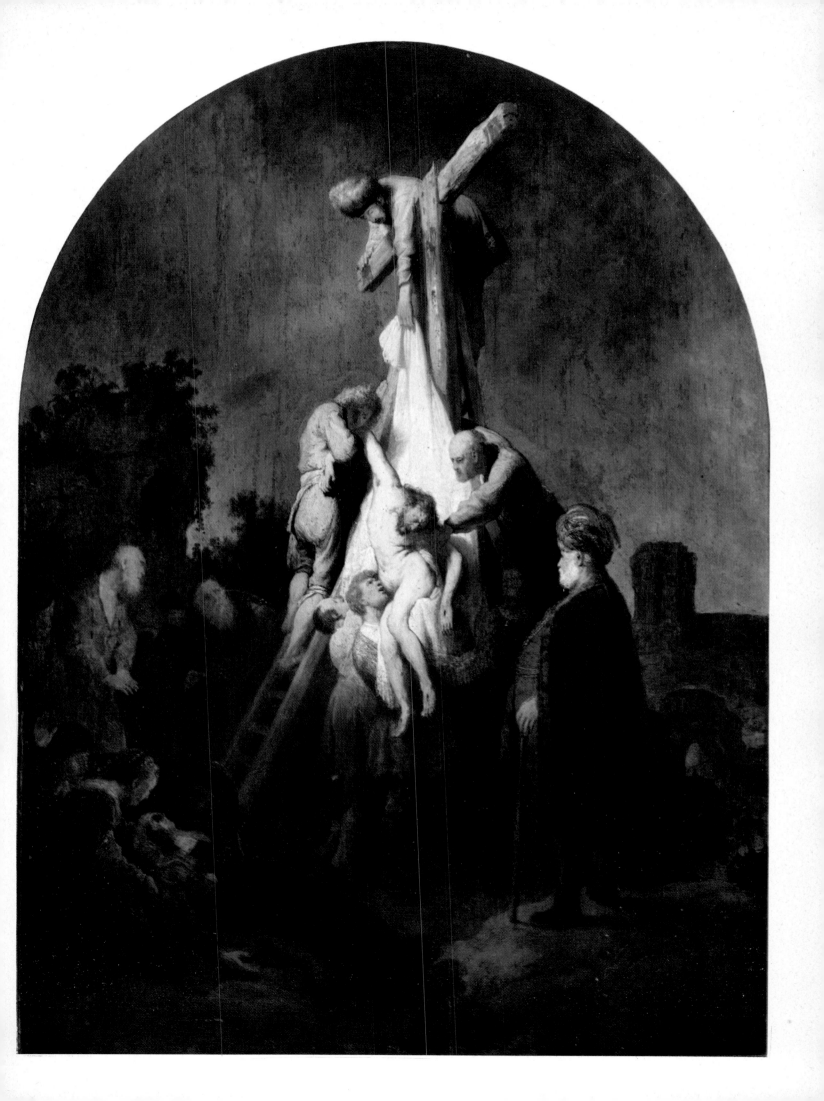

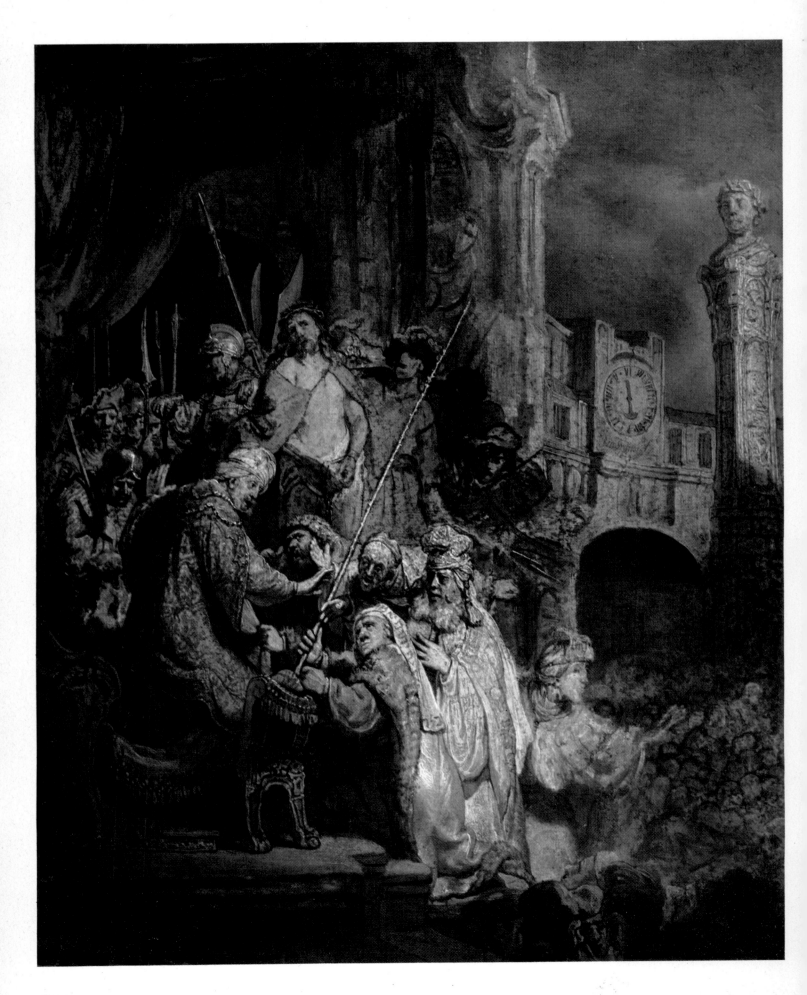

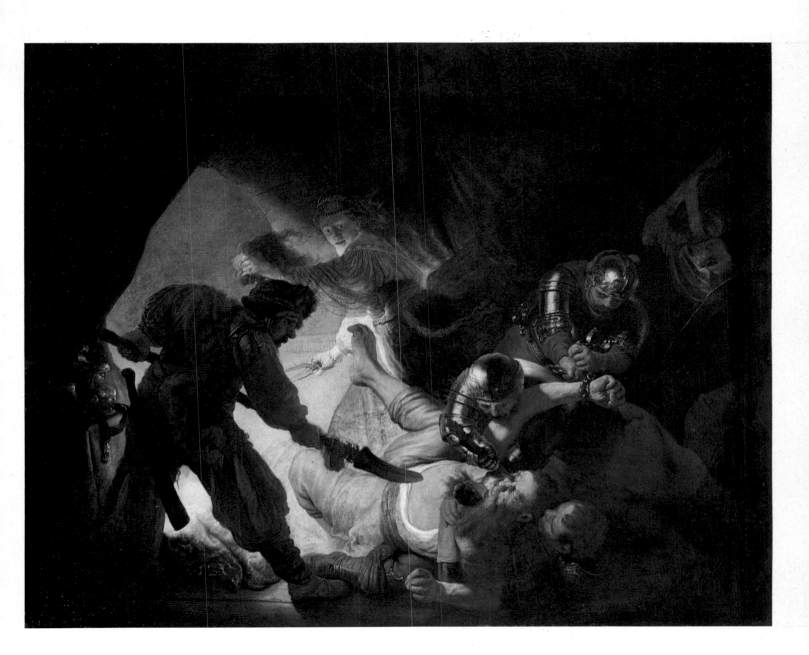

The death of Saskia in 1642 deprived Rembrandt of his chief model and his domestic security. But she left him a small income on the condition that he did not remarry. Not surprisingly, following the public failure of the *Night Watch*, the 1640s see a decrease in the artist's activity—there are no large compositions as ambitious as the *Anatomy Lesson*, the *Blinding of Samson* or the *Night Watch*. Instead his paintings become broader in handling and more intimate in feeling and scale. A perfect example of this is the so-called *Hendrickje Stoffels in Bed* in the Edinburgh Gallery, where the artist has concentrated on the mood of a woman who has just woken from a deep sleep.

It was in the 1640s that Rembrandt took a great interest in landscape. Occasionally they are given a narrative subject, as in the *Rest on the Flight* in Dublin; at other times they are simply concerned with light and atmosphere as in the surprising little *Winter Scene* at Kassel. In turning to the highly specialized genre of landscape Rembrandt did not rely on the traditions and conventions of the local specialists. He seemed to ignore the art of his contemporaries but relied heavily on the art of the past. He drew a copy of Leonardo's *Last Supper*, presumably from an engraving or a painted copy; he copied Persian miniatures and he made sketches of Raphael's *Baldassare*

The Blinding of Samson
Canvas 236 × 302 cm (93 × 118⅞ in)
Signed and dated lower centre:
Rembrandt f. 1636.
FRANKFURT-AM-MAIN, Städelsches
Kunstinsitut
This is the most dramatic composition ever conceived by Rembrandt. The story is more usually depicted at a slightly earlier stage with Delilah actually cutting Samson's hair, which was the secret of his strength. At first the picture appears confused both in lighting and composition, but on closer inspection it proves to be very carefully balanced, with the light from the background calculated to increase the drama. The very bloodthirsty nature of the subject has perhaps led too many critics to pass this picture and regard it as an aberration or lapse in taste. But what is perfectly clear is that without steps forward of this type, in composing so elaborately so many figures in action, Rembrandt could never have acquired enough skill to achieve the Night Watch.

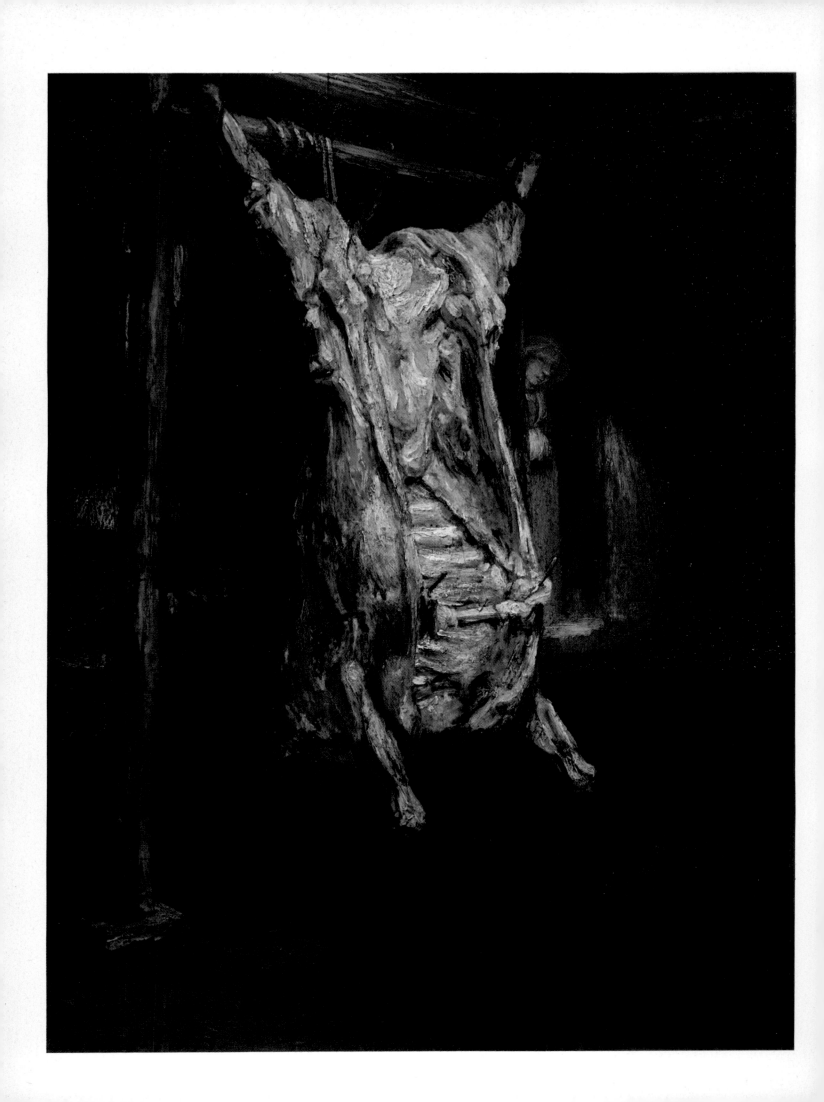

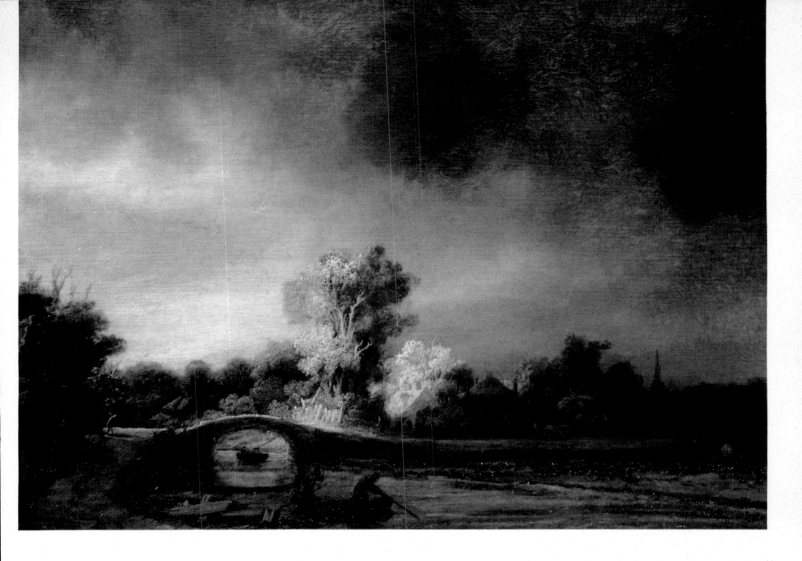

The Side of Beef
Panel 94 × 68 cm (37 × 26¾ in) Signed and
dated lower left: Rembrandt f. 1655.
PARIS, Musée du Louvre
*Rembrandt's curiosity about the visible world
extended to an enormous range of subject
matter. We are not necessarily intended to
have any sympathy with the dead animal, but
he gives the spectacle poignancy and dignity.*

Landscape with a Bridge
Panel 29.5 × 42.5 cm (11⅝ × 16¾ in)
Unsigned. Probably painted late 1630s.
AMSTERDAM, Rijksmuseum
*Rembrandt's interest in landscape is
concentrated in the middle years of his career,
although he seems to have gone out into the
countryside and drawn from nature very
frequently. His painted landscapes nearly
always have a dramatic content. Here there is a
feeling that the storm is impending; the final
shaft of yellow sunlight glances on the tree in the
centre. The location is thought to be immediately
outside the centre of Amsterdam, and the
obelisk-like landmark in the right distance has
been interpreted as the spire of the Oude Kerk.*

*The picture was first recorded when it
appeared in the Laperière Sale, Paris, in
1817—Vermeer's* Lacemaker *was in the same
sale. It was then in an English collection and it
was bought by the Rijksmuseum in 1900 with
the assistance of the Rembrandt Society.*

Castiglione (Paris, Louvre) and of Titian's so-called *Ariosto* (London, National
Gallery) when it passed through an Amsterdam saleroom. Thus Rembrandt's
source material is as complex as it is elusive. The finding of a particular
source or precedent for one of his pictures does not produce a simple
explanation for the picture's inspiration. The Dublin *Rest on the Flight* is
unthinkable without the Elsheimer (Munich, Alte Pinakothek) which inspired
it, but Rembrandt has transformed the German's clarity into a mysterious
and atmospheric landscape.

The last 20 years of Rembrandt's life see him becoming increasingly
independent and detatched from his artistic environment. His pictures become
far more inwardly emotional. The Berlin *Man in a Golden Helmet* is both a
still life of an ageing man in an extravagent gold helmet and a statement
about the contrast between the untarnishable gold and the fragile human
underneath it.

A surprising number of the paintings from these years are of uncertain date.
The artist was beginning to suffer from the financial troubles, perhaps caused
by extravagance and carelessness, which eventually resulted in his bankruptcy
in 1656. It was about this time that the artist had his most important
commission from abroad. This came from Don Ruffo, a Sicilian merchant
resident in Messina. The commission was for the *Aristotle Contemplating the
Bust of Homer* which is in the Metropolitan Museum, New York. Don Ruffo
was so pleased with the picture that he ordered a pendant for it from Guercino,
remarking to the Italian artist that he had better paint it in his earlier darker
manner, in order that it should not clash with his Rembrandt. Don Ruffo
then commissioned Rembrandt to paint an *Alexander*, and this is almost
certainly the picture in Glasgow.

Unidentified Couple (The Jewish Bride)

Canvas 121.5 × 166.5 cm (48 × 65¾ in)
Signed and dated lower right: Rembrandt
f. 16(?).

AMSTERDAM, Rijksmuseum
*Well-known because of the beautiful sentiment
of love which it expresses, the subject of this
picture remains ambiguous. Various suggestions
have been put forward, none of them
convincing. It is easy to be impressed by the
dazzling texture of this picture, and many
critics have exalted the brushwork of the
famous yellow sleeve to a point where they
forget to look at the whole painting. What is
even more important than the bravura is the
control with which the hands and faces are
painted, contrasting so perfectly with the rest of
the picture which is not in focus. The painting
is usually dated in the mid-1660s.*

*The picture was first recorded as late as 1825
when it was acquired by John Smith, the
indefatigable cataloguer of Dutch paintings. It
was then in the van der Hoop collection,
Amsterdam and was bequeathed to the city in
1854.*

It is this group of pictures—the two for Don Ruffo and the *Polish Rider* in the Frick Collection, New York—which sum up Rembrandt's career. They all have his near-miraculous brushwork, an ambiguity of subject matter which makes the spectator want to enquire further without ever having the possibility of an easy or explicit solution. We are never sure quite what the *Polish Rider* is doing.

Until his very last years, which fall into a different category, Rembrandt exerted a profound influence on certain of his contemporaries. This was not general: Aelbert CUYP did not modify his landscapes in the light of Rembrandt's experiments. But it was through the medium of the master-pupil relationship that Rembrandt was able to train a large number of artists to paint in his manner. The less good pupils never recovered, but some of them, like Carel FABRITIUS, became very good painters in their own right. Rembrandt in fact taught artists as different from one another as Dou, Nicolaes MAES, Gerbrand EECKHOUT, and Samuel van HOOGSTRATEN. Not surprisingly this has led to many problems of authenticity in evaluating Rembrandt's own work. What is convenient to believe, although it need not be the entire truth, is that Rembrandt often corrected his pupil's work, or occasionally collaborated, as with Dou (an example is in the National Gallery, London). But he seems not to have permitted his pupils to interfere with his own compositions, however

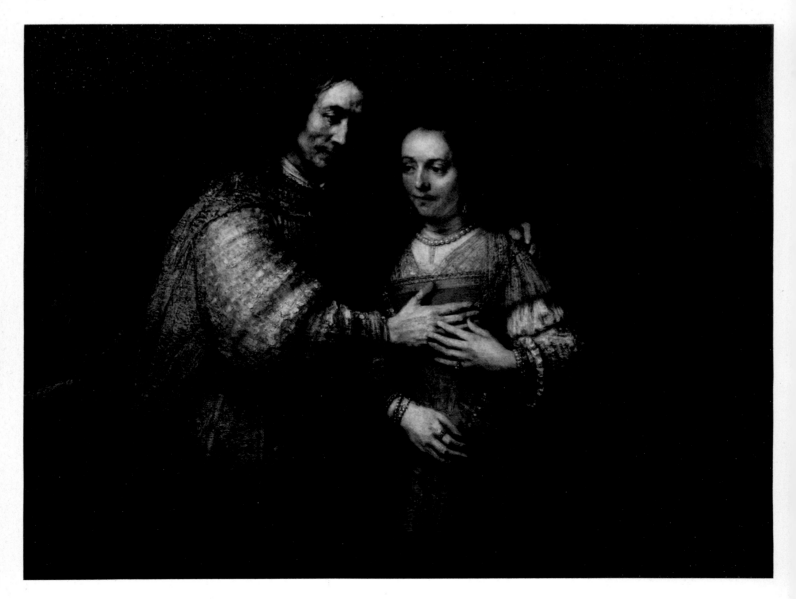

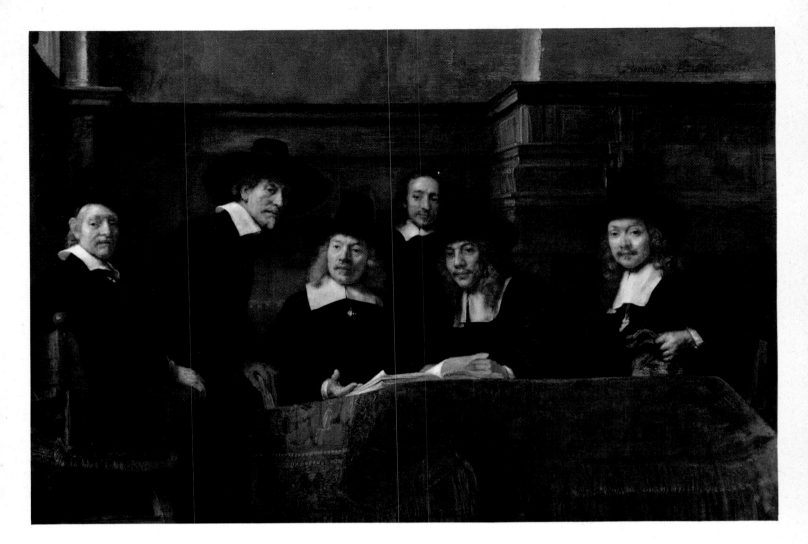

large. Thus when he came to paint the most important commission of his last years, the *Conspiracy of Claudius Civilis*, it was entirely from his own hand.

The contract was first given to one of Rembrandt's own pupils, Govaert FLINCK, but he died immediately and Rembrandt himself was asked to paint this colossal picture which was to decorate the whole end wall of the main chamber of the new Town Hall of Amsterdam. In the eyes of his contemporaries it must have been one of the most prestigious commissions of the century. The result was a failure, for reasons which are not exactly clear. The painting was taken down at the artist's own request and never replaced. A fragment of it survives in Stockholm.

Rembrandt's last years must not be seen simply as those of a misanthropic and misunderstood genius struggling and ultimately failing. He was not without commissions in the 1660s, for example the *Syndics* of 1661/2. But he probably did not have enough official work to make a proper living. Undoubtedly his last years were clouded with domestic failure, and this contributed to the nineteenth-century myth of a romantic and bohemian figure. This makes people see the last self-portraits, not for what they are, as careful pieces of self-observation and analysis, but as symbols of romantic failure.

Rembrandt lived his whole artistic life full of passion and curiosity. He was insatiable for new visual experiences. This is what sets him apart from his contemporaries. Even Frans HALS and VERMEER spent their lives trying to perfect their chosen paths. Rembrandt seems never to have been interested in perfection; there is almost the feeling that he was constantly dissatisfied with

The Sampling Officials of the Amsterdam Drapers' Guild (The Syndics)
Canvas 191.5 × 279 cm (75¼ × 109¾ in)
Signed and dated upper right: Rembrandt f. 1661. Signed and dated on the tablecloth: Rembrandt f. 1662.
AMSTERDAM, Rijksmuseum
The calm order of this obviously successful group portrait dispels the myth that Rembrandt spent his last years in impoverished obscurity. The commission was an important one and the artist rose to the occasion. In painting this group of middle-aged officials round a table, Rembrandt respected the conventions of his time: he gave them equal prominence, and no face is obscured by the dramatic fall of light as in the Night Watch. *Indeed, if the picture were not dated it could be placed much earlier on grounds of style. The only evidence of the artist's final manner of painting as seen in the unfinished* Family Group *at Brunswick is in the broad handling of the magnificent red tablecloth.*

The picture always hung in the Cloth Hall in the Staalstraat, Amsterdam until transferred to the Town Hall in 1771. After 1808 it became the property of the city, which subsequently lent it to the Rijksmuseum.

his work and tried to find a different solution each time. He loved glitter. His work is full of gold objects, fur, embroidery, fancy helmets, elaborate costumes. His house was full of such objects at the time of the bankruptcy in 1656.

On the other hand it is not often realized that a surprisingly high proportion of his surviving output is of conventional portraiture painted to order. There are a relatively larger number of them in the early part of his career, although they occur right until the end in diminished quantities.

Perhaps one of the secrets of Rembrandt's subsequent reputation is his variety. Collectors responded to his art relatively early on. The galleries of Brunswick, Cassel and Düsseldorf (now in Munich) were formed in the early years of the eighteenth century. Quite often, collectors preferred the artist's earlier pictures. Later in the eighteenth century Sir Joshua Reynolds made a collection of Rembrandt's pictures in which those of the middle period predominated and which included the Glasgow *Alexander*. In the nineteenth century his late pictures became popular; the *Jewish Bride* was discovered and became better known than much of the rest of his work. But it has been left to the twentieth century to produce a more balanced assessment of his genius. Blind admiration has gone too far. Rembrandt has been credited by Romantics with painting the spirit of man, which is not the secret of his greatness. Rembrandt observed the world around him more clearly and with greater insight than any of his contemporaries. In the words of the late-nineteenth-century French critic Emile Michel, 'Rembrandt, in effect, belongs to the race of artists who cannot have descendants, the race of Michelangelo, the race of Shakespeare, of Beethoven; like these Prometheuses of art he wanted to ravish the celestial fire, to put the vibrations of life into still form, to express in the visible, that which by its very nature is non-material and undefineable'.

Aix-en-Provence; Amsterdam★; Antwerp; Baltimore; Basle; Bayonne; Berlin★; Boston (Gardner Museum, Museum of Fine Arts); Brooklyn (New York); Brunswick★; Brussels; Bucharest; Budapest; Cambridge; Cambridge (Massachusetts); Chapel Hill (North Carolina); Chicago; Cincinnati; Cleveland; Cologne; Columbus (Ohio); Copenhagen; Cracow; Darmstadt; Denver (Colorado); Detroit; Dresden★; Dublin; Edinburgh; Epinal; Florence (Uffizi); Frankfurt★; Glasgow (Art Gallery, Burrell Collection, University); Gothenburg; Groningen; The Hague (Bredius Museum, Mauritshuis★); Hamburg; Hanover; Hartford (Conn.); Helsinki; Indianapolis; Innsbruck; Kansas City; Karlsruhe; Kassel★; Leeuwarden; Leiden; Leipzig; Leningrad★; Liverpool; London (Dulwich, Kenwood, National Gallery★, Victoria and Albert Museum, Wallace Collection★); Los Angeles; Lyons; Madrid; Le Mas d'Agenais; Melbourne; Metz; Milan; Minneapolis; Montreal; Moscow; Munich★; New York (Frick Collection★, Metropolitan Museum★); Nivaa (Denmark); Nuremberg; Omaha (Nebraska); Oslo; Ottawa; Oxford; Paris (Cognacq-Jay, Jacquemart-André, Louvre★, Petit Palais); Philadelphia (Museum of Art, Johnson Collection); Prague; Raleigh (North Carolina); Richmond (Virginia); Rochester (New York); Rotterdam★; St Louis; San Diego (Fine Arts Society, Timken Foundation); San Francisco (California Palace, De Young Museum); São Paolo; Sarasota (Florida); Shelburne (Vermont); Stockholm★; Stuttgart; Tokyo (Bridgestone Gallery); Toledo (Ohio); Toronto; Tours; Turin; Utrecht (Rijksmuseum Het Catherijn Convent); Vienna (Academy, Kunsthistorisches Museum★); Warsaw; Washington (Corcoran Gallery, National Gallery★); Williamstown (Mass.); Worcester (Mass.); Zurich.

Self-Portrait

Panel 49.2 × 41 cm (19½ × 16 in) Signed top left: Rembrandt f. Painted late 1650s. VIENNA, Kunsthistorisches Museum

Like so many of the artist's late self-portraits, the picture has to be dated on grounds of style and the apparent age of the artist. The facial expression is closest to the large Self-Portrait with a Staff *in the Frick Collection, New York, which bears a repainted signature and date of 1658. The artist's face in the Self-Portrait of 1657 in the collection of the Duke of Sutherland (lent to the National Gallery of Scotland, Edinburgh) appears slightly younger and therefore a dating in the late 1650s would be safe. Although this picture is solemn there is a genial feeling as well. There is an unwarranted tendency to read melancholy into all Rembrandt's portraits, including those painted when he was still happy and successful.*

The picture was first mentioned in the 1783 catalogue of the Vienna collection.

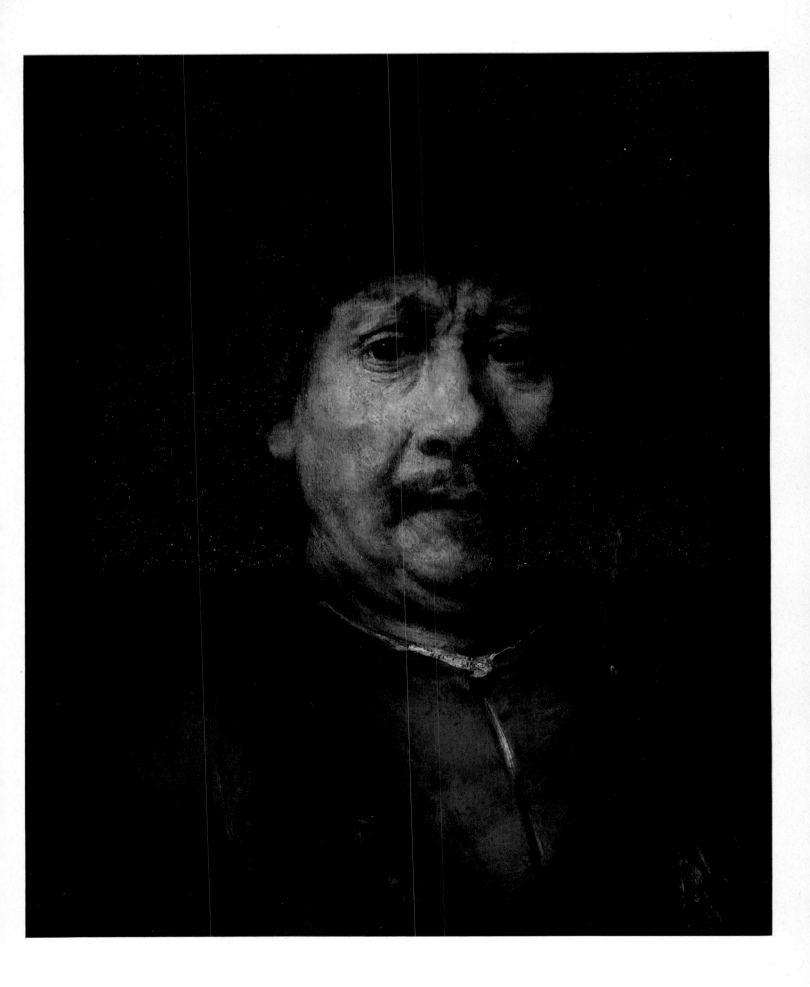

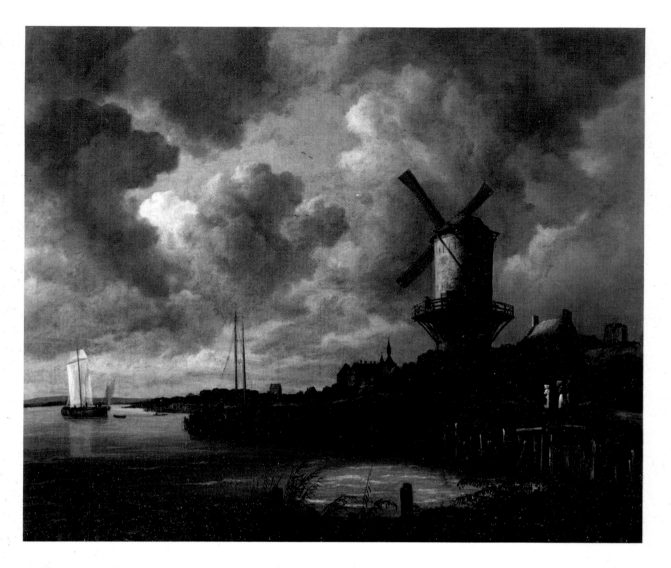

Jacob Isaacksz. van RUISDAEL

Haarlem 1628/9—Amsterdam or Haarlem 1682

Ruisdael's position as one of the most influential landscape painters of all time has often been overlooked, especially in recent years. Apart from his numerous followers and imitators in his own lifetime, especially his great pupil Meyndert HOBBEMA, his influence on landscape painting in the eighteenth and nineteenth centuries (especially in France and England) is underestimated. Ruisdael's pictures inspired Goethe and Fromentin to write memorable passages in their praise.

Ruisdael came of a family of painters. His father was Isaac Jacobsz. van Ruisdael, who is recorded as a painter—unfortunately none of his work seems identifiable today. His uncle was Salomon Jacobsz. van RUYSDAEL, the distinguished landscape painter of the earlier generation, and his cousin and imitator was Jacob Salomonsz. van Ruysdael. His early life was spent in Haarlem as the pupil of his father; here he would have been in contact with an enormous variety of artists as different from one another as Pieter de MOLIJN and Nicolaes BERCHEM. In 1657 he moved to Amsterdam, where he spent the rest of his life and where it is believed that he died, although he was buried at Haarlem.

Like so many imaginative and original painters the sources of his style are difficult to pin-point. There is a discernable but not important influence of his

The Windmill at Wijk bij Duurstede

Canvas 83 × 101 cm (32¾ × 39¾ in) Signed lower right JvRuisdael. Probably painted in the early 1670s.
AMSTERDAM, Rijksmuseum
The picturesque aspects of landscape appear but rarely in Ruisdael's art; this picture is an exception as the windmill plays such an important part in the composition. The painting has perhaps been over-exposed through constant reproduction and only in front of the original can the severity and dignity of the composition be appreciated. As is usual with Ruisdael the colour scheme is predominately grey and green and the surface never sparkles as in Hobbema's paintings.

The painting was first recorded in an Amsterdam sale in 1817. Subsequently it was the property of the dealer and scholar John Smith and it was then in the van der Hoop collection which was bequeathed to the city of Amsterdam in 1854 and transferred to the Rijksmuseum in 1885.

The Jewish Cemetery
Canvas 84 × 95 cm (33 × 37½ in) Signed
lower left: JvRuisdael. Probably painted
after 1670.
DRESDEN, Gemäldegalerie
*In the first instance this picture is a
melancholy and moving masterpiece. It has
been rightly interpreted as an allegory on the
transience of human life. Each one of the
elements in the picture—ruins, tombs, broken
trees—can be seen to have a specific meaning.
Everything man has wrought is depicted in
decay and the transience of all things is
indicated by the rainbow. The picture has been
at Dresden since 1754.*

uncle, especially in the manner of handling trees. In spirit Ruisdael's land-
scapes come much closer to those of the Alkmaar painter Allart van
EVERDINGEN, in particular the solemn landscapes painted after he had visited
Scandinavia.

Once Ruisdael had achieved maturity (by the late 1650s) he developed little,
maintaining a consistent style for more than 30 years. The bustling city never
seems to enter his art; even when he was moved to paint it, he kept his
distance and made the Amstel river the most important part of the
composition (as in the exceptionally beautiful picture in the Fitzwilliam
Museum, Cambridge).

In effect, Ruisdael's art, for all its genius, is rather cold. He had none of
the seductive picturesqueness of his pupil Hobbema or the delicate charm of

Jan van GOYEN. Instead Ruisdael gave the Dutch landscape grandeur: the grey clouds take on the significance of vast mountains, like a Himalayan backdrop to the flat land below. He was also fascinated by mountain scenery which he may never have experienced. He certainly travelled as far as Bentheim, which is the first high ground reached on leaving the United Provinces towards Germany. He made several paintings of the castle at Bentheim, usually exaggerating the height of the rock on which it stands. Topographical pictures play a relatively unimportant part in Ruisdael's art; the inclusion of a recognizable landmark is not the real intention of the picture. His real interest was pure, undiluted landscape. There are rushing torrents or still and stagnant pools in woods, almost always with grey skies. Fromentin noted that he never painted a sunny day.

In the *Jewish Cemetery* (of which there are versions in Dresden and Detroit) he made his melancholia more explicit, musing on the vanity of human life. Almost all his work has a sad feeling: storms are about to break and trees lie broken by the force of the wind.

As his range is, relatively speaking, so narrow, it is an all-important question why he should occupy such an exalted place in the history of landscape painting. The answer, as Fromentin found, is that more than any other Dutch painter of his time he observed the world around him. Most Dutch landscapes, especially those of Jan van Goyen and Salomon van Ruysdael, have a consciously decorative end which made them appeal to the collectors of cabinet pictures. Ruisdael's work, on the other hand, is usually much larger in scale and seeks to record, as accurately as possible, the clouds and trees before the rain. This is achieved without dashing brushwork— his handling sometimes appears almost hesitant, especially when compared with Hobbema.

In later centuries Ruisdael's art was much appreciated. His numerous pictures have found their way into all the great collections of Europe. They exerted an enormous influence on the Barbizon school of painters in France in the middle years of the nineteenth century. In England much of Gainsborough's early work is based on Ruisdael and he could well be described, along with the Frenchman Claude Lorrain, as the father of English landscape.

Amsterdam★; Angers; Antwerp; Augsburg; Basle; Berlin★; Birmingham (Barber Institute); Boston; Brunswick; Brussels; Budapest; Chantilly; Cleveland (Ohio); Chicago; Coburg; Cologne; Copenhagen; Darmstadt; Detroit★; Douai; Dresden★; Dublin; Edinburgh★; Enschede; Florence (Uffizi); Frankfurt; Glasgow; Haarlem; The Hague (Gemeentemuseum, Mauritshuis); Hamburg; Hanover; Hartford (Connecticut); Indianapolis; Kassel; Leeds; Lille; Leipzig; Leningrad; London (Dulwich, Greenwich, National Gallery★, Wallace Collection); Los Angeles (Norton Simon Museum); Lyons; Madrid; Manchester; Melbourne; Montpellier; Mulhouse; Munich; Münster; Nancy; New York (Frick Collection, Metropolitan Museum); Northampton (Massachusetts); Orléans; Oxford (Ashmolean, Worcester College); Paris (Musée Jacquemart-André, Louvre, Petit Palais); Petworth (Sussex); Philadelphia (Johnson Collection); Polesden Lacey (Surrey); Prague; Rotterdam (Boymans-van Beuningen Museum, Vorm Foundation); Salzburg; San Diego; Schwerin; Southampton; Speyer; Strasbourg; Turin; Upton House (Warwickshire); Vienna; Waddesdon Manor (Buckinghamshire); Washington; Warsaw; Weimar; Williamstown (Massachusetts); Zurich.

A Distant View of Haarlem from the North-West
Canvas 43 × 38 cm (17 × 15 in) Signed lower left: JVRuisdael. Probably painted early 1670s.
AMSTERDAM, Rijksmuseum
From time to time Ruisdael worked on a small scale, although his conceptions were always spacious and grand. Even on this minute scale his whole preoccupation is with space and distance. This illusion is increased by the fact that the landscape is seen from an artificially high viewpoint. Then as now the Groote Kerk (St Bavo) of Haarlem dominates the whole panorama, its colossal scale contrasting with the tiny windmills and buildings in the distant town.

The picture was bequeathed to the Rijksmuseum by L. Dupper Wzn. of Dordrecht in 1870.

Rachel RUYSCH
Amsterdam 1664—Amsterdam 1750

Rachel Ruysch was aged 36 when the seventeenth century came to an end, and her style of painting, which seems largely derived from that of Jan Davidsz. de HEEM, was continued right up to the end of her long life. She thus spans the first half of the eighteenth century, still painting in the seventeenth-century traditions into which she had been born.

She was one of the most talented flower painters who ever lived. Her observation of the character of each flower was unerring, her colours clear but subtle; throughout her long life in Amsterdam she maintained the same standards of exquisite finesse. Her work has always been much in demand by connoisseurs and her pictures are still jealously guarded by collectors.

Aix-en-Provence; Amsterdam; Basle; Bayeux; Bonn; Brunswick; Brussels; Cambridge; Cheltenham; Cherbourg; Darmstadt; Dresden; Düsseldorf; Emden; Florence (Pitti); Geneva; Ghent; Glasgow; The Hague; Hamburg; Hanover; Heidelberg; Innsbruck; Karlsruhe; Kassel; Leeds; Leipzig; Liège; London (National Gallery, Victoria and Albert Museum); Mannheim; Melbourne; New York; Oxford; Prague; Quimper; Rostock; Rotterdam; Rouen; Stockholm (Hallwylska Museet); Vienna (Academy, Kunsthistorisches Museum); Wroclaw.

Still Life with Fruit and Insects
Canvas 89 × 78 cm (35 × 30¾ in) Signed lower left RACHEL RUYSCH (this is now almost illegible). Probably painted in the last years of the century.
FLORENCE, Galleria Pitti
This is an exuberant example of this remarkable woman's style. She mainly concentrated on flower paintings, although there are a number of fruit and insect pictures surviving. Even today visitors to picture galleries marvel at the bloom on her grapes and at the numerous slugs, snails, weevils, snakes, lizards and other small creatures which all seem to inhabit her pictures as one happy family.

The painting was bought by the Grand Duke Ferdinand III of Lorraine in 1823 and it has been in the Pitti Gallery ever since.

River Scene
Panel 75 × 106.5 cm (29½ × 42 in) Signed and dated: S V RUYSDAEL 1644 (or 7?)
THE HAGUE, Mauritshuis
This picture is almost identical to those of Jan van Goyen in style except for its exquisite tonality of blues and greens, colours which van Goyen avoided on the whole in combination. In pictures of this type, which are in fact removed from nature, the result is an evocation of landscape rather than any real observation of one.

The picture belonged to the great scholar and collector Abraham Bredius, who bequeathed it to the Mauritshuis in 1946.

Salomon Jacobsz. van RUYSDAEL
Naarden (Gooiland) 1600/3 (?)—Haarlem 1670

In recent years Salomon van Ruysdael has enjoyed a sudden revival of popularity; in the saleroom his pictures fetch almost the same high prices as those of his nephew Jacob van RUISDAEL. Modern taste approves of the evanescent quality of many of his pictures, especially those which are close in style to those of Jan van GOYEN.

Ruysdael's origins in Gooiland are obscure, but he was already a member of the Haarlem guild of painters in 1623. He remained in Haarlem for the

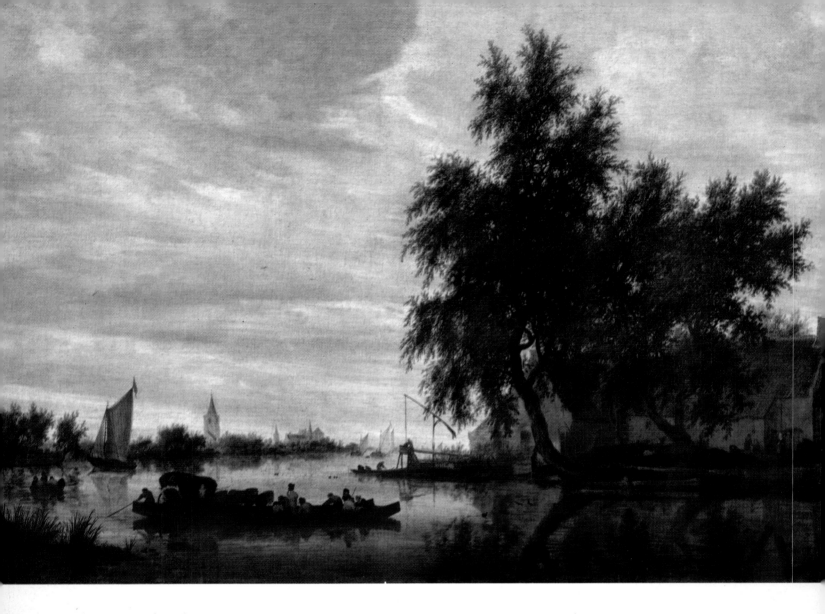

whole of his life, although there are one or two pictures which depict sites some distance from Haarlem, implying that he travelled occasionally.

As a young man Salomon van Ruysdael was influenced by Esaias van de VELDE; the same influence on the young van Goyen meant that during the 1620s the two artists were very close to one another in style. Their work is in fact sometimes difficult to distinguish. In general, Ruysdael's pictures are slightly more intense in colour than those of van Goyen. In his maturity Ruysdael evolved a very personal style, mainly concentrating on river scenes with large overhanging trees. Often the sky is free to the point of being sketchy and the overall effect of his pictures is one of openness. His landscapes are spacious, airy and picturesque, but they never have the robust quality of those of his nephew.

Amiens; Amsterdam★; Antwerp; Arnhem; Aschaffenburg; Basle; Berlin★; Bordeaux; Budapest; Caen; Cambridge; Cologne; Copenhagen; Dresden; Dublin; Frankfurt; Grenoble; Haarlem; The Hague (Bredius Museum, Mauritshuis); Kansas City; Karlsruhe; La Fère; Leicester★; Leiden; Leipzig; Leningrad; Lille; Liverpool★; London; Malibu (California); Manchester; Melbourne; Metz; Minneapolis; Munich; New York (Frick Collection, Metropolitan Museum); Ottawa; Oxford; Paris (Musée des Arts Décoratifs, Louvre); Petworth (Sussex); Philadelphia (Johnson Collection); Polesden Lacey (Surrey); Poznan; Prague; Rotterdam (Boymans-van Beuningen Museum, Vorm Foundation); Salzburg; San Francisco; Stockholm; Strasbourg; Toronto; Upton (Warwickshire); Vienna; Warsaw; Worcester (Massachusetts).

River Scene (The Ferry)
Canvas 91 × 130.5 cm (35¾ × 51½ in)
Signed and dated on the boat S.V
RvysDAEL 1647.
BRUSSELS, Musée Royal des Beaux-Arts
Apart from painting many small pictures Ruysdael sometimes worked on a much larger scale, as in this picture. By working in this format he was able to give his river scenes a breadth and spaciousness which van Goyen could achieve on a tiny scale. As is so often found in Salomon van Ruysdael's pictures, the trees are 'edited' to make a pleasing form— their leaves obligingly grow the same way. This gives his pictures a decorative appeal which makes them very popular at the present time.

The painting was acquired by the museum at a Paris sale in 1881.

Pieter Jansz. SAENREDAM

Assendelft 1597—Haarlem 1665

The Old Town hall, Amsterdam
Panel 64.5 × 83 cm (25⅜ × 32¾ in)
Inscribed as follows: Pieter Saenredam
Heeft dit eerst naer't Leeven Geteeckent,
met al sijn Coleuren int Jaer 1641 en dit
Geschildert int jaer 1657. Dit is het oude
Raethuijs der stadt Amsterdam, weck
afbrande int jaer 1651 den 7 Julij, in 3 uren
tyt sonder meer.
AMSTERDAM, Rijksmuseum
*The ramshackle air of the old town hall of
Amsterdam is caught perfectly in this
meticulous picture. The long inscription records
that the drawing was done in 1641 and the
picture in 1657, after the building had been
destroyed by fire. It was commissioned by the
city of Amsterdam, presumably as a memorial
and a reminder. The replacement is seen
in Jan van der Heyden's picture (see page 113).*

*The painting has been lent by the city of
Amsterdam, who have always owned it, to the
Rijksmuseum.*

Saenredam was the most meticulous of all the Dutch painters of church interiors. He recorded them with an accuracy which has few parallels in the whole history of art. The method by which he arrived at these exceptional results is known, as he left meticulous drawings executed on the spot of each of the places which he visited. He then worked up the drawings into paintings, sometimes several years later.

Most of his career was spent in Haarlem and he is recorded there in 1612 as a pupil of Pieter de GREBBER. There is no discernable influence of de Grebber on Saenredam, who pursued his church-interior and topographical painting with a single-mindedness which amounts to an obsession. Not since van Eyck's backgrounds to his pictures of the Virgin and saints had gothic architecture been observed with such exactness.

Saenredam travelled all over the United Provinces, drawing almost all the important Romanesque and Gothic churches. He was particularly attracted to Utrecht which had, like some of the great cities of the southern Netherlands such as Ghent and Bruges, a number of prominent churches dominated by a colossal cathedral. This is in contrast to most Dutch towns,

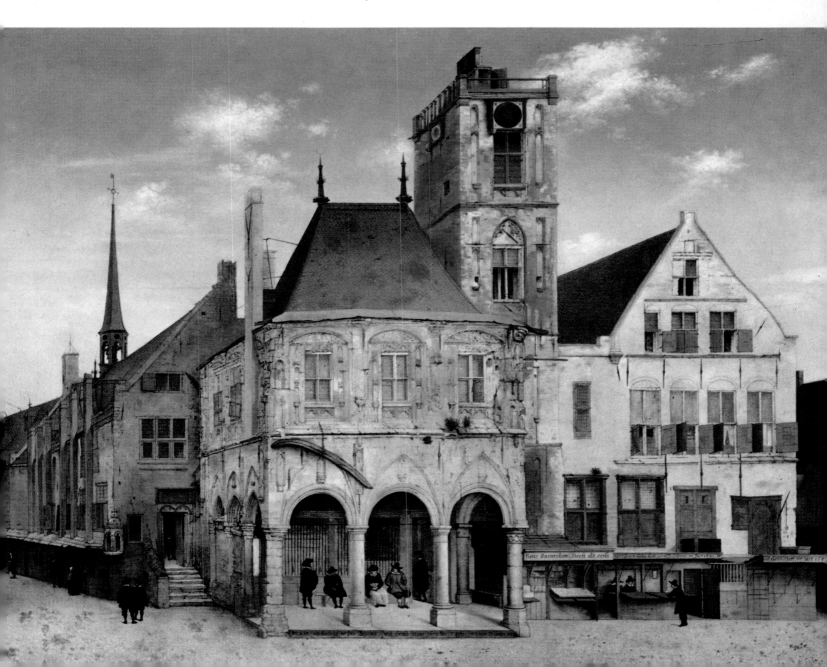

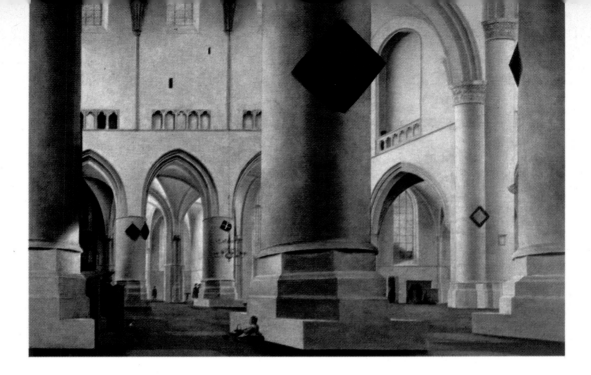

where there is usually only one large medieval church. The precision with which Saenredam painted is so startling that in picture galleries his paintings stand out from other Dutch pictures by their expanse of whitewashed church wall and the occasional use of gold. He also made use of the diamond-shaped hatchments which were hung in the churches in memory of prominent persons or families buried there.

More than any other painter of the period Saenredam captures the feeling of these vast, cold edifices, shorn of their 'popish' imagery in the crisis of the previous century, and given over to being preaching halls for austere Protestants.

Alkmaar; Amsterdam★; Berlin; Boston; Budapest; Brunswick; Glasgow; Haarlem (Bisschoppelijk Museum, Frans Hals Museum); The Hague; Hamburg; Kassel; London; Munich; Philadelphia (Johnson Collection); Rotterdam★; Turin; Upton House (Warwickshire); Utrecht; Warsaw; Washington; Worcester (Massachusetts).

Interior of St Bavo at Haarlem
Panel 59.5 × 81.7 cm (23½ × 32⅛ in) Unsigned. The preparatory drawing for this painting is dated 1636 and bears the inscription that the painting was finished by May 1637.
LONDON, National Gallery
It is still possible today to stand in the same position in the church as Saenredam did and observe the building virtually unchanged. Just visible on the right is part of the painting of the exterior of the church (see page 8) which may well be by Geertgen tot Sint Jans and which is still in the church. Saenredam took a delight in selecting awkward angles from which to paint his churches, as this made his compositions more interesting.

Godfried Cornelisz. SCHALCKEN
Made (near Dordrecht) 1643—The Hague 1706

Schalcken was taken as a child to Dordrecht, where he was probably a pupil of Samuel van HOOGSTRATEN. But the chief influence on his style was Gerard DOU, whose pupil he may have been, presumably in the late 1650s and early 1660s. Much of the rest of his career was spent in Dordrecht until his last years when he lived at The Hague, during which time he made a prolonged visit to London in order to paint the portrait of the Stadholder William who had become king of England in 1689.

Schalcken's fame rests, not on his competent portrait style, but on his painting of night scenes. They are usually rather warm in tone, and their composition and sentiment are derived from Dou's genre pieces. Many of them are on a small scale and are painted with tremendous regard for detail.

Aachen; Arnhem; Amsterdam; Antwerp; Aschaffenburg; Augsburg; Barnsley; Bath; Berlin; Blois; Boston; Brussels; Budapest; Cambridge; Cheltenham; Cologne; Copenhagen; Darmstadt; Dordrecht; Dublin; Florence (Pitti); The Hague (Bredius Museum, Mauritshuis); Hamburg; Karlsruhe; Kassel; Leamington Spa; Leiden; Leipzig; Le Mans; Leningrad; Lille; London (Dulwich, National Gallery, Wallace Collection); Lyons; Madrid; Mazamet; Nantes; Nuremberg; Oxford; Paris; Prague; Salzburg; Schwerin; Sibiu; Speyer; Stockholm; Turin; Upton House (Warwickshire); Utrecht; Vienna; Warsaw.

Girl with a Candle
Canvas 61 × 50 cm (24 × 19¾ in) Signed at the left G. SCHALCKEN. Probably painted in the 1660s.
FLORENCE, Galleria Pitti
The reason for Schalcken's enormous reputation as a night-scene painter is easy to see in this picture. He attained unsurpassed skill in the difficult art of painting artificial light. He also had a direct approach to his subject matter. Here the girl's expression is all-important—she is both happy and mysterious. There is in this picture a distant debt to Gerard Honthorst, but Schalcken's expression is much more refined.

The painting was first recorded in 1773 in the villa at Poggio a Caiano. It was subsequently in the Uffizi Gallery in Florence and was transferred to the Pitti in 1928.

Hercules Pietersz. SEGHERS (Segers)

Haarlem 1589/90—The Hague or Amsterdam by 1638

For a painter and draughtsman of his importance and influence Seghers has left remarkably few clues for the reconstruction of his career and personality. Indeed, he is one of the enigmas of seventeenth-century art.

He painted landscapes exclusively, using a broad manner both in terms of conception and technique. REMBRANDT's landscape-painting style is based directly on Seghers, even to the handling of the light. It appears that most of the painter's life was spent in Haarlem and he certainly visited Rhenen, as he painted two views of that town. He was last recorded living in The Hague in January 1633. Nobody has yet given a satisfactory explanation as to why Seghers's pictures are so rare, as they are frequently documented in early sources. Many have been forged in recent years; perfectly genuine seventeenth-century landscapes have often been given a few eccentricities of brushwork and then have been passed off as genuine works by this master. Amsterdam; Berlin★; Cologne; Florence (Uffizi); Rotterdam★.

River Landscape
Canvas 70 × 86.6 cm (27½ × 34 in)
Unsigned. Probably painted in the mid-1620s.
ROTTERDAM, Boymans-van Beuningen Museum
As in all Seghers's work there is an eerie feeling about this landscape: it is completely devoid of human activity. This is rare in Dutch painting, as even the most desolate-looking mountain torrent by Jacob van Ruisdael will have a few figures added. Seghers's colour scheme, predominately brown, also creates an unnatural effect. Such a picture, apart from influencing Rembrandt, was also to be important for Philips Koninck, who specialized in flat landscapes although of a very much more prosaic quality than this. The site has been thought to be the river Maas.

The picture was acquired by the museum in 1958 along with the rest of the celebrated van Beuningen collection.

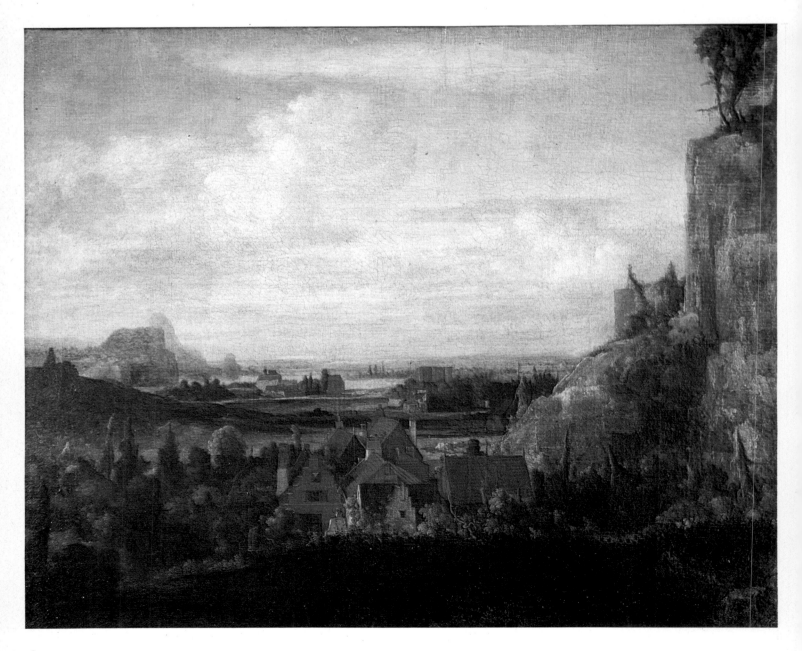

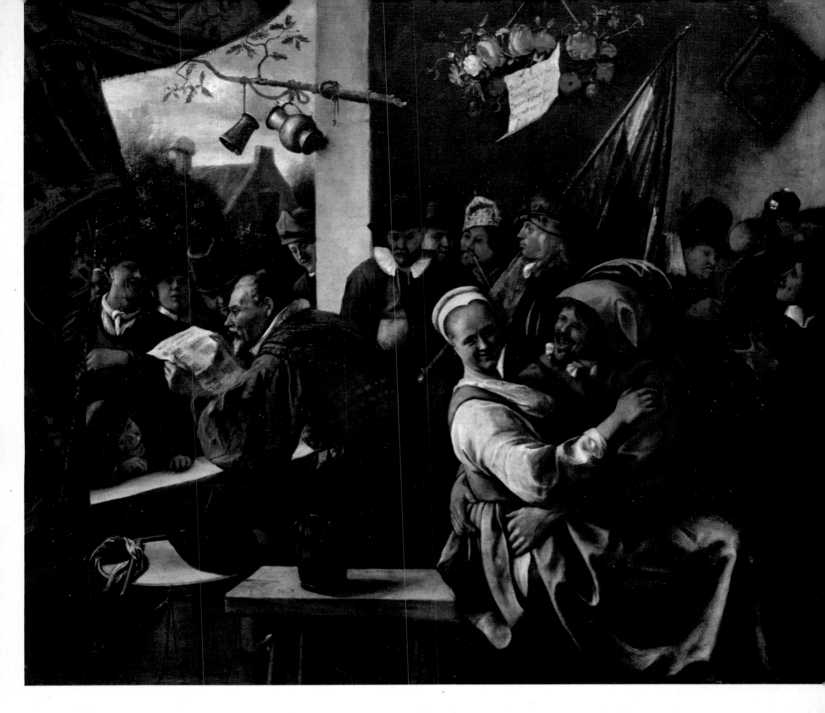

The Rhetoricians

Canvas 86 × 100 cm (33⅞ × 39⅜ in) Signed
and inscribed on the paper suspended from
the garland: IN Liefde vrij Steen.
BRUSSELS, Musée Royal des Beaux-Arts
*This type of picture is full of complicated
plays on words and people's reactions to them.
The leader of the group of itinerant
Rhetoricians is reading a long poem, no doubt
of vulgar content, to a group of amused
villagers. Behind him stands an elderly man
unmoved by the pandemonium around him. In
the foreground is a couple indulging in what
can only be described as a drunken frolic,
encouraged by the inscription hanging from the
garland above them: 'in love be free'. Steen's
pictures of this type are difficult to date, as he
painted in the same boisterous style throughout
his career.*

*The picture was acquired by the museum in
1856.*

Jan Havicksz. STEEN

Leiden 1626—Leiden 1679

Jan Steen is perhaps the best known and certainly the most lively Dutch
painter of genre scenes. He had an infinite capacity for the observation
of human foibles, emotions and ridiculous situations—gluttony, quackery or
simply a noisy scene.

Steen epitomizes the low-life side of the spirit of his times without the
banalities of Adriaen van OSTADE. But this is only part of the truth, as he
was a very much more complex painter. He had a varied career producing
many different types of picture both in handling and subject matter.
His career took him to several different places: up to 1649 he was in Leiden;
in 1649 in The Hague; in 1654/7 in Delft; in 1656/60 in Warmond; in
1661/70 in Haarlem; in 1670/79 back in Leiden. As a very young man he
was trained in various places including The Hague.

Van Goyen left very little influence on Steen, whose sources go back to the
sixteenth-century type of peasant genre scene initiated by Pieter Aertsen. Steen

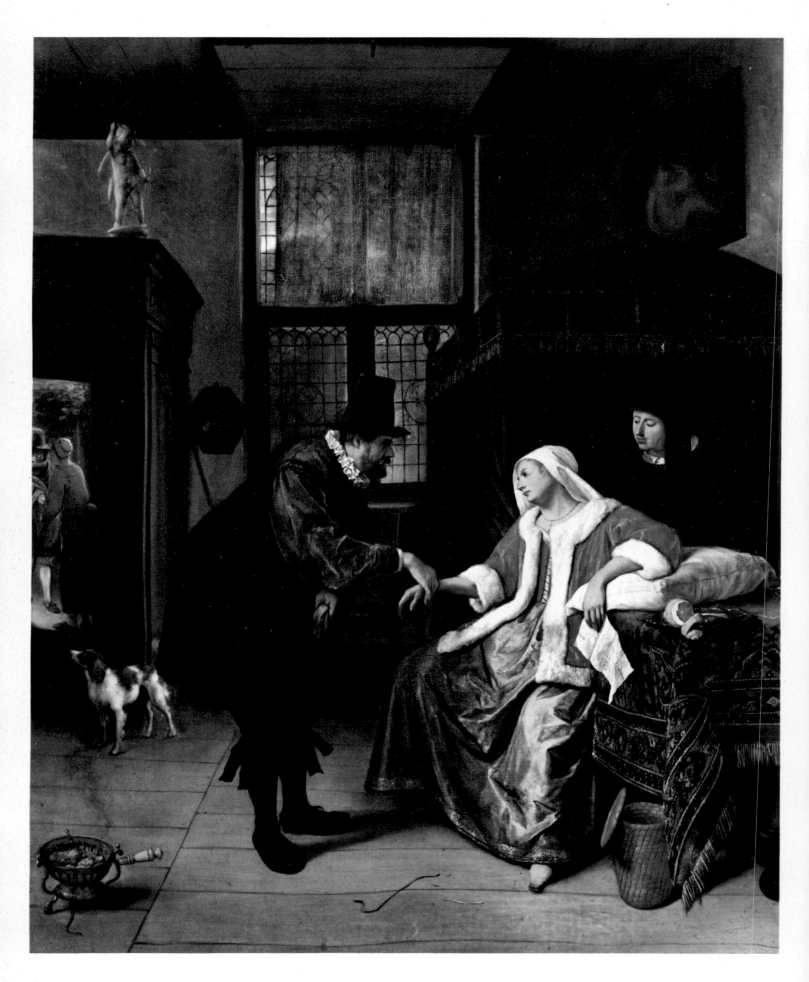

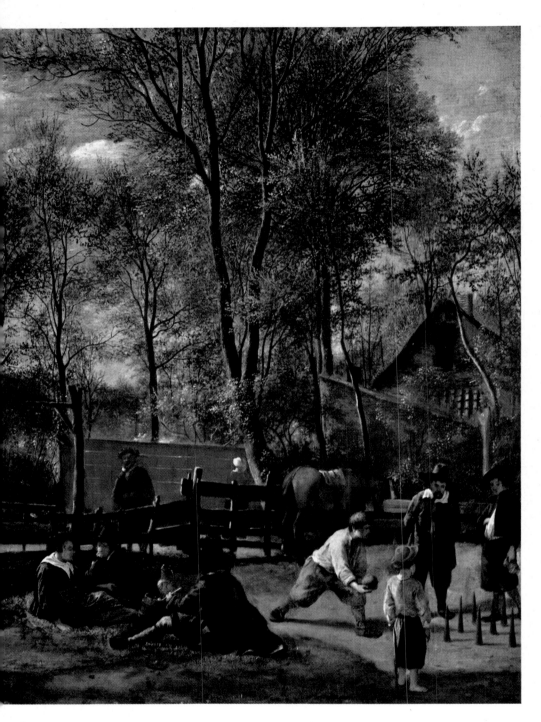

The Love-Sick Woman
Canvas 61 × 52.5 cm (24 × 20¾ in)
Inscribed and signed on the letter: Daar
baat geen/medesyn/ want het is/minepyn/
JSteen.
MUNICH, Alte Pinakothek
*Jan Steen often painted this type of anecdote:
the quack doctor is pretending to help cure the
young woman, who is, of course, sick with
love. Seventeenth-century painters on the
whole saw doctors as figures of fun, which is
curious as much serious and important medical
research was being done at the time, especially
at the University of Leiden. The costume
suggests a date in the 1660s.*

*The painting was recorded in the electoral
picture gallery at Düsseldorf as early as 1719;
it was later transferred to Munich.*

Skittle Players outside an Inn
Panel 33.5 × 27 cm (13⅛ × 10⅝ in)
Unsigned. Probably painted in the 1660s.
LONDON, National Gallery
*The predominance of the landscape in this
delightful picture is unusual for Steen, who
usually preferred to concentrate on people. The
delicate filigree of the trees against the sky is
reminiscent of the similar effect in Adriaen van
de Velde's Farm (see page 195). Only rarely
did Steen achieve so successfully this open-air
effect with figures happily engaged in their
amusements.*

*The picture was sold many times in the
eighteenth and nineteenth centuries and finally
came into the collection of George Salting, who
bequeathed it to the National Gallery in 1910.*

did in fact come from a family of brewers; his father took out the lease of a brewery in Delft for Jan Steen and he lived in the town 1654/7. There, precisely the opposite happened to what might be expected. Steen did not act as a corrupting influence on the painters active in Delft at the time—Pieter de HOOGH and VERMEER. Instead he painted elegant genre pictures—one of them with a view of the Oude Kerk in the background, now in a private collection, was shown at the exhibition held in the National Gallery, London in 1976. In such pictures Steen shows himself to be under the spell of de Hoogh. It was perhaps in Delft that he perfected the brilliant technique which he was to use with such effect for his dissolute households, quack doctors and scenes of roistering.

Throughout his life Steen also had other interests: he liked to paint religious and mythological pictures, some of them quite serious and while others, like the *St Michael strangling the Devil* in the Bredius Museum at The Hague (see page 37) cannot help but raise a smile.

Steen was exceptionally prolific. His pictures have varying degrees of finish. Some of his elegant concert pictures are worthy of Gabriel METSU or Gerard TERBORCH while other pictures seem to be deliberately painted in a coarse manner in order to match their subject matter. These differences are often so great that it is difficult to imagine that they are by the same painter.

Jan Steen is now very much appreciated; his pictures are interesting from the point of view of their subject matter, distasteful though it often is. The same reason has made him a victim of ill-informed criticism in the past, from Reynolds to Fromentin.

Aix-en-Provence; Amsterdam; Antwerp; Arnhem; Ascott (Buckinghamshire); Augsburg; Basle; Berlin; Birmingham (Barber Institute); Boston; Bristol; Brunswick; Budapest; Cambridge; Cheltenham; Chicago; Cleveland (Ohio); Cologne; Copenhagen; Dessau; Dresden; Dublin; Dunkirk; Edinburgh; Florence (Uffizi); Frankfurt; Gotha; Göttingen; Haarlem; The Hague (Bredius Museum, Gemeentemuseum, Mauritshuis★); Hamburg; Kansas City; Kassel; Leiden; Leipzig; Leningrad★; Lille; London (National Gallery, Wallace Collection★, Wellington Museum★); Luxembourg; Malibu (California); Manchester; Melbourne; Milan; Minneapolis; Montpellier; Mulhouse; Munich; New York; Northampton (Massachusetts); Oberlin (Ohio); Otterlo; Paris (Louvre, Petit Palais); Philadelphia (Johnson Collection); Prague; Richmond (Virginia); Rochester (New York); Rotterdam★; Rouen; Saint-Omer; San Francisco; Schwerin; Stockholm; Strasbourg; Upton House (Warwickshire); Utrecht; Vienna; Warsaw; Worcester (Massachusetts).

Matthias STOMER
Amersfoort c. 1600—Sicily (?) after 1650.

All Stomer's surviving pictures are in the Caravaggesque idiom and he continued to paint in the style long after it had gone out of fashion. Dirck van BABUREN and Hendrick TERBRUGGHEN both died young and Gerard HONTHORST and Jan van BIJLERT changed their style in the later 1620s as taste changed. Stomer's early life is undocumented and it has been assumed that he studied at Utrecht because of the superficial resemblance to the work of Joachim WTEWAEL in terms of composition. He was recorded in Rome by 1630 which was already late for a follower of Caravaggio, as the new generation of artists such as Nicolaes BERCHEM and Jan BOTH were more interested in landscape. Stomer then went to Naples and finally to remote Sicily where it is believed that he died. His paintings are usually in a slightly coarsened but more vigorous version of the Caravaggesque manner of Honthorst, with whose work they have been confused. Pictures by Stomer are still being discovered and the rehabilitation of this underestimated artist is not yet complete. A reconstruction of his career is very difficult, owing to the fact that almost no documents about him exist.

Berlin; Birmingham (City Art Gallery); Catania; Copenhagen; Darmstadt; Dresden; Dublin; Genoa (Palazzo Bianco); Göttingen; Greenville (South Carolina); Grenoble; The Hague; Houston (Texas); Karlsruhe; Leeds; Leningrad; Madrid; Marseilles; Messina; Munich; Nantes; Naples (Capodimonte, Museo Filangiei); Ottawa; Paris; Providence (Rhode Island); Rennes; Rome (Galleria Nazionale); Rouen; Stockholm; Sydney; Toulouse; Turin; Valencia; Valletta (Malta); Vienna; Warsaw.

The Incredulity of St Thomas
Canvas 125 × 99 cm (49¼ × 39 in)
Unsigned.
MADRID, Prado
Although superficially similar to Honthorst's style the picture is clearly by Stomer as it betrays his preoccupation with hard edges, especially in the draperies of the figure on the left. Even the hair has a metallic feeling. Probably dating from soon after his arrival in Rome about 1630, this is one of Stomer's best pictures as it is based on careful observation. Later in his career, especially in Sicily, he repeated the motifs from his own pictures and his art became much coarser.

The picture was first recorded in the Spanish royal collection in the Alcázar in 1700. It was in the Royal Palace in 1772 when it was described as being by the Italian painter Guercino. Although attributed to Stomer since 1924, as recently as 1963 it was labelled Terbrugghen by the catalogue of the Prado.

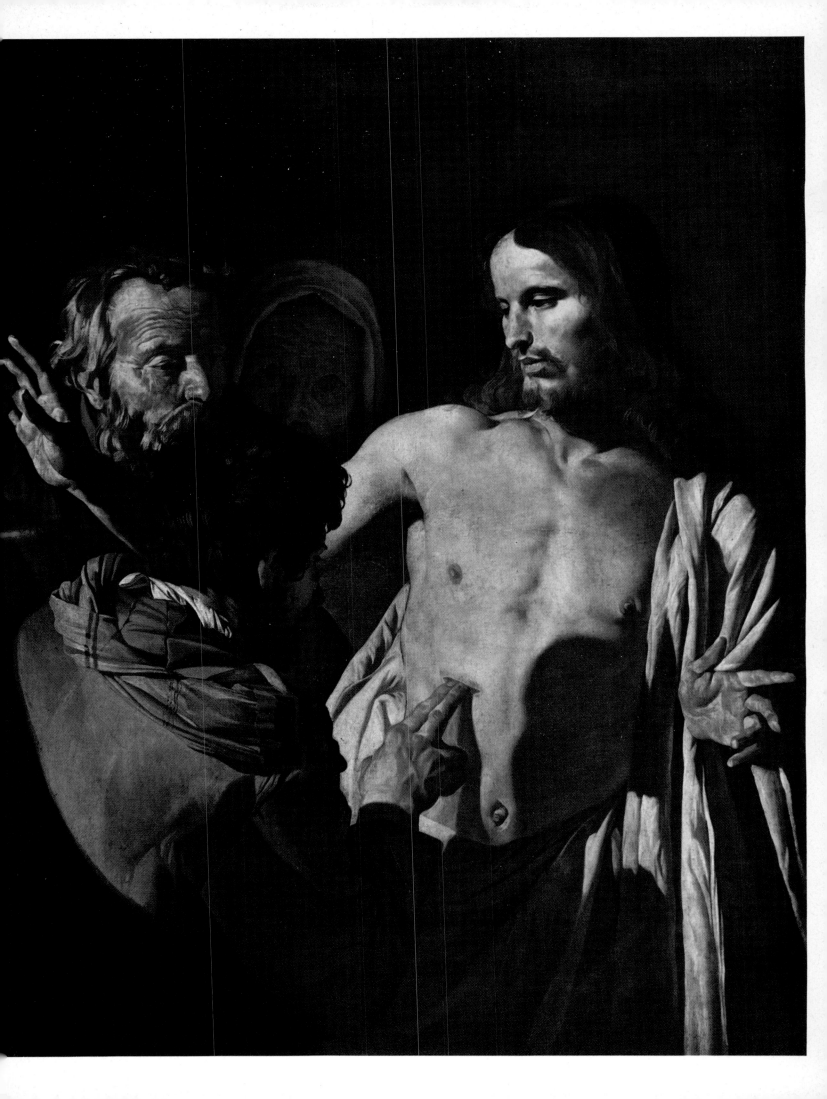

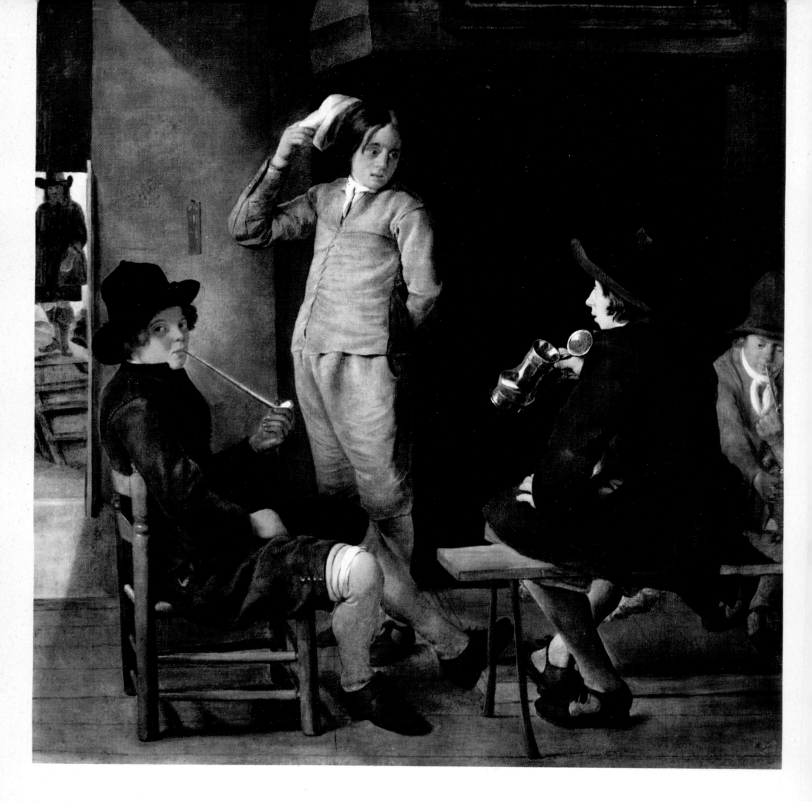

Michiel SWEERTS

Brussels 1624—Goa (Portuguese India) 1664

Sweerts's preoccupation with the human condition—with the sadness on a young child's tear-stained face, with men wrestling, with old care-worn women—seems to detach him from his time and place and give him the universal appeal so obvious in REMBRANDT.

 His birth in Brussels seems to have had little influence on his style of painting, which is strictly Dutch in feeling. His early career was spent in Rome and in the later 1650s he settled in Amsterdam, leaving for Goa in 1662.

 Sweerts used a palette quite unlike any other painter—he seems to infuse faces and sometimes whole pictures with a delicate lilac flush. Most of his

Youths in a Tavern
Canvas 100 × 95.9 cm (39¼ × 37¾ in)
Unsigned.
MUNICH, Alte Pinakothek
Sweerts often painted languid young men wasting their time sitting around in a tavern. Here they seem to be aping the attitudes of their elders, smoking and drinking. The seated youth on the left is in the attitude of a pompous and disdainful old man, and the others do not seem to be the slightest bit amused by their activities. It is quite in keeping with Sweerts's perverse temperament not to paint a real tavern but a mock-up of one, and yet to people it with very real young men.

The Swearing of the Oath of Ratification of the Treaty of Munster, 15 May 1648
Copper 45.4 × 58.5 cm (17⅞ × 23 in)
Signed and dated on the tablet hanging on the left-hand wall: G T Borch F.
Monasterij: A. 1648.
LONDON, National Gallery
It is rare in Dutch seventeenth-century painting to find an event of such historical significance painted with such accuracy. A contemporary description of the event survives, and it seems that Terborch recorded everything that took place on that momentous day when Spain officially recognized the existence of the Dutch Republic. It is not known whether the picture was commissioned.

During the nineteenth century the picture had many different owners in England and France. It was finally acquired by Lord Hertford (who put together a large part of the Wallace Collection) and was inherited by Sir Richard Wallace in 1870; he gave it to the National Gallery in the following year.

pictures are genre paintings of widely differing types, ranging from scenes from an artist's studio (example in the Rijksmuseum, Amsterdam) to the amazing *Two Men wrestling* (in the Kunsthalle at Karlsruhe). His best paintings are the small heads of wide-eyed children, observed with a freshness and deeply felt emotion worthy of Rembrandt himself.

Amsterdam★; Detroit; Groningen★; Haarlem★; The Hague; Hartford (Connecticut); Karlsruhe; Leicester; Leningrad; Le Puy; Munich★; Nîmes; Oberlin (Ohio); Paris; Rome (Galleria Spada); Rotterdam; Sorrento; Strasbourg; Stuttgart; Worcester (Massachusetts).

Gerard TERBORCH
Zwolle 1617—Deventer 1681

Terborch is admired both as a painter of genre pictures and as a portraitist. In his youth he also painted barrack-room scenes, but these are less appreciated today.

His life was relatively uneventful; he left his native Zwolle at an early age and it is likely that he travelled extensively, working in both Haarlem and Amsterdam. He was also in Münster in Germany during the years 1646–8, painting miniature portraits of many of the people concerned with the peace

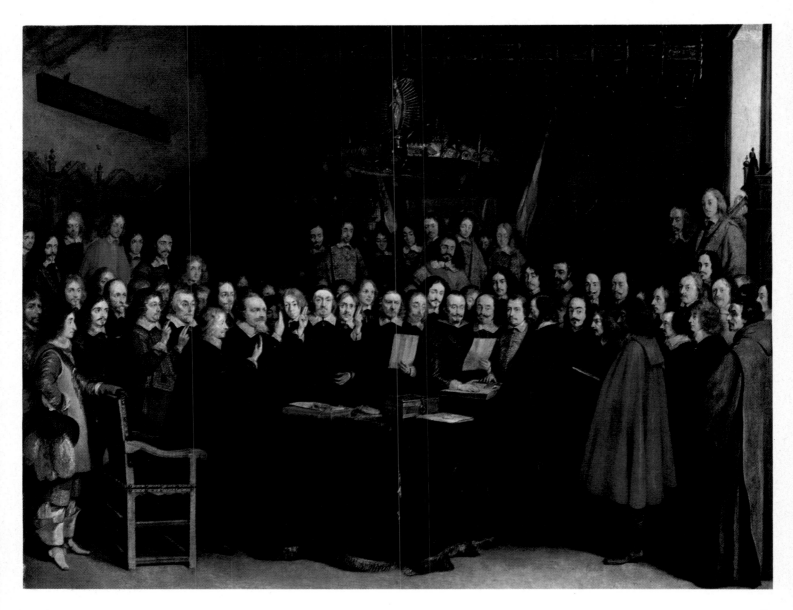

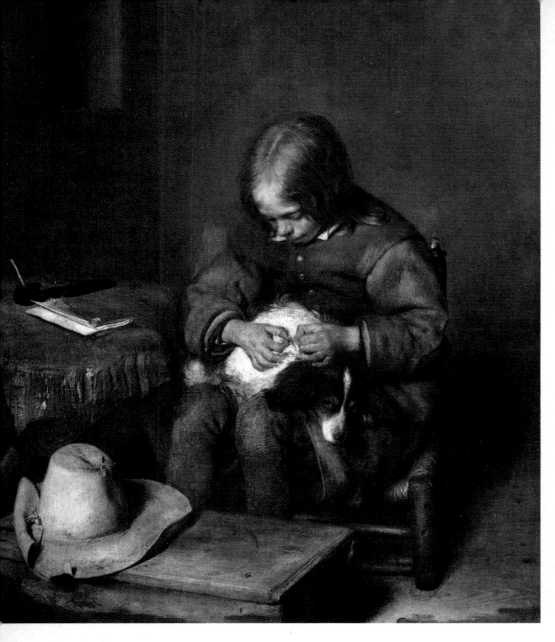

Boy removing Fleas from his Dog
Canvas 34.4 × 27.1 cm (13½ × 10¾ in)
Signed in monogram lower left GTB.
Probably painted in the late 1650s.
MUNICH, Alte Pinakothek
*This type of situation must have been a
common sight in the seventeenth century, even
amongst the wealthier classes. Terborch has
observed the disagreeable job with compassion.
The look of resignation on the dog's face is
particularly amusing as the creature accepts the
search for fleas by its determined young master.*

*The picture was recorded in an Amsterdam
sale in 1705 and it was subsequently in the
celebrated gallery of the Elector Palatine at
Düsseldorf; along with the rest of the
collection it was transferred to Munich at the
end of the eighteenth century.*

Interior with a Lady peeling an Apple
Panel 36.3 × 30.7 cm (14¼ × 12¼ in)
Unsigned. Probably painted c. 1660.
VIENNA, Kunsthistorisches Museum
*Terborch has caught perfectly the matter-of-fact
expression of a woman doing the routine task
of peeling an apple. Obviously it is for the
small child at her right whose facial expression
is full of eager excitement. The way the still
life is handled, especially the cushion on the
right, is reminiscent of Willem Kalf.
Unusually for Terborch, in this picture he has
achieved a calm and serenity reminiscent of
Vermeer.*

*The painting was recorded in Vienna at the
end of the eighteenth century and was removed
to Paris between 1809 and 1815 by the
Napoleonic occupying troops.*

negotiations which were finally settled in 1648. In 1650 he was recorded in Kampen and four years later he settled in Deventer, where he spent the rest of his life.

As a young man Terborch painted many rather elaborate guardroom scenes of exactly the type which would be expected of a young artist studying in Haarlem, where he would have been familiar with the work of Pieter CODDE, Dirck HALS and Willem DUYSTER. However, he soon changed his style, again under Haarlem influence, and acquired a considerable reputation for the painting of small portraits—usually of figures in black set against a plain background. It has even been suggested that Terborch could have derived this type of picture from a knowledge of Spanish painting; it is believed he may have travelled to Spain as a young man. What is much more likely is that his style developed from the monochrome portraits of the Haarlem school, even those of Frans HALS himself. The major difference is that Terborch never used dazzling brushwork but painted in a sober, painstaking manner quite different from most of his *bravura*-conscious Haarlem contemporaries.

It is as a genre painter that Terborch is most admired. He was in no way an innovator and he derived his style of painting from similar pictures by Gabriel METSU. It would not be possible, however, to confuse the two

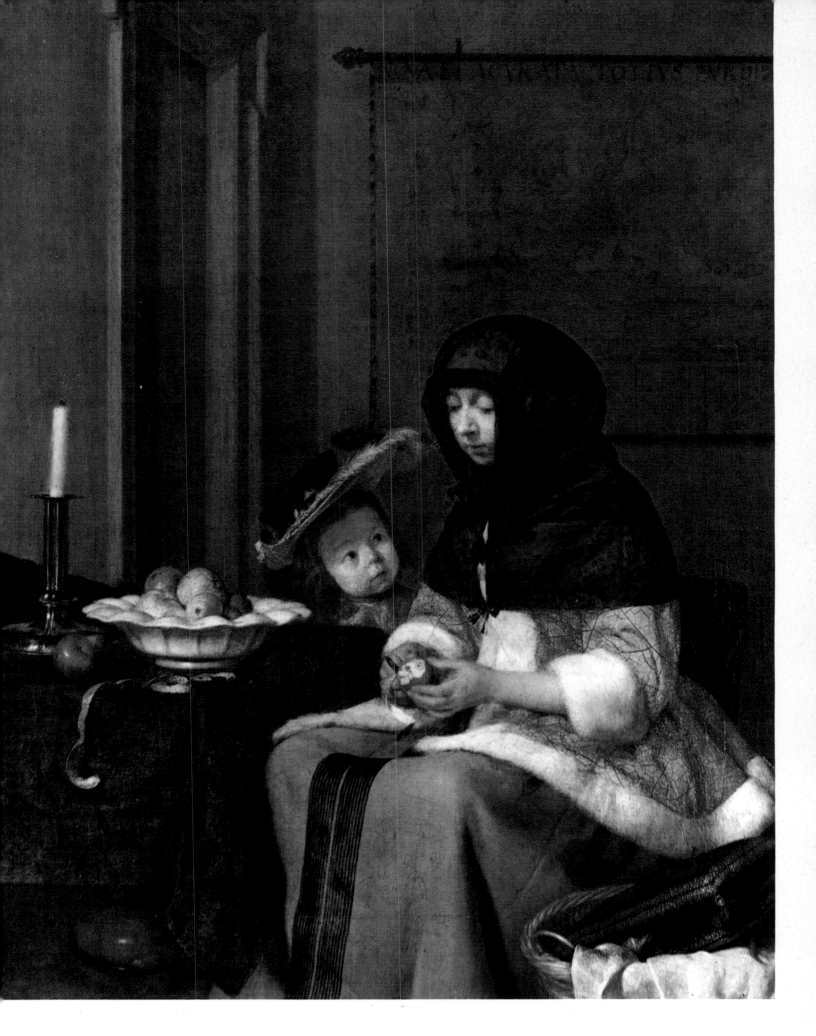

painters even though their subject matter is so similar, as Terborch was slightly less meticulous than Metsu and was more interested in surface glitter. Indeed it is Terborch rather than Metsu who is the best painter of shimmering silk and satin, although there is usually more incidental detail in Metsu's pictures.

Many of Terborch's genre pictures depict elegant ladies and gentlemen engaged in elegant pursuits. But there was another side to his painting: he also painted such pictures as a boy removing the fleas from his pet dog.

Once Terborch had evolved his style of painting he changed it little. He was obviously able to satisfy the demand for his type of art in the area of Zwolle, Kampen and Deventer. His pictures must have appealed very much to the local bourgeoisie, who also patronized him for portraits. Although Terborch worked away from the real centre of artistic activity, which by the 1650s and the 1660s had moved to Amsterdam, there is never any hint of provincialism in his art even though he was satisfying the demands of the relatively remote province of Overijssel.

Aachen; Amsterdam★; Antwerp; Arnhem; Berlin★; Besançon; Boston; Bremen; Brooklyn (New York); Budapest; Chicago; Cleveland (Ohio); Cologne; Copenhagen; Deventer; Detroit; Dresden; Dublin; Frankfurt; Glasgow (Burrell Collection); Haarlem; The Hague (Bredius Museum, Gemeentemuseum, Mauritshuis); Hamburg; Hanover; Helsinki; Indianapolis; Innsbruck; Kansas City; Kassel; Kiev; Leipzig; Leningrad; London (National Gallery★, Victoria and Albert Museum, Wallace Collection); Los Angeles; Lyons; Manchester; Marseilles; Melbourne; Montpellier; Moscow; Munich★; Münster; New York (Frick Collection, Historical Society, Metropolitan Museum); Paris (Louvre, Petit Palais); Philadelphia (Museum of Art, Johnson Collection); Polesden Lacey (Surrey); Prague; Richmond (Virginia); Rotterdam (Boymans-van Beuningen Museum, Vorm Foundation); Rouen; St Louis; Saint-Omer; San Francisco; Schwerin; Toledo (Ohio); Vienna (Academy, Kunsthistorisches Museum); Waddesdon Manor (Buckinghamshire); Warsaw; Washington (Corcoran Gallery, National Gallery); Zwolle.

Hendrick Jansz. TERBRUGGHEN
Province of Overijssel 1588—Utrecht 1629

Almost all Terbrugghen's surviving pictures date from the last ten years of his life. The early records are not clear with regard to his first years, but he probably spent at least ten years in Rome; he was back in Utrecht by the end of 1614 and spent the rest of his life there.

Terbrugghen exerted a significant influence on his Utrecht contemporaries, painting in a Caravaggesque idiom tempered by his own fascination with low-life genre. His range of subject matter was wide. He painted religious pictures in the style of Caravaggio himself, sparing the spectator none of the harsh realities of scenes of martyrdom or betrayal. He was much more brutal than his contemporary Gerrit HONTHORST, whose pure Caravaggism disappeared soon after his return from Rome. Terbrugghen, on the other hand, modified his style but little, although his palette became lighter.

It is a curious paradox that at the very moment when Terbrugghen's pictures had gone out of fashion and were already being forgotten—he had died young in 1629—the young VERMEER's first faltering steps in the 1650s were taken in imitation and admiration of Terbrugghen. Vermeer's *Christ in the House of Martha and Mary* in the Edinburgh Gallery is indebted to Terbrugghen, especially in the bold and crisp handling of the paint.

Algiers; Amsterdam★; Augsburg; Basle; Berlin (Schloss Grunewald); Blois; Bordeaux; Chicago; Cologne; Copenhagen; Crefeld; Deventer; Edinburgh; Erlau (Hungary); Gateshead; Gothenburg; The Hague; Kassel★; Kansas City; Le Havre★; Leningrad; London; New York★; Malibu (California); Minneapolis; Northampton (Massachusetts); Oberlin (Ohio)★; Oxford; Paris (Louvre, Musée de l'Assistance Publique); Potsdam; Rome (Palazzo Barberini); Schwerin; Stockholm; Stuttgart; Turin; Utrecht; Vienna; Warsaw.

St Sebastian tended by the Holy Women
Canvas 150.2 × 120 cm (59⅛ × 47¼ in)
Signed and dated top left: HBrugghen 1625.
OBERLIN (Ohio) Allen Memorial Art Museum
In no other picture did Terbrugghen manage to combine such intensity of emotion with so much technical brilliance. St Sebastian as a popular subject seems to have undergone a revival throughout Europe at this time as the saint to be invoked against the plague. The low view-point of the figure of the saint, which dominates the whole picture, is reminiscent of Caravaggio himself.

All trace of the picture had been lost since it was last recorded in an Amsterdam sale in the early eighteenth century. It was acquired by the museum in 1952.

Still Life
Panel 74.7 × 67.2 cm (29½ × 26½ in) Signed
on the tub J. Treck.
OTTERLO (Gelderland), Rijksmuseum
Kröller-Müller
*The only indication that this is not in fact a
Haarlem-school picture lies in the slightly
increased elaboration of the objects. Most of
Treck's still-life objects have a four-square
quality derived from Pieter Claesz. The whole
picture is beautifully balanced; the white cloth
has been arranged to give the maximum
contrast to the other objects on the table.*

 *The picture was first recorded in an
Amsterdam sale in 1906.*

Jan Jansz. TRECK
Amsterdam c. 1606—Amsterdam 1652

Jan Treck is a good example of a minor master about whom little is known and from whose hand very few pictures seem to have survived. He spent his whole life in Amsterdam, painting exclusively still-life pictures which are always influenced by the Haarlem still-life painters Pieter CLAESZ. and Willem Claesz. HEDA. Treck is only one of the many hundreds of painters whose work, although derivative, achieved an acceptable standard of craftmanship which enabled him to earn a living even in the face of competition from much more fashionable painters.

Amsterdam; Antwerp; Budapest; Leningrad; London; Otterlo.

Adriaen van de VELDE
Amsterdam 1636—Amsterdam 1672

The art of Adriaen van de Velde does not fall into any particular category, and he is therefore too easily left out of anthologies or general discussions of Dutch painting although he was a painter of ability. Although principally a landscape artist with Italianate leanings, he may not have visited Italy at all. Thus he cannot be classified with the Italianate landscapists like Jan BOTH and Adam PIJNACKER. On the other hand his landscapes are contrived with shepherds and animals, and he did not make any real contribution to the development of the realistic tradition of landscape which leads from Jan van GOYEN through to Jacob van RUISDAEL.

Van de Velde's career seems to have been spent mostly in Amsterdam. He may have been the pupil of his father Willem van de VELDE the elder, who specialized in monochrome seascapes. He was obviously not influenced at all by his elder brother Willem Willemsz. van de VELDE, the important seascape painter.

The major influence, in fact, seems to have been Nicolaes BERCHEM in his less Italianate mood and it is sometimes difficult to distinguish between the two painters. Adriaen van de Velde also liked to collaborate with other painters who were less skilled than he was at figure painting. He worked with Philips KONINCK and Jacob van RUISDAEL, among others.

Amsterdam; Antwerp; Barnsley; Berlin★; Boston; Budapest; Cambridge; Chicago; Cleveland (Ohio); Copenhagen; Darmstadt; Dijon (Musée Magnin); Dresden; Edinburgh; Frankfurt; Glasgow; Groningen; The Hague (Bredius Museum, Gemeentemuseum, Mauritshuis); Hamburg; Karlsruhe; Kassel; Leipzig★; London (Dulwich, National Gallery, Wallace Collection); Manchester; Montpellier; Munich; Narbonne; Oxford; Paris (Louvre, Petit Palais); Philadelphia (Johnson Collection); Rotterdam; Salzburg; Schwerin; Stockholm; Strasbourg; Vienna.

The Farm
Canvas laid down on panel 63 × 78 cm (24¾ × 30¾ in) Signed and dated left under the hedge: A.V. Velde F. 1666.
BERLIN-DAHLEM, Staatliche Gemäldegalerie
This is one of the key pictures for the subsequent development of landscape painting, especially in England in the following century. It is, however, unusual in the work of van de Velde, who was usually less realistic in his approach. There is a particularly sensitive rendering of the sunlight as it flashes through the trees; it was this mood which Crome, Gainsborough and Constable often sought.

The painting was acquired by the then Kaiser-Friedrich Museum in Berlin from an English collection in 1899.

Landscape with Two Horsemen
Panel 25 × 32.5 cm (10 × 12¾ in) Signed
and dated lower right to the left of the left
horseman: E. VANDERVELDE 1614.
ENSCHEDE, Rijksmuseum Twenthe
*The frank openness of this picture and its early
date of 1614 show how original Esaias van der
Velde was in his approach. At this time there
was virtually no other pure landscape being
produced in Haarlem. Van Goyen's debt to a
picture of this type is enormous, as in his
Village Scene of 1626 at Leiden; there has
been little change of style, merely an adoption
of Esaias van de Velde's way of painting trees
and figures on a small scale.*
*The picture was acquired by the museum in
recent years.*

Esaias van de VELDE
Amsterdam c. 1591 — The Hague 1630

Esaias van de Velde holds a position of great importance in the development
of landscape painting in the early years of the seventeenth century. The
first part of his career until about 1618 was spent at Haarlem, and he then
moved to The Hague where he spent the rest of his life. Like so many
painters whose significance lies in their influence rather than their actual talent
as painters, Esaias van de Velde lived in relative obscurity. He painted small
landscapes, some of them topographical like the *View of Zierikzee* in Berlin,
in a direct and unaffected manner. He was able to observe with accuracy but
was unable to control atmosphere. He influenced Jan van GOYEN very strongly,
and it was that painter whose mastery of aerial perspective enabled him to
develop into one of the best painters of his time.

Arnhem; Amsterdam*; Berlin*; Brighton; Brunswick; Cambridge; Cologne; Copen-
hagen; Enschede; Glasgow; Haarlem; The Hague; Indianapolis; Kassel; Leipzig; London;
Manchester; Oberlin (Ohio); Prague; Raleigh (North Carolina); Rotterdam; Stockholm;
Vienna.

Willem Willemsz. van de VELDE

Leiden 1633 — Westminster 1707

Willem van de Velde the Younger (as he is more usually known) is the most famous Dutch painter of seascapes and shipping scenes, particularly in England where he spent the latter part of his career. Some connoisseurs prefer Jan van de CAPPELLE or Hendrick Cornelis VROOM, but in the category of broad, calm shipping scenes Willem van de Velde is without rival. So perfect are some of his calm seas that they succeed in giving a feeling of serenity and well-being to the spectator. His cleverness with storms, too, is unequalled, and his ships in distress can often raise a shudder.

As a young man the artist left his native Leiden and went to Amsterdam, where he was probably a pupil of Simon de VLIEGER, who, after 1650, moved to Weesp, which was close to Amsterdam on the east side. Willem van de Velde's father Willem van de Velde the Elder (1611–93) specialized in small monochrome seascapes drawn with a reed pen in black or brown ink on a white ground. It is curious that the real influence on the painter was neither of these two seascape artists but the seascapes of Hendrick DUBBELS and Ludolf BAKHUYSEN, both of whom specialized in calm seas. It is generally assumed that Willem van de Velde's best pictures date from the 1660s and that following the French invasion of 1672, his decision to travel to England (along with his father) was the beginning of a decline in his art. Some of the best surviving work from the English period is the series of seascapes which he executed in 1673 for Ham House near Richmond (Surrey), where they still remain. It is, in fact, quite likely that his own art did not decline but that because he was so widely imitated in England many inferior works have been attributed to him.

Considering his long career, authentic pictures by van de Velde are rare. The reason for this is probably because they took a long time to paint. The enormous and complicated *Battle of the Texel* in the National Maritime Museum, Greenwich must contain several months' work.

Willem van de Velde, unlike many of his contemporaries, was also a draughtsman of significance. Most of his surviving drawings are in the National Maritime Museum, Greenwich. They range from slight impressions of boats or groups of boats to the most incredibly detailed studies of individual ships or parts of them. It was only by making such painstaking observations that his paintings could be built up to form some of the most informative and accurate seascapes ever painted. Hals and Vermeer, on the other hand, do not seem to have drawn at all, but painted directly onto the canvas. In general, the role of drawings in Dutch art is an area which has been little studied.

Most of the seascapes painted in England in the eighteenth century and the early part of the nineteenth are in some way influenced by Willem van de Velde; he initiated a whole school of painting. His younger brother was Adriaen van de VELDE, the landscape painter, and it is curious that from a stylistic point of view there is no contact between the two brothers.

Alkmaar; Amsterdam★; Antwerp; Barnsley; Berlin; Birmingham (City Art Gallery); Bournemouth; Brussels; Budapest; Carcassonne; Copenhagen; Detroit; Dublin; Edinburgh; Frankfurt; Ghent; The Hague; Hamburg; Hanover; Indianapolis; Jacksonville (Florida); Kansas City; Kassel; Leiden; Leipzig; Leningrad; London (Dulwich, Greenwich★, Kenwood, National Gallery★, Wallace Collection★, Wellington Museum); Manchester; Montpellier; Munich; Nîmes; Otterlo; Paris (Louvre, Petit Palais); Philadelphia (Johnson Collection); Polesden Lacey (Surrey); Richmond (Surrey) (Ham House★); Rotterdam; San Francisco; Stockholm; Strasbourg; Vienna (Academy, Kunsthistorisches Museum); Waddesdon Manor (Buckinghamshire).

Overleaf:
Ship in a Storm
Canvas 77 × 63.5 cm (30¼ × 25 in) Signed left foreground: W v velde f. Probably painted c. 1670.
AMSTERDAM, Rijksmuseum
This picture is, on close inspection, not the observation of a real storm but a piece of carefully contrived artifice which gives the impression of one. The wind appears to come from the right, which would make the ship lurch at a sharp angle, but the clouds appear to be moving in the opposite direction. Nevertheless the artist has succeeded in creating an image of terror. As is usual, the ship itself is perfectly observed.

The picture's pendant, The Cannon Shot, is also in the Rijksmuseum. They were both in the same English collection in the early nineteenth century and this picture was acquired by the Rijksmuseum on the Paris art market in 1900.

Page 199:
The Cannon Shot
Canvas 78.5 × 67 cm (30¾ × 26⅜ in) Signed lower right: W.V. velde J. Probably painted c. 1670.
AMSTERDAM, Rijksmuseum
Because the painter understood the minute complexities of the construction of a sailing ship he was able to suggest the vessel brilliantly without the inclusion of every detail, which would make the picture look fussy. There is a beautiful contrast between the absolute calm of the sea and the firing of the cannon.

The picture was meant to be hung with its pendant, the Ship in a Storm. *The two pictures became separated and this picture was in the van der Hoop collection, which was bequeathed to the city of Amsterdam in 1854 and transferred to the Rijksmuseum in 1885. It was fortunately joined by its pendant in 1900.*

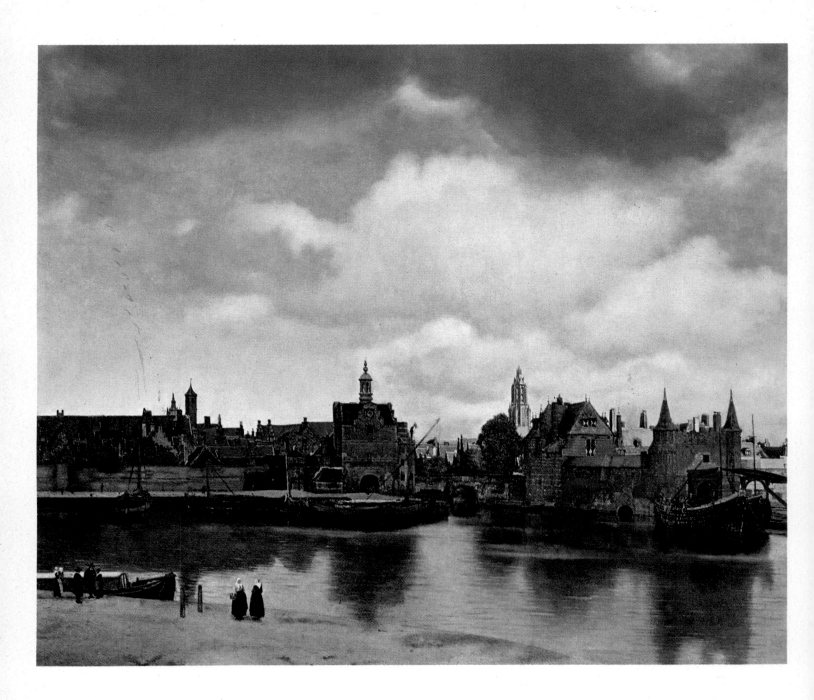

Johannes VERMEER of Delft

Delft 1632—Delft 1675

Vermeer is now considered to be one of the greatest painters of all time, but this reputation is only just over a century old. Obscure in his lifetime, Vermeer was rehabilitated in the public eye by the French scholar and critic Thoré-Bürger in a celebrated article in the French periodical *Gazette des Beaux-Arts* in 1866.

How could an artist of Vermeer's stature suffer such neglect in his lifetime? Part of the answer lies in the fact that he was such an individualist, and worked so slowly, that he could not possibly cope with the enormous amount of competition which he had around him. Also painting exquisite genre paintings in Delft at exactly the same time and a little before was Pieter de HOOGH, and elsewhere the market was cornered, especially in Amsterdam, by Gabriel METSU. Gerrit DOU was in Leiden and Gerard TERBORCH and Nicolaes

View of Delft
Canvas 98.5 × 117.5 cm (38¾ × 46¼ in)
Signed in monogram on the boat: JvM.
Probably painted about 1660.
THE HAGUE, Mauritshuis
Although this painting is one of Vermeer's best-known and consequently one of the best-known Dutch pictures altogether, it is unique both in terms of Vermeer's art and also in the context of the development of landscape in the seventeenth century. No other picture records with so much accuracy, sensitivity and poetry the skyline of a Dutch town on a day of alternating cloud and sunshine. Today, seen from this angle, Delft has changed—the spire of the Oude Kerk is just visible on the left (the whole building is clearly seen in the picture in Oslo by Jan van der Heyden, page 114). The Niewe Kerk is visible on the right.

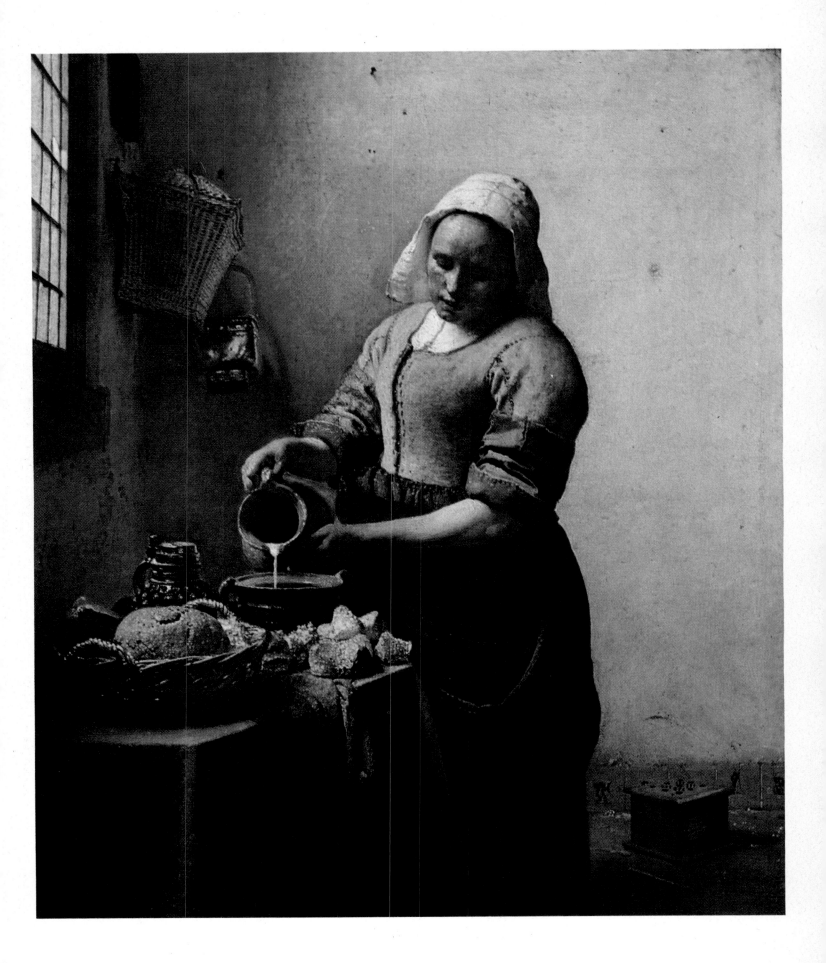

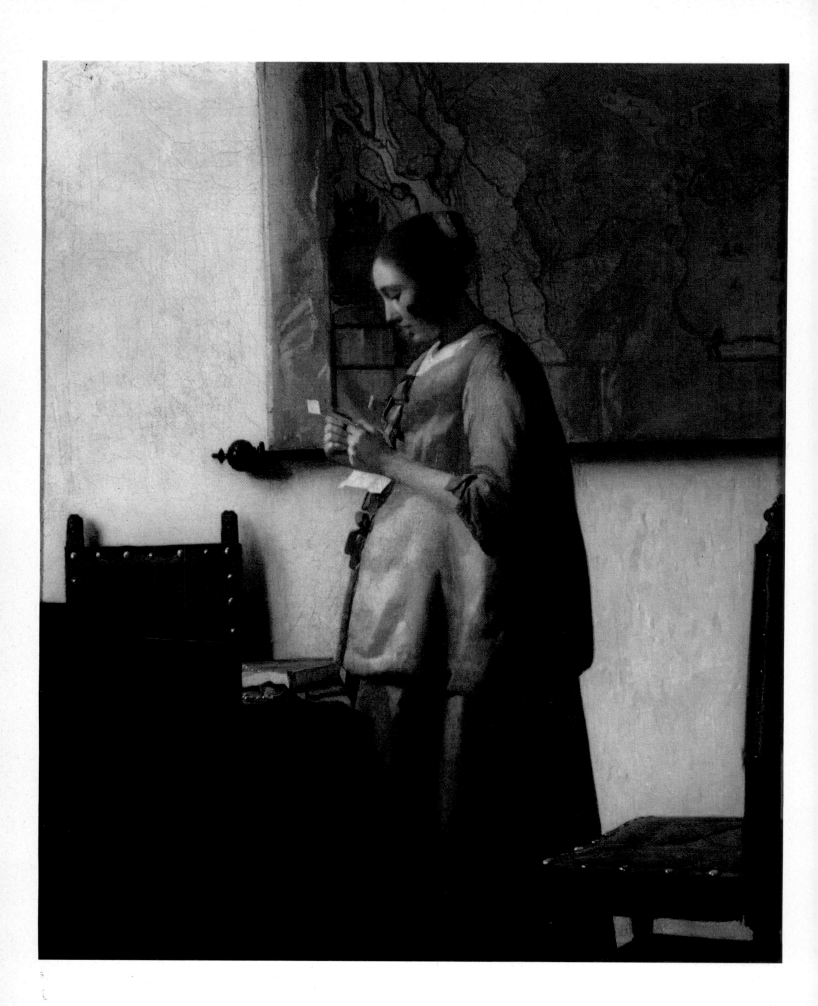

Previous page:

Interior with a Maidservant pouring Milk

Canvas 45.5 × 41 cm (17⅞ × 16⅛ in)
Unsigned. Probably painted in the early 1660s.
AMSTERDAM, Rijksmuseum

Most of Vermeer's genre pictures depict well-dressed people in more elegant situations—making music, engaged in polite conversation, or weighing or admiring their treasures. Here the situation is different; a simple kitchen-maid is discovered in the act of performing one of her numerous daily duties. As in all Vermeer's pictures there is a peculiar intensity of both tone and colour, especially in the blues and yellows which dazzle in a manner quite unlike any other Dutch painter. Perhaps Vermeer had learned the secret of really intense colour from the study of the old Italian masters on which he is recorded as being an expert.

The picture was acquired by the Rijksmuseum in 1908 with the aid of the Rembrandt Society. It had formerly been in the Six collection in Amsterdam.

Interior with a Lady reading a Letter

Canvas 46.5 × 39 cm (18¼ × 15¾ in)
Unsigned. Probably painted in the mid-1660s.
AMSTERDAM, Rijksmuseum

Intimacy is the keynote of this picture. The lady is not aware of the prying eyes of the artist; instead she is preoccupied with the contents of the letter. Here, too, the technique is exceptional. The blue is less intense than that found in the Interior with a Maidservant pouring Milk, *but the illusion of reality is created by the introduction of a very subtle afterglow which is visible right down the edge of the woman's back.*

The picture was recorded in several early nineteenth-century sales and eventually it became part of the celebrated van der Hoop collection, which was bequeathed to the city of Amsterdam in 1854. The city loaned it, along with the rest of the collection, to the Rijksmuseum in 1885.

MAES in Deventer and Dordrecht respectively. All these painters were very much more prolific than Vermeer and all of them were successful.

Very little indeed has been found out about Vermeer and his very greatness as a painter makes the enquiry all the more tantalizing. His only known patron—if he can be dignified with that title—was the local baker, who is recorded as owning one of his pictures in the 1660s. After his death a Delft bookseller, Jacob Dissius, owned at least 20 pictures by Vermeer, but it is not known whether they were acquired directly from the painter.

The artist's evolution can only be surmised, through lack of dated pictures; an enormous amount of research has been done on the problem. The most significant event of his early life in Delft was the explosion in October 1654 of the powder magazine. Carel FABRITIUS was killed and much damage was done not only to the town itself but to the artistic tradition. Paradoxically, Vermeer's early pictures seem not to have affinities with the Delft school of painting at all. They have been said to be like Carel Fabritius, but the closest links are with Utrecht painters, in particular Hendrick TERBRUGGHEN. Even the *Procuress* in Dresden, which is dated 1656, seems much closer to the type of bawdy art practised in Utrecht rather than the more severe and conventional subject-matter preferred in Delft.

Perhaps it will never be known what persuaded Vermeer to abandon the painting of large-scale religious and genre pictures. It may have been the success of Pieter de Hoogh, who by the mid-1650s was painting a series of courtyard scenes in a meticulous style and with pale and delicate colouring.

The earliest of Vermeer's surviving genre pictures is generally believed to be the Amsterdam *Interior with a Maidservant pouring Milk*. However, his development as a genre painter in the 1660s still remains obscure as only two of his pictures are dated—the Dresden *Procuress* of 1656 and the privately owned *Astronomer* of 1668.

It is little short of incredible how in the twentieth century Vermeer should be regarded as one of the greatest painters of all time. Pictures like the *Girl with the Pearl Eardrop* (The Hague, Mauritshuis) are now very famous, but the earliest record of its existence is in an obscure sale in the 1880s, when it changed hands for a very small sum. Vermeer's past obscurity is all the more difficult to explain in the context of the esteem in which most Dutch painters were held in the eighteenth and nineteenth centuries—an esteem which was even greater than today's. Hardly a single word of praise for Vermeer can be found, nor a single high price in a saleroom. When George III acquired the *Music Lesson* it was thought to be by Pieter de Hoogh and had been accordingly provided with a false signature, in spite of the fact that Vermeer's own signature was still visible.

Although Vermeer concentrated on a relatively narrow range of subject matter, his pictures are now being reassessed for double meanings. This is always a hazardous undertaking, since there is no contemporary evidence of hidden meanings—old inventories of pictures give straightforward descriptions of the contents of the painting and do not attempt to explain their messages. Some of Vermeer's works do have clear double meanings—the *Woman weighing Gold* with the Last Judgment in the background is one example, and the *Artist's Studio* may be another. But with other paintings this type of interpretation becomes more difficult. The two pictures in the National Gallery, London—the *Lady standing at the Virginals* and the *Lady seated at the Virginals*—have been thought of as a pair; they are quite similar but not identical in dimensions and in the handling of the paint. The *Lady seated*, with Baburen's *Procuress* in the background, has been seen as an allegory of profane love, and the *Lady standing* as sacred love—the cupid in the background of this picture,

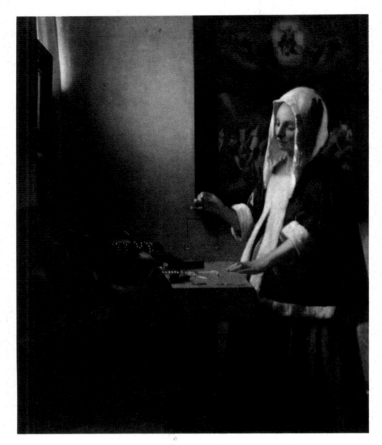

Interior with a Lady weighing Gold
Canvas 42.5 × 38 cm (16¾ × 15 in)
Unsigned. Probably painted in the mid-1660s.
WASHINGTON, National Gallery of Art
Although much of Vermeer's art can be interpreted as a simple record of human activity, occasionally, as in this picture, he introduced double meaning. The picture exists on the level of genre as an interior with a lady indulging in the perfectly natural job of weighing her valuables. On the other hand the picture in the background, probably in the manner of Joachim Wtewael, is of the Last Judgement, and an allegory may have been intended. The weighing in the room may refer to the weighing of souls or at least act as a reminder to the spectator.

The picture changed hands many times in the early nineteenth century and was given to the newly founded National Gallery in 1942 by Joseph Widener of Elkins Park, Philadelphia.

it is suggested, symbolizes *honourable* love. The truth will probably never be known, but the problems which these two pictures pose for critics who specialize in the complex area of the interpretation of subject matter illustrate that a picture may not always be so simple as a casual glance may suggest.

In the way he treated his subject matter Vermeer can be said to have followed the conventions of his time, especially in the depiction of ladies reading letters, making music, weighing gold. All these are familiar from Pieter de Hoogh and Gabriel Metsu. What makes Vermeer uniquely different is the *way* in which the pictures were painted. Throughout his life he used a meticulous technique which gradually changed in emphasis. His earliest pictures, like the *View of Delft* in The Hague, have the paint quite thickly applied and impasto is used. He later refined this into a rather smoother surface which gives the impression of an immense variety of texture, as in the Amsterdam *Interior with a Lady reading a Letter*. Later in life his style changed again and his pictures seem to become hard and brittle with very clearly defined edges, as in the Amsterdam *Interior with a Lady reading a Letter with her Maid*.

Vermeer is rightly seen as the most perfect of all Dutch genre painters, but his pre-eminence must not cause the excellencies to Pieter de Hoogh to be ignored. Metsu, Maes, and Terborch may have lacked Vermeer's genius for distilling everything down to absolute essentials, but they are nevertheless worthy of consideration as being only a very little less good than the great master of Delft.

Amsterdam★; Berlin★; Boston (Gardner Museum); Brunswick; Dresden★; Edinburgh; Frankfurt; The Hague★; London (Kenwood, National Gallery); New York (Frick Collection★, Metropolitan Museum★); Paris; Vienna★; Washington.

Interior with an Artist painting a Model (The Artist's Studio, or An Allegory of Painting)
Canvas 120 × 100 cm (47¼ × 39⅜ in)
Unsigned. Probably painted early 1670s, although this is in doubt.
VIENNA, Kunsthistorisches Museum
This is Vermeer's most complex and brilliant picture. The subject matter has been given many different interpretations. Thoré-Bürger was the first to suggest that the painting could be a self-portrait; if this is so then it must be the most enigmatic self-portrait in the whole history of art. Modern scholarship has tried to interpret the subject matter as an elaborate allegory of painting, as the artist appears to be painting a Muse.

From the point of view of technique all Vermeer's skill from all his other pictures seems to be included, from the glittering brass chandelier to the simple tiled floor.

The painting was first recorded in the Czernin collection in the early nineteenth century with an attribution to Pieter de Hoogh. It remained in the Czernin family until seized by Hitler. It was acquired by the museum in 1946.

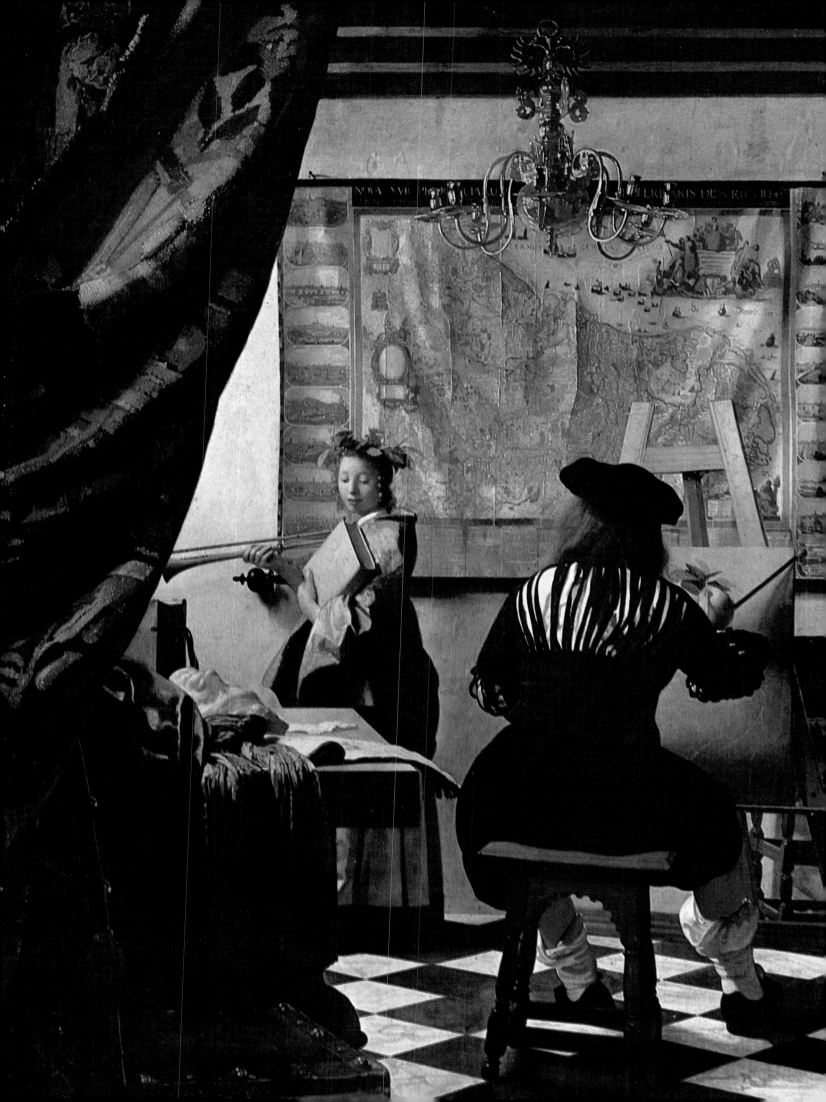

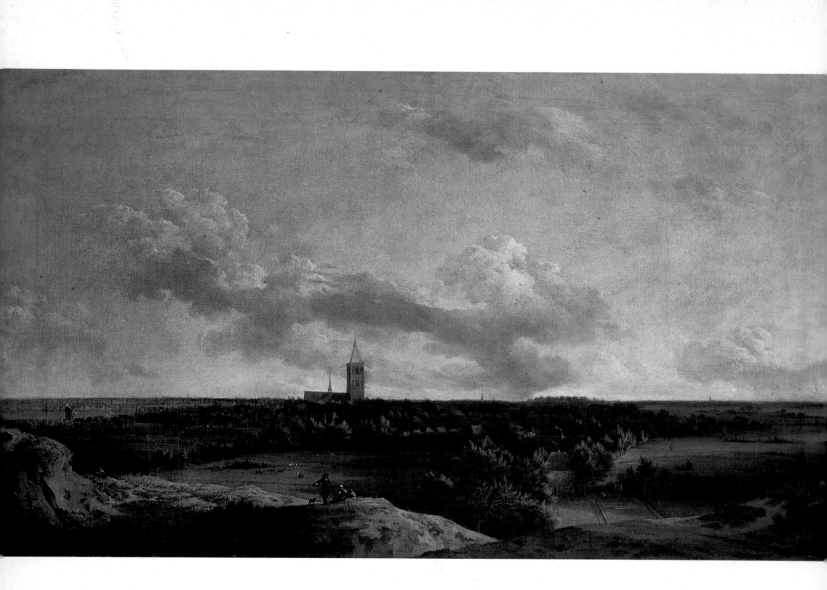

Jan VERMEER van Haarlem (van der Meer)
Haarlem 1628—Haarlem 1691

There is absolutely no connection between this painter and his great Delft namesake. Vermeer of Haarlem was an imitator of Jacob van RUISDAEL, and most of his pictures are derived from a certain type of Ruisdael painting— chiefly the distant views of Haarlem. He never copied Ruisdael directly but adapted his motifs, always giving his pictures a pleasant feeling of the open air. He spent all his life in Haarlem and must have visited neighbouring villages, as there are several quite accurate topographical views by him. His success must have been because he was able to provide a commodity which was similar to, but cheaper than, the work of his source of inspiration, the great Jacob van Ruisdael. In the nineteenth century his pictures, on account of his signature, were were sometimes ascribed to his great Delft contemporary, and he is still misunderstood today.

Brunswick; Brussels; Budapest; Cologne; Dresden; Haarlem; The Hague; Hamburg; Hanover; Leipzig; Leningrad; London (Wellington Museum); Oldenburg; Oxford (Christ Church); Rotterdam; Salzburg; Vienna; Warsaw.

Landscape with a Distant View of Noordwijk
Canvas 88.5 × 154 cm (34$\frac{7}{8}$ × 60$\frac{5}{8}$ in)
Signed and dated lower left: J.v. der meer A° 1676.
ROTTERDAM, Boymans-van Beuningen Museum
The source of this picture is Jacob van Ruisdael's View of Beverwijk *in the Alte Pinakothek at Munich. Vermeer of Haarlem could not handle the distance as well as Ruisdael, however. By comparison the church in Ruisdael's landscape in the National Gallery, London appears very much more solid than the rather cut-out feeling of the church in this picture. Nevertheless, Vermeer of Haarlem always achieves a pleasant effect in his pictures; they are sensitive records of the open landscape around Haarlem. The painting was acquired by the museum in 1866.*

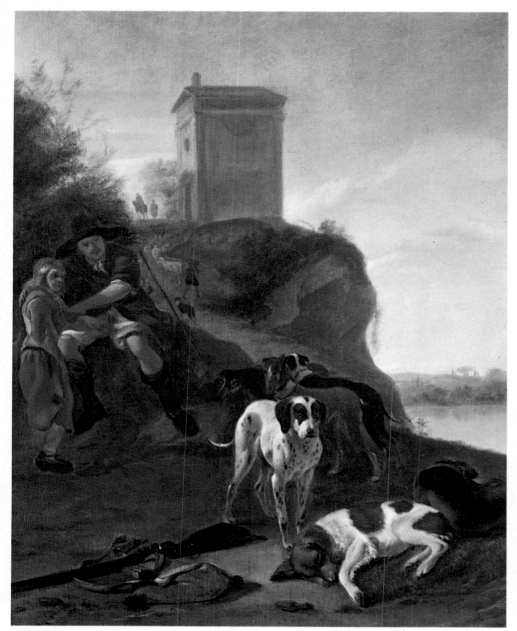

Landscape with Hunters resting
Panel 41.3 × 31.5 cm (16¼ × 12½ in)
Signed: H. VERSCHURING. Probably
painted in the 1660s.
THE HAGUE, Mauritshuis
*This particular example of Verschuring's work
is very close to the style of Philips
Wouwermans, who was largely responsible for
the evolution of a particular type of hunting or
cavalry scene in an Italianate landscape setting.
This picture's charm lies in the gentle golden
light and the rather clumsy building in the
background, which looks exactly like what it
is—a Dutchman's attempt to paint an Italian
building from memory.*

*The picture was given to the Mauritshuis in
1897.*

Hendrick VERSCHURING

Gorkum 1627—Gorkum 1690

In 1641 the young Verschuring left his native Gorkum to become a pupil
of Jan BOTH at Utrecht, the latter artist having just returned from Italy. This
early training must have inspired Verschuring to travel to Italy himself, and
he spent at least eight years there in the late 1640s and early 1650s. On his
return he spent the rest of his life in Gorkum. As might be expected,
Verschuring specialized in Italianate landscapes, but he also achieved a con-
siderable reputation as a painter of battle scenes, for which he is best known
today. His pictures are usually in the style of Philips WOUWERMANS, though
he never achieved the enormous reputation of the latter artist.

Aschaffenburg; Bamberg; Brunswick; Châteauroux; Copenhagen; The Hague (Bredius
Museum, Mauritshuis); Leipzig; Leningrad; London; Nantes; Richmond (Virginia);
Rotterdam; Salzburg; Stuttgart; Utrecht.

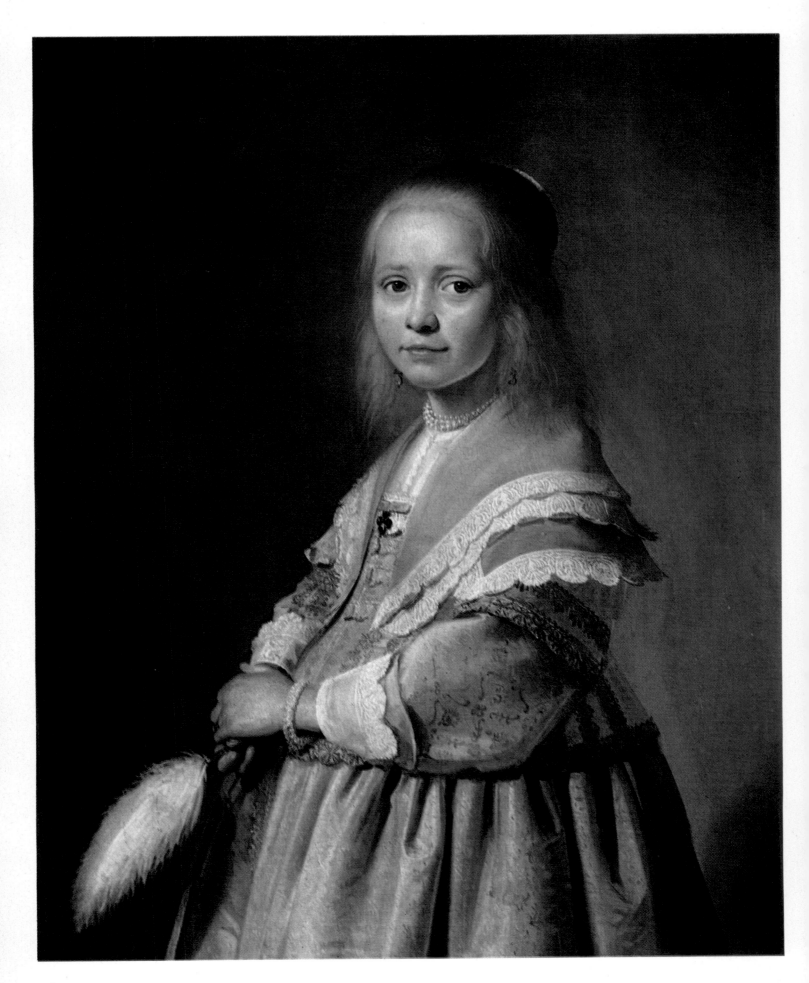

208

Portrait of an Unknown Girl

Canvas 82 × 66.5 cm (32⅜ × 26¼ in) Signed and dated lower left: J. VSpronck Anno 1641.
AMSTERDAM, Rijksmuseum
This is the artist's best known picture. He painted elderly burghers with equal facility but the girl's happy face and lively expression have an obvious appeal. Like his Amsterdam contemporary van der Helst, Verspronck was also brilliant at the painting of draperies—in this instance the handling of the blue silk dress is outstanding. Although an enormous amount of detail is suggested, the whole is quite broadly painted, which may suggest some influence from Frans Hals himself.

A Cow on a Ferry-Boat

Canvas 72 × 91 cm (28⅜ × 35⅞ in) Signed and dated: J. Victors 1650.
COPENHAGEN, Statens Museum for Kunst
As an accurate record of a humble daily event this picture is invaluable. The problem of transport is often overlooked by historians, and painters have obliged much less often in this area than in topography. Even today most Dutch fields are surrounded by water and it must have been a delicate and difficult matter to transport a large cow from one field to another. The style of Victors's picture is reminiscent of Govert Camphuysen.
 The picture was acquired by the museum in 1902.

Jan Cornelisz. VERSPRONCK

Haarlem 1597—Haarlem 1662

Verspronck never seems to have left his native Haarlem, and apart from Frans HALS he must be considered as the most important portrait painter of his generation. He was especially good at group portraits of staid burghers dressed in black as well as single portraits of the successful bourgeoisie. His polished style is easily recognizable—he gave his sitters' faces a porcelain-like glow and almost always placed them against a plain background. Verspronck occupies in Haarlem the same position as van der HELST in Amsterdam.

Amsterdam; Boston; Budapest; Evansville (Indiana); Haarlem★; The Hague; Leningrad; Lille; Manchester; Paris; Speyer.

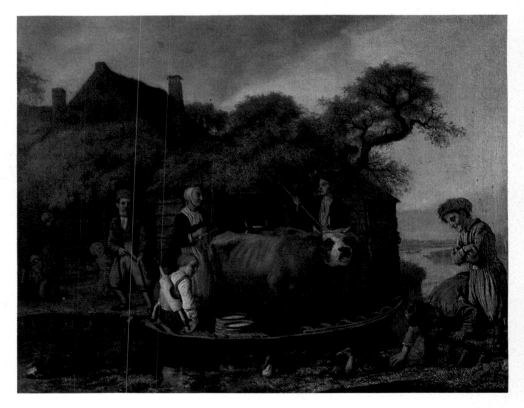

Jan VICTORS

Amsterdam 1620—Dutch East Indies 1676 or later

Jan Victors's career divides into two quite distinctly different periods. As a young man he was apprenticed to REMBRANDT and was able to paint quite competently in his master's manner. The important Rembrandt in Dresden, *The Angel Ascending in the Flames of Manoah's Sacrifice*, has even been attributed to Victors by some scholars.

The second part of his career is difficult to explain, as Victors changed completely. He specialized in outdoor genre scenes, butchers' shops and markets painted in a style reminiscent of Adriaen van OSTADE rather than any other Amsterdam painter.

Amiens; Amsterdam; Antwerp; Brighton; Brunswick; Brussels; Budapest; Cardiff; Cologne; Copenhagen; Dordrecht; Dresden; Dublin; Gateshead; Greenville (South Carolina); Haarlem; Leipzig; Leningrad; Lille; Liverpool; London (National Gallery, Wallace Collection); Oldenburg; Paris; Toulon; Warsaw; York.

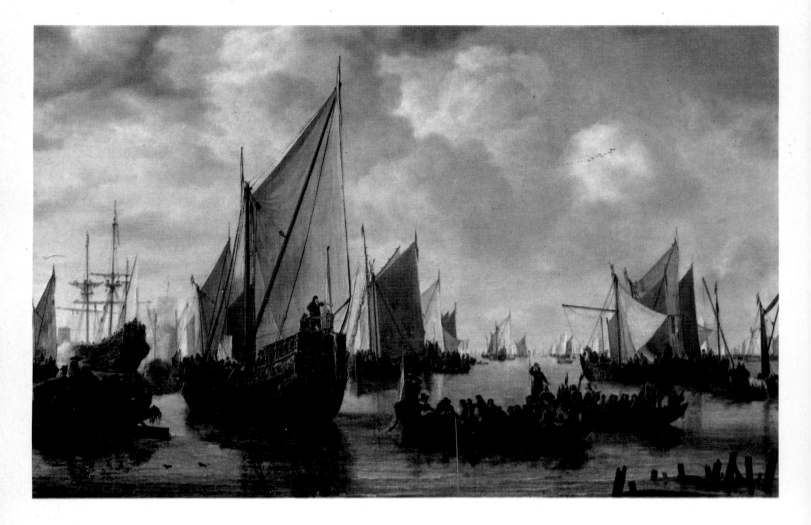

Simon Jacobsz. de VLIEGER
Rotterdam 1601—Weesp 1653

Simon de Vlieger's seascapes form the transition between the monochrome pictures of Jan Porcellis and the fully developed art of the younger Willem van de VELDE. His early life was spent in Rotterdam and he is recorded as living in Delft in the 1630s. Later he moved to Amsterdam but spent the last three years of his life at Weesp, which lies just to the west of the city. De Vlieger's seascapes are much broader in the angle of vision and much more elaborate than those of Porcellis, which they resemble in their cool grey tonality. De Vlieger had a light touch and there is sometimes an evanescent quality about his ships on a breezy day which is reminiscent of Jan van GOYEN. His pictures never achieve the monumental calm of Willem van de Velde the younger or even of Jan van de CAPPELLE or Hendrick DUBBELS, but he was certainly the most competent seascape painter active in the 1630s and 1640s. He was also the painter of a few landscapes and genre pictures.

Aix-en-Provence; Amiens; Amsterdam; Antwerp; Aschaffenburg; Barnard Castle; Basle; Bonn; Brunswick; Budapest; Cambridge; Cape Town; Cologne; Copenhagen; Detroit; Douai; Frankfurt; The Hague; Hamburg; Leningrad; London (Greenwich, National Gallery); Mainz; Manchester; New York; Paris; Philadelphia (Johnson Collection); Prague; Rotterdam (Boymans-van Beuningen Museum, Vorm Foundation); Schwerin; Stockholm; Strasbourg; Vienna (Academy, Kunsthistorisches Museum).

The Fleet of the Stadholder Frederick Henry at Dordrecht
Panel 71 × 92 cm (28 × 36¼ in) Signed and dated on the rudder of the large yacht in the centre: S. DE VLIEGER 1649.
VIENNA, Kunsthistorisches Museum
De Vlieger's seascapes are rarely as monumental as this composition, which is reminiscent of the style which Jan van de Cappelle was to favour. However, de Vlieger, even in this picture, is much more linear in treatment than van de Cappelle. Note, for instance, the treatment of the small waves in the foreground, which is typical of de Vlieger's rather nervous approach. In the background at the right can just be seen the tower of Dordrecht cathedral.

The painting was recorded in several private collections in The Hague in the eighteenth century and was acquired by the Vienna museum in 1950 from a local collection.

Hendrick Cornelisz. van der VLIET
Delft 1612—Delft 1675

Vliet worked all his life in Delft, painting almost exclusively the interiors of the two main churches of the town—the Oude Kerk and the Nieuwe Kerk. (For the exterior of the Oude Kerk see van der Heyden (page 114), Daniel Vosmaer (page 24), and Vermeer's *View of Delft* (page 200); for the exterior of the Nieuwe Kerk see also Daniel Vosmaer and for the interior see Emmanuel de Witte (page 218).) Vliet was the nephew of Willem van der Vliet (1583/4—1642), who worked in the style of the Delft portrait painter Michiel Jansz. van Mierevelt (1567–1641). Vliet himself introduced little that was new in his church interior painting—he had not the precision of Pieter SAENREDAM or the skill with light of Emanuel de WITTE. Nevertheless his pictures are workmanlike and carefully painted, and they must have satisfied the enormous demand for accurate records of these two great churches.

Anspach; Antwerp; Baroda (India); Birmingham (Barber Institute); Bordeaux; Boston; Brunswick; Brussels; Calais; Cambridge; Châteauroux; Cherbourg; Clermont Ferrand; Copenhagen; Detroit; Dijon; Dublin; Frankfurt; Ghent; Glasgow (Burrell Collection); Haarlem; Hamburg; Kansas City; Karlsruhe; Kassel; Leipzig; Leningrad; Manchester; Melbourne; Nîmes; Oxford; Paris; Philadelphia; Rotterdam; Rouen; San Francisco; Sarasota (Florida); Stockholm; Tours; Vienna (Academy).

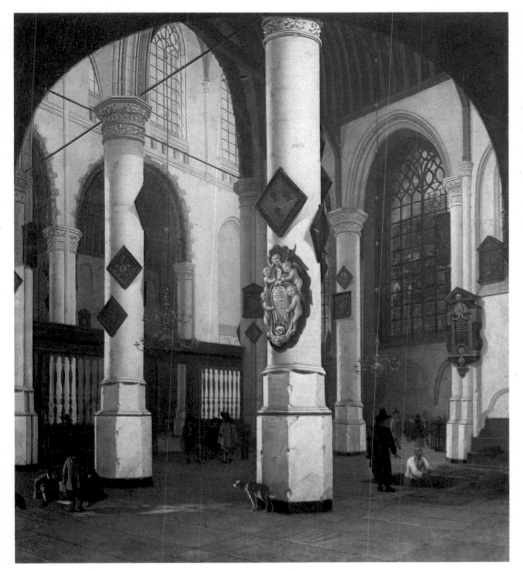

Interior of the Oude Kerk at Delft
Canvas 77 × 69.3 cm (30⅜ × 27¼ in) Unsigned (?) Probably painted in the 1660s.
MANCHESTER, City Art Gallery
Vliet liked to paint the interior of the Oude Kerk at Delft seen from an angle across the transepts and aisles which gave the maximum possible combination of columns in the angle of vision. He was not interested in exciting effects of light, and his pictures are usually rather pale in tone and colour. The contrasts are achieved by the inclusion of numerous monuments, inscriptions and also figures. A grave is being dug on the right; it was still the custom for people to be buried inside churches.

The painting was bought by the museum in 1953.

Jacobus VREL

working, probably in Delft, 1654—1662

Of all the minor Dutch painters of the seventeenth century Vrel is one of the most enigmatic. The location of his activity can only be surmised through searching for the possible sources of his style, and there is a general agreement that this was probably Delft, although there is no record of him in the town. His few dated pictures range from 1654 to 1662.

Vrel concentrated on two distinctly different types of painting. Half of his pictures depict rather bare interiors painted in the manner of Pieter Janssens or Pieter de HOOGH. He liked to paint bare walls in a manner reminiscent of VERMEER. The other half of his work consists of street scenes where the houses tend to be seen frontally, as in Vermeer's *Little Street* in the Rijksmuseum, Amsterdam. Perhaps one day more information will come to light about this beautiful painter.

Amsterdam; Antwerp; Brussels; Groningen; Hamburg; Hartford (Connecticut); Leningrad; Lille; Malibu (California); Oldenburg; Oxford; Philadelphia (Johnson Collection); Vienna.

Street Scene
Panel 41 × 34.2 cm (16¼ × 13½ in)
Unsigned. Formerly signed VMEER.
Probably painted c. 1660.
MALIBU (California) J. Paul Getty
Museum
Vrel's few surviving pictures stray far from the accepted conventions of his time. Street-scene painting had reached a high level of development and was about to see its purest expression in the art of Jan van der Heyden. In contrast, Vrel's work appears almost naive. But in his own way Vrel achieves an exquisite feeling of the claustrophobia of a town street where nature is shut out. The sky is barely visible and the small figures seem lost in a man-made world of endless bricks.

The picture has the distinction of once having been in the collection of Thoré-Bürger, the discoverer of Vermeer, and that great connoisseur was under the impression that it was by Vermeer himself. The picture was acquired on the Paris art market in 1951 by J. Paul Getty.

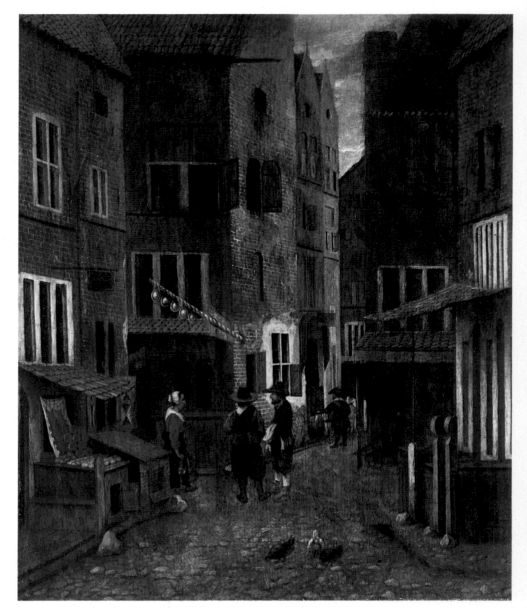

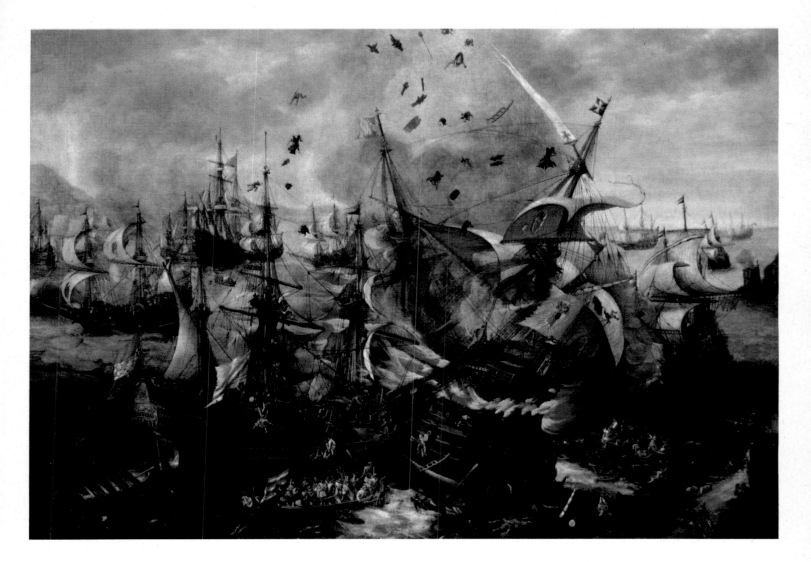

The Explosion of the Spanish Flagship during the Battle of Gibraltar, 25 April 1607

Canvas 137.5 × 188 cm (54⅛ × 78 in)
Unsigned. Probably painted soon after the event.

AMSTERDAM, Rijksmuseum

Vroom creates a splendid feeling of drama by choosing to paint the moment of an explosion. The shattered fragments of the exploding ship fly through the air in a graphic way. The fact that it was a Spanish ship would, quite naturally, have made the picture popular among the newly patriotic Dutchmen who already realized that the secret of their power lay in the sea and its control. Vroom's influence on other painters was general rather than specific. Here, all is meticulously painted; very few painters imitated his very personal style directly but were able to build on and interpret his peculiar mastery of this difficult genre.

The picture was acquired by the museum in 1905 at an Amsterdam sale.

Hendrick Cornelisz. VROOM

Haarlem c. 1566—Haarlem 1640

Hendrick Cornelisz. Vroom, who is not to be confused with his son, the sea and landscape painter Cornelis Hendricksz. Vroom (Haarlem 1591/2—Haarlem 1661), could well be described as the father of seascape painting in the United Provinces. It is difficult to believe that he was of exactly the same generation as Abraham BLOEMAERT, Hendrick GOLTZIUS, CORNELIS van Haarlem and Joachim WTEWAEL, as there is not the slightest trace of an Italianizing style in his art. His source was probably Pieter Brueghel the elder but this influence was indirect. As a young man he spent some time in Rome, where he met Paul Bril. Vroom spent his whole career producing immaculately painted seascapes and sea battles, which were much sought after by the patrons of the time. In 1610 the States General gave two of his seascapes to Prince Henry of England. Surprisingly, Vroom's pictures are now rather rare.

Alkmaar; Amsterdam★; Budapest; Copenhagen; Florence (Pitti); Haarlem★; Hoorn; London (Greenwich); Utrecht.

Jan WEENIX

Amsterdam 1642—Amsterdam 1719

Jan Weenix's work is too easily confused with that of his father Jan Baptist WEENIX. Like his father he painted Italianate landscapes and an equally enormous number of pictures of dead game. He spent some time in Utrecht in the 1660s but lived most of the time at Amsterdam. During the period 1702–12 he was court painter to that indefatigable collector of Dutch art, the Elector Palatine Johann Wilhelm, at Düsseldorf. He painted numerous pictures of game for the Elector's residence, the Schloss Bensberg. Weenix was enormously popular in the eighteenth century and his reputation survived until the middle years of the nineteenth.

Barnsley; Bath (Holburne Museum, Victoria Art Gallery); Brest; Bristol; Caen; Cambridge; Chalon-sur-Saône; Chambéry; Colchester; Kassel; Leeds; Le Puy; London (National Gallery, Victoria and Albert Museum, Wallace Collection★); Montpellier; New York; Nîmes; Oberlin (Ohio); Paris (Louvre, Petit Palais); Plymouth; Quimper; Salzburg; Schwerin; Strasbourg; Toronto; Vienna (Academy, Kunsthistorisches Museum); York.

Still Life: The Dead Hare
Canvas 105 × 94 cm (41¼ × 37 in)
Signed and dated: J. Weenix 1704
PARIS, Musée du Petit Palais
Both Jan Weenix and Jan Baptist Weenix specialized in pictures of dead game; this late example by the son is dated 1704 and shows the continuing strength of a tradition popular more than 50 years before. Jan Weenix observed with an unerring eye and his high finish and observation of detail delighted connoisseurs for two centuries until the twentieth, which found no use for this type of realism.

One of Weenix's best-known pictures, this work was bequeathed to the city of Paris in 1902 by Auguste Dutuit as part of one of the most important collections of Dutch pictures in France outside the Louvre.

Jan Baptist WEENIX
Amsterdam 1621—Huis ter Mey (near Utrecht) before 1663

Although he had only a short career, Jan Baptist Weenix, who was the father of Jan WEENIX, had an enormous output of greatly varied subject matter. Much of his early life was spent in Rome, where, quite naturally, he learned to paint Italianate-type landscapes. He also painted a colossal number of still-life pictures, mostly of dead game, and these became so famous that few great picture galleries in Europe in the eighteenth century were without one. On his return from Italy in 1647 and after a brief stay in Amsterdam he went to the Huis ter Mey near Utrecht, where he died. His son imitated his work and the two painters are easily confused.

Amiens; Amsterdam; Antwerp; Basle; Brighton; Brunswick; Budapest; Caen; Cherbourg; Copenhagen; Dijon; Edinburgh; Frankfurt; The Hague; Hartford (Connecticut); Karlsruhe; Kassel; La Fère; Leipzig; Leningrad; London (Dulwich, Kenwood, National Gallery, Victoria and Albert Museum, Wallace Collection); Lyons; Munich; New Haven (Connecticut); Paris; Quimper; Richmond (Virginia); Rotterdam; Schwerin; Sibiu; Southampton; Speyer; Stuttgart; Stockholm; Utrecht; Warsaw; Wroclaw.

Landscape with Shepherds and Shepherdessess
Canvas 112 × 134 cm (44⅛ × 52¾ in)
Unsigned. Probably painted late 1660s.
BASLE, Kunstmuseum
The style of this picture is such that it could be by either Weenix, father or son. The Italianate landscape is more-or-less derived from Jan Both or even Nicolaes Berchem. There is some feeling of accurate observation, especially in the foreground. In order to achieve a less realistic feeling the painter has included the statue and urn on the left. The figures seem quite close to those of Adriaen van de Velde.

The picture was acquired by the museum in 1887.

Self-Portrait with a Portrait of the Artist's Wife

Canvas 81.5 × 65.5 cm (31⅞ × 25¾ in)
Signed and dated lower left:
Adr. v. werff. fec. 1699.
AMSTERDAM, Rijksmuseum
The contrast between this happy and successful man and the last self-portraits of Rembrandt could not be greater. Van der Werff is concerned with the outward appearance of things, Rembrandt with the inner meaning. They both observe with equal accuracy, but not with equal perception. Self-portraits of Dutch seventeenth-century painters are not as common as might be expected. This could be caused by the fact that many painters regarded themselves as craftsmen doing a humble task and no more thought of recording their own appearance than would a carpenter.

The picture was acquired by the Rijksmuseum from a sale in Rotterdam in 1827.

Adriaen van der WERFF

Kralinger-Ambacht 1659—Rotterdam 1722

Adriaen van der Werff has been much neglected in recent years, but in his lifetime he was the most successful and highly paid Dutch artist. He was sought after by kings and princes—the Elector Palatine, the King of Poland, the Duke of Brunswick. Houbraken genuinely believed that he was the greatest Dutch painter, as well as the most successful. He was a pupil of Eglon van der NEER and it must have been from him that van der Werff learned his minute and carefully polished style of painting. His subject matter differed very much from that of his master, because van der Werff preferred to paint historical, religious and mythological pictures as well as portraits and genre works. His highly polished surfaces made him very popular in the courts of Europe. Van der Werff spent most of his life in Rotterdam, although he had to spend some six months of the year at Düsseldorf as he was under contract to the Elector Palatine. His reputation declined in the nineteenth century and disappeared altogether in the twentieth.

Amsterdam; Augsburg; Bamberg; Bordeaux; Brunswick; Budapest; Cambridge; Chambéry; Coblenz; Copenhagen; Darmstadt; Dijon; Erlangen; Florence (Pitti); Glasgow; Gotha; The Hague; Hanover; Karlsruhe; Kassel; Leeds; Leningrad; Lille; London (Dulwich, National Gallery, Wallace Collection); Montpellier; Morlaix; Moscow; Munich; New York; Oberlin (Ohio); Paris; Potsdam; Rennes; Rotterdam; Schwerin; Speyer; Turin; Versailles; Vienna; Waddesdon Manor (Buckinghamshire); Warsaw.

Matthias WITHOOS

Amersfoort 1627—Hoorn 1703

As a young man Matthias Withoos travelled to Italy in the company of
the Dutch still-life painter Otto Marseus van Schreick (Nijmegen c. 1619—
Amsterdam 1678), but it seems that apart from a predilection for allegorical
subject-matter the art of Italy had a minimal effect on either painter. Withoos
concentrated on the painting of insects and birds in landscape settings—or
rather surrounded by luxuriant vegetation. Many of his pictures have a
bluish tonality, almost indigo, with touches of cool green and pale yellow.
He returned from Italy in 1653 to his native Amersfoort and in 1672 moved
to Hoorn, where he spent the rest of his life. In both these towns he would
have been the chief still-life painter, as there was little local competition
from painters of talent in small towns such as these. His pictures are
rarely found today.

Avignon; Basle; Bourg-en-Bresse; Dunkirk; Hoorn; La Fère; Le Mans; Leningrad;
Rome (Galleria Spada); Rotterdam.

Mors Omnia Vincit (Death Conquers All Things)

Canvas 82 × 67 cm (32¾ × 26¾ in) Signed
and dated on the right of the altar:
Mathias Withoos Amisfoort A° 166(?).
LA FERE (Aisne), Musée Jeanne d'Aboville
*Every single object in this crowded picture has
a specific meaning and is directed towards
warning the spectator of the inevitability and
permanence of death, in contrast to the transience
of human life. Such elaborate allegories had
been produced in Italy, especially by Salvator
Rosa, whose* Umana Fragilità *in the
Fitzwilliam Museum, Cambridge could well
have been the source of inspiration for Withoos.
The hour-glass in the centre of the picture acts
as an obvious reminder of time. The owl, a
bird of the night, is also intended to symbolize
death.*

*In the early nineteenth century the picture
was in the collection of Jeanne d'Aboville and
was bequeathed to the museum in 1860 by the
Comtesse d'Héricourt de Valincourt.*

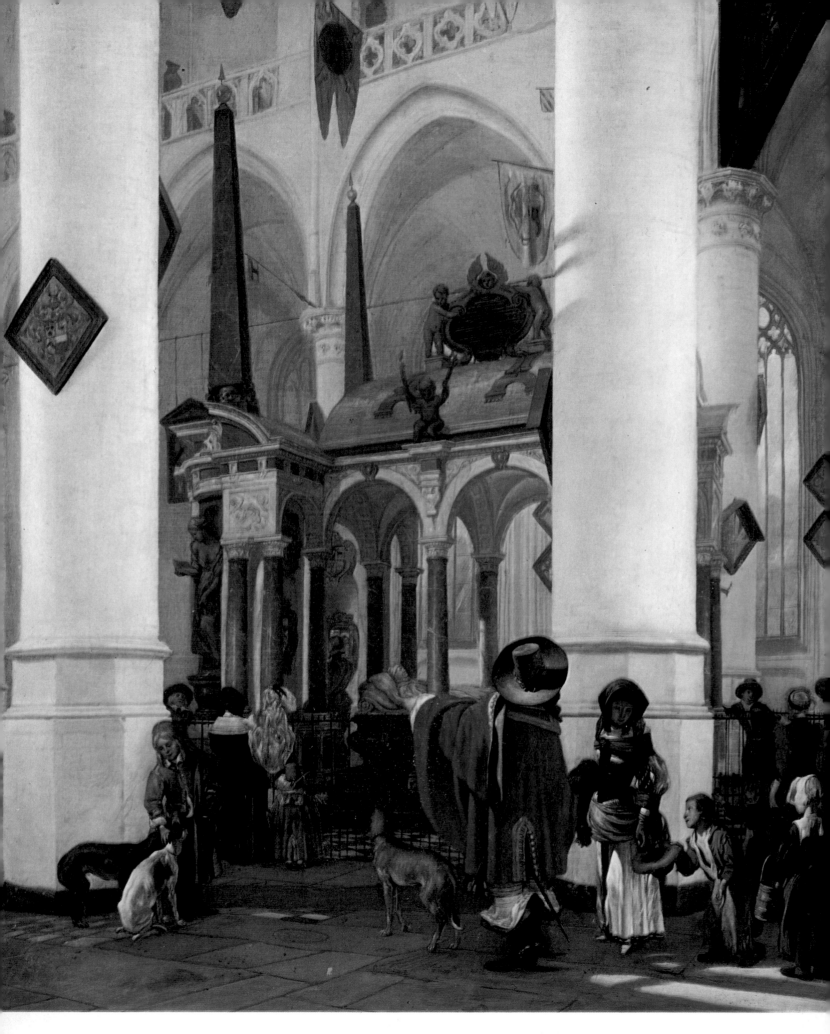

Interior of the Nieuwe Kerk, Delft
Canvas 97 × 85 cm (38⅛ × 32½ in) Signed
and dated lower left: E. de Witte A° 1656.
LILLE, Palais des Beaux-Arts
*The interest of this picture lies in the fact that
it depicts the tomb of the sixteenth-century
Dutch patriot and hero William of Orange
(called The Silent). Elaborate funerary
monuments of this type were extremely rare in
Dutch churches and only the most respected
citizens were accorded such an honour. Most of
them had to be content with a painted coat of
arms (hatchment), of which there are several
examples seen in this picture. The style of
painting is unusually pale and colourful for
de Witte, and here he approaches Hendrick van
der Vliet in bland tonality.*

*The picture was first recorded in an
Amsterdam sale in 1775 and was acquired by the
museum in 1890 for the relatively high sum of
11,500 francs.*

Emanuel de WITTE
Alkmaar c. 1616/18—Amsterdam c. 1691/2

Emanuel de Witte occupies an important place in the development of Dutch painting in the middle years of the seventeenth century, both in the painting of church interiors and domestic interior scenes. He appears to have been trained in Alkmaar and was a member of the guild there in 1636. He then spent a short time in Rotterdam and by about 1641 was living in Delft. It was there that his style was formed—a style which was to have some influence on the next generation of painters. He painted a number of rather sombre interior scenes in which the fall of light plays an important part, and it may well be that he had a certain influence on Pieter de HOOGH and even on Nicolaes MAES, who was influenced by the Delft school.

Most of de Witte's middle years were devoted to the painting of church interiors. He had moved to Amsterdam in 1652, thus avoiding the explosion of the powder magazine in Delft two years later. A surprisingly high proportion of de Witte's church interiors are imaginary, and it is difficult to see why people wanted pictures of church interiors which did not exist. By contrast, for instance, nearly all Hendrick van der VLIET's surviving church interiors depict the two churches in Delft. De Witte's work is sombre in mood, with contrasts of light and shade and with a certain air of mystery quite unlike the feeling of most Dutch church interiors. For accuracy of tone and atmosphere it is necessary to look at Pieter SAENREDAM. In his last years in Amsterdam de Witte diversified his subject matter and painted several market scenes of a peculiar intimacy. He also painted one especially beautiful evening seascape which is in the Rijksmuseum, Amsterdam.

Amsterdam★; Antwerp; Basle; Berlin; Birmingham (Barber Institute); Boston; Brunswick; Brussels; Budapest; Cape Town; Chicago; Cologne; Detroit; Dublin; Düsseldorf; Edinburgh; Ghent; Groningen; The Hague; Hamburg★; Hanover; Hartford (Connecticut); Kassel; La Fère; Le Havre; Leipzig; Leningrad; Lille★; London (National Gallery, Wallace Collection); Montreal; Moscow; Oberlin (Ohio); Rotterdam (Boymans-van Beuningen Museum★, Vorm Foundation★); Salzburg; Stockholm (Hallwylska Museet, Nationalmuseum); Strasbourg; Vienna (Academy); Weimar; Worms; Wroclaw; Zurich.

Overleaf:
The White Horse
Panel 43.5 × 38 cm (17¼ × 15 in) Signed in
monogram in the foreground: HW.
Probably painted in the 1660s.
AMSTERDAM, Rijksmuseum
*The white horse has always been seen as a
symbol of Wouwermans, and this picture is the
most perfect expression of that symbol—a white
horse on its own. The very pose and
composition suggest the influence of Paulus
Potter, who favoured the emphasis of the
animal's silhouette. As in all Wouwermans's
authentic pictures, the technique is meticulous
and polished.*

*The picture was recorded in several
Amsterdam sales in the nineteenth century and
was bought by the Rijksmuseum in 1894 with
the aid of the Rembrandt Society.*

Philips WOUWERMANS (Wouwerman)
Haarlem 1619—Haarlem 1668

His brilliant painting of white horses and battle and camp scenes led to pictures by Philips Wouwermans adorning all the major picture galleries of Europe by the end of the eighteenth century. Like so many Dutch artists whose technique was meticulous but whose output was large—Gerard DOU for example—he enjoyed an enormous reputation both in his lifetime and in the hundred years or so after his death.

Wouwermans appears to have spent most of his life in Haarlem, never making the expected journey to Italy although quite often there are Italianate overtones in his pictures rather in the way Nicolaes BERCHEM employs them—there is just a hint of a foreign land. His major contribution to his time was the painting of simple landscapes of the dunes near Haarlem. They are fresh, open and beautifully painted and not enough appreciated by connoisseurs today. Wouwermans's fame also rested, particularly in his lifetime, on the painting of battle-pieces. All over Europe battles and cavalry skirmishes were daily occurrences and there seems to have been a demand for battle painting in Italy as well as in the North. Together with Hendrick VERSCHURING, Wouwermans virtually cornered the market of this specialized

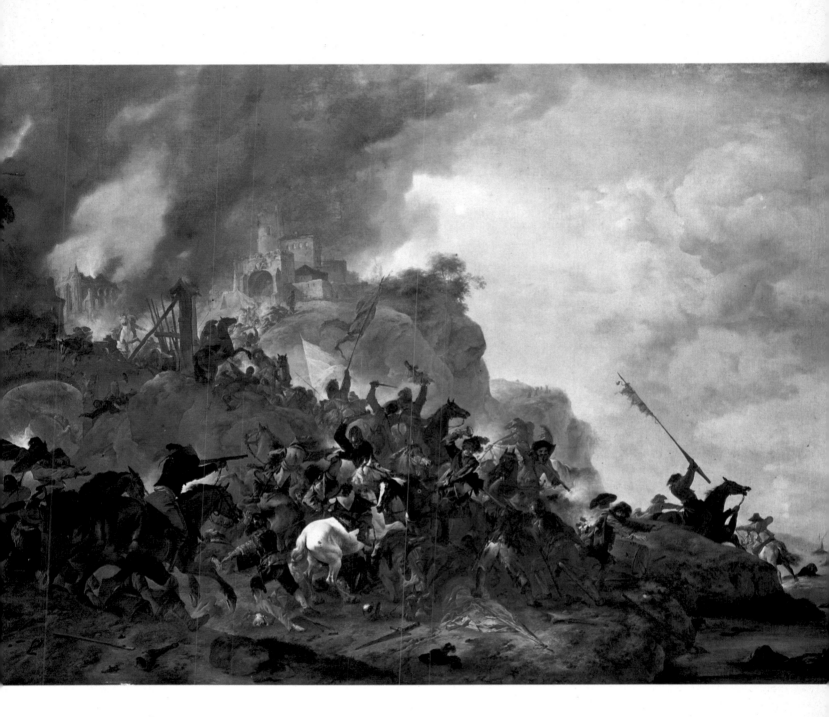

Cavalry making a Sortie from a Fortress on a Hill

Canvas 139 × 190.5 cm (54¾ × 75 in)
Signed and dated bottom left:
PHILWouwermans A° 1646.
LONDON, National Gallery

This is Wouwermans's largest surviving military scene. A battle is not actually taking place, but the picture is painted with the intention of depicting the maximum possible confusion. As is usual, Wouwermans has included a white horse in the brilliantly painted turmoil. He has succeeded in conveying the horror which such events must have brought into the daily lives of so many people who had the misfortune to live in the path of a passing army.

The earliest record of the picture is in the nineteenth century at Blenheim Palace, Oxfordshire. It was bought by the National Gallery in 1956.

and difficult genre. It is sad that by modern standards Wouwermans has slipped from the second to the third rank among Dutch painters. This is almost certainly because his subject matter is no longer appreciated. His great battle scenes give the impression of having been observed from life, and for those who look carefully they can still give the intended thrill of horror. Wouwermans had many imitators in the seventeenth and eighteenth centuries.

Aix-en-Provence; Alençon; Amsterdam★; Antwerp; Arnhem; Aschaffenburg; Ascott (Buckinghamshire); Augsburg; Basle; Bergues; Berlin; Bristol; Brunswick; Brussels; Budapest; Caen; Cambridge; Chantilly; Cheltenham; Cleveland (Ohio); Cologne; Copenhagen; Cracow; Dessau; Dresden★; Dublin; Frankfurt; Glasgow (Art Gallery, Burrell Collection); Haarlem; The Hague (Bredius Museum, Mauritshuis); Hamburg; Hanover; Karlsruhe; Kassel★; Leeds; Leipzig; Leningrad★; Lierre; London (Dulwich★, National Gallery, Wallace Collection, Wellington Museum); Madrid; Montpellier; Munich★; Nantes; New York (Frick Collection, Metropolitan Museum); Nuremberg; Paris (Louvre★, Petit Palais); Philadelphia (Johnson Collection); Prague; Rotterdam (Boymans-van Beuningen Museum, Vorm Foundation); Salzburg; Schwerin; Seville; Sibiu; Speyer; Stockholm; Strasbourg; Stuttgart; Toulouse; Turin; Vienna (Academy, Kunsthistorisches Museum); Warsaw.

Joachim Antonisz. WTEWAEL
Utrecht 1566—Utrecht 1638

Wtewael was probably the pupil of Joos de Beer (d. 1591) in Utrecht and as a young man travelled extensively both in France and Italy. By 1592 he had returned to Utrecht, where he spent the rest of his life. He never forgot his Mediterranean experiences, and, except in his few surviving portraits, which are more northern in style, his art remained consistently mannerist throughout his life. He based his style on the exaggeration of all human form, some of it wildly extravagant with arms and legs flying in all directions. His pictures are therefore much more restless than those of his contemporary Abraham BLOEMAERT. Wtewael also sometimes painted small, meticulous cabinet pictures where dozens of figures gesticulate in a tiny space. Wtewael remained quite unmoved in the 1620s and 1630s by the great changes which were taking place in Utrecht. Caravaggesque pictures and the new Italianate landscapes had no place in his vision.

Amiens; Amsterdam; Arnhem; Brunswick; Budapest; Cologne; Copenhagen; Dijon (Musée Magnin); Gateshead; The Hague; Karlsruhe; Lille; London; Nancy; New Haven (Connecticut); Oxford; St Louis; Upton House (Warwickshire); Utrecht*; Vienna; Waddesdon Manor (Buckinghamshire); York.

The Adoration of the Shepherds
Canvas 75 × 97 cm (29½ × 38⅛ in) Signed lower right on the base of the column: JOACHIM WTEWAEL FECIT. Probably painted c. 1600. OXFORD, Ashmolean Museum
This subject was a favourite of Wtewael and there are several variants surviving. That at Utrecht is dated 1598 and this picture probably dates from the same time. The exaggeration of the figures in this composition is relatively restrained, as if the artist kept himself in control for the sacred subject matter. The use of heavy shadows which seem to envelop the whole is also a characteristic of much of Wtewael's work.

The picture was bought by the museum in 1948.

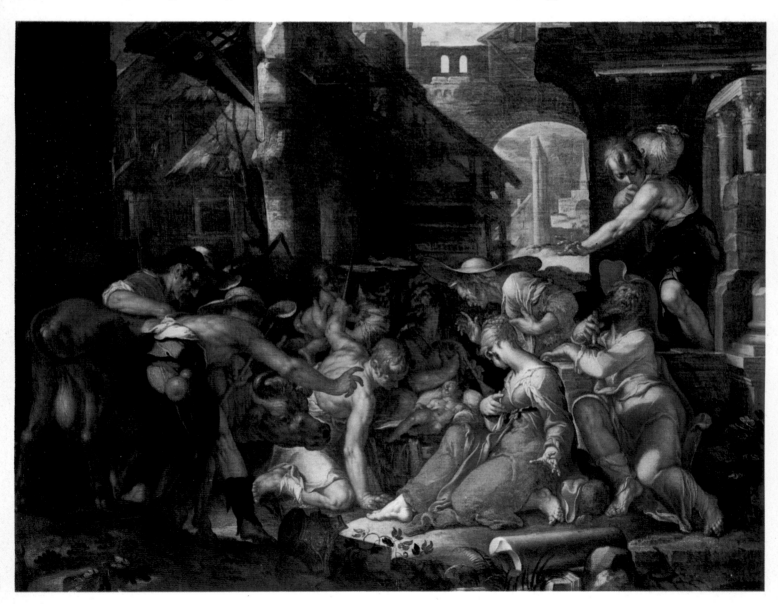

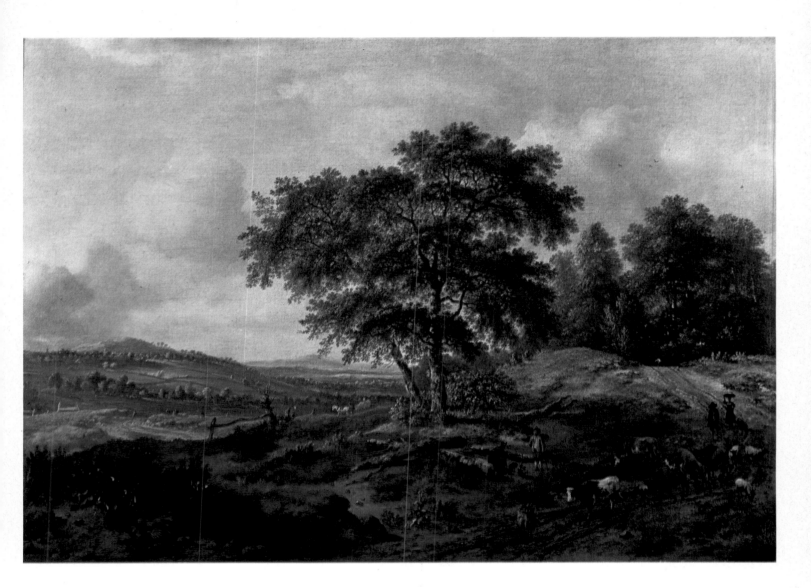

Landscape with Cattle
Canvas 64 × 91 cm (25 × 35⅝ in) Signed
and dated in the foreground: J. Wijnants
1661.
LONDON, Wallace Collection
*The left-hand side of this picture shows
Wijnants's ability to create a feeling of distance
in a natural way. He is never interested in
atmospherics, just in ordinary daylight without
dramatic effects of sunlight and shadow. The
right half is unusually solid—the artist
commonly preferred to paint less densely leaved
trees—this may show the influence of Jacob van
Ruisdael. Both the cattle and the figures have
been attributed to Adriaen van de Velde
although there is no precise evidence for this.*

*The picture was probably in the collection of
the Marquess of Hertford in the early nineteenth
century. It was bequeathed to the nation along
with the rest of the collection by Lady Wallace
in 1897.*

Jan WYNANTS (Wijnants)
Haarlem 1631/2—Amsterdam 1684

Wynants specialized in dunescape paintings which were based on the country-
side in the neighbourhood of his native Haarlem. They are airy and pleasant;
they appealed to connoisseurs in the eighteenth century and exerted an
influence on the development of landscape painting in England, especially
on the young Gainsborough. The latter part of Wynants's life was spent in
Amsterdam, where he was recorded as an innkeeper as well as a painter.
Quite often, Wynants's dunescapes are close in style to those of Philips
WOUWERMANS, and it is not clear who originated the type and who was the
derivative painter. Wynants painted, it appears, very few figures; almost all
of those in his pictures are by other artists.

Amsterdam; Ascott (Buckinghamshire); Barnsley; Bath; Bremen; Bristol; Brussels;
Budapest; Caen; Cambridge; Cleveland (Ohio); Cologne; Dublin; Edinburgh; Haarlem;
The Hague; Hanover; Huelva (Spain); Karlsruhe; La Fère; Leipzig; Leningrad; London
(Dulwich, Kenwood, National Gallery, Wallace Collection★); Lyons; Maidstone; Man-
chester; Montpellier; Nottingham; Oldenburg; Paris (Musée Jacquemart-André, Louvre);
Quimper; Rennes; Rotterdam; Salzburg; Speyer; Stockholm; Strasbourg; Tours; Vienna;
Warsaw; Worthing; Würzburg; Wroclaw.

223

Collections
The Main Public Collections of Dutch Pictures

Part 1

The following collections of Dutch pictures are more or less comprehensive. The occasional gaps, like the lack of Vermeers in the Hermitage, only serve to emphasize how complete the collections are. A careful study of any one of these collections will enable the visitor to gain a general idea of most aspects of Dutch seventeenth-century painting.

AMSTERDAM, Rijksmuseum
The largest collection of Dutch pictures in existence. It is completely representative of every aspect of the national art, built up over a century and a half of enlightened purchases and occasional important bequests. The only failing is the possession of medium rather than high-quality works of the odd painter, especially Hobbema and Cuyp.

BERLIN-DAHLEM, Staatliche Gemäldegalerie
A collection largely built up by purchase by the celebrated director Wilhelm von Bode. The representation of Rembrandt is unforgettable. The collection is comprehensive in most areas except mannerism and seascape.

DRESDEN, Staatliche Gemäldegalerie
Largely built up in the middle years of the eighteenth century, the collection still reflects the taste of those years. The Rembrandts of the middle period are important and the representation of genre painting is unequalled. The collection also contains two Vermeers and Ruisdael's *Jewish Cemetery* (page 173).

THE HAGUE, Mauritshuis
The smallest representative collection of Dutch painting, where each painter is represented by one outstanding example. Especially important are Vermeer's *View of Delft* (page 200) and Rembrandt's *Anatomy Lesson of Dr Tulp* (page 40). The collection is also especially important for portraits of the House of Orange.

LENINGRAD, Hermitage
One of the largest collections of Dutch pictures, and, like Dresden, largely built up in the eighteenth century. It has perhaps the best collection of Rembrandts in existence, and is at least equal to Dresden for genre.

LONDON, National Gallery
A collection mostly acquired by bequest in the nineteenth century and therefore particularly strong in the British predilection for Ruisdael, Cuyp and Hobbema. It is rich in seascape pictures and genre and has an important group of Rembrandts. The chief weakness is in the field of flower painting, still life in general, and the mannerists.

MUNICH, Alte Pinakothek
Most of the pictures in the collection come from the celebrated electoral picture gallery at Düsseldorf, including Rembrandt's *Passion Series*. The collection is especially rich in landscape and genre. The enormous collection of pictures by Adriaen van der Werff and the Italianizing landscapists is kept at the gallery's outpost at Schleissheim.

PARIS, Louvre
A relatively small collection, but well balanced, with good pictures by Rembrandt from every period of his career and with a good example of each of the other main painters. Like all French collections it is weak in seascapes.

ROTTERDAM, Boymans-van Beuningen Museum.
A well-balanced and comprehensive collection whose only weakness is the lack of supreme masterpieces. The collection is important for its adequate and sometimes brilliant representation of most of the minor masters. The deposit by the Trustees of the Vorm Foundation of their important collection in the museum has strengthened the representation of several areas, in particular Rembrandt.

VIENNA, Kunsthistorisches Museum
One of the best balanced of the great eighteenth-century collections to which Vermeer's *The Artist in his Studio* (page 205) was added in 1946. The collection is especially rich in landscape and genre.

Part II

This section includes those collections which are distinguished in representing some aspect of Dutch painting or one particular painter in a way which makes them unique or very important. However, there are gaps in each one which prevent the collections from being described as comprehensive.

AMSTERDAM, Historisch Museum
A recently redesigned museum showing the history of Amsterdam. The most important surviving collection of group portraits in existence is exhibited here, along with numerous topographical pictures relating to Amsterdam in the seventeenth century.

BRUSSELS, Musée Royal des Beaux-Arts
Important pictures by Hals and Hobbema (page 116). Many minor landscape and genre painters are represented.

BRUNSWICK, Herzog Anton Ulrich-Museum
A collection formed in the late seventeenth and eighteenth centuries with a good representation of mannerists and Caravaggesque painters. There is an unforgettable late Rembrandt *Group Portrait* and an important picture by Vermeer.

BUDAPEST, Szépmüvészeti Múzeum
Especially good representation of landscape, seascape and genre, with examples of all the important and most of the minor painters.

CAMBRIDGE, Fitzwilliam Museum
A collection strong in landscape painting of high quality, including Hobbema, Ruisdael (page 45) and Allart van Everdingen (page 92). A unique representation of flower painting from the bequest in recent years of the Broughton Collection; most flower painters are included.

COPENHAGEN, Statens Museum for Kunst
A large collection including numerous examples of landscape and genre. Also on loan is Hals's tiny *Portrait of Descartes.*

DETROIT, Institute of Arts
The other version of Ruisdael's *Jewish Cemetery* is in the collection, which is well-balanced for landscapes and owns several small but high-quality pictures by Rembrandt.

DUBLIN, National Gallery of Ireland
A large collection with a good representation of genre. Some landscapes, including an outstanding one by Rembrandt.

FLORENCE, Uffizi and Pitti Galleries
Over the years pictures have been exchanged between the two galleries. There is a unique representation of the Italianate landscapists, especially Poelenburgh, and Breenbergh, an important picture by Honthorst (page 118) and a memorable group of Rembrandt self-portraits.

GLASGOW, Art Gallery
A large collection mostly acquired by bequest in the nineteenth century. It concentrates on genre and landscape, with important pictures by Ruisdael and Cuyp. The other version of Rembrandt's *Side of Beef* and his *Alexander* are here.

HAARLEM, Frans Hals Museum
Arguably the most moving assembly of Dutch pictures in existence. Frans Hals dominates because of the group portraits. There is a large collection of pictures by Cornelis van Haarlem and Verspronck, and a good example of most members of the Haarlem school of painters.

HAMBURG, Kunsthalle
A large collection with particular emphasis on landscape. Especially important are the groups of paintings by Ruisdael and Aert van der Neer.

KARLSRUHE, Staatliche Kunsthalle
A large collection of pictures, mostly by minor painters, with all types of subject matter represented.

KASSEL, Hessisches Landesmuseum
A celebrated collection of pictures by Rembrandt brought together in the eighteenth century, together with good examples of most of the minor masters.

LEIPZIG, Museum de Bildenden Künste
A representative collection of Dutch landscapists, especially the Haarlem school. There is a large group by van Goyen and an early Rembrandt *Self-Portrait.*

LILLE, Palais des Beaux-Arts
Almost as large but not as representative as the Louvre. It is especially strong in landscape and genre, together with a few good examples of the mannerists and Caravaggesques.

LONDON, Dulwich College Picture Gallery
A collection formed at the end of the eighteenth century with special emphasis on the Italianate landscapists. There are important groups of pictures by Cuyp and Wouwermans, and the three Rembrandts are of high quality.

LONDON, Greenwich, National Maritime Museum
The largest collection of seascape paintings in existence. Almost every known seascape painter is represented, including thirty pictures by or attributed to Willem van de Velde the Younger.

LONDON, Wallace Collection
One of the best surviving examples of mid-nineteenth-century taste in Dutch pictures. It is especially strong in Italianate landscapists and Cuyp, and there are also important pictures by Ruisdael and Hobbema, a dazzling collection of genre pictures of the highest quality, nine pictures by Rembrandt, and Hals's *Laughing Cavalier*.

NEW YORK, Metropolitan Museum of Art
Four pictures by Vermeer of Delft give this collection an enormous and justified prestige. There is also an important array of pictures by Rembrandt, including the *Aristotle*, and some representation of the minor masters.

OXFORD, Ashmolean Museum
The best collection in existence of still-life painting with a good example by each painter. There are also good pictures by unusual painters, those by Wtewael and Vrel being outstanding.

PHILADELPHIA, John G. Johnson Collection
One of the largest collections of Dutch pictures in America. Almost all the minor landscape and genre painters are represented.

PRAGUE, Narodne Galerie
A medium-sized collection of quality, with especially important pictures by Ruisdael and de Gelder. Landscape and genre are most strongly represented.

SCHWERIN, Stadisches Museum
An important collection with emphasis on the Italianate landscapists and genre, and an outstanding picture by Carel Fabritius.

STOCKHOLM, Nationalmuseum
A collection of good quality, dominated by Rembrandt's great *Conspiracy of Claudius Civilis*.

TOLEDO (Ohio) Museum of Art
A carefully chosen and well-balanced collection with emphasis on landscape and portraiture; good pictures by Hobbema and Rembrandt.

UTRECHT, Centraal Museum
This collection concentrates exclusively on the Utrecht school, which is well represented—both mannerists and Caravaggesques. There is an outstanding group by Terbrugghen.

WARSAW, Muzeum Narodwe
A large collection with especial emphasis on the minor painters; both mannerists and Caravaggesques are included.

WASHINGTON, National Gallery of Art
Justly famous for its representation of Rembrandt and Vermeer. There are excellent pictures by Hobbema, Saenredam and Cuyp, but very few others.

Other Collections Containing Important Works

Most museums with a collection of Old Master paintings have some Dutch pictures. The following list is a selection of the more important small collections and those places where the odd outstanding work can be found.

AACHEN, Suermondt Museum
Many of the minor masters are represented in this collection.

ANTWERP, Musée Royal des Beaux-Arts
There are good portraits by both Rembrandt and Hals and an uneven collection of other Dutch painters.

ASCOTT (Buckinghamshire), National Trust
Cuyp's *View of Dordrecht* (page 27) and an important landscape by Hobbema are outstanding.

BARNSLEY, Cannon Hall
This small collection is especially strong in the Italianate landscapists; there are also interesting pictures by Cesar van Everdingen and Frans van Mieris (page 141).

BASLE, Kunstmuseum
A small collection with an emphasis on the Italianate landscapists, and also a work by Terbrugghen.

BIRMINGHAM, Barber Institute of Fine Arts
A small group of well-chosen pictures, including an outstanding early portrait by Hals.
 City Museum and Art Gallery
 There are good pictures by Bramer, van Goyen, Ochtervelt (page 148), and Willem van de Velde the Younger.

BOSTON, Museum of Fine Arts
A small collection with exceptional portraits by Rembrandt.
 Isabella Stewart Gardner Museum
 Vermeer's *Concert* and Rembrandt's *Christ stilling the Waters on the Sea of Galilee* are of the highest quality in this collection.

BRISTOL, City Art Gallery
A small collection with good pictures by Pieter Claesz. (see endpapers) and Jan van der Heyden.

CHICAGO, Art Institute
A small group of pictures by Rembrandt, the *Girl at a Window* being outstanding.

CHELTENHAM, Art Gallery
A late-nineteenth-century collection with an emphasis on genre.

CINCINNATI, Museum of Art
Important pictures by Frans Hals, Terborch and de Hooch.
 Taft Museum
 The group of excellent portraits by Frans Hals is testimony of the esteem in which Hals was held in late-nineteenth-century America.

COLOGNE, Wallraf Richartz Museum
A collection with many different aspects of Dutch painting represented, all of high quality; the coverage of Rembrandt is outstanding.

DIJON, Musée Magnin
An extensive collection of pictures by very minor masters. There is a superb portrait by van der Helst.

DORDRECHT, Dordrechts Museum
Several examples of most of the best local painters, including Cuyp, Maes and Hoogstraten—some of them of the very highest quality.

DOUAI, Musée de la Chartreuse
Interesting as a collection, with good representation of the mannerist painters Goltzius and Cornelis van Haarlem. The important Jan Lievens *Portrait of Constantin Huyghens* (page 23) is on loan to the Rijksmuseum, Amsterdam.

EDINBURGH, National Gallery of Scotland
A small collection, but of the choicest quality—one of the few museums where it is possible to see Rembrandt, Hals and Vermeer together. The Sutherland loan of outstanding pictures by Rembrandt and Steen augments the collection.
 University
 The outstanding pictures by Ruisdael and ten Oever (page 33) are lent to the National Gallery of Scotland.

EPINAL, Musée Departemental des Vosges
The late Rembrandt *Portrait of a Woman as the Magdalen* deserves to be better known; it is one of his most touching late pictures.

GOTHENBURG, Konstmuseum
The late Rembrandt *Portrait of a Falconer* is now very well known, having been much reproduced in recent years.

GRONINGEN, Groninger Museum voor Stadt en Lande
A small collection but with outstanding pictures by Carel Fabritius and Sweerts.

THE HAGUE, Gemeentemuseum
As the municipal collection, the museum has collected examples of the local painters active in the seventeenth century. There is an important van Goyen *View of the Hague*.

HANOVER, Landesgalerie
An interesting small collection with a beautiful landscape by Rembrandt.

HARTFORD (Connecticut), Wadsworth Atheneum
An important collection of pictures by the minor masters.

HULL, Ferens Art Gallery
A small collection of good pictures by the minor masters. The Frans Hals *Portrait of a Woman* ranks as one of his best pictures.

LA FERE (Aisne), Musée Jeanne d'Aboville
An interesting collection of pictures by very obscure painters. There is a particularly good Salomon van Ruysdael and a *Vanitas* by Matthias Withoos (page 217).

LIVERPOOL, Walker Art Gallery
A small collection of pictures of high quality, including works by Rembrandt, Carel Fabritius, and Salomon van Ruysdael.

LONDON, Kenwood, Iveagh Bequest
Three important pictures, one each by Rembrandt (the famous *Self Portrait*), Hals and Vermeer.

Victoria and Albert Museum
Many minor masters are represented in the collection, but there are good pictures by Rembrandt, Terborch and Koninck.

Wellington Museum
The group of pictures by Steen is justly famous and there are excellent pictures by some of the Italianate landscapists, Breenbergh and Poelenburgh in particular.

LYONS, Musée des Beaux-Arts
A small collection with one of the earliest known Rembrandts, the *Stoning of Stephen* of 1624.

MAINZ, Gemäldegalerie
This little-known collection contains an exceptionally beautiful picture by Dirck Hals, *A Woman tearing up a Letter*. Cornelis van Haarlem and Baburen are also represented.

MALIBU (California), J. Paul Getty Museum
A small but representative collection of pictures by the minor masters, especially subject-pictures (see page 212 for an example by Vrel). There is also an important late Rembrandt.

MADRID, Prado
There are a few Dutch pictures of quality in the collection, especially by Metsu and Rembrandt.

MANCHESTER, City Art Gallery, Collection of the Assheton Bennett Trustees
A collection of small pictures by many different minor masters. There are especially charming works by Ochtervelt and van Goyen.

MILAN, Brera
A small collection with a good early Rembrandt portrait.

MONTPELLIER, Musée Fabre
The chief emphasis of the collection is on landscape and genre.

NEW YORK, The Frick Collection
The three pictures by Vermeer and Rembrandt's *Polish Rider* make this handful of pictures one of the greatest in terms of quality.

NOTTINGHAM, Castle Museum
A small group of pictures, chiefly landscapes and genre. See page 146 for the picture by Eglon van der Neer.

OSLO, Nasjonalgalleriet
A small collection of pictures of good quality. See page 114 for van der Heyden's *View in Delft*.

PARIS, Musée du Petit Palais
An extensive well-balanced collection.

PETWORTH HOUSE (Sussex), National Trust
Good pictures by van Goyen, Ruisdael and Hobbema.

POLESDEN LACEY (Surrey), National Trust
A small collection of high quality; outstanding pictures by Terborch, Ruisdael and Cesar van Everdingen.

ST LOUIS, City Art Museum
A small but well-balanced collection with good pictures by Rembrandt, Frans Hals and de Hoogh.

STUTTGART, Staatsgalerie
A small collection with Rembrandt's early *St Paul in Prison*.

TURIN, Galleria Sabauda
The best collection of Dutch painters in Italy, the works by Rembrandt and Saenredam being noteworthy.

WADDESDON MANOR (Bucks.), National Trust
A dazzling assembly of pictures by Cuyp in one unforgettable room.

YORK, City Art Gallery
An off-beat collection with interesting pictures by Wtewael, Baburen (pages 56–7) and Berchem.

Bibliography
General Works
and Exhibition Catalogues

General

There have been several general books on Dutch seventeenth-century painting, and all of them contain some valuable material. However, remarkably few of them survey the whole field. By far the best is the work of collaboration in the Pelican History of Art series: Jacob Rosenberg, Seymour Slive and E. H. ter Kuile, *Dutch Art and Architecture 1600–1800*, 1966.

General critical and historical surveys of the period are also rare; by far the best is the very moving essay by J. Huyzinga, *Dutch Civilisation in the 17th century*, English edition 1968.

The best literary criticism of Dutch painting occurs in Eugène Fromentin, *Les Maîtres d'Autrefois*, English edition 1948. Fromentin is especially eloquent on Paulus Potter and Jacob van Ruisdael and devotes important passages to Rembrandt and Hals.

Genre
Interest in this area has only recently been revived; see under Exhibitions, 1976 for the most up-to-date references.

Landscape
By far the best book, which renders obsolete all previous general studies, is Wolfgang Stechow, *Dutch Landscape Painting of the Seventeenth Century*, 1966.

Portraiture
Very much neglected as a general study. The only important study of group portraits is A. Riegl, *Das Holländische Gruppenporträt*, 2 vols, Vienna, 1931.

Seascape
There is no really adequate general literature on this difficult subject, as several of the important painters still lack modern studies. The best general book is L. J. Bol, *Holländischer Marinemalerei des 17 Jahrunderts*, 1973. Also useful is Rupert Preston, *The 17th Century Marine Painters of the Netherlands*, 1974.

Still Life
The only really thorough survey is by Ingvar Bergström, *Dutch Still-Life Painting of the 17th century*, 1956. A useful catalogue of a specific collection is the Oxford, Ashmolean Museum, *Catalogue of the Collection of Dutch and Flemish Still-Life Pictures bequeathed by Daisy Linda Ward*, 1950.

Exhibitions

Much recent research has been concentrated on exhibition catalogues, both of specific painters, which are listed here under the heading of the painter concerned, and on general exhibitions. Often these catalogues become indispensable as the only reliable literature in a given field. The most important exhibitions since 1945 are listed here.

1952–3
London, Royal Academy, *Dutch Pictures, 1450–1750*. A colossal survey with 644 exhibits and many famous masterpieces brought from all over the world. The catalogue was summary but listed the important literature.

1965

Utrecht, Centraal Museum, *Italianiserende Landschapschilders*. An indispensable catalogue with an exhaustive bibliography, rehabilitating this hitherto neglected area.

1966–7

San Francisco/Toledo/Boston, *The Age of Rembrandt*. A beautifully chosen selection of masterpieces of every type of subject matter and style. One of the best-balanced exhibitions held in recent years.

1967

Paris, Musée des Arts Decoratifs, *La Vie en Hollande au XVIIe Siècle*. Although designed to illustrate the Dutch way of life, this was an important survey of genre painting.

1970–71

Paris, Musée du Petit Palais, *Le Siècle de Rembrandt*. A brilliant exhibition bringing together all the most important Dutch pictures from French public collections.

1971

Cleveland, Ohio, Museum of Art, *Caravaggio and his Followers*. Although devoted to French and Italian painters as well, the entries on Dutch Caravaggesque painters are very well done and summarize the state of the literature in that year. The catalogue was reissued in 1976 in paperback with corrections.

1976

London, National Gallery, *Art in 17th Century Holland*. Important loans were secured from British private collections and the catalogue gives a summary of the current state of research in each entry.

London, John Mitchell and Sons, *The Inspiration of Nature*. A small exhibition of flower and still-life pictures of the highest quality.

Amsterdam, Rijksmuseum, *Tot Lering en Vermaak*. An exhibition which set out to explore the hidden meanings in genre pictures. Many important masterpieces were included.

Source Material

Very little of the source material has been translated and therefore remains in the realm of the specialist. A list of the most important sources is given here:

Carel van Mander, *Het Schilderboeck*, Haarlem, 1603–4. Joachim von Sandrart, *Teutsche Academie*, Nuremberg, 1675–9. Samuel van Hoogstraten, *Inleyding tot de Hooge Schoole der Schilder-Konst anders de Zichtbaere Werelt*, Rotterdam, 1678. Gerard de Lairesse, *Het Groot Schilderboeck*, Amsterdam, 1707. Arnold Houbraken, *De Groote Schouburgh der nederlantsch konstschilders en schilderessen*, Amsterdam 1718–21.

Documents

The two fundamental studies and editions of documents are A. van der Willigen, *Les Artistes de Harlem*, 2nd edition, 1870, and Abraham Bredius, *Künstler-Inventare: Urkunden zur Geschichte der Holländischen Kunst des XVI ten XVII ten und XVIII ten Jahrhunderts*, The Hague, 1915–22.

Works on Individual Painters

The literature on individual painters is very uneven, in some areas non-existent. Very little of what has been written is in English. Most of the serious literature is in German and was written in the early part of the twentieth century, at a time when Germany dominated the critical field. The English-speaking world has not devoted itself, except in recent years, to the academic study of Dutch painting. This is surprising, as the collections in America and England contain a high proportion of the surviving Dutch pictures outside the great national galleries of Europe.

The following abbreviations are used throughout this part of the bibliography:

Thieme-Becker: Ulrich Thieme and Felix Becker, *Allgemeines Lexikon der bildender Künstded*, Leipzig, 1907–50. This is still the standard reference work for many of the biographies of a number of the painters in this book, particularly those who have not been the subject of a more modern critical study nor of a proper catalogue raisonné.

HdG: Cornelis Hofstede de Groot, *A Catalogue Raisonné of the Works of the Most Eminent Dutch Painters of the 17th Century*. Vols. I–VIII were translated by Edward G. Hawke, London, 1908–27; vols. IX–X were not translated from the German. This set of volumes still remains as the basic source material on which many modern studies have been based. From the lists which Hofstede de Groot compiled it is possible to gain a general idea of the range of each painter. In numerous instances his work has not been brought up to date.

Willem van AELST
There has never been a serious study of this painter. See Thieme-Becker for biography.

Jan ASSELIJN
A. C. Steland-Stief, *Jan Asselijn nach 1610 bis 1652*, 1971. The published version of a thesis written ten years earlier; a thorough catalogue and stylistic analysis.

Hendrick AVERCAMP
C. J. Welcker, *Hendrick Avercamp (1585–1634), bijgenaamd 'de Stomme van Kampen', en Barent Avercamp (1612–1679), Schilders tot Kampen*, 1933. This was a beautifully produced book which included a catalogue of the work of both artists. A new edition was issued in 1976.

Dirck van BABUREN
L. J. Slatkes, *Dirck van Baburen*, 1962. A thorough and scholarly study and catalogue of the thirty or so surviving pictures by Baburen.

Ludolf BAKHUIZEN
HdG, Vol. VII. There has been no other study of this important seascape painter.

Adriaen BEELDEMAKER
There has never been a study of this painter. For biography see Thieme-Becker.

Nicolaes BERCHEM
HdG Vol. IX. HdG listed a colossal number of pictures under Berchem's name and no modern scholar has yet tried to sort them out. A group of his best pictures was catalogued by Albert Blankert in the 1965 Utrecht exhibition catalogue.

Gerrit BERCKHEYDE
There has never been a serious study of this painter. The most recent biography is in Neil Maclaren, London, National Gallery, *Catalogue of the Dutch School*, 1960.

Abraham van BEYEREN
H. E. van Gelder, *W. C. Heda, A. van Beyeren, W. Kalf*, 1941. A short study of three important still-life painters.

Abraham BLOEMAERT
G. Delbanco, *Der Maler Abraham Bloemaert*, 1928. This is now out-of-date, but still the only serious study of this important painter.

Ferdinand BOL
Albert Blankert, *Ferdinand Bol 1616–1680, een Leerling van Rembrandt*, a thesis presented to the University of Utrecht, 1976. This is a careful study with emphasis on his commissions and relationship to Rembrandt, and a catalogue raisonné reducing Bol's oeuvre to about 200 pictures.

Paulus BOR
Vitale Bloch, 'Zur Malerei des Paulus Bor' *Oud Holland*, XLV, 1928 and 'Orlando', *Oud Holland* LXIV, 1949. Although there has never been a full study of this painter, these two articles are representative of the author's efforts to rehabilitate this type of art.

Ambrosius BOSSCHAERT
L. J. Bol, *The Bosschaert Dynasty*, 1960. This is a catalogue of a whole generation of flower painters and a brilliant essay on the flower lovers of Middelburg. One of the best books ever written on a flower painter.

Jan BOTH
J. D. Burke, *Jan Both*, 1976. A published thesis bringing HdG, Vol. IX up to date. The author has been severe with his attributions, producing a very limited corpus.

Leonaert BRAMER
H. Wichmann, *Leonart Bramer*, 1923. Now out-of-date, but a thorough study with a catalogue raisonné.

Bartholomeus BREENBERGH
W. Stechow, 'Bartholomeus Breenbergh, Landschafts und Historienmaler', *Jahrbuch der Preussischen Kunstsammlungen*, Vol. LI, 1930. The first general study, complemented by A. Blankert in the 1965 Utrecht exhibition catalogue.

Jan van BIJLERT
Arthur von Schneider, *Caravaggio und die Niederländer*, 1933 pp. 44–47, 131–132. There has been no recent study of this painter and the above work, although it deals with the whole field, is still reliable. See also Richard Spear in the 1971 Cleveland exhibition catalogue.

Govert CAMPHUYSEN
No study has been made of this underestimated painter. For biography see Thieme-Becker.

Jan van de CAPPELLE
HdG, Vol. VII. Revised and brought up to date by Margarita Russell, *Jan van de Cappelle*, 1975, which features a good corpus of plates including attributed works.

Pieter CLAESZ.
Ingvar Bergström, *Dutch Still-Life Painting*, 1956 pp. 114–123. No individual study has been devoted to Claesz.

Pieter CODDE
Jr. P. Brandt, 'Notities over het Leven en Werk van den amsterdamschen Schilder Pieter Codde', *Historia*, XII, 1947. This is the only study so far on this painter.

Adriaen COORTE
Exhibition Catalogue by F. J. Bol, Dordrecht Museum, *Adriaen Coorte*, 1958. Short introduction and catalogue of most of the extremely rare pictures by this obscure master.

CORNELIS van Haarlem
Carel van Mander, *Het Schilderboeck*, 1604. In default of a modern biography, van Mander remains the only accessible account of the first part of his career.

Aelbert CUYP
HdG, Vol. II. HdG included far too many pictures in his work, but the opposite extreme has been taken recently by Stephen Reiss, *Aelbert Cuyp*, 1975, where many important pictures have either been left out or rejected. It has useful plates and a concordance with HdG.

Arent DIEPRAAM
There has been no study of this painter. A succinct analysis of the biographical problem was given in Neil Maclaren, London, National Gallery, *Catalogue of the Dutch School*, 1960.

Gerrit DOU
HdG, Vol. I; W. Martin, *Klassiker der Kunst, Gerard Dou*, 1913. Both of these are useful, and Martin's has a good selection of plates.

Hendrick DUBBELS
L. J. Bol, *Holländischer Marinemalerei des 17 Jahrunderts*, 1973. Dubbels is included in this general survey.

Karel DU JARDIN
HdG, Vol. IX. The only recent study is by Albert Blankert in the 1965 Utrecht exhibition catalogue.

Willem DUYSTER
The most recent summary is found in Neil Maclaren, London, National Gallery, *Catalogue of the Dutch School*, 1960 p. 116.

Gerbrand van den EECKHOUT
R. Roy, *Studien zur Gerbrand van den Eeckhout*, 1972. A study which is still in typescript but includes a catalogue raisonné.

Allart van EVERDINGEN
S. Kalff, 'Twee Alkmaarder Schilders', *Elsevier's geïllustreerd Maandschrift*, Vol. LIII, 1922. A study of both Allart and Cesar van Everdingen.

Cesar van EVERDINGEN
V. Bloch, 'Pro Cesar Boetius van Everdingen' *Oud Holland*, 1936. Along with Kalff's work (see above) this is one of the few studies of this important painter.

Barent FABRITIUS
D. Pont, *Barent Fabritius, 1624–1673*, 1958. A well-illustrated catalogue raisonné.

Carel FABRITIUS
HdG, Vol. I. Very few new pictures have been discovered since HdG, and although several important specialist studies have appeared there has been no general analysis of the work of this interesting and important painter.

Aert de GELDER
K. Lilienfeld, *Arent de Gelder*, 1914. This is the standard catalogue raisonné, now out of date but still useful.

Hendrick GOLTZIUS
D. Hirschman, *Hendrick Goltzius als Maler, 1600–1617*, 1916. No study of Goltzius as a painter has been made since this one although brilliant studies by Reznicek have been devoted to his work as a draughtsman.

Jan van GOYEN
HdG, Vol. VIII; Hans-Ulrich Beck, *Jan van Goyen, 1596–1656*, 1972–3. The latter is an enormous work bringing HdG up to date and adding many new pictures. It is profusely illustrated. A supplement is in preparation. For pictures in English collections see Christopher Wright, *Jan van Goyen*, London, Alan Jacobs Gallery, 1977.

Pieter de GREBBER
There has been no recent study of this painter. For biography see Thieme-Becker.

Dirck HALS
W. Bürger (Thoré-Bürger), 'Dirck Hals et les fils de Frans Hals', *Gazette des Beaux-Arts*, Vol. XXV, 1868. A pioneer study by the discoverer of Vermeer.

Frans HALS
All the extensive earlier literature has now been superseded by Seymour Slive, *Frans Hals*, 3 vols, 1970–4. This is one of the best books ever written on a Dutch painter, copiously illustrated both with the masterpieces and with extensive comparative material. Its brilliance and thoroughness make most other recent studies appear amateur.

Willem Claesz. HEDA
H. E. van Gelder, *W. C. Heda, A. van Beyeren, W. Kalf*, 1941. A short study of three important seventeenth-century still-life painters.

Jan Davidsz. de HEEM
Ingvar Bergström, 'De Heem's Painting of his First Dutch Period', *Oud Holland*, Vol. LXXI, 1956. Bergström is the most reliable authority of Dutch still-life painting. There is still no catalogue of de Heem's work.

Bartholomeus van der HELST
J. J. de Gelder, *Bartholomeus van der Helst*, 1921. A thorough study and catalogue raisonné.

Jan van der HEYDEN
HdG, Vol. VIII; Helga Wagner, *Jan van der Heyden, 1637–1712*, 1971. The latter is a well-illustrated updating of HdG with a short introduction.

Meyndert HOBBEMA
HdG, Vol. IV. Hobbema has been badly served since HdG, although there have been several important studies on his very early period and his relationship with Jacob van Ruisdael.

Melchior de HONDECOETER
There has been no recent study of this painter, although the documents were published at the end of the nineteenth century. For a short biography see Neil Maclaren, London, National Gallery, *Catalogue of the Dutch School*, 1960.

Gerrit van HONTHORST
J. R. Judson, *Gerrit van Honthorst*, 1959. A curious example of taste influencing a historical study: the portraits and later work are excluded from the catalogue raisonné. For a recent summary see Richard Spear in the 1971 Cleveland exhibition catalogue, *Caravaggio and his Followers*.

Pieter de HOOGH
HdG Vol. I; W. R. Valentiner, *Klassiker der Kunst, Pieter de Hoogh*, 1929. Valentiner's book contains the best group of reproductions to date, including pictures by followers. A new study is in active preparation.

Samuel van HOOGSTRATEN
There is no general study of the painter; all the literature has concentrated on the artist's interest in perspective. A thorough study of the famous 'peep-show' or perspective-box is included in Neil Maclaren, London, National Gallery, *Catalogue of the Dutch School*, 1960 pp. 191–195.

Willem KALF
L. Grisebach, *Willem Kalf*, 1974. An up-to-date study and catalogue raisonné.

Thomas de KEYSER
R. Oldenbourg, *Thomas de Keysers Tätigheit als Maler*, 1911. A catalogue raisonné, now out of date.

Philips KONINCK
Horst Gerson, *Philips Koninck*, 1936. A well-written and illustrated study and catalogue raisonné. Very few new pictures have since appeared.

Pieter van LAER
Albert Blankert has written about this artist in the 1965 Utrecht exhibition catalogue. There is still no thorough study of this painter.

Pieter LASTMAN
K. Freise, *Pieter Lastman, sein Leben und sein Kunst*, 1911. Now out of date, but still the only general survey.

Jacob LEVECQ
There has been no study of this painter. For biography see Thieme-Becker.

Judith LEYSTER
J. Harms, 'Judith Leyster, Ihr Leben und ihr Werk', *Oud Holland*, 1927. A general survey in a series of articles.

Jan LIEVENS
H. Schneider, *Jan Lievens, sein Leben und seine Werke*, 1932. A general study and catalogue raisonné, reprinted and revised by R. E. O. Ekkart, 1973.

Johannes LINGELBACH
There has been no recent study. For biography see Thieme-Becker.

Nicolaes MAES
HdG Vol. VI; W. R. Valentiner, *Nicolaes Maes*, 1924. No new study has since appeared since these two basic works.

Gabriel METSU
HdG Vol. I; Franklin W. Robinson, *Gabriel Metsu*, 1974. The latter is a general and well-illustrated study of all the artist's most important pictures.

Frans van MIERIS
HdG Vol. X. There has been no recent study of this painter.

Jan Miensz. MOLENAER
There has been no recent general study, but for biography and bibliography see Neil Maclaren, London, National Gallery, *Catalogue of the Dutch School*, 1960.

Pieter de MOLIJN
Two specialist studies appeared in Swedish in the 1880s. The only general survey is found in Wolfgang Stechow, *Dutch Landscape Painting in the Seventeenth Century*, 1966.

Aert van der NEER
HdG Vol. VII. For a general survey see Wolfgang Stechow, *Dutch Landscape Painting in the Seventeenth Century*, 1966.

Eglon van der NEER
HdG Vol. VII. There has been no recent study of this painter.

Caspar NETSCHER
HdG Vol. V. There has been no recent study.

Jacob OCHTERVELT
For biography and bibliography see Neil Maclaren, London, National Gallery, *Catalogue of the Dutch School*, 1960.

Adriaen van OSTADE
HdG Vol. III. There has been no recent study.

Anthonie PALAMEDESZ.
For biography see Thieme-Becker.

Cornelis van POELENBURGH
The only recent study is by Albert Blankert in the 1965 Utrecht catalogue.

Frans POST
E. Larsen, *Frans Post*, 1962; J. de Soûsa-Leão, *Frans Post*, 1973. The latter catalogue raisonné supersedes Larsen's. Both books are well-illustrated.

Hendrick POT
For short biography and bibliography see Neil Maclaren, London, National Gallery, *Catalogue of the Dutch School*, 1960.

Paulus POTTER
HdG Vol. IV. Unusually there were two monographs, by Westrheen in 1867 and Michel in 1907, before that of HdG. There has been no study in recent years.

Adam PIJNACKER
HdG Vol. IX. The recent study is by Albert Blankert in the 1965 Utrecht catalogue.

Pieter QUAST
A. Bredius, 'Pieter Jansz. Quast', *Oud Holland* Vol. XX, 1902. There has been no recent study.

REMBRANDT Harmensz. van Rijn
The following catalogues of Rembrandt's work have so far been made. None are definitive and all are useful; they often chart the changes in taste quite accurately by the pictures they omit or include. John Smith, *A Catalogue Raisonné of the Works of the Most Eminent Dutch, Flemish and French Painters*, Vol. VII, *Rembrandt van Rhyn*, 1836.
Wilhelm von Bode and Cornelis Hofstede de Groot, *The Complete Works of Rembrandt*, 8 vols, 1897–1906.
W. R. Valentiner, *Klassiker der Kunst, Rembrandt*, various editions, 1908, 1922.
A. Bredius, *The Paintings of Rembrandt*, 1935, second edition revised by Horst Gerson, 1969.
Kurt Bauch, *Rembrandt Gemälde*, 1966.
Giovanni Arpino and Paolo Lecaldano, *L'Opera Completa di Rembrandt* 1969.
There have been innumerable specialist studies and a selective list of 119 of these was provided by Rosenberg, Slive and Ter Kuile in *Dutch Art and Architecture, 1600–1800*, 1966. There have also been many general introductions to Rembrandt's art and a full bibliography would run to several thousand items.

Jacob van RUISDAEL
HdG Vol. IV; Jacob Rosenberg, *Jacob van Ruisdael*, 1928. This monumental and well-illustrated work is at present under revision by the author.

Rachel RUYSCH
HdG Vol. X; M. H. Grant, *Rachel Ruysch*, 1956. This is an updating of HdG with many illustrations.

Salomon van RUYSDAEL
Wolfgang Stechow, *Salomon van Ruysdael*, 1938. A full catalogue raisonné and stylistic analysis. A new edition of this work was produced in 1976.

Pieter Jansz. SAENREDAM
P. T. A. Swillens, *Pieter Jansz. Saenredam*, 1935. This excellent study was brought up to date in the fully illustrated exhibition catalogue and catalogue raisonné, Utrecht, Centraal Museum, *Pieter Jansz. Saenredam*, 1961.

Godfried SCHALCKEN
HdG Vol. V. There has been no recent study.

Hercules SEGHERS
Almost all the extensive literature concentrates on the etchings. For biography see Neil Maclaren, London, National Gallery, *Catalogue of the Dutch School*, 1960.

Jan STEEN
HdG Vol. I. There have been a large number of specialist studies in recent years; the most up-to-date general study is by P. N. H. Domela in the exhibition catalogue, The Hague, Mauritshuis, *Jan Steen*, 1958–9.

Matthias STOMER
For a biography and account of the current state of research see Richard Spear in the 1971 Cleveland exhibition catalogue.

Michiel SWEERTS
Most of Sweerts' pictures were brought together in 1958 for an exhibition in Rotterdam and Rome. Catalogue by R. Kultzen, *Michiel Sweerts*, 1958.

Gerard TERBORCH
HdG Vol. V; S. J. Gudlauggson, *Gerard Ter Borch*, 2 vols, 1959–60. One of the most thorough monographs written on a Dutch seventeenth-century painter; profusely illustrated.

Hendrick TERBRUGGHEN
Benedict Nicolson, *Hendrick Terbrugghen*, 1958. An exemplary and well-illustrated monograph on a painter who had previously been little studied.

Jan TRECK
For biography see Neil Maclaren, London, National Gallery, *Catalogue of the Dutch School*, 1960.

Adriaen van de VELDE
HdG Vol. IV. There has been no recent study of this painter.

Esaias van de VELDE
The real importance of this painter is assessed by Wolfgang Stechow in *Dutch Landscape Painters of the Seventeenth Century*, 1966.

Willem van de VELDE the Younger
HdG Vol. VII. There has been no recent study of the paintings, although a great deal of research has been published on the drawings at Greenwich.

VERMEER of Delft
The following catalogues have been produced:
W. Bürger (Thoré-Bürger), 'Van der Meer de Delft', *Gazette des Beaux-Arts,* Vol. XXI, 1866. The fundamental study rediscovering the artist.
HdG Vol. I.
A. B. de Vries, *Jan Vermeer van Delft,* 2nd ed. 1948.
André Malraux, *Tout Vermeer de Delft,* 1952.
Vitale Bloch, *Tutta La Pittura di Vermeer di Delft,* 1954.
Ludwig Goldscheider, *Jan Vermeer,* 1958.
Giuseppe Ungaretti and Piero Bianconi, *L'Opera Completa di Vermeer,* 1967.
Albert Blankert, *Johannes Vermeer,* 1975.
Christopher Wright, *Vermeer,* 1976.
There have also been many important critical studies, notably B. T. A. Swillens, *Johannes Vermeer,* 1950, and Lawrence Gowing, *Vermeer,* 1952.

Jan VERMEER of Haarlem
The only general comments on this little-known painter are found in Wolfgang Stechow, *Dutch Landscape Painting in the Seventeenth Century,* 1966.

Hendrick VERSCHURING
For biography see Neil Maclaren, London, National Gallery, *Catalogue of the Dutch School,* 1960.

Jan VERSPRONCK
S. Kalff, 'Een haarlemsche Portretschilder uit de gouden Eeuw', *Nieuwe Gids,* Vol. XXXIV, 1918.

Jan VICTORS
For biography see Neil Maclaren, London, National Gallery, *Catalogue of the Dutch School,* 1960.

Simon de VLIEGER
For biography see Neil Maclaren, London, National Gallery, *Catalogue of the Dutch School,* 1960.

Hendrick van VLIET
For biography see Thieme-Becker.

Jacobus VREL
C. Brière-Misme, 'Un Intimiste hollandais: Jacob Vrel', *Revue de l'Art Ancien et Moderne,* Vol. LXVIII, 1935. A study by the author who later wrote on Pieter Elinga Janssens.

Hendrick Cornelisz. VROOM
There is no general study of Vroom, but he is included in L. J. Bol, *Die Holländische Marinemalerei des 17 Jahrhunderts,* 1973.

Jan WEENIX
For biography see Neil Maclaren, London, National Gallery, *Catalogue of the Dutch School,* 1960.

Jan Baptist WEENIX
The artist was studied by Albert Blankert in the 1965 Utrecht exhibition catalogue.

Adriaen van der WERFF
HdG Vol. X. There has been no recent study.

Matthias WITHOOS
For biography see Thieme-Becker.

Emanuel de WITTE
I. Manke, *Emanuel de Witte, 1617–1692,* 1963. A well-illustrated and thorough catalogue raisonné.

Philips WOUWERMANS
HdG Vol. II. There has been no recent study.

Joachim WTEWAEL
C. M. A. A. Lindeman, *Joachim Anthonisz. Wtewael,* 1929. Well-documented and illustrated, but now out of date. Anne W. Lowenthal, *The Paintings of Joachim Anthonisz. Wtewael,* Thesis, Columbia University, 1975.

Jan WYNANTS
HdG Vol. VIII. A general survey of the artist is also included in Wolfgang Stechow, *Dutch Landscape Painting of the Seventeenth Century,* 1966.

Index

Numbers in bold indicate main entries; numbers in italics indicate illustrations. Note that in Dutch names ij = y.